THE SACRED MADE REAL

SPANISH PAINTING AND SCULPTURE 1600–1700

Xavier Bray

*with Alfonso Rodríguez G. de Ceballos,
Daphne Barbour and Judy Ozone*

*and contributions by Maria Fernanda Morón de Castro, Marjorie Trusted,
Eleonora Luciano, Rocio Izquierdo Moreno, Ignacio Hermoso Romero
and Maria del Valme Muñoz Rubio*

NATIONAL GALLERY COMPANY, LONDON
DISTRIBUTED BY YALE UNIVERSITY PRESS

Published to accompany the exhibition
The Sacred Made Real: Spanish Painting and Sculpture 1600–1700
The National Gallery, London, 21 October 2009–24 January 2010
National Gallery of Art, Washington, 28 February–31 May 2010

The exhibition at the National Gallery, London, is supported by The American Friends of the
National Gallery as a result of a generous grant from Howard and Roberta Ahmanson

The Henry Moore Foundation Special photography of sculptures reproduced in this book was
generously supported by a grant from The Henry Moore Foundation

GOBIERNO DE ESPAÑA MINISTERIO DE CULTURA DIRECCIÓN GENERAL DE BELLAS ARTES Y BIENES CULTURALES SUBDIRECCIÓN GENERAL DEL INSTITUTO DEL PATRIMONIO CULTURAL DE ESPAÑA

National Gallery publications generate valuable revenue for the Gallery to ensure
that future generations are able to enjoy the paintings as we do today.

First published in Great Britain in 2009 by
National Gallery Company Limited
St Vincent House
30 Orange Street
London WC2H 7HH
www.nationalgallery.org.uk

ISBN 978 1 85709 422 0 hardback 525537
ISBN 978 1 85709 448 0 paperback 525536

British Library Cataloguing-in-Publication Data
A catalogue record is available from the British Library
Library of Congress Control Number: 2009924276

Publisher: Louise Rice
Project Editor: Jan Green
Editor: Diana Davies
Designer: Libanus Press
Picture researcher: Maria Ranauro
Production: Jane Hyne and Penny Le Tissier
Printed and bound in Italy by Conti Tipocolor

Measurements of paintings give height before width;
measurements of sculpture give height, width and depth, in that order

Front cover: Juan Martínez Montañés and Francisco Pacheco, *Saint Francis Borgia*,
about 1624 (cat. 14, detail)
Back cover: Diego Velázquez, *The Immaculate Conception*, 1618–19
(cat. 8, detail); Juan Martínez Montañés and Francisco Pacheco, *The Virgin
of the Immaculate Conception*, 1606–8 (cat. 7, detail)
Frontispiece: Pedro de Mena, *Christ as the Man of Sorrows*, 1673
(cat. 20, detail)
Pages 12–13: Gregorio Fernández and unknown polychromer, *Dead Christ*, 1625–30
(cat. 27, detail)
Endpapers: Francisco Pacheco, 'A los professores del' Arte de la Pintura' ('To the
practitioners of the art of painting'), Seville 1622. Detail of Pacheco's
reply to Juan Martínez Montañés, 16 July 1622.
Biblioteca Nacional de España, Madrid (Mss 1713 fols 283 and 290)

Contents

Sponsor's foreword 6

Directors' foreword 7

Acknowledgements 8

Map of modern Spain 11

The Sacred Made Real: 15
Spanish Painting and Sculpture 1600–1700
XAVIER BRAY

The Art of Devotion: 45
Seventeenth-Century Spanish Painting and
Sculpture in its Religious Context
ALFONSO RODRÍGUEZ G. DE CEBALLOS

The Making of a Seventeenth-Century Spanish 59
Polychrome Sculpture
DAPHNE BARBOUR AND JUDY OZONE

CATALOGUE
Introductions by Xavier Bray

The Art of Painting Sculpture: The Quest for Reality 73

The Virgin of the Immaculate Conception 91

A True Likeness: Portraits 105

The Passion of Christ 129

Saint Francis in Meditation 173

The 'Spanish Paragone': Saint Serapion 191

Francisco Pacheco's Dispute with 194
Juan Martínez Montañés

Biographies of the Artists 196

Bibliography 198

Index 206

List of lenders 208

Photographic credits 208

Sponsor's Foreword

In the fall of 2002, my husband and I, together with our son and four friends, walked the Camino de Compostela from León, in north-west Spain, to Santiago in Galicia. Sore feet, burning knees, sunburn, aching limbs, and glory. So much glory. For our family, the journey began in Paris where we took our picture at the marking stone in front of Notre-Dame, the starting point for the Rue de St Jacques. We stopped in St Jean Pied de Port and then climbed and wound our way over the Pyrenees into Spain – to Pamplona, Burgos, León.

Our family had spent the fall of 1998 in Spain, exploring California's other mother country. The time was a visual and intellectual feast, so much to see, to learn, to absorb, and to comprehend. In Valladolid we briefly visited the sculpture museum, where I was introduced to an art form we know too little of in the United States. That art form is polychrome sculpture, and the Spanish were masters of it. But it wasn't until we drove and then walked the Camino that I saw just how magnificent and how compelling this work truly is. I think of the Siloe altars in Burgos Cathedral and the statue of Saint Bruno at the Carthusian monastery just outside the city. Then came the altar in the cathedral in Astorga, and others all along the way. The Camino was in some ways a walk through one of the world's greatest sculpture gardens.

Of course, Baroque Spanish painting was something I had learned about in school and then in art history in college. I had seen paintings, some of the greatest at galleries across the United States and in Europe, and I loved their power and their juxtaposition of darkness and light. But, when I saw the sculpture, I failed to connect it to the paintings. So, when Xavier Bray told me about his dream to do a show demonstrating how early Baroque Spanish painting and sculpture spoke to each other and influenced each other, I was excited. And so was my husband. Now, we are thankful to be part of this groundbreaking exhibition. And we hope that each one who sees it, in person or in print, will experience some of the joys and challenges of the Camino and the unflinching humanity of Baroque Spanish art.

ROBERTA GREEN AHMANSON
Corona del Mar, California
Memorial Day, 25 May 2009

Directors' Foreword

The Sacred Made Real introduces to a large public in Great Britain and the United States of America masterpieces by several European artists of the first rank whose work is not widely known outside their native Spain except to specialist art historians. It would perhaps be impossible to organise an exhibition which did full justice to the sculpture of Alonso Cano, Gregorio Fernández, Francisco Antonio Gijón, Juan Martínez Montañés, Pedro de Mena, Juan de Mesa and José de Mora because so much of it is still, to use the anthropologist's term, 'in worship' – but what has been assembled here, thanks to the extraordinary generosity of ecclesiastical and civil institutions in Spain, demonstrates that Spanish polychrome wood sculptures are worthy of the same attention as the paintings by Zurbarán, Murillo and Velázquez that are displayed beside them. The exhibition is designed to address a neglect that has its roots in the disdain with which the Enlightenment regarded these devotional works of art as objects of superstitious veneration, a disdain that was often mingled with the Protestant distaste for Mariolatry and martyrs.

The exhibition, however, has an additional argument. It does not merely make a claim for a technique of sculpture, but it also explores the complex and reciprocal relationship between the sister arts in seventeenth-century Spain. This exploration begins with the fact that painters were responsible for colouring carved wooden sculptures, and this created a mutual dependency – and rivalry – between painter and sculptor. However, the chief models for religious imagery, whose compelling power was sanctioned by popular appeal as well as official approval, were more often sculptures than paintings. The painters seem to have striven to emulate the enhanced vividness and three-dimensionality of polychrome sculpture, although there is a paradox in the case of Velázquez, whose mature work with its supreme illusionism in its attention to light and atmosphere successfully renders the impalpable features of the real world. It is our hope that those who have viewed the exhibition, whether in the National Gallery in London or the National Gallery of Art in Washington, will find that their understanding of Spanish painting and sculpture has been altered and enhanced and will be inspired to discover for themselves the glories of the museums, churches, and monasteries in Spain.

NICHOLAS PENNY, *Director*
The National Gallery, London

EARL A. POWELL III, *Director*
National Gallery of Art, Washington

Acknowledgements

This exhibition could not have been realised without the support and extraordinary generosity of certain institutions and individuals in Spain. The Ministry of Culture played more than a crucial role in securing key loans for us, and we are especially grateful to the General Director of Fine Arts and Cultural Assets, José Jiménez, and his adviser, Emma Brasó, for their invaluable help. We would also particularly like to thank Antón Castro Fernández and Monica Redondo Álvarez from the Instituto del Patrimonio Cultural de España and their sculpture conservators and photographers; Laura Ceballos Enríquez, Marta Fernández de Córdoba, José Luis Muñizo, Tomás Antelo, Araceli Gabaldón, Miriam Bueso and Ángeles Anaya, who restored the *Saint Francis standing in Ecstasy* by Pedro de Mena, which has never before left Toledo Cathedral, as well as verifying the condition of the *Ecce Homo* by Gregorio Fernández. Their care and attention to detail assured the safe travel of the sculptures to London and Washington.

The support of the Spanish Church has been fundamental in granting permission for a number of sculptures featured in the exhibition to leave their religious context for the first time. Archbishop Antonio Cañizares Llovera, formerly Primate of Spain, now prefect of the Congregation for the Divine Worship at the Vatican, Archbishop Braulio Rodríguez Plaza, the present Primate of Spain, and Archbishop Carlos Amigo Vallejo, have been especially generous in advocating the loans of three masterpieces of Spanish sculpture. Special thanks are also due to the Deans of these Cathedrals, Juan Sánchez Rodríguez, Sebastián Centeno Fuentes and Francisco Ortiz Gómez. We are also especially grateful to Padre Juan Dobado Fernández from the Convent of the Santo Ángel, Seville; Padre Juan José Andrés Romero from the parish church of El Pedroso; the Abbess, Ana María Voces Sierra Ruda, and her community of the Real Monasterio de San Joaquín y Santa Ana, Valladolid; Padre Javier Carlos Gómez from the parish church of San Miguel, Valladolid; and the nuns from the royal convent of the Descalzas Reales, Madrid, for sharing with us their sculptures that are still so much a part of their daily devotions. We would also like to thank the members of the Archicofradía del Santísimo Cristo del Amor, particularly Luis Torres Palazón, Fernando Candau del Cid, Ángel Cano Goicoechea and Joaquín Víctor Ruiz Franco-Baux, for lending their *Crucifixion* by Juan de Mesa, which is also still part of the Confraternity's devotional practices.

The museums of Spain have been exceptionally generous in lending masterpieces of religious painting and sculpture under their care. Miguel Zugaza Miranda and Gabriele Finaldi from the Museo Nacional del Prado provided invaluable moral support and endorsed the exhibition from the outset. Not only did they lend important paintings from the Prado's collection but they also helped secure the loan of two Spanish sculptures that are currently on permanent display in the Museo Nacional del Colegio de San Gregorio in Valladolid (*Mary Magdalene* by Pedro de Mena and Gregorio Fernández's *Dead Christ*). Special thanks are also due Javier Portús, Leticia Azcúe Brea, Leticia Ruiz Gómez, Pilar Sedano, Carmen Garrido and Sonia Tortajada from the Prado. We would like to extend our gratitude to the Museo Nacional del Colegio de San Gregorio and its director, Maria Bolaños, as well as curators José Ignacio Hernández Redondo, Manuel Arias, Miguel Ángel Marcos Villán, for their willingness to lend Mena's *Mary Magdalene* and Fernández's *Dead Christ*, particularly since the museum has recently re-opened to the public. We would like to thank Yago Pico de Coaña, José Antonio Bordallo Huidobro, Juan Carlos de la Mata González and María Jesús Herrero Sanz from the Patrimonio Nacional, Madrid, for securing on our behalf Pedro de Mena's great *Ecce Homo*.

In Seville, the Museo de Bellas Artes have been exceptionally generous in lending two of their greatest possessions, the large canvas by Zurbarán of the *Virgin of Mercy of Las Cuevas* and Juan Martínez Montañés's carving of *Saint Bruno*. We are especially grateful to the museum's director, Antonio Álvarez Rojas, and his curatorial and conservation team, María del Valme Muñoz Rubio, Rocío Izquierdo Moreno, Ignacio Hermoso Romero, Ignacio Cano Rivero and Fuensanta de la Paz Calatrava, for permitting these key works of art to travel to London. The University of Seville have been extremely sympathetic to the exhibition, and we are very grateful to the Rector, Joaquín Luque Rodríguez, and the University collections' curator, María Fernanda Morón de Castro, for sending two superb sculptures by Montañés and Pacheco. In Granada, we would like to thank Ricardo Tenorio Vera from the Museo de Bellas Artes and José María Luna Aguilar and Javier Moya Morales from the Fundación Rodriguez-Acosta for their key contributions. From the Museu Nacional d'Art de Catalunya, Barcelona, we would like to thank María Teresa Ocaña, Margarita Cuyas and Joan Yeguas i Gassó for making it possible to lend their treasured Zurbarán of *Saint Francis standing in Ecstasy*. Finally, we are very grateful to the private collector who has once again so generously agreed to lend his portrait of Jerónima de la Fuente by Velázquez to the National Gallery.

Special thanks are due to Jim Cuno and Martha Wolff from the Art Institute of Chicago who early on agreed to lend Zurbarán's masterpiece of 'sculptural painting', *Christ on the Cross*, an exceptional loan that is central to this exhibition. We are grateful also to Susan L. Talbott and Eric Zafran from The Wadsworth Atheneum, who made it possible for another great masterpiece by Zurbarán, *Saint Serapion,* to return to London for the first time since the nineteenth century, when it left the collection of the British Hispanist Richard Ford.

Our partner in this exhibition is the National Gallery of Art in Washington. We are delighted to have this opportunity to offer our heartfelt thanks to Earl A. Powell III, director, for his wholehearted support of this project from its inception.

Gallery conservators Shelley Sturman, Brittany Dolph, and Steve Wilcox aided us with their contributions to didactic material, while Dylan Smith, Katy May and Simona Cristianetti offered their expertise in computer imaging. Daphne Barbour and Judy Ozone shared with us their profound experience with the techniques of polychromy. Julia Sybalsky, formerly of the object conservation department, provided a superb schematic drawing. Curators Mary Levkoff and Eleonora Luciano, in the department of sculpture and decorative arts, offered invaluable scholarly insights, and, with curators David Brown and Gretchen Hirschauer of the department of Renaissance painting, advocated the participation of the National Gallery of Art. We are grateful for the efforts of D. Dodge Thompson, Jennifer Cipriano, and Lauren Mecca in the exhibitions office; Mark Leithauser and Donna Kirk in the design office; Michelle Fondas in the registrar's office; Michael Pierce in conservation; and Susan Arensberg in exhibition programs.

In London, we would like to thank the British Museum's Prints and Drawings Department, particularly Anthony Griffiths, Mark McDonald and Marta Cacho Casal. At the Victoria and Albert Museum, one of the earliest public collections outside Spain to include Spanish sculpture, we are extremely grateful to Mark Jones and Marjorie Trusted, along with their conservators, Charlotte Hubbard and Sofía Marqués, for lending us two sculptures for our techniques section of the exhibition.

In organising this exhibition, we benefited from the help of the following individuals: in Spain, Miguel Ángel Cortés played a fundamental role in facilitating the loans with the Cathedrals of Toledo and Valladolid; Andrés Álvarez Vicente was extraordinarily helpful with his contacts with the confraternities and ecclesiastical institutions in Valladolid. In London, the former Spanish Ambassador, Carlos Miranda, Count of Casa Miranda, and Ambassador Carles Casajuana i Palet have been consistently obliging with requests; in particular Juan Mazarredo and his assistant, Carmen Brieva, provided instrumental leads and introductions. The staff of the Spanish Embassy in Washington, notably Jorge Sobredo and Francisco Tardio Baeza, was tremendously helpful. We are very grateful to the former Archbishop of Westminster, Cormac Murphy O'Connor, who kindly wrote on our behalf to ecclesiastical institutions in Spain in support of this exhibition. We are also indebted to the Papal Nuncio in London, Archbishop Faustino Sainz Muñoz, for his assistance.

We received much help from the regional governments of Andalucía and Castilla y León. At the Consejería de Cultura in Seville, Pablo Suárez, Jesús Romero Benítez, José Luis Romero Torres, José Luis Ravé, Lorenzo Pérez del Campo, Pablo Hereza Lebrón shared their passion for Andalusian sculpture with us. We are also very grateful to the Instituto Andaluz del Patrimonio Histórico de Restauración and their conservators, especially Gabriel Ferreras Romero, for letting us see sculptures in the process of restoration. From the Junta de Castilla y León, María José Salgueiro Cortiñas was very supportive in our requests to borrow works from Valladolid, particularly from the Real Monasterio de San Joaquín y Santa Ana. Last but not least, we could not have done without the sterling assistance of Esther Moreno-Barriuso and Mercedes Cerón for translating much of the loan correspondence.

The fieldwork and documentary research for this exhibition was generously supported by the Getty Fellowship programme, which allowed the exhibition's curator, Xavier Bray, to spend three months in Spain. The teaching staff from the Universities of Seville, Granada, and Vallalodid have been unfailingly generous with their time and knowledge. In Seville, we would like to thank Emilio Gómez Piñol, José Roda Peña, Rafael Ramos Sosa, Enrique Valdivieso, Jesús Palomero Páramo, Alfredo Morales, Luis Méndez and the library staff from the Laboratorio del Arte, and in Granada, we owe much to Juan Jesús López-Guadalupe Muñoz, Domingo Sánchez-Mesa Martín, Lázaro Gila Medina. In Valladolid, it was Jesús Urrea Fernández who inspired us with his knowledge about the work of Gregorio Fernández. In London, at the Warburg Institute, we would like to thank Elizabeth McGrath, François Quiviger and Paul Taylor. We are very grateful to Antonio Mazzotta for his help with the bibliography of the exhibition catalogue.

The staff of the National Gallery, which is traditionally devoted exclusively to paintings, greatly benefited from the technical advice on polychrome wood sculptures offered by Francisco Arquillo Torres from the Escuela de Bellas Artes, Seville, and 'imagineros' Juan Manuel Miñarro López and Darío Fernández in Seville and Miguel Ángel Tapia in Valladolid communicated to us their passion for an art form that is thriving in Spain today. We would also like to thank Jane Bassett from the J. Paul Getty Museum for sharing her findings about the technique of Luisa Roldán's San Ginés, as well as Patrick Lenaghan and Monica Katz for allowing us to have access to sculptures while in the process of restoration at the Hispanic Society of America, New York. We are also very thankful to Patrick Matthiesen, Nicolás Cortés and Jorge Coll for sponsoring the commission of Darío Fernández's copy of the head and shoulders of Saint John of the Cross for the materials and techniques section of the exhibition.

Special photography of sculptures illustrated in this book was made possible by a grant from The Henry Moore Foundation.

Without the generous support of Howard and Roberta Ahmanson, the exhibition in London would not have been possible. We hope they will feel that both the exhibition and the catalogue do justice to their vision.

Numerous individuals shared with us their insights about Spanish art.
It is a pleasure to acknowledge them here.

Javier Alaminos
Monica Andrada Vanderbilde
Bentley Angliss
Jacqui Ansell
Piru Araoz y Marañón
Ildefonso Asenjo
Richard Aster
Ángel Aterido Fernández

Ronni Baer
Belén Bartolomé Francia
Ana María Bermúdez
Andreas Blühm
David Bomford
Antonio Bonet Correa
Antonia Boström
Bruce Boucher
Beatriz Anabitarte Bravo
 de Laguna
Hugh Brigstocke
Jonathan Brown

Luis Caballero García
Enrique de Calderón
Francisco Calvo Serraller
Marietta Cambareri
Amalia Cansino
Imma Casas
Manuel Cascales Ayala
Peter Cherry
Keith Christiansen
Jesús Clavero Rodríguez
Inés Cobos
José Luis Colomer
Ilenia Colon
Brian Considine
Antonio Bonet Correa
David Cox
Nicholas Cranfield
Fernando Cruz-Conde
María Cruz de Carlos
Penelope Curtis

María Teresa Dabio González
David Davies
Odile Delenda
Fr Francis Dobson

David Ekserdjian
John Elliott
Felipe Esteban Alonso

Miguel Falomir
Guillaume Faroult
Antonio Fernández
Consuelo Fernández de
 Córdoba Ybarra
Felipe Fernández-Armesto
Víctor Franco de Baux
David Freedberg

Fernando García Gutiérrez
Francisco García Mota
Pierre Géal
Véronique Gérard-Powell
Nigel Glendinning
John Gibbons
Ian Gibson
Anastasio Gómez Hidalgo
José Antonio Gómez Mateo
Christopher González Aller
Stéphane Guégan
Olivier Guérin

Rebecca Hast
Karen Hellwig
Gijs van Hensbergen
Antonio Hernández Jilgueras
Mayra Herrera
Jason Herrick
Nicholas Holtam
Stephen Hough
Daniel Hunt
Abigail Hykin

Carmen Íñiguez Berbeira

Michael Jacobs
Donald Johnston

Ronda Kasl
Daniel Katz
Tim Knox

Teresa Laguna
Erika Langmuir
Adrian Lock
Todd Longstaffe Gowan
Fernando López Barrau
Félix López Zarzuelo
Consuelo Luca de Tena
José María Luzón Nogué

Ignacio Mantilla de los Ríos
 de Rojas
Fernando Marías
Miguel Marín
Manuela Mena
Nuria de Miguel Poch
Minna Moore Ede
Anabel Morillo León
Rosemary Mulcahy

Benito Navarrete Prieto
Cristóbal Navarro Belda
Francisco Navarro Ruiz

Roberta Panzanelli
René Jesús Payo Hernanz
Antonio Piñero
Alfonso Pleguezuelo
Jesús Porres Benavides
Sara Puig Alsina

Michael Rainey
Martin Randall
Claudie Ressort
Mark Richter

Jesús Antonio del Río Santana
Joe Rishel
Mark Roglán
Conchita Romero
Martin Royalton-Kisch

Luis Sagrera
Miguel Sánchez
Juan Antonio Sánchez López
José Luis Sancho
Charles Saumarez Smith
Eike Schmidt
Sarah Schroth
Keith Sciberras
Jan Siegel
Antonio Silva de Pablos
Maria Sidsel Søndergaard
Angus Stewart
Susanne Stratton-Pruitt
Jan Stubbe Østergaard

Rachel Thomas
Magdalena Torres
Gail Turner Mooney

José Antonio de Urbina
Fiona Urquhart

José Luis Velasco Martínez
Zahira Véliz
Richard Verdi
Alberto Villar Movillán

Alison Watt
Catherine Whistler
Richard de Willermin
Christopher C. Wilson
Juliet Wilson Bareau
Tom Windross

Pascal Zuber

CATALOGUE ENTRIES WRITTEN BY

XB	Xavier Bray
MFMC	María Fernanda Morón de Castro
MT	Marjorie Trusted
EL	Eleonora Luciano
RIM	Rocío Izquierdo Moreno
IHR	Ignacio Hermoso Romero
MVMR	María del Valme Muñoz Rubio

Xavier Bray is Assistant Curator of Seventeenth- and Eighteenth-century Painting at the National Gallery, London. Alfonso Rodríguez G. de Ceballos was formerly Professor at the Universidad Autónoma, Madrid. Daphne Barbour and Judy Ozone are Senior Object Conservators and Eleonora Luciano is Associate Curator of Sculpture, all at the National Gallery of Art, Washington. Marjorie Trusted is Senior Curator of Sculpture at the Victoria and Albert Museum, London. María Fernanda Morón de Castro is Curator of Collections, University of Seville. María del Valme Muñoz Rubio is Chief Curator and Rocío Izquierdo Moreno and Ignacio Hermoso Romero are curators at the Museo de Bellas Artes, Seville.

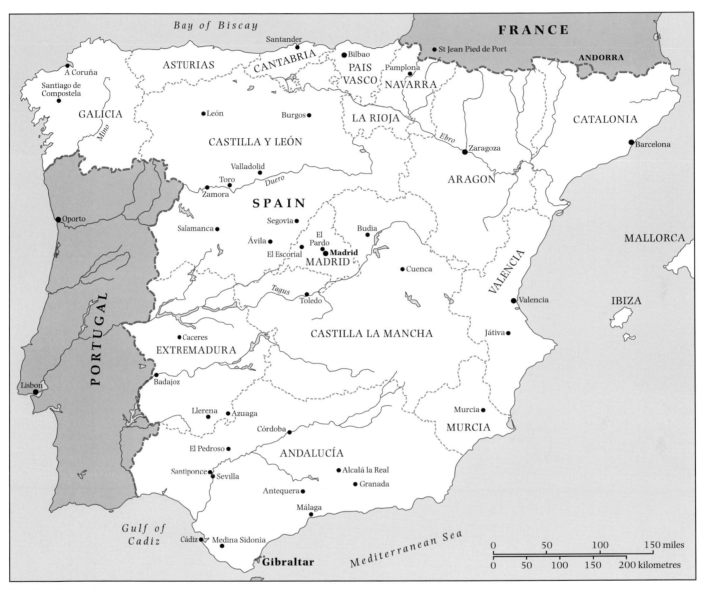

Map of modern Spain

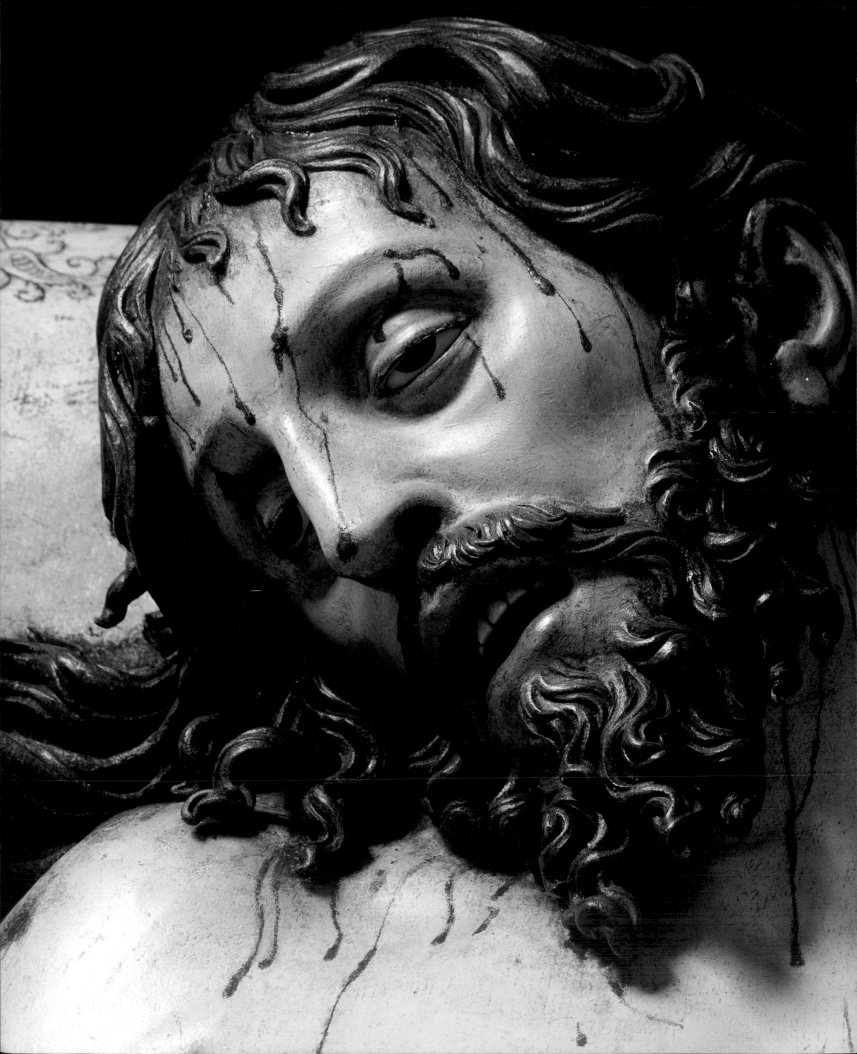

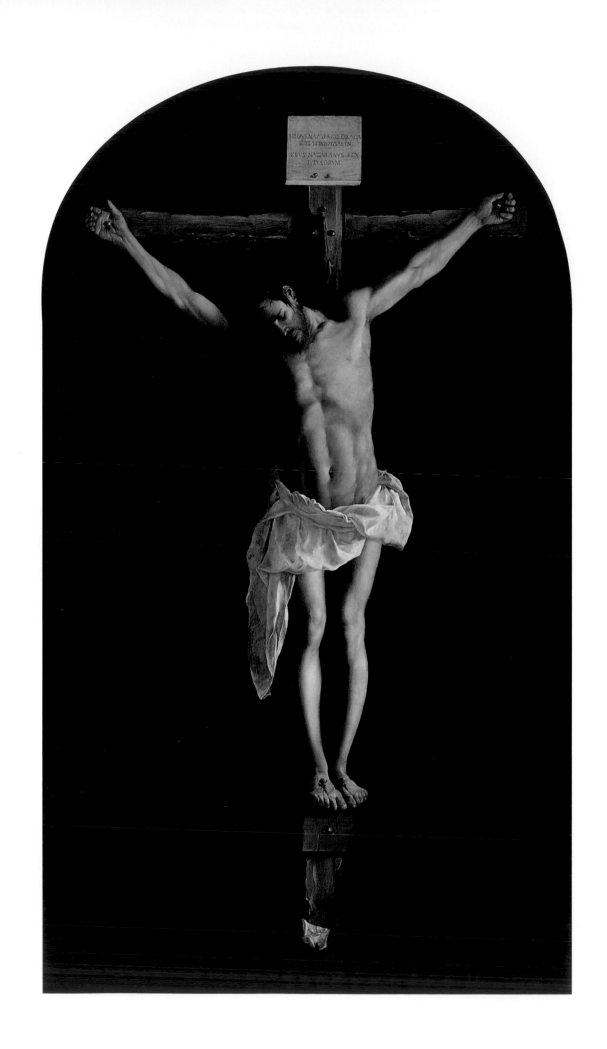

The Sacred Made Real

Spanish Painting and Sculpture 1600–1700

XAVIER BRAY

In 1627, Francisco de Zurbarán made a painting of Christ on the Cross for a small oratory attached to the sacristy of the Dominican friary of San Pablo in Seville. It was quickly recognised as a masterpiece (fig. 1 and cat. 25).[1] Those who saw it were impressed above all by the illusion of its three-dimensionality. When in the early years of the eighteenth century the Spanish art historian and painter Antonio Palomino (1653–1726) recorded the details of his visit there, he wrote: 'there is a crucifix from his [Zurbarán's] hand which is shown behind a grille [*reja*] of the chapel (which has little light), and everyone who sees it and does not know believes it to be sculpture.'[2]

Palomino's observation is revealing. It is significant that in this case the illusion of three-dimensionality is identified with that in polychrome sculpture, not with that in painting. Although it is generally accepted that the realism of seventeenth-century Spanish painting reflects pictorial traditions, especially as manifested in the art of Caravaggio and his followers, and in Netherlandish prints, it will be argued in this essay that the very act of painting three-dimensional sculptures also played a major role. Indeed the paintings and polychrome sculptures discussed here would seem to reveal that the influence was more widespread and profound than proposed hitherto. It is partly as a result of this dialogue between the arts of painting and sculpture that the sacred was made real in such a distinctive way.

Realism manifested itself in many different ways in painting throughout seventeenth-century Europe. In Italy, Caravaggio developed a mode of painting in which ordinary people were made to pose and re-enact episodes from the Bible. By using strong contrasts of light and shade, his compositions were transformed into dramatic 'tableaux vivants', giving the faithful a sense of direct access to the scene depicted. Such careful staging, controversial at first for reasons of decorum, was soon modified and sanctioned by the Church in its concern to shock the senses and stir the soul.

In Spain, a very different and a much starker brand of realism developed. Although painters such

2 Juan de Mesa (1583–1627)
Christ on the Cross, known as the *Cristo de la Buena Muerte*, 1620
Polychromed wood, life-size
Chapel of the University of Seville

Opposite: **1** Francisco de Zurbarán (1598–1644), *Christ on the Cross*, 1627 (cat. 25), as it would originally have been displayed, with an arched top

3 Juan Martínez Montañés (1568–1649)
Christ carrying the Cross, known as the *Cristo de la Pasión*, 1619, in procession during Holy Week
Cofradía del Cristo de la Pasión, Collegiate Church of El Salvador, Seville

as Zurbarán would have certainly been aware of Caravaggio's art through at least one original work by him and several copies available in Spain,[3] they had access to an art form that was exceptionally real in its very nature and part of their own religious and cultural heritage: painted wooden sculptures. Works such as Juan de Mesa's (1583–1627) life-size polychromed sculpture of *Christ on the Cross*, for example, commissioned in 1620 for the Jesuit house in Seville, were hugely venerated (fig. 2). Popularly known as the *Cristo de la Buena Muerte* ('Christ of the Good Death'), Christ is vividly depicted moments after his death, his body rigid, his head down, his flesh colour white. Hyper-real sculptures such as these made the sacred truly palpable. To approach this sculpture was to feel that one was truly in the presence of the dead Christ.

In their original context such sculptures, whether positioned on altars and lit by candles or processed through the streets on religious feast days, would have had a strong impact not only upon the faithful but also on painters' visual imaginations. Today, when the *paso* (float) carrying Juan Martínez Montañés's (1568–1649) sculpture of *Christ carrying the Cross* (1619) is carried on the shoulders of thirty men during Holy Week in Seville, the effect is astounding (fig. 3).[4] The movement of the *paso* as it sways from side to side endows the sculpture with a disconcerting sense of life, as if the streets of Seville had suddenly turned into the streets of Jerusalem. Similarly, Francisco Ribalta's (1565–1628) painting of the *Vision of Father Simón* shows the priest kneeling in the streets of Valencia as he has a vision of Christ carrying the cross, and one can imagine that Ribalta himself witnessed such a scene during Holy Week processions (fig. 4).

The tradition of painting sculpture began before recorded history. Neolithic cult objects were painted and the Ancient Egyptians, Greeks and Romans routinely coloured the sculptures of their gods to maximise the impression of divinity.[5] Spanish sculpture of the seventeenth century derives most clearly from the tradition of polychroming wood that began in the Middle Ages throughout Europe; moreover, the majority of the stone portals of cathedrals, churches and monasteries were covered

with lively colours.[6] The practice was so popular that Saint Bernard of Clairvaux criticised this opulence, caustically observing that for a figure of a saint displayed in a church, 'the more coloured it is, the holier it is held to be' (see cat. 10).[7] The practice nevertheless continued uninterrupted particularly in Germany and in the Southern Netherlands; in the latter, between 1380 and 1550, large carved altarpieces were mass produced and sold on the open market, ending up as far afield as Sweden and Spain.[8]

The Spanish mystic Saint John of the Cross (1542–1591), who had himself spent part of his youth in a sculptor's workshop, wrote of the value of polychromed sculptures, which he said were useful and even necessary to inspire reverence for the saints,

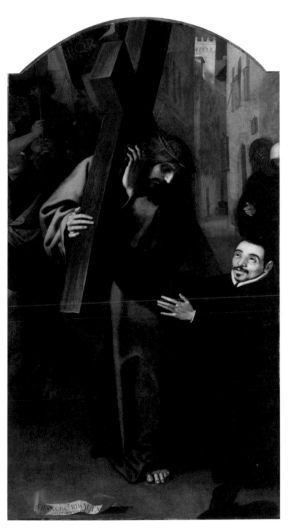

4 Francisco Ribalta (1565–1628)
The Vision of Father Simón, 1612
Oil on canvas, 210.8 x 110.5 cm
The National Gallery, London (NG 2930)

to move the will, and to awaken devotion (see cat. 17).[9] Contemporary preachers such as Francisco Fernández Galván believed sculpture to be far more effective than painting as an art form.[10] As Alfonso Rodríguez G. de Ceballos explains elsewhere in this volume (see pp. 45–57), it was believed that faithful representations of sacred subjects or a lifelike Saint Francis or Saint Bruno enabled those contemplating them to relive the experiences of these figures and imbibe their Christian messages. Compared with Italy, where during the Renaissance the plain colours of unadorned marble gradually replaced the polychroming of sculpture, in Spain the practice of painting wooden statues continued uninterrupted in the service of the Church and remains alive today.[11]

The seventeenth century – the period on which this essay focuses – was exceptional in Spanish art history for the levels of realism to which its artists aspired. In contrast to sculptors from the sixteenth century such as Alonso Berruguete (1488–1561) and Gaspar Becerra (1520–1568) who emulated the Italian idealisation of Michelangelo, seventeenth-century sculptors like Juan de Mesa attempted instead to make their sculpture increasingly lifelike and realistic. Some sculptors introduced glass eyes and tears, and even ivory teeth. To simulate the effect of coagulated blood on the wounds of Christ, the bark of a cork tree, painted red, was often employed. It is this shocking realism that makes Spanish seventeenth-century sculpture such a contrast to the more idealised bronzes and marbles produced in Italy in this period.

Palomino's comment that Zurbarán's painting *Christ on the Cross* was so realistic that it could be mistaken for a sculpture raises interesting artistic questions about the realism found in the art of not only Zurbarán but also in the religious paintings of many of his contemporaries. The trend towards realism had a strong effect on Francisco Pacheco (1564–1644), Diego Velázquez (1599–1660) and Alonso Cano (1601–1667) early in their careers. This may be due to an aspect of their training which has been less emphasised by scholars, namely the requirement for all young painters in Spain in this period to learn the art of painting wooden sculpture.

The close relationship between Spanish painting and sculpture resulted from a number of factors. At an institutional level the two arts were to some degree distinct. However, at a practical level their interdependence was more apparent. The production of religious sculptures in Spain (as in the rest of Europe) was strictly governed by guilds, the Guild of Carpenters (*carpinteros*) for the sculptors (*escultores*), and the Guild of Painters for the painters who polychromed them. Sculptors would carve their sculptures and gesso them 'in white' (*en blanco*) but were strictly prohibited from painting them themselves. This was reserved for a specially trained painter commonly known in Spain as a '*pintor de ymaginería*', a 'painter of [religious] imagery'. The title appears on all the *cartas de examenes* (diplomas) awarded to painters who had been examined before the painters' guild.

A recently discovered contract confirms that Francisco de Zurbarán (1598–1664) painted a wooden sculpture right at the beginning of his career. In 1624, he was commissioned by the Mercedarian monastery in Azuaga, near Llerena, in the western province of Extremadura (see map, p. 11), to carve and paint a life-size wooden sculpture of the Crucifixion.[12] Although the whereabouts of the sculpture is not known, this document would appear to illuminate a previously unknown aspect of Zurbarán's artistic activity. Whether or not he subcontracted the actual carving to a sculptor, it is significant that Zurbarán was responsible for the polychromy.[13]

THE ART OF PAINTING SCULPTURE

In the past, when art historians discussed polychrome sculpture they tended to consider only the sculptor, ignoring the polychromer.[14] Although sculpture and painting are traditionally executed by different hands, a polychromed sculpture was conceived as a single, seamless work of art. A good polychrome sculpture should appear so lifelike that one is at first unsure if it is alive or not.[15] Sculptors and painters were therefore dependent on each other's skill. A sculptor had to create a figure whose form was clearly defined, while the painter had to respect the undulations of the surface he was painting.[16]

Successful partnerships between sculptor and

painter have existed since Antiquity. The ancient Greek sculptor Praxiteles is said to have favoured the painter Nikias as the polychromer of his sculptures because he made them look so real.[17] In the fourteenth century, the Netherlandish sculptor Claus Sluter and the painter Jean Malouel together created what was said to have been an extraordinary feat of realism, the so-called *Well of Moses* at the Charterhouse of Champmol, just outside Dijon, which has since been irreparably weathered by the elements and the polychromy severely damaged.[18] But it was in Spain during the seventeenth century that some of the most successful partnerships existed between sculptor and painter: in Seville, Juan Martínez Montañés and Francisco Pacheco, Pedro Roldán and Juan de Valdés Léal; in Madrid, Manuel Pereira and José Leonardo and Francisco Camilo; and in Valladolid, Gregorio Fernández and Diego Valentín Díaz.

Probably the most celebrated and best documented collaboration between a painter and sculptor in the first half of the seventeenth century in Spain was that of the painter Pacheco and Montañés, a sculptor so revered that he was known as 'el dios de la madera' ('the god of wood') by his contemporaries. Pacheco's *Arte de la Pintura*, published posthumously in 1649, is our most important source of information about the production of sculpture and painting in seventeenth-century Seville. A successful painter in his own right, Pacheco also ran a thriving workshop that taught painting, including the polychromy of sculpture. He is now perhaps best known as the teacher and father-in-law of Velázquez. The third and final part of Pacheco's treatise, entitled 'On the practice of painting and all its uses', contains a section on how one should paint sculpture.[19] He believed it was colour which gave life to such works,[20] and the technique of painting in flesh tones was in fact known as *encarnación* (incarnation) – literally, made flesh.

Montañés had trained as a sculptor in Granada before settling in Seville in 1587 where he set up a successful workshop. He executed numerous altarpieces and individual figures of saints, some for the city and others for export to Peru.[21] His *Niño Jesús* (Christ Child) for the Confraternity of the Holy Sacrament in 1606 and *Inmaculada* (Virgin of the Immaculate Conception) made in the same year for the church of Santa María de la Consolación, El Pedroso (see cat. 7), were reproduced in variant forms by Montañés himself, as well as by his followers, establishing standard types which were to be imitated long after his death.

Pacheco and Montañés worked together on several occasions. One of their most ambitious commissions was the multi-tiered altarpiece made for the Hieronymite monastery of San Isidoro del Campo, Santiponce, just outside Seville (1609–12) (fig. 5). For the central niche they produced a life-size figure of *Penitent Saint Jerome,* of which Pacheco later proudly said, 'among present-day sculpture and painting it has no equal.'[22] As well as multi-figured altarpieces, Pacheco and Montañés collaborated on a number of single life-size statues of religious figures, notably a sculpture of Francis Borgia, the sixteenth-century Jesuit who had died in 1572 and was beatified in 1624 (he was canonised in 1671). To celebrate this event, the Jesuits in Seville commissioned a life-size sculpture of him (see cat. 14 and front cover). This sculpture was originally an '*imagen de vestir*', that is, a manikin that was dressed in real fabric: only the head and hands were carved and painted.

In his treatise, Pacheco discusses the technique of *encarnación,* or the painting of flesh tones and, by extension, of facial expression (for more on this see the essay by Daphne Barbour and Judy Ozone on pp. 59–71). There were essentially two ways of painting flesh tones: *polimento* (glossy) and *mate* (matt, that is, lustreless). The *polimento* technique consisted of grinding together lead white and pigments with an oil medium or a light clear varnish, and applying this over the white gessoed surface of the wooden sculpture, which was then polished with a dampened scrap of glove leather or a *veriga*, a pig's bladder, and varnished. The overall result was a glossy and shiny surface.

Pacheco had especially strong opinions about the effect glazed flesh tones (*polimento*) had on sculpture, believing them to be distracting because the way in which they reflected light did not approximate the true quality of human flesh. For this reason, he advised that *polimento* flesh tones be used on inferior works: 'It is good to use over bad sculptures because the shininess and brightness of the *encarnación* diminishes defects.'[23]

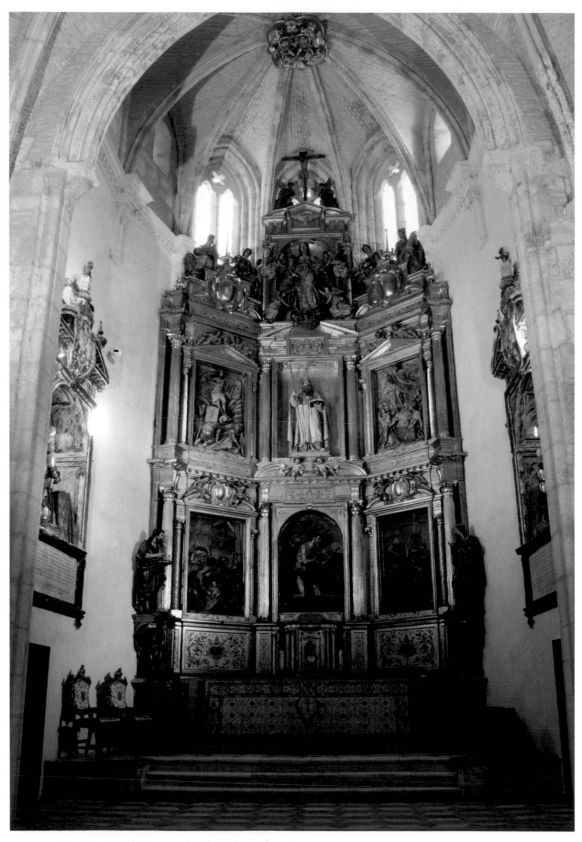

5 Juan Martínez Montañés (1568–1649) and Francisco Pacheco (1564–1644)
Penitent Saint Jerome, in the large retable in Santiponce, 1609–12
Polychromed wood, life-size
Monasterio de San Isidoro del Campo, Santiponce

He cautioned against using it on better works because of its heaviness and tendency to mask 'the expressive carving of good sculpture'.[24] On the other hand, the practice of employing a matt finish, which he claims to have revived and introduced in Seville in 1600, satisfied his desire for a more realistically painted statuary: 'God, in His mercy, banished from the earth these glazed flesh tones (*platos vedriados*) and caused the more harmonious matt flesh tones to be introduced.'[25] Contracts, particularly in southern Spain, frequently specified matt *encarnación* rather than *polimento*, as was the case with Zurbarán's contract for the sculpture of the Crucifixion.[26]

The preparation of matt *encarnación* was a simpler process. When painting sculptures by Montañés, or by Gaspar Núñez Delgado, active in Seville 1581–1606, Pacheco says their skill was such that the surface rarely needed extra preparation; a simple coat of glue-size was applied and then two or three layers of unpolished gesso and white lead. This was sanded down until 'hair and beard and all the elevations and depressions remain without a single rough spot'.[27] For flesh, a coloured priming was then applied, a mixture of white and vermilion for female saints and children, and ochre or red earth for 'penitents and aged people'.[28]

When polychroming the head and hands of *Saint Francis Borgia* (cat. 14), Pacheco employed the matt technique he had developed himself, onto which he built up darker flesh tones and facial features. The final effect is a skin colour that absorbs light rather than reflects it and therefore appears more natural and real. Borgia's skin is tanned and leathery, taut with youthful energy as he focuses on the skull he holds. Almost like a make-up artist, Pacheco has applied darker shades of brown so that the hollows caused by the cheekbones are emphasised and the aquiline character of the nose sharpened. Relief combined with subtle colouring define details such as the veins and lines around the eyes. There are flecks of white in the irises to make them look more alive, and for the eyelashes, Pacheco said, 'I do not use eyelashes [of real hair] because they spoil sculpture but rather strokes of colour smoothly blended together.'[29] The final touch which Pacheco believed brought 'life' to a sculpture was to 'varnish the eyes only with a very clear dark varnish, regardless of the material [of the sculpture]. An egg-white varnish, applied twice, is very good for this because, as everything else is matt, the faces come alive and the eyes sparkle.'[30]

For Pacheco, the work of a sculptor was imperfect until the painter had completed it. He would have considered lifeless, for example, the unpainted wooden sculpture of Saint Francis attributed to Montañés, in the Convent of San Francisco in Cádiz (fig. 6), compared to the same artist's *Saint Bruno* (cat. 12).[31] In Pacheco's opinion, the application of colour revealed 'the passions and concerns of the soul with great vividness' (see pp. 144–5). Alonso Cano, a pupil of Pacheco, was among the foremost sculptor-painters. His *Saint John of God* shows how startlingly lifelike polychromy could be (see fig. 8 and cat. 6). Although no documentary proof has yet been found to confirm Cano's training as a sculptor, other documents establish that he entered Pacheco's workshop in 1616 and obtained his diploma as a *pintor de ymaginería* in 1626.[32]

In order to avoid the inevitable conflict of interests between the guilds, Cano often engaged another artist to polychrome his sculptures, although he probably

6 Attributed to Juan Martínez Montañés (1568–1649)
Saint Francis, about 1630
Wood (without polychromy), life-size. Convento de San Francisco, Cádiz

7 Juan Martínez Montañés (1568–1649) and unknown polychromer
Saint Bruno meditating on the Crucifixion, 1634 (cat. 12)

painted his own works later in his career, such as the *Saint John of God*.[33] The different techniques Cano has used to indicate the hair on his head and the more bristly eyebrows are exemplary. In accordance with Pacheco's teaching, Cano first painted over the sculpted hair and then, with a fine brush, painted individual strands that continue the hairline from the scalp to the forehead and neck: 'And where the hair meets the forehead or the neck, use a middle tone made from the same flesh colours and a darkening element, lightening the colour where it meets the flesh, so that it does not look chopped off and hard.'[34] Where Cano diverged from Pacheco's instructions – and actually went against his advice – is in his introduction of glass eyes. To do this, Cano carved the front part of Saint John's face separately and inserted from the back two small glass 'cups', which were painted brown and white from the inside. The front part of the face was then attached to the rest of the head.

In combining the roles of a carver of sculpture, a polychromer of sculpture and a painter, Cano was an exception to the rule. Although the arts of polychromy and sculpture were interdependent, they were in practice kept very much separate, at least, as we shall see, for the first half of the seventeenth century. Pacheco felt strongly that this should remain the case and when in 1621 Montañés was assigned complete control, that is, control of all the sculpture, painting and gilding of the altarpiece of the convent of Santa Clara in Seville, and declared he intended to keep three-quarters of the 6,000 ducat payment, leaving the rest for the painter Baltasar Quintero (documented between 1622 and 1632), whom he had subcontracted, Pacheco threatened to take him to court.[35] The news of this breach of contract outraged the painters'

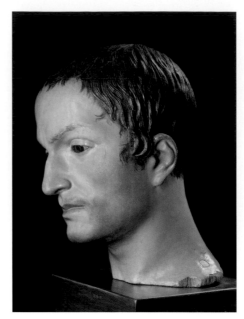

8 Alonso Cano (1601–1667)
Saint John of God, about 1660–5 (cat. 6)

Opposite: 9 Juan Martínez Montañés (1568–1649) and Francisco Pacheco (1564–1644)
Saint Francis Borgia (detail), 1624 (cat. 14)

guild as a violation of their essential rights.

Pacheco's response was a short tract signed and dated 16 July 1622, and entitled, 'A los profesores del arte de la pintura', which explains in detail the position of the painters (see pp. 144–5).[36] Not only does he cite examples from Antiquity – such as the sculptures by Praxiteles painted by Nikias – as exemplary models, but he also defines the rights and limits of each branch of polychrome sculpture citing the different clauses imposed by the civic ordinances (*ordenanzas de Sevilla*) drawn up in 1527 and which were to be reprinted in 1632.[37] In essence, Pacheco argued, if an artist had not received the right training and had not passed the

When Cano was already in his death throes, the priest took him a sculpted Crucifix (which was not by a good artist) in order to exhort him with it, and Cano told him to take it away. The priest became so alarmed that he was about to exorcise him and said 'My son, what are you doing? Look, this is the Lord who redeemed you and who will save you.' And he answered, 'I so believe, my father, but do you want me to get angry because it is poorly done and have the Devil take me? Give me a bare cross, that I will venerate and revere Him there with my faith as He is in essence and as I behold Him with my idea.'

FROM PALOMINO'S *LIFE OF ALONSO CANO*

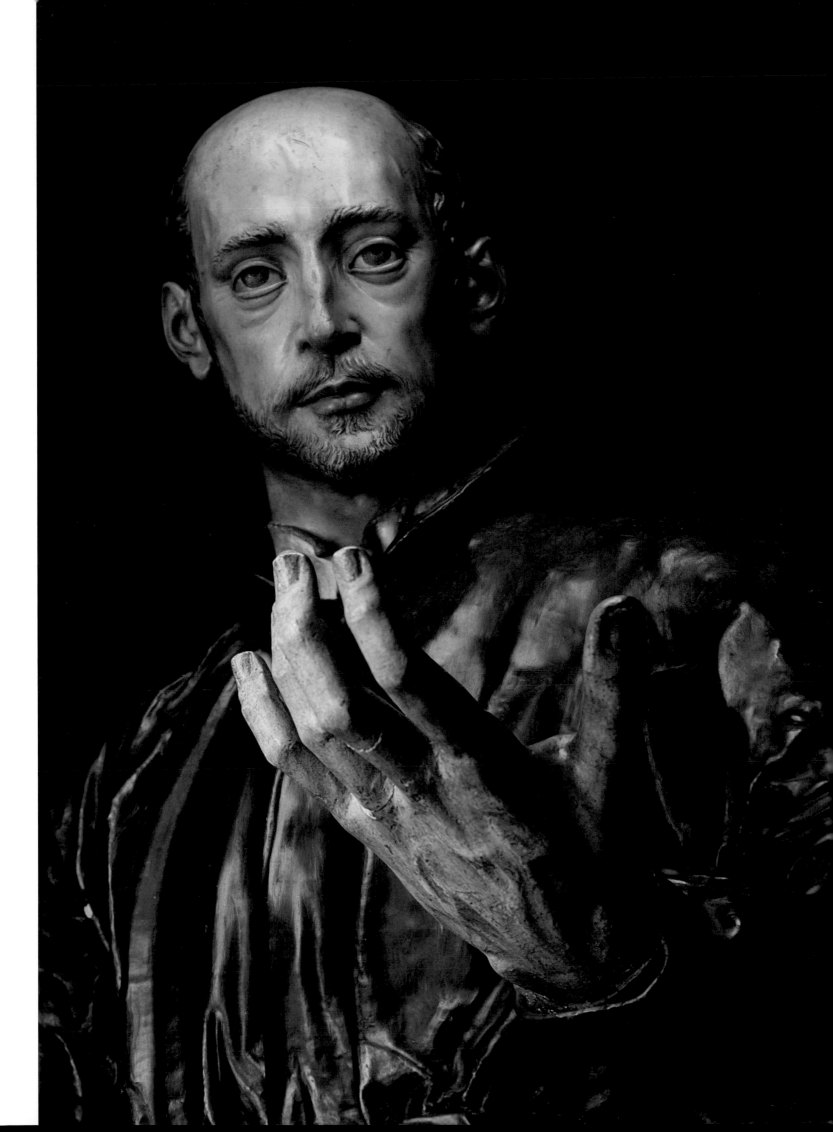

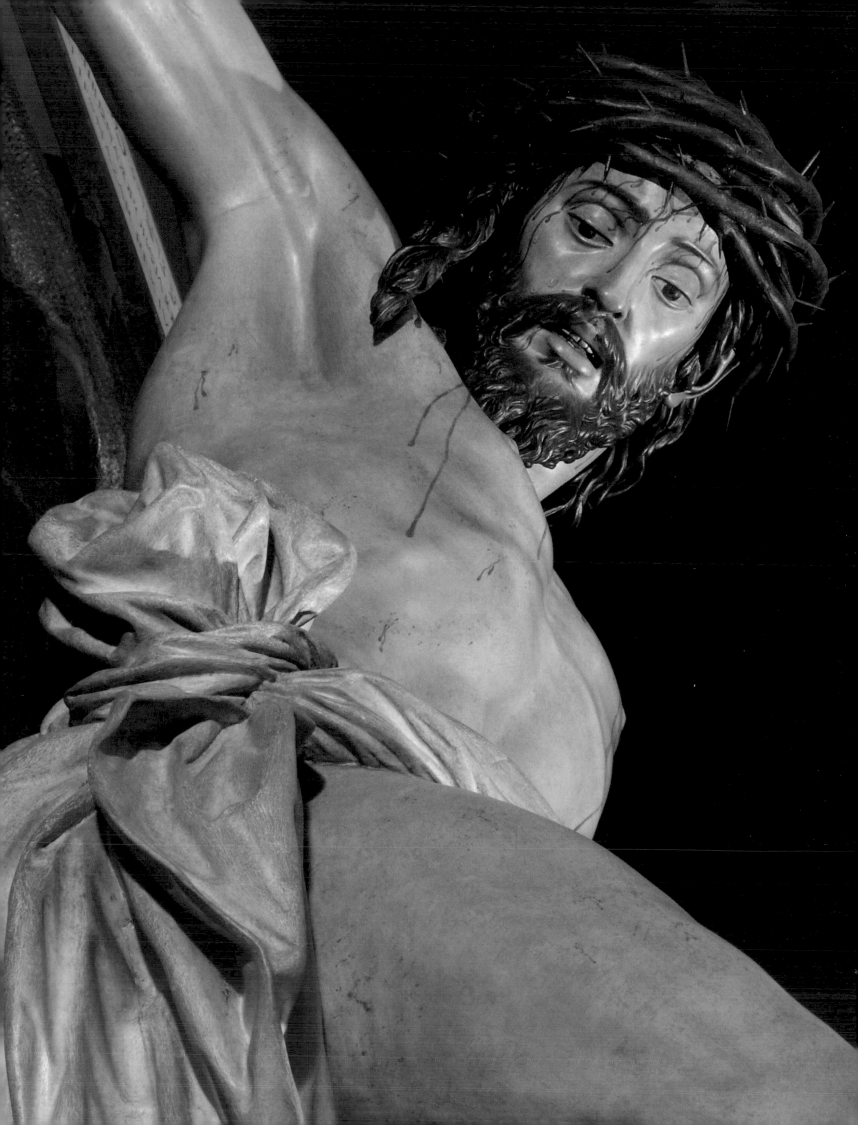

*el dho Xpo crucificado a de estar bibo antes de auer espirado con la cabeça ynclinada
sobre el lado derecho mirando a qualquiera Persona que estuuiere
orando a El pie del, como que le está el mismo Xpo Hablandole, y como quexandose
que aquello que padeçe es por el que está orando. y assi a
de tener los ojos y Rostro con alguna seberidad y los ojos del todo abiertos.*

FROM THE ORIGINAL CONTRACT FOR
CRISTO DE LA CLEMENCIA

appropriate examination to practise the art of painting sculpture, a sculpture would be badly painted and lose its quality and power to communicate higher ideals, be they artistic or religious. He also claimed the supremacy of painting over sculpture, because in his opinion, it was colour that brought a sculpture to life.

One understands what he means when one looks closely at what is probably the most famous sculpture Pacheco and Montañés ever conceived together – a Crucifixion, better known as the *Cristo de la Clemencia* ('Christ of Clemency') (figs 10 and 20). It was commissioned in 1603 for the private chapel of Mateo Vázquez de Leca, archdeacon of Carmona. Leca had definite ideas of how Christ should look. The contract stresses that Christ was 'to be alive, before He had died, with the head inclined towards the right side, looking to any person who might be praying at the foot of the crucifix, as if Christ Himself were speaking to him'[38] (quoted above). Montañés and Pacheco fulfil this to the letter. Christ's flesh has not been given the pallor of the dead but the matt pink tone of a man still alive. Blood from the crown of thorns has just started to trickle down his body. This is an image of Christ just before the moment of death.

One of the remarkable aspects of the *Cristo de la Clemencia* is that Pacheco, as he did for *Saint Francis Borgia*, has also painted shadows, using a darker tone of the same flesh colour to suggest the hollows beneath Christ's ribs and under his armpits. This is of course

a technique more usual in painting, where the artist always has to add the fall of light and shade on figures, but Pacheco's decision to add shadow to Christ's body here is testimony to his training as a painter and points to the crossover techniques between the two art forms (see cat. 2). He himself remarks on this technique in his treatise, saying that by using 'shadows in the flesh part', 'the figures are made to appear more rounded as in pictures'.[39]

Pacheco also knew that the bold painted details of Christ's face, quite crude in close-up, appear convincingly lifelike from a distance. The lips, the shading under the nose, the thick dark line emphasising the edge of the eyelid, all dramatically define Christ's facial expression. The three tears on each side of his nose are also remarkable. Painted transparent white, outlined in black, and with a (painted) highlight at the centre, they are almost more effective than glass tears, thanks to the illusory volume and reflection created by the painter's skill. The polychromy of such a work must have had a profound impact on contemporary painters.[40]

The dispute between Pacheco and Montañés that took place in 1622, however, indicates that relationships between sculptors and painters were not always harmonious. Sculptors were increasingly becoming frustrated by the fact that they had to hand over their sculpture to a professional painter and were therefore unable to see their creation through to its final stage, which disbarred them from receiving the full financial reward. The solution for Montañés was to subcontract the painter Baltasar Quintero, something he continued to do later, regardless of Pacheco's complaints.[41] The next generation of Sevillian sculptors

10 Juan Martínez Montañés (1568–1649) and
Francisco Pacheco (1564–1644)
Christ on the Cross, known as the *Cristo de la Clemencia*,
1603–6, detail of fig. 20
Polychromed wood, h 190 cm
Museo de Bellas Artes, Seville (on long-term loan to Seville Cathedral)

such as Pedro Roldán (1624–1699) actually took the exam of *pintor de ymagineria* in order to obtain greater autonomy.[42] When working on large and ambitious commissions such as the high altarpiece of the Hospital de la Caridad in 1670–1, Roldán did, however, work very closely with the painter Juan de Valdés Léal (1622–1690), though it seems that they, like Montañés and Pacheco earlier, had set up a business deal together (Valdés Léal was to be godfather to one of Roldán's daughters). And when Cano returned to Granada in 1652 and produced some of his best carvings, among them the *Immaculate Conception* for the cathedral (see fig. 38), he tended to paint them himself, a skill he was to teach his two best sculpture students, Pedro de Mena (1628–1688) and José de Mora (1642–1724).

As the art of polychromy gradually ceased to be the responsibility of the painters, a completely new style of realism was developed by sculptors, who rejected Pacheco's concepts in favour of employing glass eyes and tears and real hair for the eyelashes. The polychromy, particularly the flesh tones, became more strident and expressive. This can be seen particularly in José de Mora's *Ecce Homo* and *Virgin of Sorrows* from the Convent of Santa Isabel, Granada (figs 11–14). Mora has applied touches of blue around the Virgin's eye sockets to capture the effect of tender flesh, and for the blood that oozes from Christ's crown of thorns he has used a thickly impastoed red paint in the most dramatic way, letting it trickle into and out of Christ's mouth. The glass eyes add to the reality, and the falling tears are slightly bloodied, details that Pacheco would have found excessive.

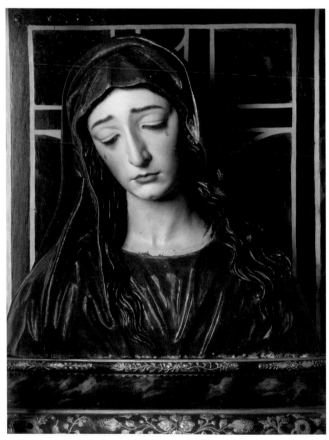

11 José de Mora (1642–1724)
The Virgin of Sorrows (Mater Dolorosa), 1680s
Polychromed wood, 49 x 46 cm
Convento de Santa Isabel la Real, Granada

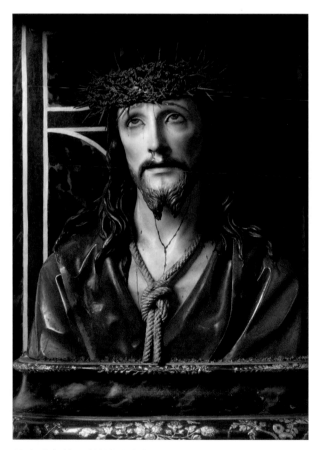

12 José de Mora (1642–1724)
Ecce Homo, 1680s
Polychromed wood, 49 x 46 cm
Convento de Santa Isabel la Real, Granada

13 and **14** Details of fig. 11 (top) and fig. 12 (bottom)

'SCULPTURAL' PAINTERS

The three-dimensional nature of sculpture could serve as a useful visual aid for painters. Some painters owned and worked from wax and plaster models,[43] while others found sculptures such as Pietro Torrigiano's (1472–1528) *Penitent Saint Jerome* from the Hieronymite Monastery of Buenavista in Seville, particularly useful in order to learn the basics of anatomy.[44] It was also common in Spain for painters to make painted copies after popular religious sculptures.[45] The still-life painter Tomás Yepes (*c.*1610–1674), for example, made an exact copy in 1644 of the much venerated Gothic statue of the *Virgen de los Desamparados* ('Virgin of the Helpless') in Valencia for the nuns of the Descalzas Reales, Madrid, which appears so real that it functions almost as a *trompe l'oeil*. Like icons, such painted copies were meant to uphold the sacredness of the original.

15 Tomás Yepes (about 1610–1674)
Virgen de los Desamparados, 1644
Oil on canvas, 206 x 130.5 cm
Convento de las Descalzas Reales. Patrimonio Nacional, Madrid (00610871)

When it came to painting a figure on a two-dimensional surface, however, the experience painters would have gained as part of their training when colouring sculpture must have had some effect on their concept of volume and texture. For an artist like Pacheco, who had painted many sculptures, this experience was powerfully brought to bear when painting on canvas or panel, although he was probably better at polychromy than painting. The majority of his religious paintings could be categorised as watered-down versions of Italian Mannerism and were largely dependent on print sources, but for a picture like *Christ on the Cross* in 1614 (see fig. 18 and cat. 2), his skills as a polychromer and his familiarity with sculpture in general were to his advantage. More specifically, we may note that the brush marks applied to provide the pools of shadow beneath Christ's armpits and across his left arm, as well as the trickles of blood, are extraordinarily close to the way the sculpture of the *Cristo de la Clemencia* is painted.

An artist who must certainly have known the *Cristo de la Clemencia* as well as Pacheco's *Christ on the Cross* was Pacheco's most celebrated pupil, Velázquez. Although no documents survive to identify pieces of sculpture that Velázquez painted, he would have received training as a painter of sculpture. On 14 March 1617 he was examined before the Guild of Saint Luke in Seville and was granted the title 'pintor de ymaginería y al ólio y todo lo a ello anexo' ('master painter of religious images and in oils and in everything related thereto') certifying him as an independent artist.[46]

Velázquez's exposure to polychrome sculpture seems to have had an impact on some of his religious compositions. Perhaps the most obviously 'sculptural' painting Velázquez executed was the *Christ on the Cross* painted for the sacristy of the Benedictine convent of the Encarnación de San Plácido in Madrid in the early 1630s (fig. 21). The way in which he situates the body of Christ in isolation from a narrative context and illuminates it against a dark background makes it stand out. The strong shadows beneath the armpits and in the palms of Christ's hands closely resemble those cast by the fall of light on a wooden sculpture. Indeed, the silhouette of Christ's body on the cross even casts a shadow into the void behind; perhaps

Velázquez intended a deliberate play between his painted crucifixion and a wooden one.

Velázquez's debt to sculpture is particularly apparent in one of the first paintings he executed as an independent artist in around 1618, *The Immaculate Conception* (see fig. 16 and cat. 8). The somewhat brittle folds of the Virgin's mantle draped around her body and the flexed right knee are remarkably similar to the presentation of the Virgin in surviving sculptures of the subject carved by Montañés and polychromed by Pacheco (see fig. 17 and cat. 7). These sculptures would have been a readily available model for the young Velázquez in his master's studio. The sharp contours of the edges of the Virgin's bodice and the crisp definition of each painted fold echo the volumetric forms of a sculpture. What is unexpected is the face of the young Virgin; so unidealised and down to earth are her features that Velázquez must have used a life model.[47]

In his painting of *Christ after the Flagellation contemplated by the Christian Soul* (see cat. 19), the figure of Christ bears a striking resemblance to Gregorio Fernández's sculptural representations of Christ (cat. 18). Fernández (1576–1636) worked chiefly in Valladolid and Madrid and was one of the most sought-after sculptors in Castile. He specialised in Passion scenes and his work was particularly known for its gory and bloody nature, often incorporating such realistic touches as eyelashes, fingernails made from horn, and simulated coagulated blood made from cork (see cats 20 and 27).

Fernández often portrayed the figure of Christ in a distinctly classical manner, almost like an antique sculpture, which reveals a sophisticated understanding of the human body. His knowledge of anatomy may have derived from his familiarity with the Duke of Lerma's collection in Valladolid, which contained excellent examples of antique sculpture as well as contemporary Italian statuary such as Giambologna's

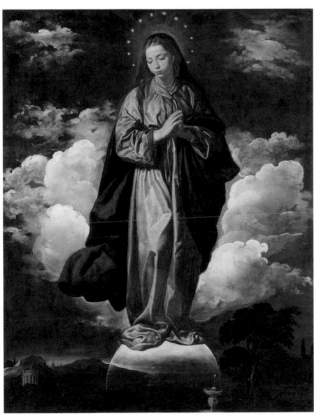

16 Diego Velázquez (1599–1660)
The Immaculate Conception, 1618–9
Oil on canvas, 135 x 101.6 cm
The National Gallery, London
Bought with the aid of The Art Fund, 1974 (NG 6424) (cat. 8)

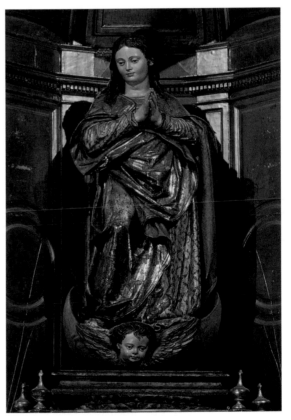

17 Juan Martínez Montañés (1568–1649) and
Francisco Pacheco (1564–1644)
The Virgin of the Immaculate Conception, 1606–8
Polychromed wood, 128 x 55.5 x 53 cm
Parish Church of Nuestra Señora de la Consolación, El Pedroso (cat. 7)

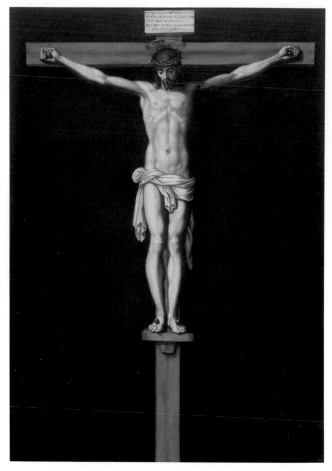

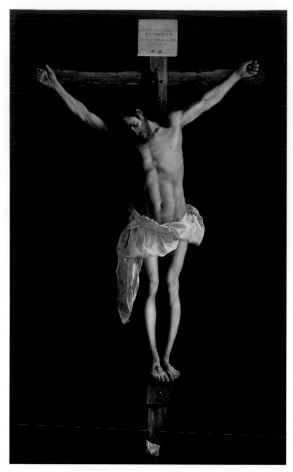

18 Francisco Pacheco (1564–1644)
Christ on the Cross, 1614
Oil on cedar, 58 x 37.6 cm
Instituto Gómez–Moreno de la Fundación Rodríguez–Acosta, Granada
(cat. 2)

19 Francisco de Zurbarán (1598–1664)
Christ on the Cross, 1627
Oil on canvas, 290.3 x 165.5 cm
The Art Institute of Chicago. Robert A. Waller Memorial Fund
(1954.15) (cat. 25)

Samson and a Philistine (London, Victoria and Albert Museum). It is highly probable that Velázquez would have seen and been inspired by a work like Fernández's *Ecce Homo* (see cat. 18). An intriguing aspect of Velázquez's *Christ after the Flagellation* is that while we, as viewers, see Christ's body from the side, the angel and Christian soul contemplate the lacerations on his back and we are aware that they see his body in the round. Following Pacheco's advice, Velázquez has concealed the gore and focused the viewer's attention on Christ's psychological condition.[48] By contrast, a polychrome sculpture by Fernández obliges the viewer to look at Christ in three dimensions and take in the atrocity of his physical sufferings. Certainly there is a strong sense of staged drama in Velázquez's painting, which perhaps derives from his experience of seeing sculptures such as these being worshipped by the

faithful during Holy Week. Fernández's *Christ at the Column* (about 1619) is in fact still carried through the streets of Valladolid on Good Friday by the Cofradía de la Vera Cruz (Brotherhood of the True Cross) (see fig. 34).

Pacheco's other star pupil was Alonso Cano who, as we have seen, had also trained as a sculptor. A few paintings that date from Cano's early career reveal an interest in introducing sculptural forms to a two-dimensional format.[49] His painting of Francis Borgia (see cat. 13), for example, made in 1624 for the Jesuits in Seville, contains a type of realism that is extremely close to the polychrome sculpture of the saint that Montañés and Pacheco executed that same year (cat. 14). The pose of Saint Francis staring into the hollow eye sockets of the skull, the plasticity of the black Jesuit garb, and especially the head and facial

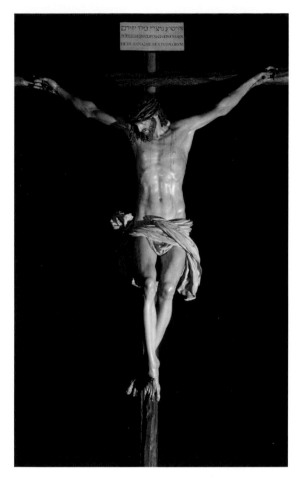

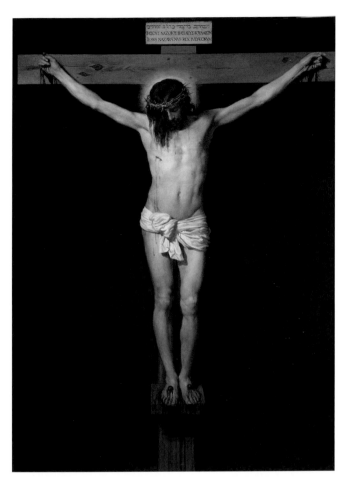

20 Juan Martínez Montañés (1568–1649) and Francisco
Pacheco (1564–1644)
Christ on the Cross, known as the *Cristo de la Clemencia*, 1603–6
Polychromed wood, h 190 cm
Museo de Bellas Artes, Seville (on long-term loan to Seville Cathedral)

21 Diego Velázquez (1599–1660)
Christ on the Cross, early 1630s
Oil on canvas, 248 x 169 cm
Museo Nacional del Prado, Madrid (P-11670)

expression seem to have been closely based on the
sculpture. Since Cano was still working in Pacheco's
workshop at the time, he quite possibly saw Pacheco in
the process of polychroming the work, enabling him to
study the process in detail. Although Cano's painterly
style developed away from this kind of realism
following his move to Madrid in 1638, he remained
aware of the visual relationships between the two
arts.[50] In his painting of Saint Bernard and the
lactating Virgin, instead of representing the Virgin as
in a vision, as is often the case with representations
of this miracle, he shows a polychrome sculpture
coming to life (see cat. 10).[51]

Francisco de Zurbarán is the only artist, apart
from Pacheco, whose early work as a polychromer of
sculpture is documented. Born in Fuente de Cantos, a
small town in the western province of Extremadura,

Zurbarán, unlike Velázquez and Cano, was not a
pupil of Pacheco. However, as a painter, he seems to
have relied on sculpture more than any other artist
of the period, and his paintings achieved a level of
hyperrealism and illusionism that was unsurpassed.
That he deliberately invites his viewer to contemplate
different levels of reality is illustrated by his painting
Saint Luke contemplating the Crucifixion (see cat. 4).
Zurbarán depicts Saint Luke, the patron saint of
painters, holding a loaded palette and brushes while
looking up at Christ on the cross. Is Saint Luke having
a vision or is he painting a picture of Christ on the
cross or perhaps even polychroming a sculpture of
Christ on the cross? There is deliberate ambiguity here,
and the play between the real and the fictive was a
feature that was particularly characteristic of
Zurbarán's early work.[52]

Zurbarán's illusionistic masterpiece is without a doubt his *Christ on the Cross* (see figs 1 and 19 and cat. 25). Made for a small oratory lit only by two windows on the right and candles on the altar, the almost three-metre-tall canvas, originally arched, would have dominated the chapel and was intended to be viewed from behind a grille. The figure of Christ emerges dramatically from the total blackness beyond, the right side of his body illuminated by a strong shaft of light, leaving the other side in darkness. Areas of deep shadow such as the space between Christ's legs give the sensation that his body is falling forwards slightly into our space. His voluminous white loincloth is stiff and creased, each fold masterfully captured in sharp focus.

There seems little doubt that Zurbarán used certain visual aids to achieve this level of reality. In the *Christ on the Cross* there is an overriding sense that he was attempting to emulate in paint the palpability of a wooden polychrome sculpture. For the extraordinary white sheet wrapped around Christ's waist (fig. 22), which is not only sculptural, but almost architectural in its construction of folds, it seems likely that Zurbarán turned to the age-old practice of stiffening white fabric with size, known in Spain as '*tela encolada*'. On occasion sculptors quite literally added a piece of '*tela encolada*' to their sculptures (see fig. 23), but Zurbarán has been able to reproduce this in paint. Like Pacheco earlier and Velázquez later (figs 18 and 21), he isolates the Crucifixion from its narrative and so encourages the viewer to believe he is witnessing a 'real' event, which makes such paintings so poignant.

For the three large canvases commissioned for the sacristy of the Charterhouse just outside Seville, the Cartuja de Santa María de la Cuevas, Zurbarán seems to have used prints, sculpture and life studies in order to construct his subjects. The centrepiece of the installation was *The Virgin of Mercy*, which shows the Virgin with her cloak outstretched to protect the living

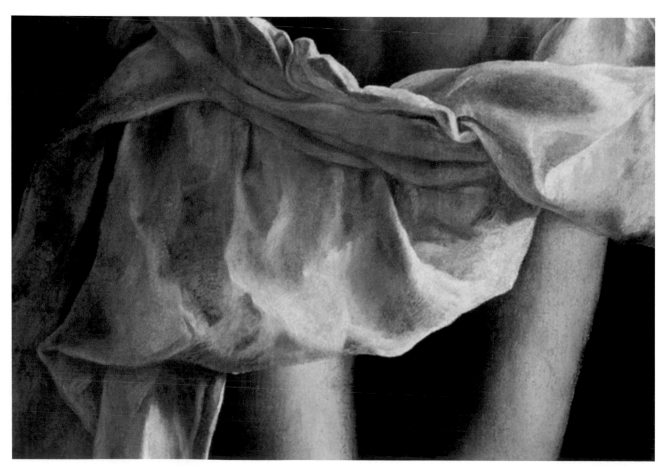

22 Francisco de Zurbarán (1598–1664)
Christ on the Cross, 1627, detail of cat. 25

Gregorio is regarded as venerable for his many virtues; he did not
undertake to make an effigy of Christ Our Lord or of His Holy Mother
without preparing himself first by prayer, fast, penitence, and communion,
so that God would confer his grace upon him and make him succeed

FROM PALOMINO'S
LIFE OF GREGORIO HERNÁNDEZ [FERNÁNDEZ]

members of the order (see cat. 11). The overall design of the composition is based on a print by the Dutch engraver Schelte Bolswert (1581–1659) that represents *Saint Augustine as Protector of the Clergy* (see fig. 75),[53] but while the image of the Virgin is reminiscent of a Gothic polychromed sculpture, the monks beneath are marvellously lifelike individualised portraits. Zurbarán must have spent a considerable amount of time at the monastery and we know that at least two of the monks were based on actual members of the order.

What has not been previously noted, however, is the striking connection between Zurbarán's painting and a polychrome sculpture by Montañés carved in 1634 that was in a chapel of the monastery depicting the founder of the Carthusians, Saint Bruno, meditating on the Crucifixion (cat. 12). The sculpture was on display on the altar of the chapel and would have certainly been seen by Zurbarán. Saint Bruno's gaunt face is extraordinarily lifelike and the flesh tones and the painted stubble visible on the unshaven parts of his tonsure make him all the more convincing.

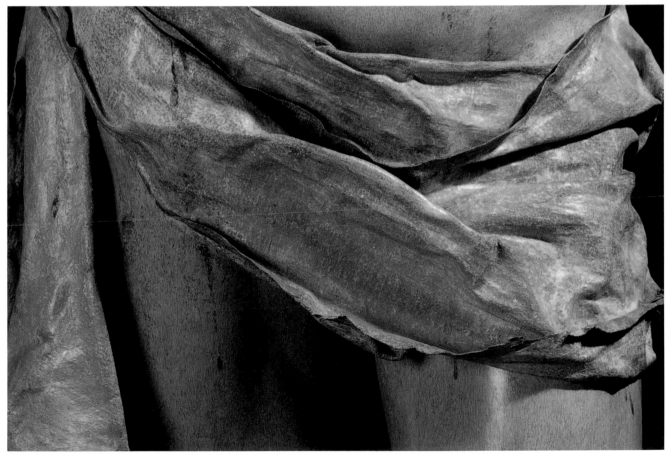

23 Gregorio Fernández (1576–1636)
Ecce Homo, before 1621, detail of cat. 18

What is especially remarkable about this piece is the quality of carving of Saint Bruno's long white robe, which was the distinctive habit of the order. The polychromer, whose identity is not known,[54] applied gold leaf beneath the white pigment (visible in some areas where the paint has been scratched off) and although it has been suggested that Saint Bruno's habit was originally intended to be decorated in the *estofado* technique (that is, gilded cloth decoration) (see cat. 12), it seems unlikely that Saint Bruno would have worn such an ostentatious garment. Instead, as with Manuel Pereira's (1588–1683) celebrated *Saint Bruno meditating on the Crucifixion* (about 1635) for the Cartuja de Miraflores (see fig. 35), the gold probably functioned as a way of softening the whites, so that the light falling on the folds of the drapery creates a diffused and rounded appearance, comparable to real white cloth.

In the same way that Zurbarán's depiction of Christ's loincloth in the *Christ on the Cross* was extraordinarily three-dimensional, so too is his painting of the monks' white robes in *The Virgin of Mercy*. The folds of the cloth are deep and fall in heavy creases around their bodies. The sculpture of Saint Bruno would have provided an ideal model and the manner in which Zurbarán has painted the monks' white habits in solid and rigid folds is very reminiscent of Montañés's carving (figs 24 and 25). While Schelte Bolswert's engraving gave Zurbarán an idea for the design of the composition, it is the volume provided by the sculpted drapery and the way light falls on each fold that would have assisted him in giving his drapery a solid quality. One can imagine how striking an image it must have been for the members of the order and the sense of continuity they must have felt with the monks in the painting, and with the figure of Saint Bruno, like themselves all dressed in white and inhabiting the same space.

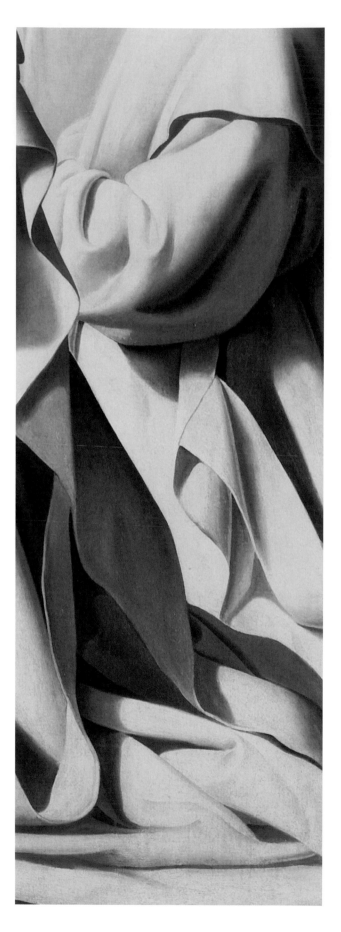

24 Francisco de Zurbarán (1598–1664)
The Virgin of Mercy of Las Cuevas, about 1644–55, detail of cat. 11

25 Juan Martínez Montañés (1568–1649) and unknown polychromer
Saint Bruno meditating on the Crucifixion, 1634, detail of cat. 12

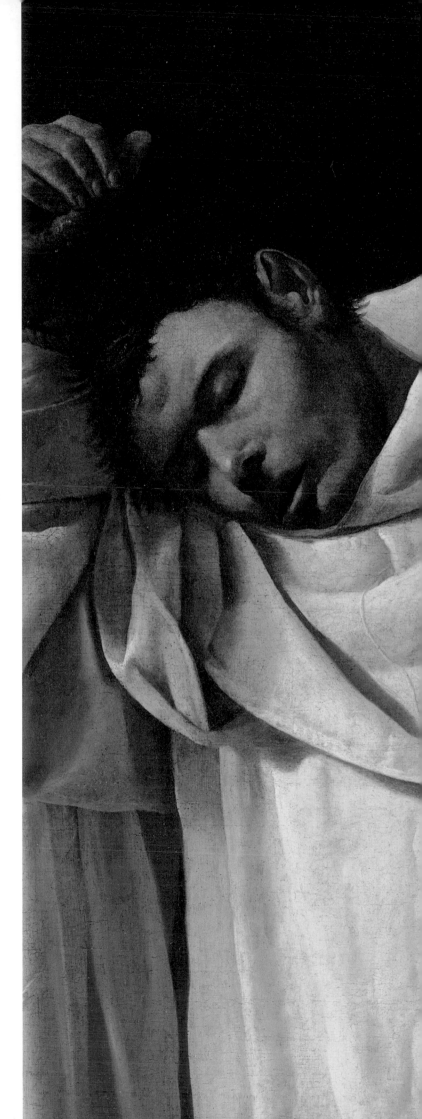

A painting that takes Zurbarán's illusionism to another level is his *Saint Serapion* (fig. 26 and cat. 35). Zurbarán has suppressed all details of the saint's suffering, and instead has focused on his white unblemished habit.[55] Voluminous and heavy, it cascades in deep folds around his collapsed body. Its extraordinary tangibility is rendered with great skill and the way in which Zurbarán has painted the areas onto which the light falls and the crevasses of deep shadow give the figure a compelling physicality. This naturalistic portrayal of a young man whose tousled hair seems to crumple forward into our space presents us with a striking image of someone hovering between life and death. There are no known sculptures of this subject and Zurbarán probably based the pose on a live model.

To perpetuate the painting's illusion of palpable reality Zurbarán has painted a piece of paper as if pinned to the canvas surface on which his signature, the date '1628' and the name 'B.[eatus] Serapius' are inscribed. As with the signature pinned to the foot of the cross in *Christ on the Cross*, Zurbarán leaves one in no doubt ultimately that this is a painting and in showing off his skill he is effectively demonstrating that painting can not only do what sculpture can naturally do, but can also play with the different levels of reality in a way that a sculpture cannot aspire to emulate.[56]

26 Francisco de Zurbarán (1598–1664)
Saint Serapion, 1628, detail of cat. 35

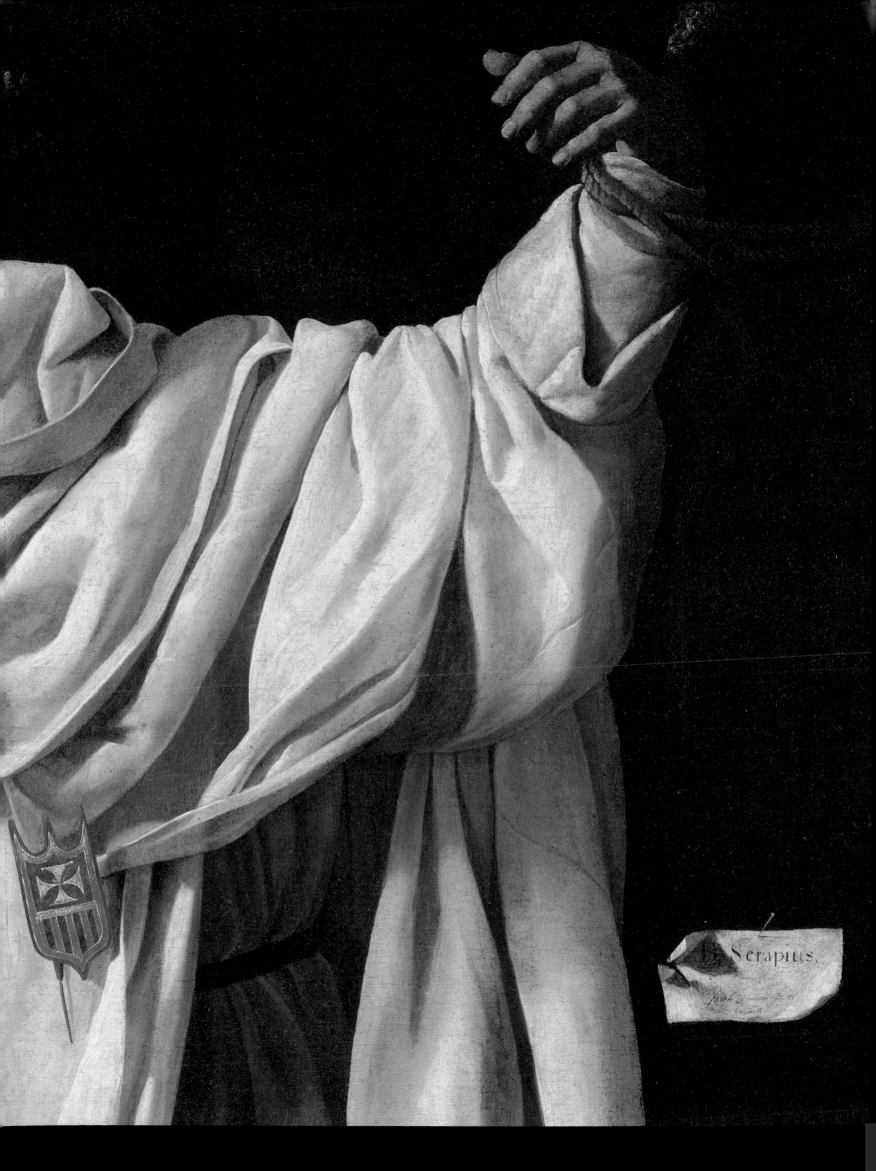

That there was indeed some kind of 'competition'– or at the very least ongoing comparison – between painting and sculpture is suggested by the fact that in 1663 the sculptor Pedro de Mena, who was trained in Granada by Cano but mainly worked in Málaga, produced a sculpture of Saint Francis (fig. 27), reproducing exactly Zurbarán's painting *Saint Francis standing in Ecstasy*, dating from some twenty years earlier (see fig. 28 and cats 31 and 32). Zurbarán's, which was probably painted for a Franciscan friary, depicts the saint in deep contemplation. According to legend, Saint Francis, who had long been dead, was discovered standing upright in his tomb by Pope Nicholas V in 1449, in an uncorrupted state and with an ecstatic expression on his face.

The essence of the legend lies in the physical presence of Saint Francis's body and it is possible that Zurbarán was himself influenced by sculptural representations of this subject.[57] He places the full-size figure of Saint Francis in a dark alcove. The coarse texture of his habit is reproduced with great precision, the knots on the rope around his waist casting their own shadow. He illuminates him with an intense golden glow. It is as if we are approaching him with a candle. Illusionistically the difference between painting and sculpture has been blurred.

Pedro de Mena translated Zurbarán's figure of Saint Francis into sculpture. His most famous version of the subject is the one he presented to the cathedral of Toledo in 1663 (see fig. 27 and cat. 33). The sculpture is an extraordinary fusion of painted fictive realism and real physical objects: diagonal rough-edged paint strokes simulate the weave of the saint's coarse habit, while a real knotted rope hangs from his waist. Glass eyes communicate his trance-like state and he has ivory teeth. It is as though Mena has tried to outdo Zurbarán's painted rendition by showing that his sculpture combines both art forms in one.

The art of painting and of polychrome sculpture in seventeenth-century Spain shared a common objective: both strove for a realistic depiction of sacred subjects so that a 'stepping stone' could be created to bring the faithful closer to the divine. The possibility that the two art forms were trying to outdo each other, however, remains a matter of conjecture. Yet, there are several instances when one feels that an element of competition did exist.[58] For example, in an attempt to prove the superiority of their artistic inheritance, sculptors claimed that the first artist on earth was a sculptor in the form of God himself who according to the Book of Genesis created Adam out of clay.[59] In response to this, painters claimed that it was when God added colour to Adam that he came to life.[60]

One of the few writers to discuss the relationship between painting and sculpture in Spain was the poet Juan de Jáuregui (*c.* 1570–*c.* 1640) who composed a treatise entitled *Diálogo entre la naturaleza y las dos artes pintura y escultura* (1618), a Spanish interpretation of the celebrated artistic debate known in Italy as the *paragone* (literally 'comparison'), which sought to establish whether painting or sculpture was the superior art.[61] The debate might be thought somewhat unnecessary in sixteenth- and seventeenth-century Spain since painters and sculptors and polychromers frequently collaborated. Despite this, Jáuregui's treatise was widely read, not least by Pacheco, who was a close friend of the author, and in an attempt to improve their artistic status it was often quoted by painters, along with other Italian treatises.

> Sculpture: *Your humble genealogy should make you silent.*
> Painting: *Well, yours is not astonishing either.*
> Sculpture: *You began in shadow.*
> Painting: *And you, in idolatry.*[62]

Sculpture's most persuasive claim to its superiority over painting was that it was three-dimensional and was therefore by its very nature better able to simulate the divine. Jáuregui, however, touches on the danger of a sculpture breaking the fourth and fifth Commandments: 'Thou shalt not make unto thee any graven image' and 'Thou shalt not bow down thyself unto them' (Exodus 20: 4–5).

27 Pedro de Mena (1628–1688)
Saint Francis standing in Ecstasy, 1663 (cat. 33)

28 Francisco de Zurbarán (1598–1664)
Saint Francis standing in Ecstasy (detail), about 1640
Oil on canvas, 209 x 110 cm
Musée des Beaux Arts de Lyon (A 115)

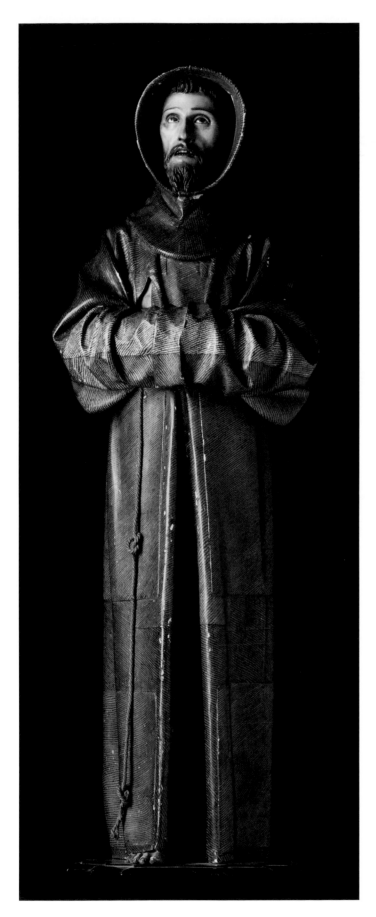
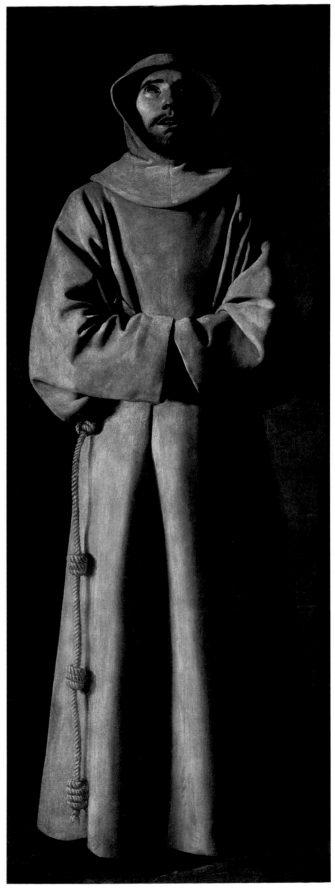

Although there is an element of literary conceit to all of this, there were also significant religious implications. Polychrome sculpture, as we have seen, had tremendous religious power. Indeed, sculptures such as Juan de Mesa's *Cristo del Gran Poder* in Seville (see fig. 29), and the *Cristo de Medinaceli* in Madrid, attracted (and still do) such devout praise that they were revered almost as divine objects. Some sculptors inserted written confessions inside images of Christ before sealing them as a way of appealing to Christ to intercede and transmit their prayer to God.[63] The sculptors themselves were even endowed with a degree of piety for having been the hand that created the images. When in 1621 the priest Bernardo de Salcedo gave his *Ecce Homo* by Gregorio Fernández (see cat. 18) to the Confraternity of the Santo Sacramento, in Valladolid, his will stipulated that the sculptor should be commemorated in the canon of the Mass.[64]

Sculpture was treading a thin line between the 'representation' of a sacred subject and becoming the sacred subject itself, which according to the twenty-fifth session of the Council of Trent in 1563 was to be scrupulously avoided.[65] As Saint Ignatius Loyola reminded his readers in his *Spiritual Exercises* (1548), statues should be venerated not for what they are but 'according to what they represent'.[66] Perhaps this was the fundamental way in which painters, by 'implying' the real, defended the superiority of painting over sculpture; with a painting, the faithful were less likely to commit idolatry. In this respect, Zurbarán's *Christ on the Cross* is a supremely successful religious image: by fusing the arts of painting and sculpture Zurbarán created a convincing illusion of the reality of the sacred.

In the Royal Monastery of La Merced there is a prodigious image of Jesus of Nazareth bearing the Cross called of the Passion, also by his hand, which has an expression of such sorrow that it moves to devotion even the most tepid of hearts; and it is said that when this sacred image was taken out during Holy Week, the artist himself would go out to meet it in the streets, saying that it was impossible that he could have executed such a marvel.

FROM PALOMINO'S
LIFE OF JUAN MARTÍNEZ MONTAÑÉS

29 Juan de Mesa (1583–1627)
Christ carrying the Cross, known as the *Cristo del Gran Poder*, 1620
Polychromed wood, life-size
Basílica de Nuestro Padre Jesús del Gran Poder, Seville

NOTES

1 On 27 June 1629, Rodrígo Suárez proposed to the Seville city council that Zurbarán should be given permission to practise as an artist in that city. As proof of his skill he adds: 'By those that are completed and by the painting of Christ which is in the sacristy of San Pablo, one can judge that he is a consummate artist.' See Cascales y Muñoz 1918, p. 137.

2 Palomino 1715–24 (1947), p. 938. For English translation see New York–Paris 1987–8, cat. no. 2, pp. 76–7. For a recent discussion of this illusionism see Stoichita 1995, pp. 70 and 72.

3 The 8th Conde de Benavente brought back from Naples in 1610 Caravaggio's *Crucifixion of Saint Andrew,* now in Cleveland Museum of Art, see London 2005, cat. 5, pp. 109–10. For a copy of Caravaggio's *Crucifixion of Saint Peter* in Valencia see Seville–Bilbao 2005–6, cat. 23, p. 174.

4 For a full discussion on the role of religious confraternities as patrons of polychrome sculpture see Verdi Webster 1998.

5 For the most recent study on the polychromy of antique sculpture see V. Brinkmann and J. S. Østergaard in Los Angeles 2008, pp. 18–39 and 40–61.

6 Most of these portals have lost their polychromy. An exceptional survival, however, is the late thirteenth-century 'Majesty Portal' of the Collegiate Church of Toro in central Spain: see Katz 2002, pp. 3–14.

7 Quoted in Malibu 2008, p. 65. Saint Bernard (c. 1090–1153), Cistercian monk and abbot of Clairvaux, was one of the most influential personalities in the cause of reform.

8 For an excellent study on Netherlandish carved altarpieces see Jacobs 1998. See also Müller 1966.

9 Saint John of the Cross, *Subida al Monte Carmelo,* chap. XXXV; cited in Checa 1983, p. 312, and Trusted 2007, pp. 28–9.

10 In a sermon given in 1615 in Madrid, Galván spoke of the merits of sculpture over painting, sculpture being the better art form for representing sacred subjects: 'Los pintores, y escultores tienen diferencia entre si, sobre qual es mas excelente arte: pero en las ímagenes espirituales tienen mucha la ventaja la estatuaria; porque la pintura consiste en sombras, y en poner una tinta sobre otra; y esto en lo espiritual huele a hipocresía: pero la estatuaria consiste en cortar y desbatar.' (See Dávila Fernández 1980, p. 120.)

11 There were of course some exceptions in Italy, the principal example being the painted wooden and terracotta sculptures that illustrate the life of Christ and his Passion installed in a series of chapels that form part of the Sacro Monte complex near the town of Varallo in Piedmont. See Freedberg 1989, pp. 192–201.

12 Delenda and Garraín Villa 1998, pp. 125 and 134: 'de hacer un Cristo del natural de dos varas de alto de madera y enbarnizado de encarnación mate y la cruz labrada con cáscara todo hecho y acabado con toda perfección para el día de señor San Francisco.'

13 Since Zurbarán is not known as a sculptor, it is possible that he subcontracted the carving of the crucifix to a sculptor and then polychromed it himself.

14 Unless a contract survives, the identity of the polychromer is often unknown, although there are very rare instances when a painter has signed a sculpture such as the fifteenth-century *Standing Virgin* in the Museum of Fine Arts, Boston, which bears the signature 'Juan de Córdoba me pinto A. D. MIIIILXXV'.

15 There are many accounts in Spain of how some sculptures were so lifelike that they appeared miraculously 'real' to their viewers. The most famous account is Palomino's: on seeing Luisa Roldán's sculpture of Christ carrying the Cross he was so 'thunderstruck at its sight that it seemed irreverent not to be on my knees to look at it, for it really appeared to be the original itself'. See Palomino 1715–24 (1987), pp. 341–2. For a full discussion of this sculpture see Nancarrow Taggard 1998, pp. 9–15.

16 In a contract signed in 1570 by the poly-chromer Juan Tomás Celma (1515–1578) to polychrome a group of sculptures by Juan de Juní in the church of San Benito el Real, Valladolid, it was stipulated that the poly-chromer should not 'cover or overwhelm the shapes and forms of the sculpture'. See García Chico 1946, p. 186: 'tapar ni aogar los senti-dos que la obra tiene en su escultura y talla'. See also Arias Martínez 2000, pp. 17–20.

17 Pliny the Elder, *Natural History*, Book XXXV. See Pliny the Elder (1876), p. 157.

18 See Nash 2005, pp. 456–67, Nash 2006, pp. 798–809, and Nash 2008, pp. 724–41.

19 Pacheco 1649 (1990), Chapter VI, pp. 494–503. For English translations of this text see Enggass and Brown 1970, pp. 217–22, and Véliz 1986, pp. 79–84.

20 F. Pacheco, 'A los Profesores del arte de la pintura' (Seville, 16 July 1622), published in. Sánchez Cantón 1941, pp. 267–74. For English translation see Enggass and Brown 1970, pp. 221–6. 'The figure of marble and wood requires the painter's hand to come to life.'

21 Montañés is recorded as having sent a Crucifixion to Lima, see Proske 1967, pp. 42–3, and Hernández Díaz 1987, p. 180. He also sent a whole altarpiece dedicated to Saint John the Baptist for the Convent of La Concepción, Lima (still in situ), see Proske 1967, pp. 52–6, and Hernández Díaz 1987, pp. 126–33.

22 Pacheco 1649 (1990), p. 498. See also Enggass and Brown 1970, p. 218

23 Pacheco 1649 (1990), p. 496. For English translation see Véliz 1986, p. 81.

24 Pacheco 1649 (1990), p. 502. For English translations see Enggass and Brown 1970, p. 221, and Véliz 1986, p. 84.

25 Pacheco 1649 (1990), p. 497. For English translations see Enggass and Brown 1970, p. 217, and Véliz 1986, p. 81.

26 A good example is the detailed contract signed by Pacheco and Montañés in 1606 for the now destroyed altarpiece of the Sagrado Corazón in the friary of San Francisco, Huelva: 'es condicion q(ue) todas las encarnaciones de la escultura ... rostro, manos, y pies ... se an de encarnar de encarnacion mate al olio.' For the full contract see Hernández Diaz 1928, pp. 148–52.

27 Pacheco 1649 (1990), p. 499. See Enggass and Brown 1970, p. 219, and Véliz 1986, p. 82.

28 Pacheco 1649 (1990), p. 499. See Enggass and Brown 1970, p. 219, and Véliz 1986, pp. 82–3.

29 Pacheco 1649 (1990), p. 500. See Enggass and Brown 1970, p. 220.

30 Pacheco 1649 (1990), p. 502. See Enggass and Brown 1970, p. 221.

31 See Hernández Díaz 1987, pp. 256–8.

32 Cano was contracted as a 'maestro ensan-blador y escultor' in 1629 when he took over the Lebrija commission: see Granada 2002, pp. 197–8. In 1635, the guild of architects and sculptors invested Cano with their power of attorney to represent them in a legal matter: see Bago y Quintanilla 1930, p. 67. And in 1638, Cano was given the power of the 'maestros escultores y arquitectos y ensanbladores' of Seville, to represent them in their appeal against being taxed in the same bracket as carpenters, for which they needed to prove that they were in a nobler profession: see López Martínez 1932, p. 264.

33 An example of this is the high altarpiece of the church of Santa María de la Oliva, Lebrija: the polychromy was subcontracted to the painter Pablo Legot. See Granada 2002, pp. 197–8, for the most recent discussion of the contract.

34 Pacheco 1649 (1990), p. 499. Enggass and Brown 1970, p. 219.

35 For the Santa Clara commission see Proske 1967, pp. 99–109, and Hernández Díaz 1987, pp. 194–220.

36 See note 20.

37 *Ordenanzas de Sevilla,* Seville 1632, pp. 162–3. For an analysis of these, see Okada 1991, pp. 233–8. For an excellent study on the guilds in Seville and the making of altarpieces see also Palomero Páramo 1983.

38 'Escritura de convenio de Juan Martinez Montañés con Don Mateo Vázquez de Leca para hacerle un crucifijo de escultura' (5 April 1603), published in Cuartero y Huerta 1992, Documento XLVII, pp. 131–2. For a discussion of the contract see Proske 1967, pp. 40–1, Palomero Páramo in Seville 1992, cat. no. 9, pp. 18–19, and Palomero Páramo 1992.

39 Pacheco 1649 (1990), p. 500. For English translation see Brown and Enggass 1970, p. 220. For an excellent appreciation of Pacheco's polychromy of the 'Christ of Clemency' see Dexter 1986, pp. 161–5.

40 Although Leca originally commissioned the 'Christ of Clemency' for his private oratory, he donated it in 1614 to the Carthusian monastery of Santa Maria de la Cuevas, Seville, where it was installed two years later in the chapel of the Santo Cristo (see Cuartero y Huerta 1988, vol. 1, pp. 25–6). Following the Secularisation Act of 1836, the sculpture became state property and although it legally belongs to the Museo de Bellas Artes, Seville, it has been on loan to the cathedral of Seville since the late nineteenth century.

41 Baltasar Quintero was employed again by Montañés in 1632 to polychrome and gild his altarpiece of Saint John the Baptist in the Convent of San Leandro, Seville. See López Martínez 1932, p. 262: 'baltasar quintero pintor soy concertado con juan martinez montañés escultor y arquiteto en tal manera que me obligo de dorar y encarnar de mate las figures del retablo de san juan ebangelista que el dho juan martinez montañés a hecho para el conbento de san leandro desta ciudad

el qual rretablo a de ir dorado y estofado y encarnado en la forma y con las calidades que tiene el rretablo…'

42 Salazar 1949, p. 319, and Bernales Ballesteros 1973, p. 28.

43 El Greco owned plaster and wax models which he used as visual aids for his compositions, see Trapier 1943, pp. 3 and 5, and Bray 2007. Pacheco too owned several models: see Salazar 1928, p. 158, and Cherry 1996, p. 72.

44 See Cherry 1996, pp. 70–2. Saint Jerome's emaciated body complete with sinews and muscles made it a masterpiece of anatomy and an ideal teaching tool for students, as well as a highly expressive piece of devotional art. Also useful to artists were sculptures of the Crucifixion. Surviving drawings attributed to Vicente Carducho and Francisco Collantes, for example, which are taken from a low viewpoint, suggest that a sculpture may have served as their model. See Angulo Iñiguez and Pérez Sánchez 1977, no. 127, p. 30, and no. 267, p. 49.

45 Alonso Cano, for example, made a painted copy of Gaspar Becerra's celebrated sculpture, the *Virgen de la Soledad* (1565) for the Chapel of San Miguel in Granada Cathedral, see Granada 2002, pp. 454–5. For a full discussion of such images see Pérez Sánchez 1992, pp. 139–55.

46 See *Varia velázqueña* 1960, II, p. 217, doc. 10.

47 Pacheco's account of his student confirms that Velázquez used life models for his *bodegones* paintings. See Pacheco 1649 (1990), pp. 527–8. For Velázquez's response to Montañés's sculpture, see Edinburgh 1996, p. 156, where it is also suggested that Velázquez may have used his sister as a model. See also Trapier 1948, p. 7, who was the first to remark on Velázquez's training as a painter of sculpture and its possible influence on his early work.

48 Pacheco 1649 (1990), p. 301.

49 A painting of the Virgin of the Immaculate Conception discovered in 1994, which undoubtedly comes from Pacheco's studio and has tentatively been attributed to Velázquez but is more likely to be by Cano,

possesses a similarly sculptural quality (see Sotheby's 1994, lot 64, and Pérez Sánchez 1999b, pp. 386–90). This painting was recently acquired by the Fundación Focus-Abengoa, Seville (see Navarrete Prieto 2009a, pp. 1–2, and Navarrete Prieto 2009b). For more on Cano as painter and sculptor see Sánchez-Mesa Martin 2001.

50 Cano's paintings for an altarpiece in Santa Paula, Seville, of 1635, have a strong sense of plasticity. The seated posture and the heavy drapery of *Saint John the Evangelist* from the Musée du Louvre, Paris, for example, reveal a strong connection with his later sculpture of the *Virgin and Child* ('Virgen del Belén') in Granada Cathedral.

51 Freedberg 1989, p. 288.

52 Stoichita 1995, pp. 70–7.

53 See Kehrer 1918, pp. 66–71, and Kehrer 1920–1, pp. 248–52. Interestingly, Bolswert's engraving was also adapted for sculpture. One such example is the large polychrome carving traditionally attributed to Montañés in Campion Hall, Oxford, which shows Saint Ignatius protecting his newly founded order. For an illustration of it, see the cover of Loyola 1996.

54 Since Montañés continued to collaborate with the painter Baltasar Quintero in the early 1630s, it is possible that he was also the painter of this carving of Saint Bruno. See López Martínez 1932, p. 262.

55 Remón 1618, folios 165–6.

56 Stoichita 1995, p. 72.

57 Some of the first sculpted interpretations of the subject seem to have been produced by Gregorio Fernández; one is in the Monasterio de las Descalzas Reales, Valladolid (*c.* 1620); another is in the church of Santo Domingo in Arévalo (Ávila) (*c.* 1625–30). See Martín González 1980, p. 249, and Valladolid 1989–90, cat. no. 1, pp. 22–3.

58 For an excellent study on the relationship between painting and sculpture in seventeenth-century Spain see Dexter 1986. For the *paragone* debate in Spain see Calvo Serraller 1981, pp. 180–3, Brown 1978, pp. 49–51, Cherry 1996, pp. 67–8, and especially Hellwig 1999a, pp. 175–252.

59 Pacheco 1649 (2001), p. 87.

60 'el soplo del Señor, dándole vida, lo pinto y retocó de variedad de colores…haciendo una perfetísima encarnación mate': Pacheco 1649 (2001), p. 89. Pacheco is here paraphrasing the *Poema de la Pintura* (undated) by the painter and humanist scholar Pablo de Céspedes (1538–1608) which survived in fragments and was partly published by Pacheco in his *Arte de la Pintura*.

61 Jáuregui (1618), pp. 151–6.

62 Jáuregui (1618), p. 151. Translation taken from Brown 1971, p. 49.

63 Sculptors such as Juan de Mesa and José de Arce inserted paper notes into their sculptures (often in the head of the figure) recording the date, the cost of the commission and the identity of the patron (see Gálvez 1928, and Agulló y Cobo 2005, pp. 32–3). Most extraordinary of all, however, is a note by Nicholas de Bussy (1650–1706) containing his confession and addressed to Christ, which was recently found inside his sculpture of the 'Christ of Blood' ('Cristo de la Sangre') belonging to the Cofradía del Carmen, Murcia (see Murcia 2003, p. 183).

64 Plaza Santiago 1973. I am grateful to David Davies and Angel García Gómez for their assistance in interpreting this clause of the contract.

65 *The Canons* (1851), p. 214: 'Moreover, that the images of Christ, of the Virgin Mother of God, and of the other saints, are to be had and retained particularly in temples, and that due honour and veneration are to be given them; not that any divinity, or virtue, is believed to be in them, on account of which they are to be worshipped; or that anything is to be asked of them; or, that trust is to be reposed in images, as was of old done by the Gentiles who placed their hope in idols.'

66 Loyola 1996, 'Rules to follow in view of the true attitude of mind that we ought to maintain [as members] within the Church militant', [360], rule 8, p. 357.

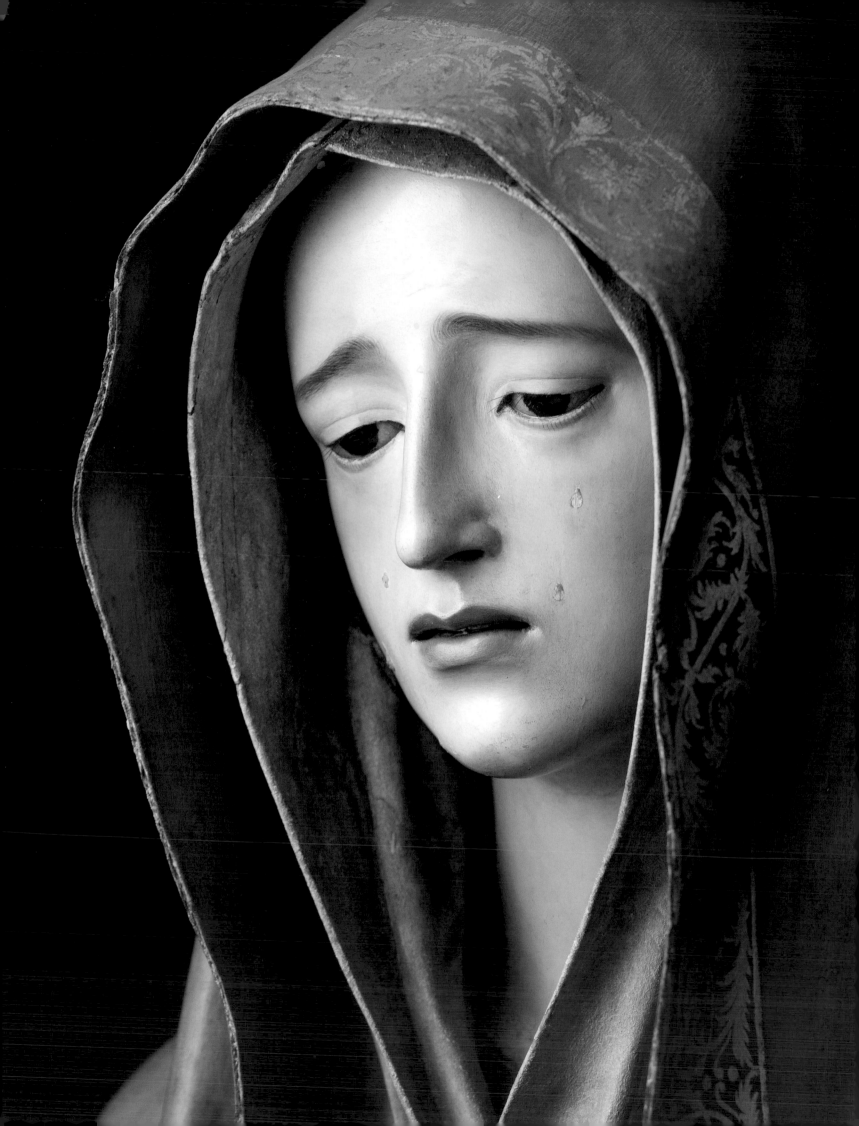

The Art of Devotion

Seventeenth-century Spanish Painting and Sculpture in its Religious Context

ALFONSO RODRÍGUEZ G. DE CEBALLOS

The subject matter of painting and sculpture in seventeenth-century Spain was essentially religious, as we might expect from a nation whose monarchy considered itself the bastion of the Catholic faith in Europe. The Spanish people saw themselves as chosen by God to preserve intact Christianity's most profound beliefs and transmit them to the lands recently discovered by the Spanish *conquistadores* on the other side of the Atlantic. Within the field of painting, artists worked in other genres of course, such as portraiture, battle scenes, mythology and allegory, still life and landscape, but works of this kind amounted to no more than occasional commissions from a wealthy and cultured social élite comprising the court, the aristocracy, the higher ranks of the church and the middle classes. In total they accounted for a very small proportion of paintings in relation to religious compositions, which were primarily intended for the instruction of the mass of the populace. Apart from court painters and those working for the aristocracy, most Spanish artists made a living from commissions for religious works for the church.

In sculpture the subject matter focused even more exclusively on religious themes and motifs. Secular works amounted to little more than a few equestrian statues of Philip III and Philip IV (commissioned from the Italian artists Giambologna and Pietro Tacca respectively, as there was no Spanish tradition of bronze sculpture or of large-scale complex casting in metal), a few portraits and funerary effigies of monarchs, viceroys and courtiers, and mythological and allegorical sculptures to adorn fountains in royal

The use of images has been ordained by the Church for two principal ends – namely, that we may reverence the saints in them, and that the will may be moved and devotion to the saints awakened by them. When they serve this purpose they are beneficial and the use of them is necessary; and therefore we must choose those that are most true and lifelike, and that most move the will to devotion.

SAINT JOHN OF THE CROSS,
THE ASCENT OF MOUNT CARMEL 3.35.3

residences and the gardens of aristocratic country mansions. The principal sculptors, and indeed painters, were to be found working in a limited number of cities such as Seville, Granada, Málaga, Valladolid and Madrid.

There is no doubt that the Council of Trent rc-affirmed the legitimacy of the veneration and cult of images, reacting against the extreme views of Calvin who considered that Catholics had made images the object of idolatry and superstition. It would be incorrect, however, to assume that the increasing number of works of art of this kind in seventeenth-century Spain can solely be explained in relation to the Tridentine decrees. The visual impact of religious images meant that they had long been considered a highly effective medium for conveying religious ideas to all sectors of the population, acting as a guide during prayer and meditation and as a vehicle for invoking Christ's grace and pardon for sins. Saints such as Teresa of Ávila and John of the Cross, who achieved the most profound level of mystic union with God, did

30 Pedro de Mena (1628–1688)
Virgin of Sorrows (*Mater Dolorosa*), 1670–5, detail of cat. 21a

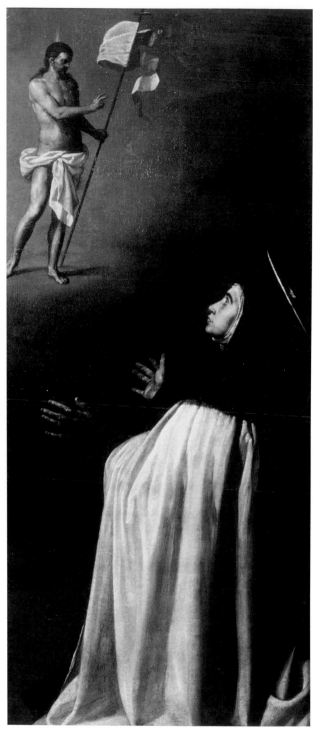

31 Alonso Cano (1601–1667)
Saint Teresa's Vision of the Resurrected Christ, about 1624–30
Oil on canvas
Colección Forum Filatélico, Madrid

not neglect the use of images to assist their meditation and contemplation (fig. 31).[1]

Those who commissioned religious images were generally the non-monastic and regular clergy, associations of lay members known as brotherhoods and confraternities, and also to a lesser extent families and individuals who commissioned such images when founding and endowing private chapels or oratories. The non-monastic clergy, responsible for cathedrals, collegiate and parish churches and hospitals, represented a sizeable sector of society in seventeenth-century Spain, although the crown and the civil courts attempted to restrict their number. In total, throughout the kingdoms and regions of Spain they numbered around 91,000, representing 1.15 per cent of a population of eight million.[2] It should be borne in mind, however, that much of the church's wealth was spent on charitable activities as well as on works of art to adorn the holy buildings in its care.

The monastic clergy were fewer in number, amounting to 20,697 monks and 20,369 nuns. In addition to the old contemplative and mendicant orders of Benedictines, Cistercians, Hieronymites, Carthusians, Augustinians, Franciscans and Dominicans, we also encounter more recently founded orders such as the Jesuits, the Theatines and the Oratorians, as well as older orders that were reformed in the wake of the Council of Trent such as the Barefoot or Discalced Carmelites, the Trinitarians and the Mercedarians.[3] Each religious order had its own distinctive character. The Benedictines, Cistercians and Hieronymites focused on the splendour of divine worship, private meditation and study. The Carthusians led a life of seclusion and silence, dedicated to asceticism and manual labour. The Franciscans and Dominicans combined the active and contemplative life, devoting themselves to preaching in cities, towns and villages. In the seventeenth century the Franciscans were still extremely popular among the humbler sectors of society due to their evangelical simplicity. The more élite Dominicans specialised in the study of theology and religious scholarship and a considerable number were appointed as confessors to the Habsburg monarchs or as ministers to the courts of the Inquisition. There were also numerous

confraternities with some 200,000 members.[4]

Of the religious orders founded or reformed in the sixteenth century and which we can associate with the Catholic Counter-Reformation, it was the Barefoot Carmelites who encouraged a new piety based on contemplation aimed at achieving unity with God. The result was the rise of mystics such as Saint Teresa of Ávila and Saint John of the Cross. In contrast the Jesuits, founded by Saint Ignatius Loyola, were dynamic and interactive, and attempted to achieve a fusion of Renaissance humanism with traditional Christian beliefs, opening colleges and universities for the teaching of lay brothers and adopting a polemical and militant tone in the face of the various Protestant reforms. These religious orders were all affected to varying degree by the reforms instigated by the Council of Trent, which were intended to reinforce the austerity and poverty of members and to ensure that monks and nuns strictly adhered to the rules of the religious life as set down by the founder of each order. As a consequence, these orders were highly esteemed by all sectors of Spanish society, who supported them with donations and charity, enabling them to commission paintings and sculptures to adorn not only their churches but also cloisters, chapterhouses, libraries and private apartments.

Seventeenth-century convents in Spain were closed communities; no teaching order of nuns was founded until the eighteenth century. To prevent the lack of discipline and avoid the laxity which had been found in such orders in the past, the Council of Trent rigorously enforced the cloistered rule, and convents became completely shut off from the outside world. Nuns lived for prayer and devotion alone. To assist their devotions they made use of a large number of images, particularly sculptures, which they looked after with maternal care. These works were located not only in the choir and in small chapels in the cloisters, but also in the nuns' private cells. As a result, convents were often the setting for apparitions, visions, ecstasies and other miraculous phenomena, depicted in painting with the immediacy of events from daily life. Many religious paintings should be seen as visual stimuli, created to encourage these mystical happenings, and Saint Teresa herself in her *Libro de la vida* recounted that

she prepared herself for prayer and union with God by looking at a religious painting or sculpture (see cats 10 and 26).[6]

The '*cofradías*' or confraternities were pious associations of laymen who organised their own religious services and other activities and also undertook works of charity. They were based in private chapels in parish churches and monasteries where the images of their patron saints were venerated. In some cases they also had their own meeting houses. Different types of such associations can be identified: Marian confraternities that promoted the cult of the Virgin in her various manifestations, particularly that of the Immaculate Conception; guild confraternities made up of tradespeople and craftsmen who took the saints of the liturgical calendar as their patrons and protectors; and finally, the so-called 'penitential' confraternities, noted for their penitential acts, especially in Holy Week processions, although all three types participated in processions.

Penitential confraternities were founded to celebrate Holy Week, when they paraded through the streets with their identifying emblems and sculptural images of their patron saints. These three-dimensional images were placed on processional floats (*pasos*) which were carried on the shoulders of members of the relevant confraternity. The most important processions took place in Seville, Granada and Valladolid. Many of the images depicted the crucified Christ and the Mater Dolorosa, some of them carved by Sevillian sculptors of the stature of Juan Martínez Montañés and Juan de Mesa. Others involved sculptural groups of figures, 'tableaux vivants', which represented different episodes of the Passion. Gregorio Fernández, the leading figure of the Castilian school of sculpture, and his extensive workshop produced numerous versions of these tableaux vivants for penitential confraternities. The figures on the *pasos* were initially made of papier mâché, presumably partly because it was light and relatively inexpensive, but as the number and size of donations increased, confraternities began to commission images in carved and polychromed wood from the leading sculptors of the day (figs 3, 32 and 34).

The *pasos*, which were processed through the streets on Ash Wednesday, Maundy Thursday and Good

Friday, were accompanied by two kinds of penitential confraternities: the so-called 'brothers of light', who carried lit torches, and the 'brothers of blood' or penitents, who physically scourged themselves with the aim of sharing in the sufferings of Christ (fig. 34). The latter group brought particular fame and prestige to their confraternities. In Seville the penitential confraternities were based in parish churches: thus the Confraternity of La Pasión, whose titular image was a Christ carrying the Cross sculpted by Montañés, was based in the collegiate church of El Salvador, while its rival confraternity, known as *Cristo del Gran Poder* (Christ of the Great Power), was based in the parish church of San Lorenzo, and its titular image, also a Christ carrying the Cross, was carved by Juan de Mesa (fig. 29). The most important confraternities in Valladolid, those of Las Angustias and the Vera Cruz (see fig. 34), had their own buildings, generally a church or chapel belonging to the confraternity itself.[7]

Aside from paintings and sculptures commissioned by parish churches, convents, monasteries and confraternities, Golden Age Spain had numerous private patrons who commissioned such works for their private devotion. The various royal palaces of Spain had their own chapels in which liturgical services, performed by special permission, were attended by the entire court. However, Philip III and Philip IV did not commission large numbers of religious paintings as they had inherited numerous works of this kind from their predecessors. The few works that they did have made are generally exceptional in nature, such as the *Cristo del Pardo* (*The Dead Christ*) by Gregorio Fernández, which was commissioned by Philip III for the Capuchin monastery at the royal site of El Pardo, outside Madrid. Aristocratic patrons commissioned paintings and sculptures for the oratories of their palaces, and surviving inventories of their possessions indicate that such works were also to

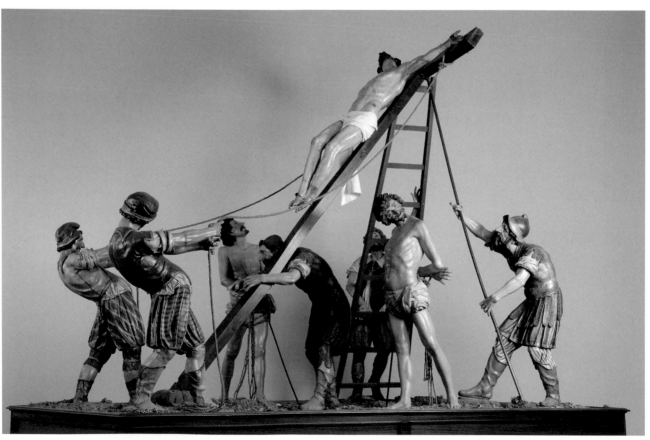

32 Francisco de Rincón (about 1567–1608)
The Raising of the Cross, 1590s
Polychromed wood, life-size figures
Museo Nacional Colegio de San Gregorio, Valladolid

be found in the principal reception room of the house and in the bedrooms.[8] They tended to be intimate, devotional images of the Virgin and saints, in front of which the worshipper prayed, invoking their protection. One example of this kind of image is the moving half-length *Virgin of Sorrows* by Pedro de Mena (fig. 30 and cats 21 a and b), commissioned in the 1670s for private devotional purposes.[9]

The decree of the Council of Trent on sacred images, dating from 1563, specifically stipulated a number of obligatory prerequisites for images that were the subject of veneration. They should depict true, not false or apocryphal stories; they should be decorous in nature; they should be lifelike; and their emotional and expressive qualities should inspire not only devotion but also the emulation of the sacred figures depicted. Philip II and his successors as well as the Spanish bishops monitored the implementation of these requirements.[10] We know that the Inquisition appointed various artists as censors, who were responsible for checking and examining images. They included the painters Francisco Pacheco in Seville and Diego Valentín Díaz in Valladolid, as well as the sculptor Pedro de Mena in Granada and Málaga, but no concrete information on cases in which they were involved has come down to us. As a result of his experience Pacheco wrote a brief treatise on sacred iconography which he included at the end of his *Arte de la Pintura* (published in Seville in 1649). The Inquisition seems to have focused less on paintings and sculptures in churches and more on the prints and engravings that entered Spain from elsewhere in Europe and which might express heretical opinions or satirise the Catholic church and its hierarchy, thus troubling the faith of the Spanish population. The verisimilitude demanded by the Tridentine Decree soon manifested itself in Spain in the form of a realist style, expressed in scenes and figures that seemed to be contemporary and extremely close to the viewer. In the field of sculpture the result was to continue the medieval tradition of carving images in wood whose clothes and flesh parts were then realistically painted (see the essay by Xavier Bray on pp. 15–43 of this catalogue). In Spain the religious image, and sculpture in particular, was considered a sacred object rather than an object to be

admired for its aesthetic qualities. Religious sculptures that had carved heads and hands like manikins and rich garments of real cloth were greatly appreciated by the public at large and conformed to popular taste even though they were disapproved of by some bishops as indecorous.[11]

In his *Arte de la Pintura* Francisco Pacheco laid down specific guidelines for the most effective, and most historical, way of depicting the Crucifixion. He believed that the Roman soldiers had attached Christ's body to the cross with four nails, two for the hands and one for each foot, a formula that was widely adopted by painters and sculptors over the next twenty or thirty years (see cat. 2).[12] Velázquez used this formula for his majestic *Christ on the Cross* (fig. 33), a work commissioned in the early 1630s by Philip IV's private secretary Jerónimo de Villanueva for the Benedictine convent of San Plácido in Madrid.[13] It is not known in which room the painting was hung, but we do know that Zurbarán's *Christ on the Cross*, painted for the Dominican friary of San Pablo in Seville (see cat. 25), was located in the darkness at the rear of an oratory chapel attached to the sacristy and that it seemed to emerge as a real vision before the eyes of the viewer because of its extraordinary three-dimensional quality.[14]

The sculpture of the *Christ on the Cross*, one of Montañés's masterpieces (figs 10 and 20), was commissioned by Mateo Vázquez de Leca, canon of Seville Cathedral, to express his repentance for a life that ill-conformed to his religious vocation. Vázquez instructed Montañés to depict Christ as still alive, with his head hanging down and his mouth open as if gently reprimanding the canon for his sins. The sculpture was installed in Vázquez's private oratory and was later bequeathed by him to the Charterhouse outside Seville (now on deposit in Seville Cathedral).[15] Montañés's pupil and collaborator Juan de Mesa specialised in more emotional figures of the crucified Christ, producing numerous versions that enjoyed great success in Spain and South America. One of the finest, his *Cristo de la Buena Muerte* (*Christ of the Good Death*), was commissioned from him by the congregation of Sevillian priests, which was governed by the Jesuits, as the principal image for their chapel in the

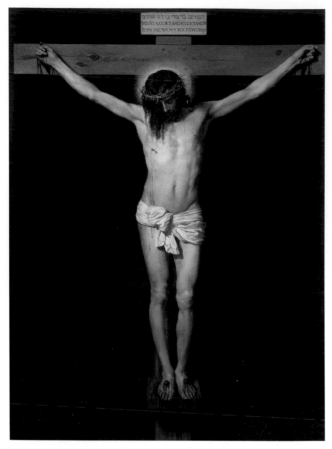

33 Diego Velázquez (1599–1660)
Christ on the Cross, early 1630s
Oil on canvas, 248 x 169 cm
Museo Nacional del Prado, Madrid (P-11670)

church of the Anunciación (now in Seville University). Christ is represented dead, his head hanging down and his eyes closed. In his *Spiritual Exercises*, Saint Ignatius Loyola instructed that meditations on personal sins should conclude with a dialogue between the sinner and the crucified Christ, in which the sinner asks for pardon and promises to amend and improve his or her way of life. The presence of this image in the chapel was almost certainly due to the influence of the Jesuits, who exhorted the members of the ecclesiastical congregations under their rule to practise the Spiritual Exercises.[16]

Repentance, or the exhortation to repent, before the figure of the crucified Christ was represented in numerous ways. The Magdalen (see cat. 23) in Pedro de Mena's sculpted image of her for the Jesuit church of the Casa Profesa in Madrid, directs her sad compassionate gaze at the crucifix that she holds in her hand.

Jerónima de la Fuente, a Franciscan nun from Toledo famed for her sanctity, was depicted by Velázquez in 1620 (see cat. 16) before she embarked on the long journey from Seville to Manila in the Philippines. She also holds a crucifix in her hand as if to show that it would provide her with all the necessary strength for her arduous mission.[17]

Episodes from the Passion such as the Flagellation of Christ by Roman soldiers and his presentation to the Jewish people crowned with thorns (the *Ecce Homo*) aroused particularly heartfelt emotion in Spaniards of all social classes. In her *Libro de la vida*, Saint Teresa of Ávila says that she decided to give her life totally to God when contemplating a sculpture of the scourged Christ in the convent of the Encarnación in Ávila. One of Velázquez's most moving religious canvases, *Christ after the Flagellation contemplated by the Christian Soul* (see cat. 19), depicts Christ fallen to the ground after his scourging, the implements of his torture scattered around him, while a kneeling child symbolising the Christian soul looks at him with compassion.

Gregorio Fernández was one of the artists who most frequently sculpted the theme of the scourged Christ isolated from the narrative. One such example is his *Christ at the Column* (fig. 34) which is still carried in procession during Holy Week. Another frequent commission was for the *Ecce Homo* (see cat. 18), which showed the single figure of Christ as he is brought before the people. In such images Christ often turns to look at the viewer as if asking for their compassion. An iconographic variant depicted Christ with open arms, kneeling on the orb of the world. This motif seems to have been taken from Dürer, who used it in his print *The Mass of Saint Gregory*. A particularly impressive version was created around 1635 by the Portuguese sculptor Manuel Pereira, who worked at the court in Madrid. The polychromy of his carved wooden image was applied by the painter Francisco Camilo.[19]

Another variant of the *Ecce Homo* showing Christ in half-length became one of the most successful compositions of the sculptor Pedro de Mena (see fig. 36 and cat. 20), a pupil and collaborator of Alonso Cano. *Ecce Homo* images of this type were frequently commissioned for closed orders of nuns. Mena himself was commissioned to work for the convent of the Barefoot

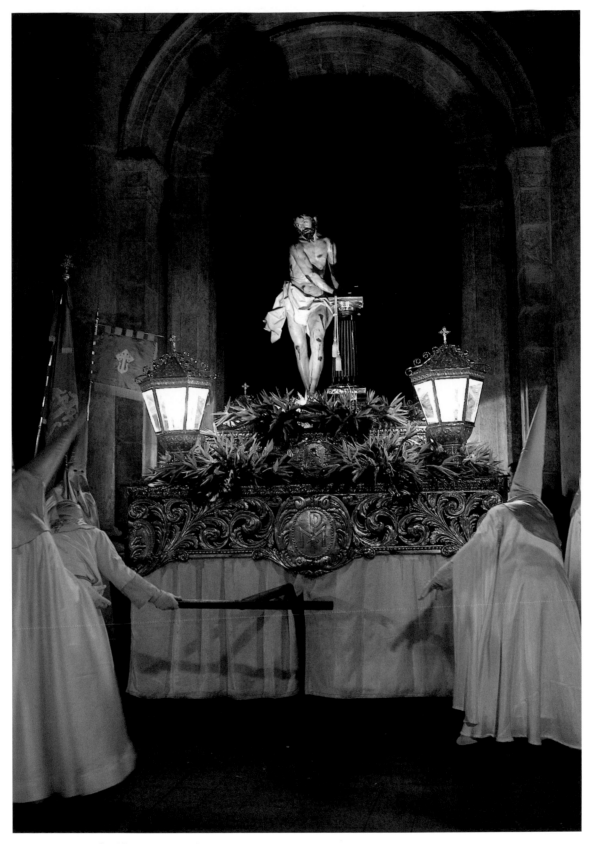

34 Gregorio Fernández (about 1576–1636)
Christ at the Column, about 1619, in procession during Holy Week
Polychromed wood, life-size
Iglesia de la Vera Cruz, Valladolid

Poor Clares or Franciscanas Descalzas in Madrid, founded by Juana, widowed queen of Portugal and sister of Philip II.

Polychromed wooden images of both the Scourged Christ and the *Ecce Homo* were painted in a manner that vividly illustrated Christ's suffering, with blood gushing from the wounds on his back (see fig. 36), as described in the *Vita Christi*, a text attributed at that time to Saint Bonaventura (1221–1274), and in Saint Bridget of Sweden's *Revelations*. Many Spanish preachers and orators of the seventeenth century echoed this visionary and devotional literature, describing in minute detail both the number of lashes of the whip and the type of wounds produced.[20]

The figure of the recumbent Christ, sculpted in almost hallucinatory detail with his eyes glazed over by death and his mouth open, was an image regularly produced by Gregorio Fernández and his studio in Valladolid. One of the finest examples was commissioned by the Jesuits for their Casa Profesa in Madrid (see cat. 27). This iconography was not necessarily intended to encourage meditation on death. In fact, in most of the known examples the recumbent Christ was installed below the altar, and the image was probably eucharistic.

After love of Christ, religious sentiment in seventeenth-century Spain was directed towards his mother, the Virgin Mary, who was the subject of numerous cults. Almost every city and village had its particular Marian devotion, but some, such as that of the Virgin of Sorrows, or *Mater Dolorosa*, were found throughout the country. Images of the Virgin at the moment when the body of her son is placed in her lap were particularly popular and are represented in both painting and sculpture. They are also referred to in the literature of the day. Celebrated preachers such as as

Luis de Granada and John of Ávila, whose printed sermons were frequently used as devotional literature in the seventeenth century, described Mary's anguish and her sorrow before the body of her dead son. Jusepe Ribera's painting *The Lamentation over the Dead Christ* (see cat. 28) seems to have derived its pathos from descriptions by such preachers.

The *Virgin of Sorrows* was represented in both processional sculpture and sculpture intended for

35 Manuel Pereira (1588–1683) and unknown polychromer
Saint Bruno meditating on the Crucifixion, about 1635
Polychromed wood, 169 x 70 x 60 cm *
Cartuja de Miraflores, Burgos

churches and other religious institutions. She is shown either with her son in an iconography that came from Flanders, or alone, full-length or bust-length. The latter type was developed with enormous success in Spain, notably by Pedro de Mena in Málaga and by his followers such as José de Mora in Granada (see cats 22 and 23, and the essay in this volume by Xavier Bray, pp. 15–43). Busts of the *Ecce Homo* and of the *Virgin of Sorrows* came to form pairs and are found in a number of convents, such as the Descalzas Reales in Madrid. The motif of the *Virgin of Sorrows* is difficult to separate from that of the Virgin of Solitude, a cult that acquired great popularity in the seventeenth century and which was celebrated in the Mass on Easter Saturday. The Virgin of Solitude can be distinguished from the *Virgin of Sorrows* by the fact that Mary is depicted clothed in a black gown and widow's cap, and sometimes holds the crown of thorns and three nails given her by Saint John the Evangelist after the burial of Christ, according to the *Vita Christi*.[21]

By far the most frequently invoked and represented image of Mary in art was, however, that of the Immaculate Conception, particularly in Andalusia. The theological dispute over whether the mother of Christ was conceived without stain of original sin arose between Franciscans and Dominicans at the height of medieval scholasticism. The population of Seville erupted onto the streets in 1613 to affirm this belief, which had been publicly denied by a Dominican friar. Francisco Pacheco set down in precise detail how the Immaculate Virgin should be represented: she was to be in the guise of the mysterious Woman of the Apocalypse, clothed with the sun, crowned with stars and with a crescent moon at her feet as described in the Book of Revelation.[22] Pacheco produced numerous paintings on this subject but these were all surpassed by the magnificent compositions by his pupil Velázquez (cat. 8) and his other pupil Alonso Cano (fig. 38). It may, however, have been the sculptor Juan Martínez Montañés who first represented the subject in this way. The earliest example by his hand was executed around 1606–8 for the church at El Pedroso (cat. 7). This was followed by numerous others for various churches and religious houses in Seville and as far away as Peru, reflecting the popularity of the

subject.[23] The foreword to the Tridentine Decree on the cult and veneration of images of the Virgin and saints legitimised their role as intercessors and as a result their depiction in painting and sculpture became widespread. Among older saints there was a particular preference for Francis of Assisi. Franciscan monasteries were numerous in seventeenth-century Spain, numbering around 700 with 6,708 friars. Ordinary citizens viewed them with affection and sympathy because of their austerity and simple, humble ways, and Spaniards, among them Francisco Pacheco, often expressed in their wills the desire to be buried wearing the Franciscan habit.

Saint Francis was most often represented standing, mummified, with his arms concealed by the sleeves of his tattered habit, as he had been found when Pope Nicholas V ordered the saint's tomb to be opened in Assisi (see cats 31 and 32). This is the manner in which he was painted by Zurbarán and sculpted by Pedro de

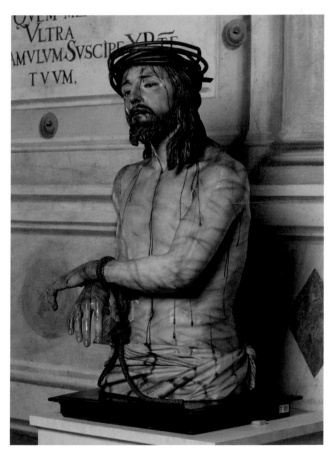

36 Pedro de Mena (1628–1688)
Christ as the Man of Sorrows, 1673
(cat. 20)

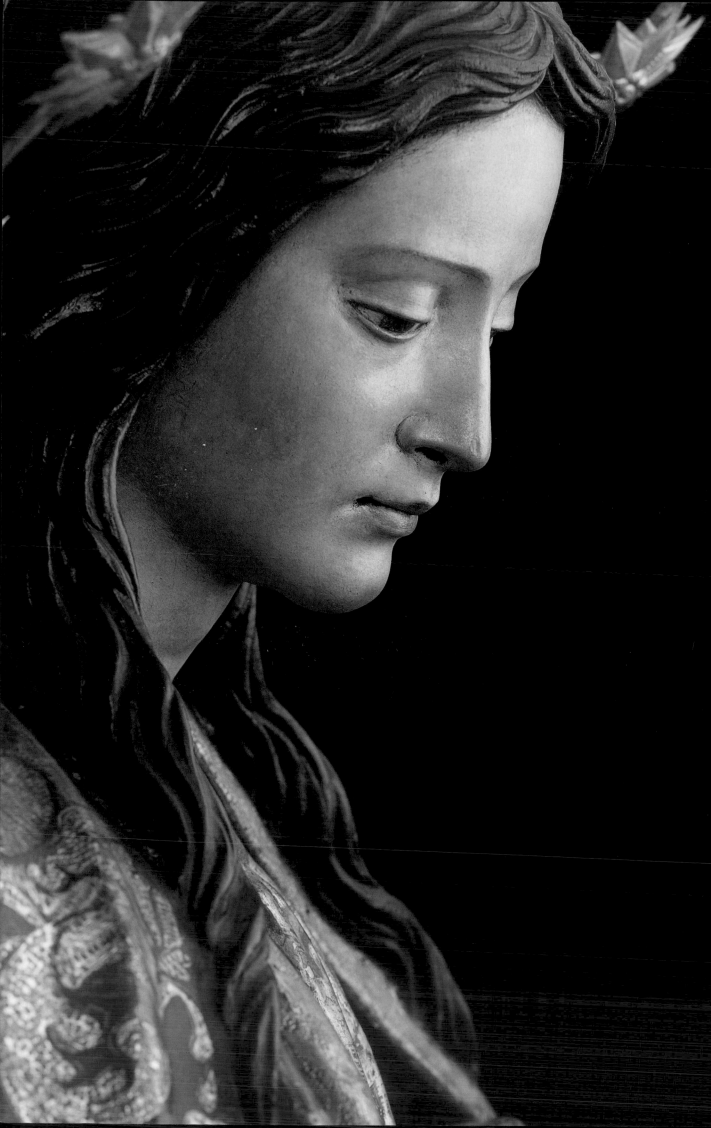

Mena in the small sculpture in Toledo Cathedral that became the prototype for other works by Mena and his studio (see cat. 33). It was also quite common to depict the saint kneeling, meditating with a skull in his hand. El Greco had already depicted him in this way, probably creating the model followed by Zurbarán (see cat. 29). Meditation on death, which encouraged reflection on the vanity of worldly pleasures, was a standard notion in ascetic literature and the skull as a symbol of disdain for the world frequently appears in so-called 'vanitas' still lifes. In addition, the military and political decline of seventeenth-century Spain encouraged the cultivation of Stoic philosophy among rulers and intellectuals.[24]

The life of the penitent is reflected in Montañés's sculpture of Saint Dominic (Domingo de Guzmán), a contemporary of Francis of Assisi and founder of the Dominican order (fig. 40). The saint is shown kneeling, bare from the waist up and whipping himself. This was not the standard iconography for Saint Dominic, who was noted for his preaching and for the institution of the cult of the rosary in honour of the Virgin, and he was probably represented in this manner because, before founding his order, he had retired to a cave in Segovia to do penance. In the late sixteenth century an energetic reforming trend among Spanish Dominicans, led by Francisco de Vitoria, Domingo de Soto and other monks of the monastery in Salamanca, called for a return to a more penitential and austere religious life of the kind observed by Saint Dominic himself and his early followers.

Despite their life of complete seclusion from the world and their extreme austerity, Carthusian monks were admired and protected, but depictions of their patron saints did not generally reach the eyes of the public. Such images were intended for the Charter-houses of the order to encourage meditation in the most profound silence. Sculpted images of Saint Bruno, the order's founder, were made by some of the greatest Spanish sculptors of the day such as Montañés in Seville (see cat. 12) and Manuel Pereira in Burgos (fig. 35).

Pereira's work, carved around 1634–5 as a commission from Cardinal Antonio Zapata, Bishop of Burgos, shows the saint standing, contemplating

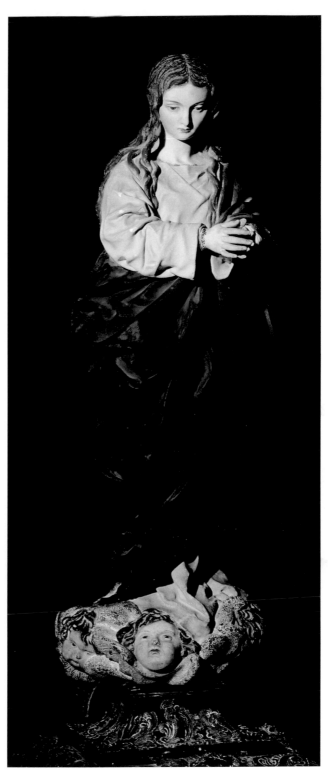

38 Alonso Cano (1601–1667)
Virgin of the Immaculate Conception, 1650
Polychromed wood, h 55 cm
Granada Cathedral

Opposite: **37** Attributed to Juan Martínez Montañés (1568–1649) and unknown polychromer
Virgin of the Immaculate Conception, about 1620
Detail of cat. 9

the crucifix in his right hand. Considered the artist's masterpiece, this sculpture has always been greatly admired: on the occasion of Philip IV's visit to the Charterhouse, a member of his entourage remarked on its naturalism, saying, 'It only lacks speech', to which the monarch is said to have replied, 'It cannot speak as he is a Carthusian', referring to the vow of silence taken by monks of this order.[25]

As might be expected, the seventeenth century saw the commissioning of numerous images of saints by orders of medieval origin that had undergone wide-ranging reforms following the Council of Trent, with the aim of restoring their original spirituality and discipline. This was the case, for example, with the Mercedarians. In the seventeenth century the order's original, thirteenth-century mission of saving Christians captured from the Turks and other Muslims became increasingly irrelevant and members of the order began to focus more on the contemplative life. Zurbarán's painting of Saint Pedro Nolasco, founder of the order, is an example of the new spirituality to which Mercedarian monks now aspired. The painting (fig. 39) shows Saint Peter the Apostle appearing in a vision to Saint Pedro Nolasco and is one of a group of works on the life of the founder which were commissioned by the Mercedarian monastery in Seville.[26] The Mercedarians' heroic mission of saving captives, which frequently ended in martyrdom, is conveyed in another moving painting by Zurbarán painted for this order, showing the tragic last moments of Saint Serapion, martyred in 1240 (see cat. 35).

It is not surprising that seventeenth-century art should depict contemporary figures who had been recently beatified or canonised. For example Francis

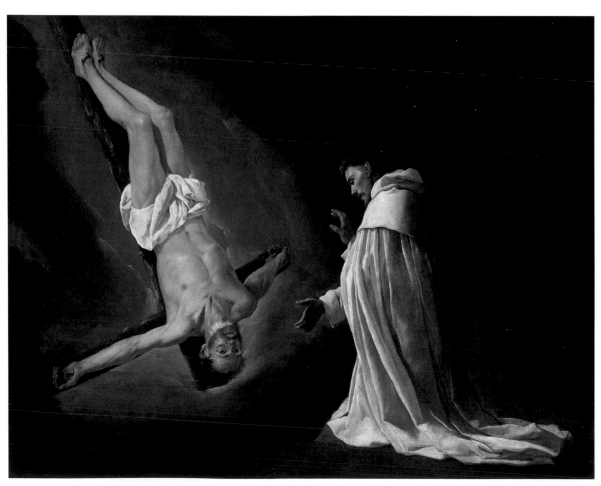

39 Francisco de Zurbarán (1598–1664)
Saint Pedro Nolasco's vision of the Crucified Saint Peter, 1628
Oil on canvas, 179 x 223 cm
Museo Nacional del Prado, Madrid (P-1237)

Borgia was sculpted by Montañés in a moving image commissioned by the Jesuits on the occasion of his beatification in 1624 (see cat. 14). It was created to form a pair with the statue of Saint Ignatius Loyola in the church of the Casa Profesa in Seville (see cat. 15). Great-grandson of Pope Alexander VI, grandson of Ferdinand the Catholic and the Duke of Gandia, Francis Borgia abandoned the world to enter the Company of Jesus after he had contemplated the decomposing corpse of the Empress Isabella, wife of Charles V, whose steward he had been. The energetic, practical character of this saint, who sent the first missionary Jesuits to Florida and to South America, was not emphasised by Montañés. He chose to focus on Francis's asceticism and love of prayer, qualities evident in his spiritual writings. Montañés conveys these ideas by depicting the saint meditating on the futility of worldly glory before the empress's skull.[27]

The sculpture of the great mystic and theologian Saint John of the Cross was probably executed in Seville by Francisco Antonio Gijón (see cat. 17) on the occasion of Saint John's beatification in 1675. Saint John, who was himself skilled at drawing and an outstanding poet, did not condemn the use of images to help him communicate with God. As he states in his famous text *The Ascent of Mount Carmel* (*Subida del monte Carmelo*), he considered them indispensable even for the most spiritual individual, although he emphasises that one should not linger on them with the intention of savouring their visual beauty. Images should function solely as a step on the upwards slope that leads to union with the divine.[28]

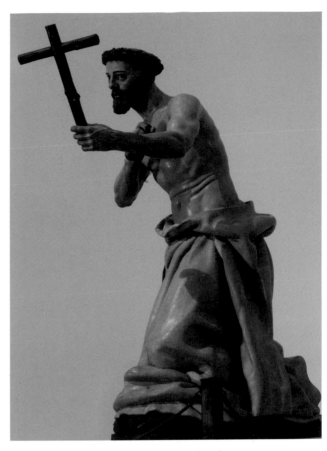

40 Juan Martínez Montañés (1568–1649) and Francisco Pacheco (1564–1644)
Saint Dominic flagellating himself, 1606–7
Polychromed wood, 147 x 68 x 126 cm
Museo de Bellas Artes, Seville

NOTES
1 Martínez-Burgos Garcia 1990.
2 Ruiz Martín1983, pp. 194–202.
3 Domínguez Ortiz 1970, pp. 85–112.
4 López-Guadalupe Muñoz 2002, pp. 49–103.
5 Sánchez Lora 1988.
6 Stoichita 1995.
7 Verdi Webster 1998.
8 For example, Velázquez and his wife Francisca Pacheco, who lived in an apartment in the annex of the Alcázar in Madrid known as the Casa del Tesoro, had paintings, sculptures, reliquaries and other devotional objects throughout their rooms: see Sánchez Cantón 1942a, pp. 642–53.

9 Orueta y Duarte 1914, p. 211.
10 Kamen 1993
11 Rodriguez G. de Ceballos 2004, pp. 4–19.
12 Pacheco 1649 (1990), pp. 713–9; Brown 1978, pp. 63–83.
13 Rodríguez G. de Ceballos 2004, pp. 4–19.
14 Baticle in New York 1987, pp. 76–9.
15 Proske 1967, pp. 39–41.
16 Rodríguez G. de Ceballos 2002.
17 Gállego Serrano in Madrid 1990, pp. 84–9.
18 Rodríguez G. de Ceballos 1991.
19 This sculpture has not survived but there is a copy in the chapel in the palace of the Marquises of Comillas (Santander); see Hernández Perera 1954, pp. 47–62.

20 Dávila Fernández 1980; Núñez Beltrán 2000.
21 Rodríguez G. de Ceballos 1990.
22 Pacheco 1649 (1990), pp. 575–7.
23 Stratton 1988.
24 Blüher 1969, pp. 333ff.; Ettinghausen 1972.
25 Ceán Bermúdez 1800, IV, pp. 69–71; Sánchez Guzmán 2008, pp. 87–9.
26 Sebastián 1975, pp. 82–8; García Gutiérrez 1985, pp. 91–5.
27 Wethey 1955, pp. 38–9.
28 San Juan de la Cruz (2003), II, pp. 209–10; Camón Aznar 1972.

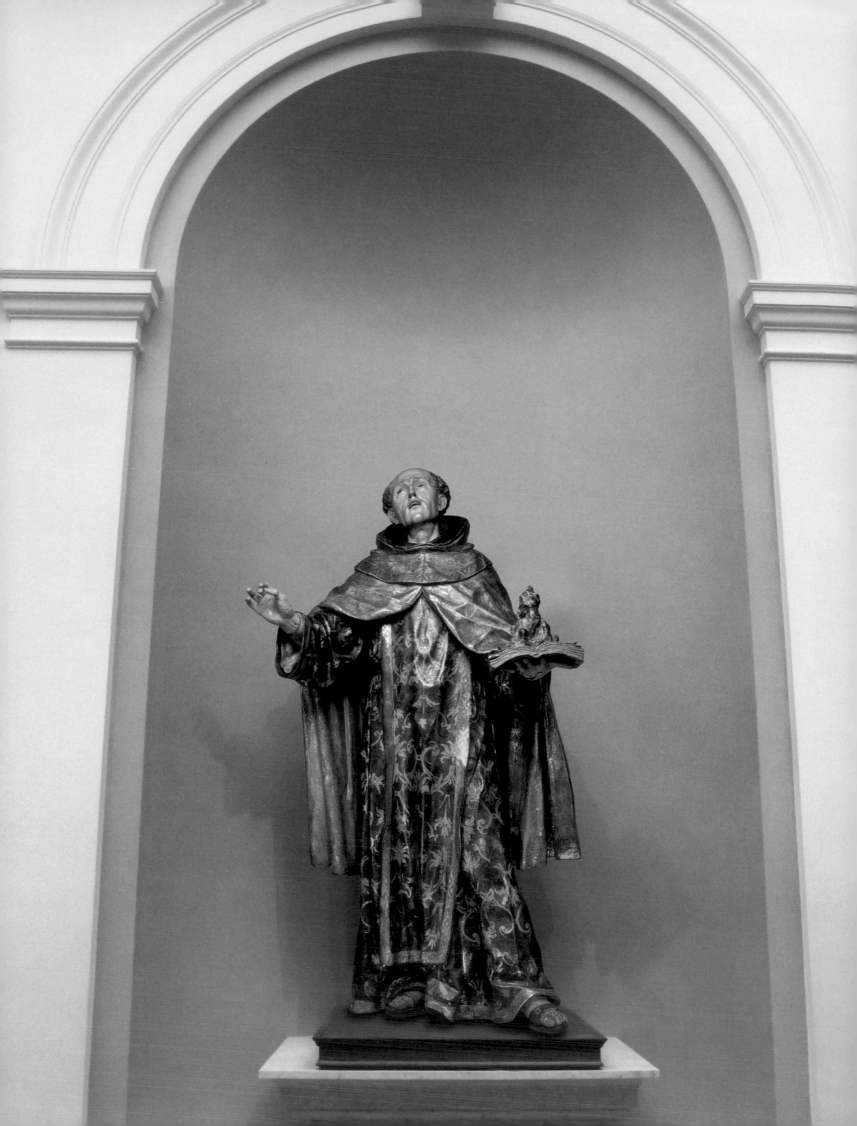

The Making of a Seventeenth-Century Spanish Polychrome Sculpture

DAPHNE BARBOUR AND JUDY OZONE

The technical aspects of creating polychrome sculpture in the Spanish Golden Age define the very essence of the sculpture not only in terms of its aesthetic appeal, but also in the context of its religious interpretation. Yet by choosing to work in wood rather than in the more classical mediums of marble or bronze, Spanish sculptors and their work were often dismissed by scholars of western art. Even the royal collections of Spain tended to reflect more mainstream European preferences, favouring foreign sculptors working in bronze and marble.[1] Thus these polychrome wood sculptures, almost exclusively religious in subject, infused with a passion and realism characteristic of the Counter-Reformation era in which they were created, were at odds with mainstream European as well as later more secular tastes. The predilection for coloured surfaces further separated Spanish polychrome sculpture from Neoclassical ideals.[2] However, despite the disdain for painted sculpture outside the Iberian Peninsula, the tradition flourished, providing works of extraordinary technical and artistic merit in a language and practice unique to Spain and its empire.

The examination of the polychrome figure of *Saint John of the Cross* from the collections of the National Gallery of Art, Washington, attributed to the Andalusian sculptor Francisco Antonio Gijón (cat. 17), provided an opportunity to study more closely the traditions of carving, gilding, painting, and *estofado* (gilded, painted and scribed decoration[3]) as practised in seventeenth-century Spain. Using this sculpture as a primary source, these techniques will be reviewed here and the respective roles of specialised artisans within

the workshop addressed. Other Spanish sculptures of the period are also included to show similarities or differences in technique, and these observations are compared to Francisco Pacheco's theoretical and practical treatise, *Arte de la Pintura* (Seville 1649).

Saint John of the Cross

Saint John of the Cross, recently attributed to Gijón by the art historian José Roda Peña, is represented as a life-size figure (fig. 41 and cat. 17).[4] A sixteenth-century mystic, Saint John of the Cross, together with Saint Teresa of Ávila, founded the order of reformed Discalced Carmelites. The carved *Saint John* holds a book in his left hand crowned by a small mountain, references to his spiritual writings such as *Ascent to Mount Carmel*.[5] His intensely expressive face and dramatic pose, complemented by the rich *estofado* decoration of the Carmelite habit, are qualities associated with Gijón and are typical of the late Baroque style.

The attribution to Gijón, convincingly presented by Roda Peña, is based on stylistic similarities with Gijón's known works and is further supported by Roda Peña's publication of a document for the commission of a life-size sculpture of Saint John of the Cross with the convent of Discalced Carmelites of Nuestra Señora de los Remedios signed by Gijón in 1675.[6] The contract details the conditions of payment, with few stipulations regarding composition and final appearance, other than specifying that the figure be 'made and finished in the way that is to the satisfaction of masters of sculpture that are knowledgeable in this'.[7] In addition to a brief list of the saint's required attributes, there is a mention of supplying the artist with 'a log of cypress three and three-quarters *baras* long and one-half *bara* wide'.[8] According to Roda Peña,

41 Francisco Antonio Gijón (1653–about 1721)
Saint John of the Cross, 1675, displayed in the National Gallery of Art, Washington (cat. 17)

59

Domingo Mejías, a master painter and gilder, who co-signed the contract as a guarantor, may also have been responsible for painting the sculpture.[9]

Gijón's training began at the age of fifteen when he enrolled in the Sevillian academy La Lonja, specialising in *dibujo escultórico* (drawing for sculpture). His apprenticeship with the sculptor Andrés Cansino the following year did not preclude continued studies at the academy under Pedro Roldán, but his three-year contract with Cansino required that he live in the master's home and share in family life.[10] This obligation apparently served him well, for within two months of Cansino's unexpected death in 1670, Gijón married Cansino's widow, who was fifteen years his senior.[11] Although Gijón's motives for this union are unknown, the fact remains that with his marriage to Teresa de León not only did Gijón inherit her three children, but the materials, models and tools of Cansino's workshop as well. However, he could not inherit the title of *maestro escultor*,[12] which would have allowed Gijón to head the workshop and solicit commissions. He had to earn that designation independently, and had done so by 1671.[13]

CREATION OF THE SCULPTURE

The Workshop

The division of labour, particularly in seventeenth-century Seville, may have had its origins in the medieval guild system.[14] Artists generally divided themselves into two major guilds, the Painters' Guild which included painters of sculpture, and the Carpenters' Guild which incorporated sculptors and woodworkers in its membership.[15] In order to practise a particular specialisation, artists were required to pass technical examinations administered by the guild. Many were proficient in more than one guild speciali-sation: for example, Juan Martínez Montañés earned three titles within the Carpenters' Guild,[16] and Alonso Cano was licensed in both the Painters' and Carpenters' Guilds.[17] Most workshops of this time, however, followed the tradition whereby carving, gilding and painting were reserved for individual specialists. Distinct roles were so familiar a concept that Saint John

of the Cross himself could use the division of prescribed tasks as an analogy in his mystical writings:

> Not everyone who can hew a block of wood is able to carve an image; nor is everyone who can carve it able to outline and polish it; nor is he that can polish it able to paint it; nor can he that is able to paint it complete it with the final touches. Each of these in working upon an image, can do no more than that with which he himself is familiar, and, if he tries to do more, he will only ruin his work.[18]

The production of *Saint John of the Cross*, although a single figure, appears none the less to have been a collaborative endeavour. To create a work of the scale and quality of *Saint John*, particularly in the time allotted (approximately seven weeks),[19] Gijón would have relied on assistance from his workshop, although

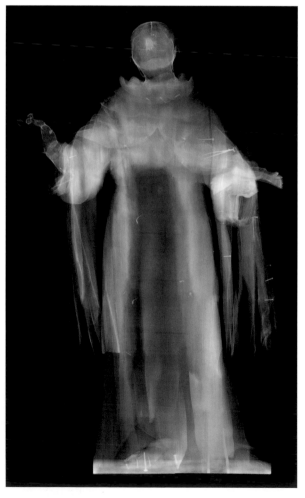

42 X–ray of *Saint John of the Cross* (cat. 17)

its division of labour can only be inferred. By 1673 Gijón contracted with apprentices of his own: one to learn the *oficio de escultor* (trade of the sculptor), a second as part of a contract arranged with an *ensemblador* (a person who assembles *retablos*, altarpieces), and a third dedicated to painting *retablos* and sculpture, all of which suggest that his workshop operated in a manner consistent with contemporary practices.[20]

Assembling and carving the sculpture

Gijón was just twenty-one-years old when he was awarded the commission for *Saint John of the Cross*, but he was already a well-known and highly paid sculptor.[21] As *maestro escultor*, he was responsible, among other duties, for the carved wood form. The sculptor often began with preparatory drawings, *dibujos escultóricos*, a skill that Gijón learned through his studies at La Lonja. Three-dimensional models in malleable materials like wax or clay were also frequently employed, as seen for example in the *Portrait of Juan Martínez Montañés* by Francisco Varela (see fig. 55) that depicts the great sculptor modelling a study for the *Penitent Saint Jerome* directly in clay.[22] Once the sculptural form was established, the sculptor proceeded with carving the wood. Comparison of *Saint John of the Cross*'s surface and wood sample with corresponding X-radiographs[23] confirmed that most of the figure was carved from a single thick column of cypress wood,[24] which was hollowed at the back from mid-chest down to the base to reduce the sculpture's weight and minimise cracking along the grain (fig. 42). The head was made separately from the body, and the neck carved with an extension shaped to fit into a hollow in the top of the trunk (fig. 43). Extra sections of wood were attached to the main column to accommodate the figure's expansive stance and three-dimensionality. These sections were carved to

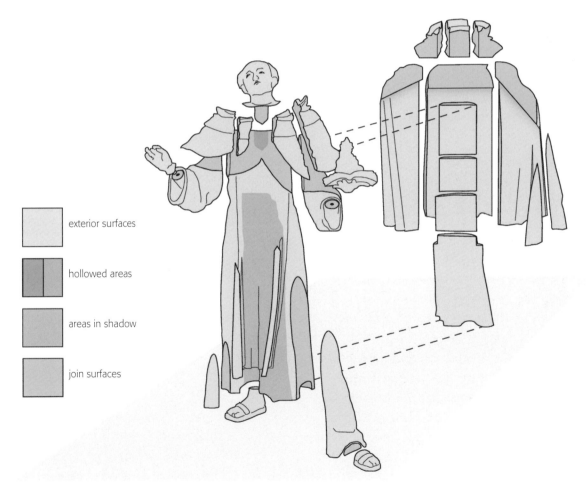

exterior surfaces

hollowed areas

areas in shadow

join surfaces

43 Schematic drawing by Julia Sybalsky of the making of *Saint John of the Cross*

form the arms, much of the extended left leg and foot, the cape and hood, and the lower scapular. The right foot is wholly separate from the body as are both hands (figs 44 and 45). Several individually carved iconographic elements are now lost: a quill placed within the right fingers, a dove mounted on the right shoulder, a diadem once attached to the head, and a cross atop the mountain. Evidence for the presence of a dove as described in the commission document is indicated by a hole in the back of the right shoulder.[25]

Both hands were made separately with a carved tenon projecting from the centre of each truncated wrist, and a corresponding mortise at the end of the forearm. Small holes at each wrist indicate that nails were once inserted at an oblique angle to secure the hands further. Less clear is the method for the attachment of the arms to the body. Several large nails pass from the left arm through the body, but none is visible on the right side in the radiograph; presumably they are secured with fabric and glue as are other components.[26] Wood blocks under the left arm and cope also appear to provide support for the hand bearing the weight of the book. Across the shoulders, the cope appears to have been carved as part of the main body, while the cowl and remaining drapery are comprised of multiple sections that have been carved separately and attached. Radiography revealed a series of cross-grain boards stacked one on top of the other to close the opening at the back of the figure and to provide support for the attached drapery (fig. 42).[27]

Technical studies of several contemporary wood sculptures provide further insight into various methods for constructing full-size figures. Radiography of Pedro de Mena's *Mary Magdalene meditating on the Crucifixion* (1664) (cat. 23 and fig. 110) shows that, as with *Saint John of the Cross*, most of the figure was created from a column of wood, the lower part of which was hollowed. The head and shoulders are solid, as are the arms and feet; these separately carved elements are fixed to the body with nails.[28] In contrast, *Saint Ginés de la Jara* (1692?) by Luisa Roldán (1652–1706) has an unusual construction, whereby two stacked wooden boxes form the central core over which additional planks and blocks of wood were glued and subsequently carved in place. Hollowing out a central

trunk served to lessen the sculpture's weight, but a core of fabricated boxes was a more economical use of wood with less waste, and it was less likely to shrink and crack, as well as being more stable than a thick wood column.[29]

Supplementary features

A significant aspect of Gijón's work is the intense expressiveness he was able to achieve, which is so sensitively captured in the face of Saint John. His furrowed brow and open mouth convey a moment of heightened sensation, and the distinctive bone structure of the face frames the eyes as the saint listens intently to the word of God. These features, which appear true to life when compared to contemporary descriptions of the saint, are integrally carved from the wood block. In contrast, other sculptors introduced glass eyes and bone or ivory teeth as a means to enhance the realism of the figures, seen for example in the *Dead Christ* (cat. 27) by Gregorio Fernández, the *Ecce Homo* (cat. 20) by Pedro de Mena and *The Virgin of Sorrows* (cat. 22) by José de Mora.[30] When ancillary elements such as these were incorporated, the face was carved as a mask, leaving cavities for the glass eyes and bone teeth (often inserted into semi-circular wooden holders rather like dentures from behind). Eyelashes of animal hair, as on de Mena's *Ecce Homo,* or finger and toenails of horn, preserved on Fernández's *Dead Christ* (figs 46 and 47), contribute to a hyperrealism intrinsic to Spanish Counter-Reformation taste.

Some sculptures were dressed in fabric such as the Montañés *Saint Ignatius* and *Saint Francis Borgia* (cats 14 and 15), although the original garments have been replaced. Such *imagines de vestir* (dressed figures) required only that the head, hands, and on occasion the lower legs and feet, be carved and painted; these sections were then attached to an internal wooden armature which in turn had been filled out with stuffing prior to having been dressed. Fabric in the form of *tela encolada* (cloth soaked and stiffened in glue size) might also be attached to fully carved sculptures. Fernández's *Ecce Homo* is an example of a fully carved standing nude whose modesty is preserved by a *tela encolada* loincloth nailed to the right hip (fig. 89).[31]

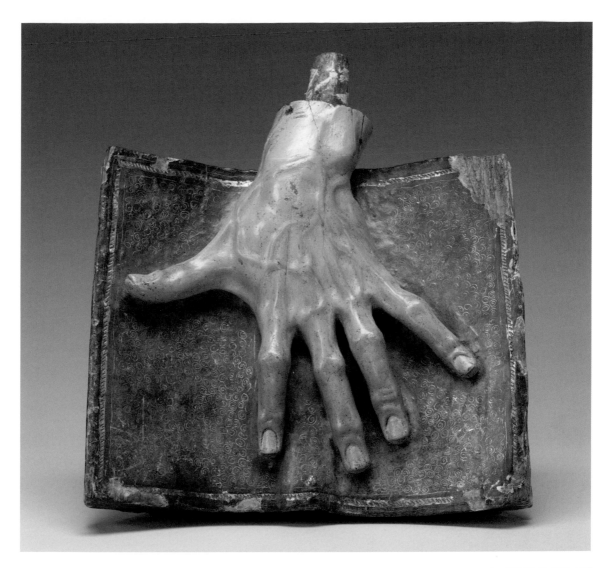

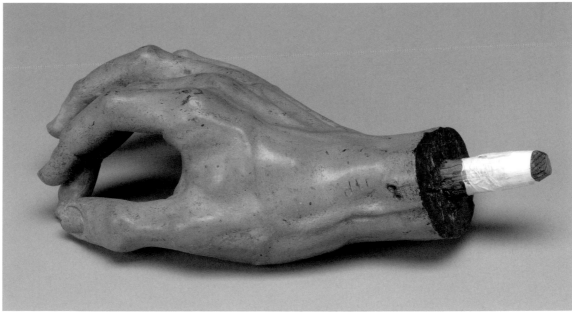

44 and 45 Details showing the separately carved hands with attachment dowels

Preparing the surfaces

Once the sculpture was completely carved and assembled, its surface was prepared to receive gold and paint (fig. 49). Sawdust was removed. Then wood knots were pierced to expel sap and rubbed with garlic to enhance adhesion, with several coats of glue applied to the entire sculpture. It is at this stage in the making of a polychrome sculpture that Pacheco's *Arte de la Pintura* becomes an invaluable reference for preparation, gilding and painting techniques.[32] Traditionally two types of paint were used: oil-based paints for the head and exposed flesh (usually hands and feet), and egg-tempera paint over gold leaf for the drapery. The physical qualities of these particular paints created different effects; oil paint can result in a smooth, reflective and more nuanced surface, while matt tempera paint contrasts with the gold below. Preparation for the *estofado* used for decorating the drapery was more time-consuming than that for the *encarnaciones* (flesh tones) of the face and hands. Both processes began with brushing the bare wood surfaces with warmed *gíscola* (animal glue and garlic essence), after which the materials and procedures varied.

Painting the flesh tones

The face, hands and feet were considered the most important parts of the commission and were the first surfaces to be prepared, the last to be finished, and the areas that demanded greatest attention from the master painter. Pacheco describes two different methods by which flesh tones could be produced, *encarnaciones de polimento* (glossy flesh tones) and *encarnaciones mates* (matt flesh tones).[33] For flesh tones painted *de polimento*, the wood surface did not need to be carved to absolute completion since it would eventually be covered with numerous layers: an initial layer of *gíscola,* followed by several layers of *yeso grueso* (a mixture of gesso [hydrated calcium sulphate] and animal glue), two to three layers of well-smoothed *yeso mate* (a mixture of finely ground gesso and animal glue) followed by several thin layers of a sized lead-white ground, prior to the last layer of a strong animal glue size, which would impart a glossy surface to the applied oil paints.

Declaring the more ancient *polimento* style to be outdated, Pacheco promoted the use of *encarnaciones mates* for a more natural appearance, and for a surface that was seen as more tolerant of the inevitable later painted repairs.[34] Pacheco cites 'many celebrated things in this city' painted in the matt flesh tone/style (and by his hand), mentioning in particular 'the two heads of Saint Ignatius and Saint Francis Xavier [sic] in the Casa Profesa' by Montañés (see cats 14 and 15).[35] This matt form of painting was also employed on the head, face, hands and feet of the Washington *Saint John of the Cross*, as is confirmed by a cross-section taken from the top of the head, described in detail below (see fig. 51).

46 and **47** Gregorio Fernández (1576–1636) and unknown polychromer
Dead Christ, about 1625–30
Details of the finger- and toenails, probably of horn (cat. 27)

48 Pedro de Mena (1628–1688)
Saint Francis standing in Ecstasy, 1663
Detail showing the glass eyes (cat. 33)

Encarnaciones mates demanded more skill from the carver, who had to produce a higher quality finish to the wood, but required fewer layers of preparation compared to the more time-consuming layering for *encarnaciones de polimento.* Following an initial layer of *gíscola*, which served both as a moisture barrier and as binder for the gesso, several layers of *yeso muerto* (gesso mixed with lead white, water, and size made from *retazo* [sheep's ear or kidskin]) were thinly applied and smoothed after each application. An *emprimación* (pigmented primer) was applied overall, as a base for the ground colours, which would have a pink tonality (combined lead white and vermilion) for children or female subjects; for 'sculptures of penitents or old men, some ochre or red earth of Levant' was suggested, to produce a darker or more aged appearance, such as on *Saint John*'s unshaven chin (fig. 50).[36]

The emotional impact of Gijón's *Saint John of the Cross* would be conveyed even if it were not painted. In order to retain the subtleties of the sensitively carved features, only minimal amounts of gesso were applied in preparation for the oil paint flesh tones. Very thin gesso/paint layers seen in a cross-section taken from the top of the head (fig. 51) confirm that the *pintor de ymaginería* worked well within established practices as outlined by Pacheco.[37] The sample shows a thin gesso ground containing calcium sulphate; a pigmented priming layer containing lead white, red lead, some charcoal black and earth; an upper paint layer containing lead white, red lead, charcoal black, a copper based

blue pigment (azurite?), as well as trace amounts of iron earth. A toned coating composed of quartz, calcium carbonate and charcoal black also identified in the cross-section may be a later addition. When comparing cross-sections from *Saint John* with those from Fernández's *Ecce Homo* (cat. 18), the flesh tones appear to be similar. Both are thinly painted using remarkably analogous palettes. Christ's flesh tones, like those of *Saint John,* contain red and white lead and finely ground azurite. A slight variation is the addition of vermilion and red lake to create a rosier cast.[38] As would be expected, all flesh tones analysed were bound in an oil medium.[39]

Gilding and estofado

Despite his own rigorous asceticism, Saint John of the Cross is represented wearing layers of richly decorated vestments of gold brocade or voided silk velvet, with gold banding along the edges and hems. As Alfonso Rodríguez G. de Ceballos notes elsewhere in this catalogue (p. 49), this apparent contradiction between the real saint's asceticism and the sculpture's splendour follows the dictates of the Council of Trent requiring that the appearance of objects of veneration be appropriately respectful. The same sentiment reflects a desire of the patrons to honour and elevate the beatified saint, and mirrors the contemporary trend for clothed processional sculpture.[40] Whereas in the sixteenth century the figures' robes were usually made of modest linen or sackcloth, the fashion during the seventeenth

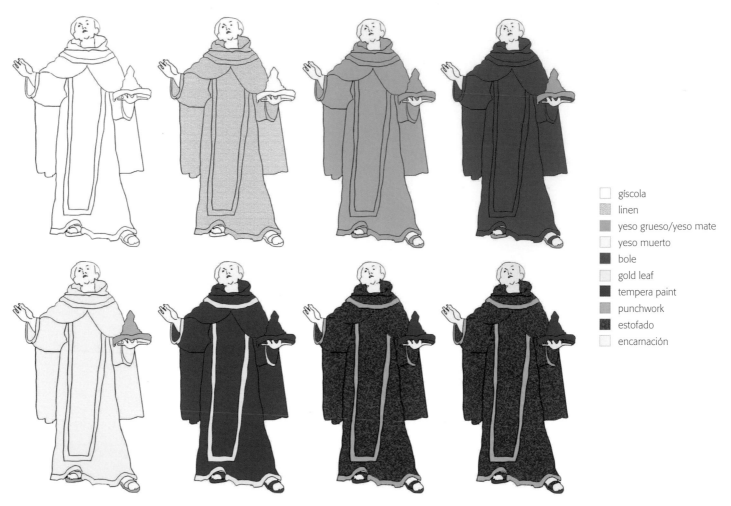

	gíscola
	linen
	yeso grueso/yeso mate
	yeso muerto
	bole
	gold leaf
	tempera paint
	punchwork
	estofado
	encarnación

49 Sequential schematic drawings of the surface preparations evident on *Saint John of the Cross* (cat. 17), prepared by Object Conservation Department, National Gallery of Art, Washington

century favoured the use of costly velvets or brocades, often with gold embellishment.[41] To create the effect of sumptuous textiles, the technique of *estofado* was often employed, and is evident on *Saint John of the Cross*. Pacheco warned against overusing gilded decoration, as not in keeping with the *buena manera*, but not all artists heeded his advice.

Since the *Saint John* was to be shown wearing vestments, the figure was carved more broadly, with just enough animation to reflect movement beneath heavy garb. Following an overall application of *gíscola*, the surfaces to be gilded were covered with linen, whose purpose was to reinforce the separate wooden elements, cover wood knots, and provide a rough surface to hold the subsequent layers of gesso. Acknowledging that 'nothing can be done to prevent the wood from opening', Pacheco recommends against

covering the wood joins, stating that subsequent repairs to gaps in the surface are inevitable.[42] In contrast, Gijón used linen to bind the discrete wooden elements on areas of the sculpture to receive *estofado*. The strength provided by the fabric precluded the need for numerous iron nails, which had the disadvantage of corroding and eventually causing the wood to crack during seasonal weather cycles. Indeed few nails are visible in the various X-radiographic views between the many boards (fig. 42).

The fabric was brushed with *gíscola*, followed by four to five layers of glue-fortified *yeso grueso*. On top of the coarser gesso, finer *yeso mate* was carefully applied in a continuous succession of several thin layers.[43] Considerable attention was paid to maintaining a smooth surface after each layer was applied, thereby contributing to a final surface that was as smooth as

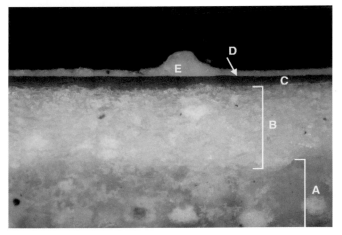

50 Detail of unshaven chin from the face of *Saint John of the Cross* (cat. 17)

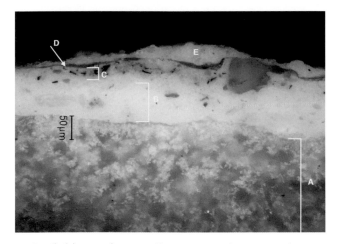

51 Detail of the use of *encarnación mate* as seen in a cross-section taken from the top of the head of *Saint John of the Cross*. The sample shows (A) a thin gesso ground containing calcium sulphate; (B) a pigmented priming layer containing lead white, red lead, some charcoal black and earth; (C) an upper paint layer containing lead white, red lead, charcoal black, a copper based blue pigment, as well as trace amounts of earth. (D) The toned coating composed of quartz, calcium carbonate, some charcoal black also identified in the cross-section is a later addition. (E) overpaint.

52 Cross-section taken from the *estofado* on the robe of *Saint John of the Cross* revealing discrete applications of (A) *yeso grueso*, (B) *yeso mate*, (C) bole, (D) gold leaf, and (E) tempera paint.

possible, and free of surface imperfections. The distinct gesso layers are clearly evident in a cross-section taken from the robe of *Saint John* (fig. 52).

To prepare the surface for gilding, bole (iron-rich clay mixed with animal glue) was applied. The bole provided a relatively tough but pliable surface upon which the gold leaf could be adhered, scratched, impressed or burnished. In addition, the colour of the bole, which varied from ochre to deep red depending on the iron constituents in the clay, also created a toned ground that enhanced the visual depth of the gold leaf. Bole occurs naturally in Spain and local tastes dictated whether Asturian bole from Llanes or Andalusian bole from Seville should be used. Castillian sculptors favoured the former, so much so that in 1613 the gilders' municipal ordinance of Madrid required the exclusive use of bole from Llanes.[44] Pacheco, on the other hand, claimed Andalusian bole was supreme, providing a surface that was 'más suave y amoroso' (softer and gentler).[45] Andalusian-style bole was finely ground and tempered in water to produce a gelatinous full-bodied consistency and was heated and applied in as many as five layers. The final layer was carefully polished, since this was the surface upon which the gold leaf was laid, and imperfections were magnified by the gold's reflection. After dampening the bole with water to activate the glue, individual gold leaf sheets were floated onto the surface and gently set down with a soft brush to expel any air bubbles, allowed to dry fully, then polished with a burnishing stone to a brilliant sheen.

The resulting golden surface was brushed with thin layers of egg-tempera paint, prepared by mixing diluted egg yolk with pigment. Offsetting the brilliant gold, the sombre palette for *Saint John*'s Carmelite vestments was limited to a deep brown for the robe and scapular as would be expected, and a warm white (presently a pale brown) for the cope and cowl; both colours are a combination of lead white and earth pigments, with occasional amounts of charcoal black.[46] When dry, the matt surface of the tempera provided maximum contrast to the brilliant gold patterns revealed by scribing to create *estofado* decoration.

Estofado *patterns*

The relatively ornate patterns on *Saint John*'s garments are generalised, and the overall execution of the polychromy is less skilful than that on Montañés's *Virgin of the Immaculate Conception* (cat. 7), for example. The central discrete motif on the scapular is a single simplified acanthus leaf surmounted by a stylised double-headed scroll that may have been derived from a dolphin-like form (fig. 53).[47] This same motif is turned upside down on the robe. Each repeated motif in the scapular and robe has very nearly the same measurements, regardless of where it appears, indicating the probable use of a flexible pattern that could follow the sculptural contours, a common technique. On the cape and collar, the decorative elements combine the traditional scribed lines of the *estofado* in the background with painted contours of floral motifs, similar to those identified on the scapular, whose interiors are punched repeatedly into the gold with a simple pointed instrument. Along less visible passages behind the arms, some floral elements are not punched and appear merely as painted silhouettes.

Painted textile patterns on sculptures were largely generic, and artisans usually had a limited selection of designs; the scribed designs rarely had the associated symbolism that might be found in paintings.[48] *Estofado* lent an impression of grandeur to the figure, which was often glimpsed only from afar. A small repertoire of standard pattern elements could be used in varying combinations and sizes, sometimes to great effect so that only a judicious eye could differentiate individual elements.

Many standard scribe marks can be found within *Saint John*'s *estofado*, including *rajado* (fine parallel lines that imitate gold thread) evident in the background overall, and *ojetado* (tiny spirals) that cover the interior of the hood and sleeves. In general, the *estofado* on the cope seems to have been executed by a more confident hand than the hand which worked on the scapular, judging from the clarity of the motif forms, outlined brushstrokes, hatch lines and punchwork. The background between the motifs consists of fine parallel hatch lines, scribed to impart visual texture, which could be further nuanced by varying the pressure of the stylus. The tiny lines give the sense of floating gold

53 Detail from *Saint John of the Cross* showing *estofado* decoration and punched border

threads like those found in silk brocades or velvets.

Bands of intricate punchwork simulating gold trim border the *estofado* decoration along all of *Saint John*'s vestments. Only three iron punch tools, one to create a small circular depression, the second to create a rectangular impression and the third an oblong recess, were used to form the visual frame that spans the painted and gilded robes. Stylised geometric and floral motifs achieved with a simple play of positive and negative space characterise the border decoration. This labour-intensive technique is often used to complement to the gilded and painted ornament.

CONCLUSION

The legacy of polychrome sculpture in Spain endures today thanks to the painstaking technical achievements of the many accomplished artists of the Golden Age. Contemporary documents referring to the production of images describe working practices and underline the status afforded the industry. Guild-regulated workshop procedures carried out by highly trained practitioners contributed to the longevity of these works of wood, a potentially ephemeral medium. Pacheco's treatise, so influential for the seventeenth-century artist, continues to be a rich resource for understanding polychromed sculpture and painting practices. The wealth of commission documents, confraternity records and church inventories offers glimpses into the contemporary religious landscape and conveys the importance these images had in their patrons' devotional lives. At first glance, it is just the sculpture's surface and form that evoke passion and instil piety, but knowledge of what lies beneath can only increase the awe inspired by these tangible representations of spirituality.

Sometimes, when our Prebendary was tired of painting, he would ask the student who assisted him for the chisels, the mallet, and other tools to work on some sculpture, saying that he wanted to rest a while. The youth would laugh at this and tell him, 'That's a fine way to rest, master, putting down a little brush and picking up a mallet!' To which the Prebendary would respond, 'You are a big fool! Don't you know that it is more work to give form and volume to that which has neither than to give form to that which has volume?'

FROM PALOMINO'S
LIFE OF ALONSO CANO

NOTES

1 McKim-Smith 1993–4, p. 26, n. 3, notes that 'Spanish sculptors . . . nevertheless obtained important commissions from royalty, aristocracy, clergy and confraternities, though the support from Spain's kings and queens tended to be more for images destined for ecclesiastical settings than for images intended for royal palaces.' McKim-Smith, p. 27, n. 13, also adds that when Philip IV commissioned a portrait from Pietro Tacca, it was Juan Martínez Montañés, summoned from Seville, who modelled the bust which was then sent to Tacca in Florence to cast into bronze (see cat. 1).

2 McKim-Smith 1993–4, p. 18. Anton Raphael Mengs, imported to assist with the founding of the Academy of Sculpture, Painting and Architecture in Madrid (1752), made his contempt for painted and gilded wooden sculpture unmistakable.

3 The scribe marks used in estofado are analogous to those of sgraffito on panel paintings, whereby a decorative design is produced by carefully scratching away paint to reveal the layer of gold leaf underneath.

4 Roda Peña 2005, pp. 304–9.

5 For a discussion on Saint John of the Cross see the entry in this catalogue (p. 122). See also Alfonso Rodriguez G. de Ceballos's essay on pp. 45–57.

6 Roda Peña 2005, p. 305.

7 Roda Peña 2005, p. 309; Verdi Webster 1998, p. 108. Though a sculpture's verisimilitude was of primary importance, contracts rarely specified aesthetic details, instead relying on subjective language requiring that the image be lifelike as agreed by the contracting commissioners.

8 Verdi Webster 1998, p. 193. One bara (vara) is considered to be the equivalent of 83.6 cm or 33 in.

9 Roda Peña 2005, p. 306.

10 Bernales Ballesteros 1982, pp. 26–7. For a discussion on apprenticeship practices in Seville see Gañán Medina 2001, pp. 40–2.

11 Bernales Ballesteros 1982, p. 31; Roda Peña 2003, pp. 28–9, argues that the two must have had an amorous liaison before Cansino's unexpected death and that Gijón had no pecuniary interests.

12 Gañán Medina 2001, p. 42. The title of maestro or oficial sabedor was the highest level attainable within a guild and enabled the bearer of the title to head his own workshop.

13 Bernales Ballesteros 1982, p. 34.

14 Gañán Medina 2001, pp. 37–52; Verdi Webster 1998, pp. 100–1; Kasl 1993, pp. 39–41. Guilds, regulated by municipal ordinances, were responsible for maintaining high standards, and could be summoned to assess the work of their members.

15 Gañán Medina 2001, pp. 43–9. The Painters' Guild was divided into four specialisations: pintor de ymagineria, painters of images on canvas or wood; doradores de talla, gilders; pintores de madera y del fresco, painters of wood and fresco, including estofado; and sargueros, painters of fabric (table linens, flags and sails). The Carpenters' Guild consisted of four distinct trades: carpintería de lo blanco techumbres, makers of architectural adornments, doors and roofing; carpintería de lo prieto, makers of wagons and mill wheels; violeros, makers of musical instruments; and entalladores, carvers of wooden sculpture.

16 Gañán Medina 2001, p. 47, notes that Montañés in 1588 was licensed as an 'escultor, entallador de romano y arquitecto'.

17 Sánchez-Mesa Martín 1971, pp. 132–4; Kasl 1993, p. 34, n 7.

18 Saint John of the Cross (1935), III, p. 89. Reprinted in Kasl 1993, p. 33. As a young boy after the death of his father, Saint John was sent by his widowed and indigent mother to learn various trades. With little success, he briefly tried his hand at carpentry, tailoring, wood carving/ sculpting (entallador) and painting. None the less, his stint in a sculptor's workshop clearly left its impression as the analogy to the artisans or the actual sculptures recurs in his writings. See Bruno de Jésus-Marie 1932, p. 376, n.3.

19 Roda Peña 2005, p. 309.

20 Bernales Ballesteros 1982, pp. 36–7.

21 Roda Peña 2003, p. 29; Verdi Webster 1998, p. 121.

22 The finished wooden sculpture of the Penitent Saint Jerome, painted by Pacheco, forms part of an altarpiece at Santiponce. See Xavier Bray on p. 19 and fig. 5 in this catalogue.

23 Three views made up of multiple films were taken using a Gemini III constant potential X-radiograph system with an industrial capability of 5 mA and 320 kV. We are extremely grateful to Julia Sybalsky for completing all of the radiography.

24 Michael Palmer and Suzanne Lomax, Conservation Scientists, Analysis Report, December 18, 2008, National Gallery of Art Scientific Research Department files. Multiple wood samples were examined by Michael Palmer.

25 The hole, 2.5 mm in diameter and 3 cm deep, may have held a wire used to support the dove.

26 It is possible that wooden dowels are present though they are not visible in the X-radiographs, perhaps obscured by the more radio-opaque gold and paint layers.

27 It is curious that the opening at the back of the figure was entirely closed with boards carved to simulate drapery, though this area was ultimately covered by the cope.

28 Garrido 1992.

29 Jane Bassett with Maria-Teresa Alvarez forthcoming. See also www.getty.edu/art/exhibitions/roldana for a video on the fabrication of the sculpture.

30 Trusted 1996, pp. 103–6.

31 Luis Cristóbal Antón, Informe de Conservatíon y Restauracíon del Cristo Yacente de Gregorio Fernández, ICROA, Madrid 1988. We are grateful to Laura Ceballos Enríquez, IPCE, Madrid, for sharing the report with us.

32 Pacheco 1649 (1956), II, p. 114; Veliz 1986, p. 86; Bruquetas Galán 2002, p. 423.

33 Veliz 1986, p. 193, defines polimento as a glossy finish applied to the flesh of polychromed figures as well as to the medium used for the technique. It is made by grinding pigment either with fat, oil, or a light, clear varnish.

34 Verdi Webster 1998, p. 109. In fact, encarnaciones de polimento continued to be the most popular technique for processional sculptures; the glossy surfaces reflected sun and candlelight more readily, animating the flesh tones and imparting life to the figure.

35 Pacheco 1649 (1956), p. 105; Veliz 1986, p. 82.

36 Veliz 1986, pp. 82–3.

37 For a discussion on the pintor de ymaginería, see Xavier Bray on pp. 18–27 in this catalogue.

38 Antón 1988; Gómez González et al. 2002, pp. 228–9.

39 See Palmer and Lomax 2008, cited in note 24.

40 See Rodríguez G. de Ceballos in this catalogue, pp. 45–57.

41 Verdi Webster 1998, pp. 112–13.

42 Veliz 1986, p. 87.

43 Veliz 1986, pp. 87–8.

44 Bruquetas Galán 2002, p. 428.

45 Bruquetas Galán 2002, p. 428; Pacheco 1649 (1956), p. 118.

46 See Palmer and Lomax 2008, cited in note 24.

47 The stylised scroll may be a simplified version of the popular double dolphin motif. See for example Meyer 1945, p. 89, plate 58.

48 Duits 2001, p. 62.

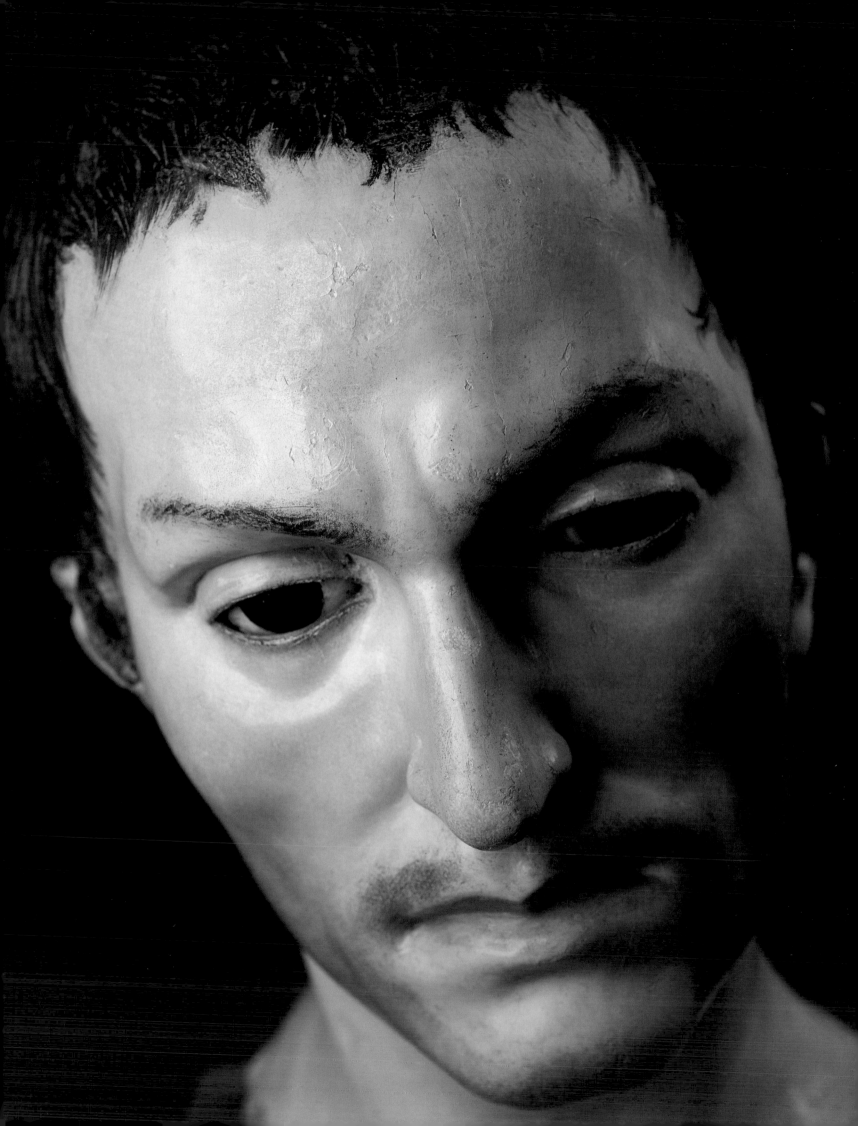

The Art of Painting Sculpture:
The Quest for Reality

The production of religious sculpture in seventeenth-century Spain was strictly governed by the guild system – the Guild of Carpenters for the sculptors, and the Guild of Painters for the polychromers or painters. By adding colour to form, the painter was not only responsible for decorating the sculpture but, more importantly, for making it lifelike. Without the skills of a painter, a carving such as Juan de Mesa's *Head of Saint John the Baptist* (cat. 5) would have been considered unfinished and not a faithful imitation of nature.

Yet the relationship between sculptors and painters was not always harmonious. Sculptors were particularly frustrated by their dependence on painters to complete what they had carved and designed; furthermore, because the work involved in making a sculpture was more laborious than painting, they were considered craftsmen rather than artists. Montañés was acutely aware of this and when he went to Madrid to model a portrait of Philip IV in 1635, he made sure that Velázquez, Court Painter to the King, who recorded the event, depicted him as a 'gentleman' artist (see cat. 1).

Polychroming sculpture was a lucrative business, and one that painters were reluctant to give up. The skills needed to paint sculpture were taught in most painters' studios throughout Spain, the most famous being that of Francisco Pacheco, with whom Velázquez and Alonso Cano studied, in Seville. Zurbarán was also qualified in the art of painting sculpture and polychromed a carving of the Crucifixion early on in his career.

Polychrome sculpture was a highly respected art form in its time, and each painter had his own personal style – Pacheco's polychromy on Montañés's sculptures tends to be precise and meticulous (see cats 7, 14 and 15), while on Cano's *Saint John of God* (facing page, and cat. 6) the paint is loosely applied, with several thin layers of colour that subtly bring warmth to the features.

One result of the direct contact painters had with religious sculpture was that when they worked on a flat format – such as canvas or panel – they often contrived to give a strong illusion of three-dimensionality. Zurbarán was the artist who more than any other experimented with this, and in his *Saint Luke contemplating the Crucifixion* (cat. 4) he invites viewers to ponder the question of what is real and to ask themselves whether they are looking at a painting of the Crucifixion or a painting of a polychrome sculpture.

54 Detail of cat. 6

1 Diego Velázquez (1599–1660)

Portrait of Juan Martínez Montañés, 1635–6

Oil on canvas, 109 x 88 cm
Museo Nacional del Prado, Madrid (P-1194)

In June 1635 Juan Martínez Montañés was invited to Madrid to make a likeness of Philip IV in clay so that it could be sent to Florence and serve as a model for the Italian sculptor Pietro Tacca who was working on a large equestrian portrait of the king. For a Spanish sculptor to receive such an important royal commission was a great honour, particularly as this type of work was generally reserved for imported Italian sculptors.

To celebrate this achievement, Velázquez was asked, either by Montañés himself or by an admirer, to paint his portrait. Velázquez shows the sculptor wearing a smart black cassock with a cloak slung over one shoulder, clothes he is unlikely to have worn while actually modelling. Montañés appears so focused that it is as though we have just interrupted him at work. He looks out directly at us, his right hand holding a modelling tool, while the other supports the clay bust.

Montañés was sixty-seven years of age when Velázquez painted him. He was at the height of his career and considered the best sculptor in Spain. Velázquez's grave and austere portrayal communicates a sense of profound respect for Montañés's artistic achievements. It also documents an important encounter between the two artists. Velázquez no doubt knew Montañés as a student in Seville when training as a painter under Francisco Pacheco. Montañés had provided several woodcarvings for Pacheco to polychrome and it is likely that Velázquez would have seen them in the studio and perhaps even helped with their polychromy (see cats 7, 14 and 15).

By 1635, Velázquez was also at the height of his career as court painter to Philip IV. The manner in which he paints this portrait demonstrates an incredible control of the brush and use of oil paint. Thick impasto denotes the relief of the white cuff and collar, which provides a clean separation between head and body. Oil paint added over still wet paint gives a slightly out-of-focus effect to Montanés's face. The black fabric and folds of his garments are painted with such assuredness that they appear three-dimensional. Quite daringly, Velázquez leaves the clay bust on which Montañés is working unfinished – black outlines delineating Philip IV's features, such as his moustache and prominent jaw, are enough to identify him. Velázquez thus not only displays his bravura but stresses that Montañés is in the act of creation. In contrast to an earlier

55 Francisco Varela (about 1580–1645)
Portrait of Juan Martínez Montañés, 1616
Oil on canvas, 60 x 51 cm
Ayuntamiento de Sevilla

portrait of Montañés by Francisco Varela , in which he is shown holding a highly finished clay model of his celebrated *Penitent Saint Jerome* (fig. 55 and see also fig. 5), Velázquez shows Philip IV's portrait in a state of suspended creativity.

Velázquez's attempt to convey Montañés in the act of making a sculpture of the king may be related to the fact that Montañés had also come to Madrid with a plea from the sculptors of Seville.[1] In Spain, sculptors were still considered artisans and had to pay the ten per cent tax known as the 'alcabala' tax whenever they sold a sculpture. In portraying Montañés as a 'gentleman' sculptor at work on a royal commission, without any signs of hard labour, Velázquez's portrait provided all the right arguments to assist him in his plea that the king would issue a royal statement abolishing the tax.

XB

SELECT BIBLIOGRAPHY
López Martínez 1928a, p. 96; Sánchez Cantón 1961, pp. 25–30; Orso 1989, pp. 21–4; Madrid 1990, cat. 48, pp. 292–7; Brown 1991a, pp. 162–3; Hellwig 1999b, pp. 298–319

NOTE
1 This plea was first published by López Martínez 1928a. For a full discussion see Hellwig 1999b.

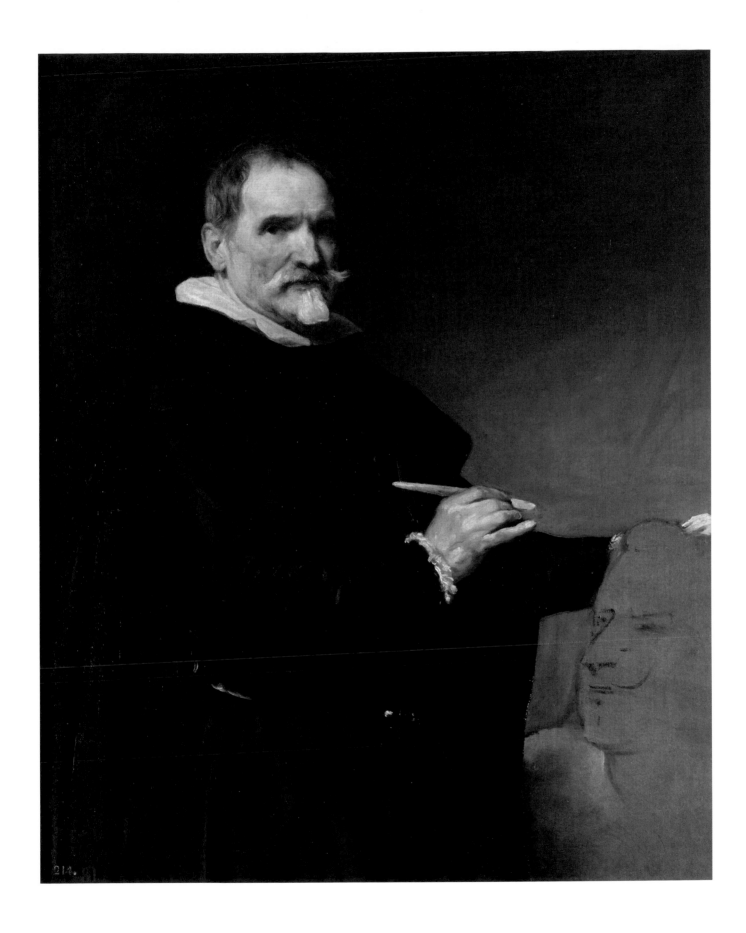

2 Francisco Pacheco (1564–1644)

Christ on the Cross, 1614

Oil on cedar, 58 x 27.5 cm
Signed and dated: *O. F. P. 1614*
Instituto Gómez-Moreno de la Fundación Rodríguez-Acosta, Granada

As censor of religious art on behalf of the Inquisition, a responsibility he was given in 1619, Pacheco had strong views on how certain religious subjects should be represented. One of his chief concerns was the number of nails used for Christ's Crucifixion. He firmly believed that four nails were used, not three. To argue his point he devoted a whole chapter to the subject in his treatise, *Arte de la Pintura* (1649).[1] Although the small size of this painting suggests it originally served as an object for private devotion, it summarises succinctly Pacheco's preoccupations and would have provided his contemporaries with a visual exposition of them.

Pacheco shows Christ standing upright on a small platform attached to the cross, and his body provides a powerful vertical line. His arms are outstretched and his hands nailed by another two nails. Had Pacheco used only one nail for the feet, Christ's legs and feet would have had to cross each other, thereby breaking the symmetry. Artists often preferred to show Christ with three nails because the effect of the bent knees and the weight of his body thrown forward heightened the drama. Pacheco, however, believing he was providing an authentic rendition of the Crucifixion, shows Christ fully frontal, his body rigid and inert. The anatomy and the musculature of his torso are precisely observed. Light and shade bring out Christ's figure, giving it a strong sculptural quality to the extent that a shadow has been cast on the neutral background behind.

The debate over the number of nails with which Christ was attached to the cross was a heated one in seventeenth-century Seville. Padre Juan de Pineda's *Sermón de las Llagas* of 1615 spoke enthusiastically in favour of four, while the 3rd Duke of Alcala, who had visited Pacheco's studio in 1619, probably to see this very painting, argued for three.[2] In support of Pacheco, Francisco de Rioja, a Jesuit, wrote an erudite letter stressing the authority of the 'four nail' thesis and praised his painting.[3]

Pacheco published Rioja's letter in his treatise together with his response in which he quoted a number of devotional sources, including Saint Bridget of Sweden's *Revelations*, whose visions of the crucified Christ significantly showed four nails.[4] Pacheco also provided an exhaustive list of examples in both painting and sculpture.[5] One of these was a silver crucifix given to Pope Leo III in 815 by Emperor Charlemagne which

56 *Crucifixion with Four Nails*, from Angelo Rocca, *Opera Omnia*, Rome 1719, vol. I, p. 252
Engraving
The British Library, London (482.e.16)

showed Christ in the same pose as in Pacheco's painting.[6] It was probably a print after this crucifix (fig. 56) that inspired Pacheco to paint his version and not, as is often suggested, Albrecht Dürer's engraving of *Calvary*.[7]

Some of the greatest examples of this subject, in both sculpture and painting, notably Juan Martínez Montañés's *Christ of Clemency*, Zurbarán's *Christ on the Cross* (see fig. 20 and cat. 25) and Velázquez's *Christ on the Cross* (see fig. 21), all kept to Pacheco's formula, producing what they thought were theologically accurate and as a result tremendously powerful renditions of Christ's sacrifice on the cross.

XB

SELECT BIBLIOGRAPHY
Gómez-Moreno 1916, pp. 179–84; Brown 1978, pp. 70–1; Valdivieso and Serrera 1985, cat. no. 135, p. 77; Seville 1999, cat. no. 36, p. 86; Granada 2002, p. 466.

NOTES
1 Pacheco 1649 (1990), Book III, Chapter XV, pp. 713–34: 'En favor de la pintura de los cuatro clavos con que fue crucificado Cristo Nuestro Redentor.'
2 See introduction by Bassegoda i Huga in Pacheco 1649 (1990), pp. 18–20, and Seville 1999, cat. no. 36, p. 86.
3 Pacheco 1649 (1990), pp. 713–19.
4 Cited in Pacheco 1649 (1990), p. 715.
5 Pacheco's main source was Rocca 1609.
6 Rocca 1609, p. 11, and Pacheco 1649 (1990), p. 729.
7 Pacheco 1649 (1990), p. 725. See also Navarrete Prieto 1998, pp. 90–1.

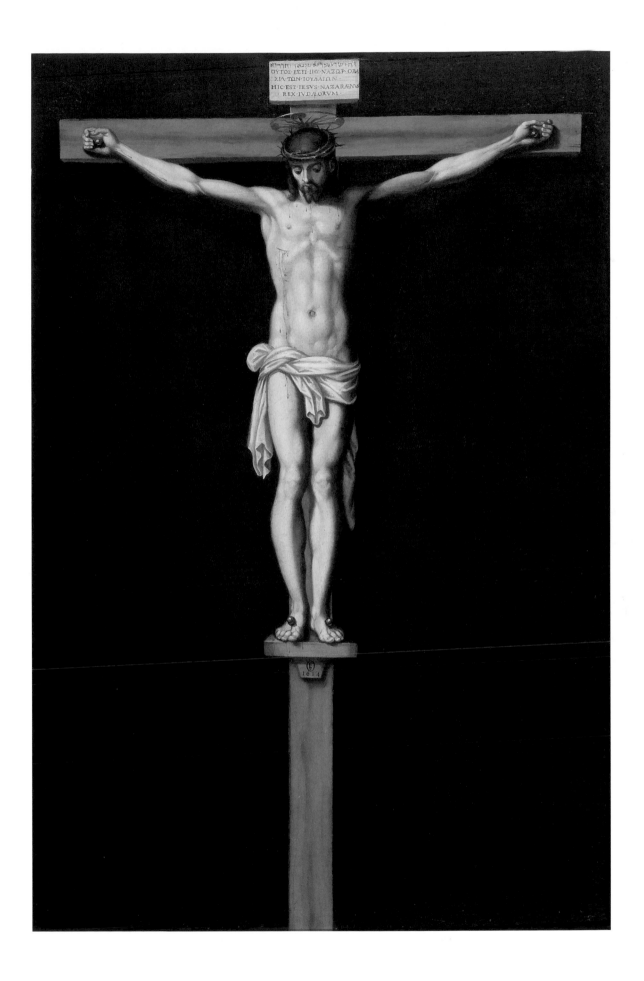

3 Juan de Mesa (1583–1627) and unknown polychromer
Christ on the Cross, about 1618–20

Polychromed wood, 100 x 65 x 22 cm
Archicofradía del Santísimo Cristo del Amor, Collegiate Church of El Salvador, Seville

Originally from Córdoba, Juan de Mesa moved to Seville in 1606 and joined Montañés's workshop. Before his death from tuberculosis in 1627, he was to produce some of the most expressive sculptures of the period. Although his early works have often been mistaken for his master's, Mesa quickly developed his own very individual style of carving, which was less refined and classicising than Montañés's and contained a much harsher sense of pathos.

This small work is closely related to a life-size polychrome sculpture of the Crucifixion which Mesa executed between 1618 and 1620 to mark the amalgamation of four religious confraternities that had been founded in the mid-sixteenth century (fig. 57). Known today as the Hermandad del Amor, the confraternity was committed to charitable works, including looking after the welfare of prisoners. On 13 May 1618, Mesa signed a contract with the confraternity agreeing to carve without the assistance of anybody else, a crucified Christ from cedar wood,[1] and an '*imagen de vestir*' (dressed manikin) of the Virgin, which was to have an expression of '*tristeza*' (sadness).

As this was one of Mesa's first independent commissions, the present work may be a *modello* or presentation piece that the artist made to show to his patrons before carving it life-size.[2] The fact that it has always belonged to the confraternity lends support to this idea. Alternatively, it is possible that this small Crucifixion was made for private devotion,[3] at the request of an individual, perhaps following the success of the large Crucifixion. Popularly known as the 'Cristo del Amor', this large Crucifixion is still today taken out into the streets of Seville during Holy Week.

The principal difference between the small Crucifixion and the life-size one is the arrangement of the loincloth. In the smaller work, the white folds of drapery are relatively simply gathered and tied together with a rope to reveal Christ's left hip. In the larger sculpture, the loincloth is arranged in a far more sophisticated manner, with no rope visible, so that the right hip is revealed instead.

This small carving reflects Mesa's ability to depict the male nude, a skill he would have learnt from Montañés. Montañés's classicism is still apparent but details such as the way in which Christ's emaciated form reveals the outline of his ribcage and

57 Juan de Mesa (1583–1627)
Christ on the Cross (*Cristo del Amor*), 1618–20
Polychromed wood, life-size
Archicofradía del Santísimo Cristo del Amor, Collegiate Church of El Salvador, Seville

muscles mark the beginning of Mesa's move towards a more expressive treatment of the human body. The authorship of the polychromy is not known and its present condition, obscured by a dirty varnish, makes it difficult to judge its quality.

XB

SELECT BIBLIOGRAPHY
Hernández Díaz 1983, p. 83; Gómez Piñol 2000, pp. 417–20; Gómez Piñol 2003, p. 83; Pareja López et al. 2006, pp. 322–5

NOTES
1 López Martínez 1928b, pp. 62–3.
2 Hernández Díaz 1983, p. 83.
3 Gómez Piñol 2000, p. 417, suggests that it may have been held by a priest while preaching from a pulpit.

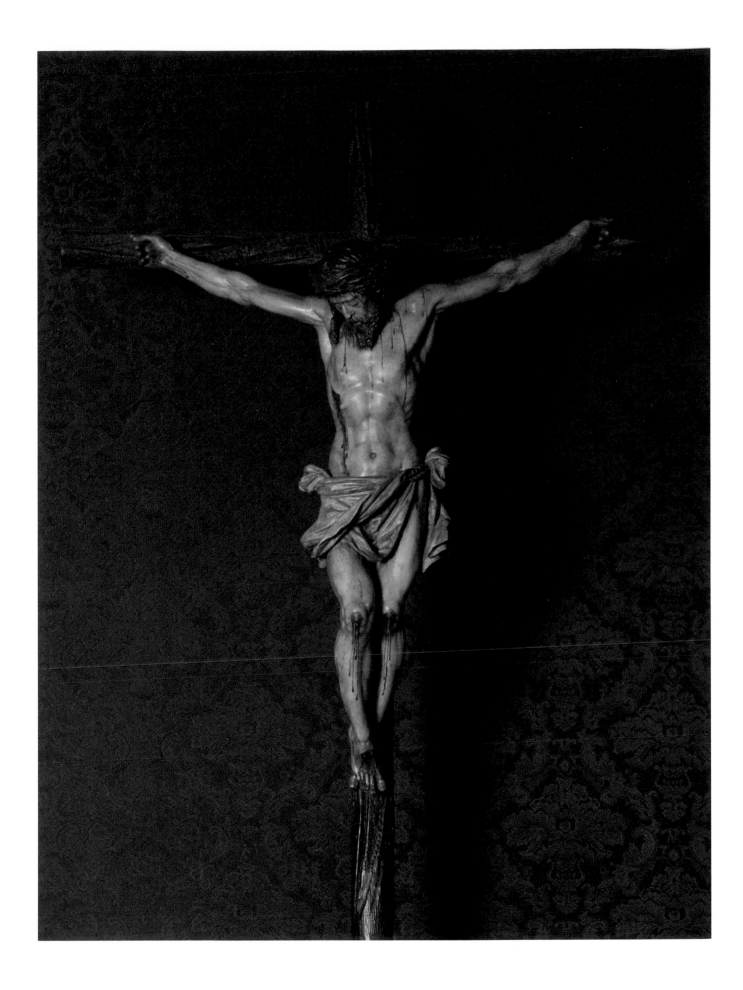

4 Francisco de Zurbarán (1598–1664)
Saint Luke contemplating the Crucifixion, 1630s

Oil on canvas, 105 x 84 cm
Museo Nacional del Prado, Madrid (P-2594)

A painter, with palette and brushes at the ready, stands before Christ on the cross. He looks up with an expression of compassion, his right hand placed on his chest in reverence. He is identifiable as the Evangelist Saint Luke, the patron saint of painters, and not as Zurbarán himself, as has previously been suggested.[1] Zurbarán has set the scene in total darkness and apart from a low diagonal line to indicate that the scene takes place on the hill at Golgotha, the background is completely barren. Like actors on a stage, only the figures of Christ and Saint Luke are lit.

Zurbarán's painting invites the viewer to deliberate on the question what is real and what is an illusion. Saint Luke is depicted either in the act of creating a painted representation of Christ on the cross or contemplating a vision of it. In fact Saint Luke may be not painting but polychroming a sculpture of Christ on the cross. The way in which artificial light illuminates only one half of Christ's figure and part of his loincloth gives a very strong sense of the three-dimensional, which suggests it could indeed be the latter.

Legend has it that Saint Luke painted portraits of the Virgin and Child – the most famous being the Byzantine icon of the *Virgin Hodigitria* – but sculptures of the crucified Christ were also alleged to have been carved and polychromed by him. In his *Arte de la Pintura* (1649), Pacheco mentions (on two occasions) the celebrated sculpture of the *Crucifixion* from Sirol, a town near Ancona in Italy, which was attributed to Saint Luke and showed Christ crucified with four nails.[2] Not only has the figure of Christ in this painting been crucified with four nails, suggesting that Zurbarán or his patron knew Pacheco's text and may have even known the Sirol sculpture, but Zurbarán was also commissioned to carve and polychrome a Crucifixion for the Mercedarian monastery of Azuaga, near Llerena, in 1624.[3]

We do not know the circumstance behind the commissioning of this small painting, but perhaps in making this image Zurbarán was simply following the tradition of his saintly predecessor. However, it may also be that Zurburán is using his own experience as a painter in two dimensions, and as a sculptor and polychromer in three dimensions, to paint an image which functions as a clever conceit, employing fictive illusionism as a demonstration of his sophistication as an artist.

XB

SELECT BIBLIOGRAPHY
Guinard 1960, no. 107, p. 221; Madrid 1988, cat. no. 95, pp. 384–5; Caturla and Delenda 1994, p. 50; Stoichita 1995, pp. 72–4; Seville 1998. cat. no. 70, pp. 206–7; Madrid 2004–5, cat. 21, p. 338; Barcelona 2005–6, cat. 73, pp. 330–3

NOTES
1 Seville 1998, p. 206.
2 Pacheco 1649 (1990), pp. 494 and 730. 'Que San Lucas hiciese imágines, no sólo de pintura sino también de escultura, lo prueba una imagen del Santo Crucifixo de cedro, clavado con cuatro clavos, que se venera en Sirol cerca de Ancona…'
3 Delenda and Garraín Villa 1998, pp. 125–6.

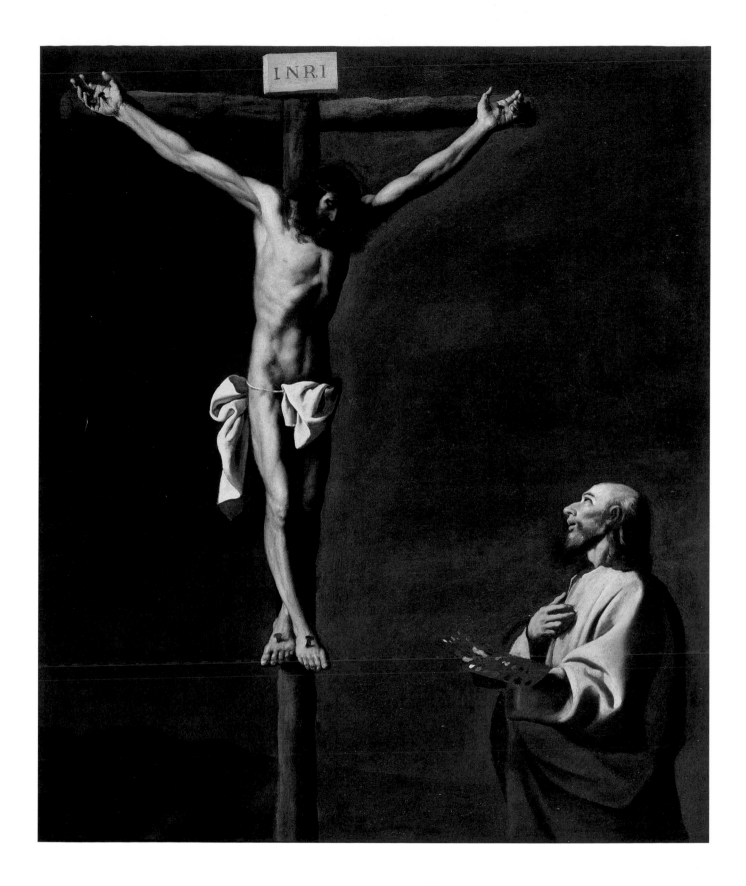

5 Juan de Mesa (1583–1627) and unknown polychromer
Head of Saint John the Baptist, about 1625

Polychromed wood, 30.5 x 31 x 20 cm
Seville Cathedral

Throughout Europe, during the Baroque period, there evolved a taste for works of art depicting scenes of violence. The New Testament story of the beheading of Saint John the Baptist was especially well suited to this taste and seventeenth-century Spain saw some of the most gory and bloody representations of the subject, particularly in sculpture. Life-size painted carvings of Saint John's severed head on a silver platter could be found in a number of cathedrals and churches across Spain, often presented in glass cabinets as if they were relics. Their size, however, also meant that they were portable and highly collectable.

This example by Juan de Mesa is one of the finest to have survived. Made in Seville around 1625, it shows Saint John's head freshly decollated, the blood on his severed neck bright red. Mesa may well have modelled his carving on a human specimen, perhaps the decapitated head of a criminal. The trachea, oesophagus and paraspinal muscles have been accurately depicted.[1] The swollen eyelids and the lifeless brown eyes beneath, as well as the half-open mouth, revealing meticulously carved and painted teeth, are all realised with macabre precision.

Mesa's dexterity with the chisel is further demonstrated in the representation of Saint John's hair and beard. Thick strands of long brown hair fall on either side of his centre parting, covering the back of his neck but leaving the ears poking out. Above his forehead is a large tuft of hair, a hairstyle characteristic of Mesa's master, Juan Martínez Montañés. For the beard, Mesa employs a more refined and undulating relief to suggest the wispiness of his facial hair.

The painter, whose identity is unfortunately not known, skilfully brings out the subtleties of Mesa's carving through colour. Employing the matt technique so that natural light does not reflect off the surface in a garish way, the deathly pallor of Saint John's skin tones is composed of greyish browns and olive greens. To avoid sharp transitions between the hair and skin, brown paint which has been lightly smudged has been applied in between. In this way, both carving and painting are harmoniously united, resulting in an exceptionally naturalistic rendition of a decapitated head.

We know that before it entered the cathedral's collection in the nineteenth century, Mesa's sculpture belonged to the convent of Santa Clara in Seville. Although it is not known how

58 Sebastián Llanos y Valdés (1605–1677)
Head of Saint John the Baptist, 1670
Oil on canvas, 52.8 x 81.7 cm
Collegiate Church of El Salvador, Seville

it was originally displayed, (the silver base to which it is now attached is not original), a surviving document states that the silversmith Juan Vázquez Cano was commissioned in 1625 by the Mother Superior of the convent to provide a casket, a platter and a diadem for a head of Saint John. The platter was probably intended to simulate the plate on which John's head was served to Herod.[2]

The subject matter offered sculptors the opportunity to demonstrate their skill in realism. Indeed these polychromed heads of Saint John may have inspired an artist like Sebastián de Llanos y Valdés (1605–1677) who produced a number of paintings of the decapitated head of the saint, using the isolation and abstraction of the image to similarly dramatic effect (fig. 58). Other examples of the subject by sculptors such as

Gaspar Nuñez Delgado (active in Seville between 1581 and 1606) or Torcuato Ruiz del Peral (1708–1773) show a similar desire to combine blood and gore with Saint John's handsome features.[3]

XB

SELECT BIBLIOGRAPHY
Gómez-Moreno 1964, no. 60, pp. 54–5; Hernández Díaz 1972, p. 79; Hernández Díaz 1983, pp. 80–1; Pareja López et al. 2006, pp. 332–3; Ciudad Real 2005–6, cat. 34, pp. 182–3

NOTES
1 I am grateful to Dr Thomas Wilson from Addenbrooks Hospital, Cambridge, for his anatomical expertise.
2 Gómez-Moreno 1964, p. 55, and Hernández Díaz 1972, p. 79.
3 Gaspar Nuñez Delgado's painted terracotta sculpture (1591) is in the Museo de Bellas Artes, Seville, and Torcuato Ruiz del Peral's polychromed wood sculpture (c.1740–50) is in Granada Cathedral.

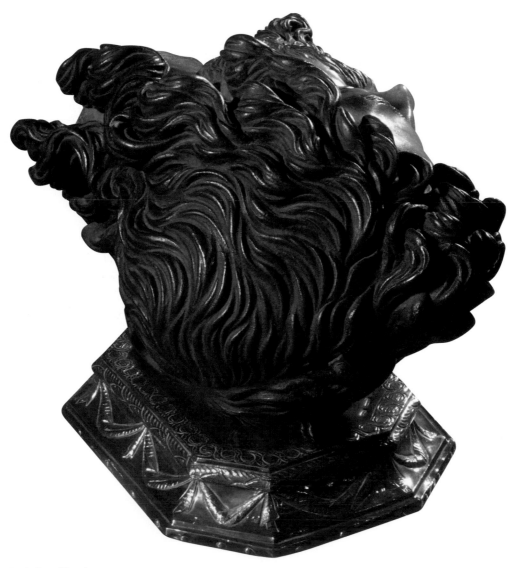

59 Cat. 5. Back view of head

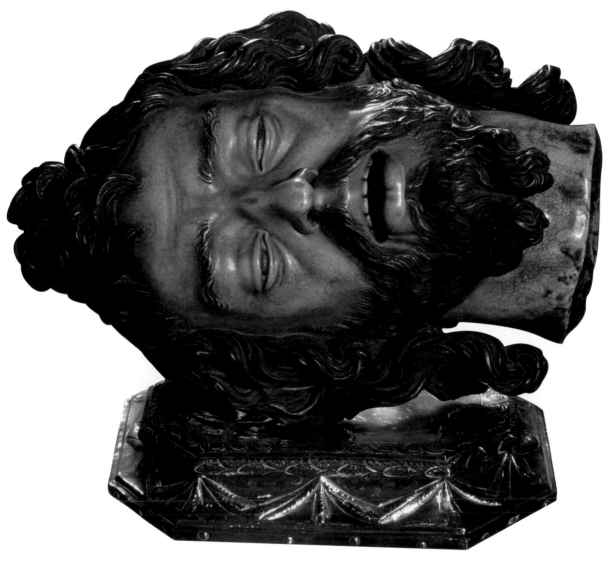

60 Cat. 5. View of head

6 Alonso Cano (1601–1667)

Saint John of God, about 1660–5

Polychromed wood and glass, 30.5 x 22 x 21 cm
Museo de Bellas Artes, Granada (CE 0153/04)

Alonso Cano was one of the few artists in seventeenth-century Spain who both painted and sculpted.[1] Although we do not know with whom he trained as a sculptor (he is traditionally said to have been taught by Juan Martínez Montañés), documents do confirm that he entered Francisco Pacheco's workshop in 1616 and obtained his diploma as a 'pintor de ymaginería' ('painter of religious images') in 1626.[2]

Saint John of God (1495–1550) had dedicated his life to helping the poor and sickly, founding hospitals in Granada. This head was probably intended as a portrait since it bears some similarity to what was deemed his true likeness as painted by the sixteenth-century Granada artist Pedro de Raxis.[3] The sculpture is one of the finest examples of Cano's

work from towards the end of his career. Carved from a single block of wood it was cut in half down the middle (the join is partly visible on either side of the saint's cheekbones), so that the inside could be hollowed out, thereby reducing the risk of the wood warping. Two glass 'cups' painted white and brown from the inside were then inserted into the eye sockets of the mask-like face.[4] This practice of employing glass for the eyes, a technique Pacheco believed unnecessary as they could be painted instead, was to become extremely popular in Granada from this period onwards, particularly with Cano's disciples Pedro de Mena and José de Mora (see cats 22 and 23). Once the two pieces of the carving were reattached, a white gesso layer was applied over the wood, providing Cano with a smooth

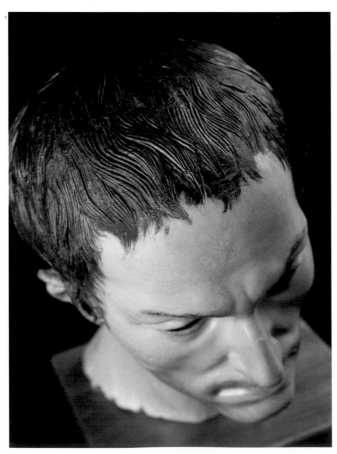

61 and **62** *Saint John of God* (cat. 6) seen from above and from the back

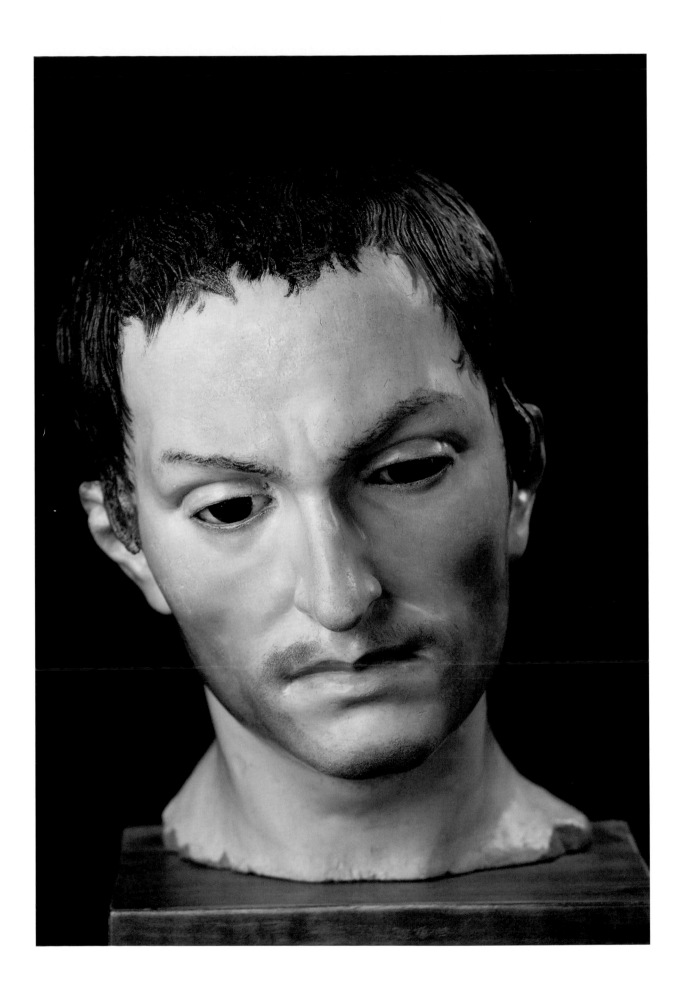

surface on which to paint. This is where Cano could not only put into effect the training he had received from Pacheco as a painter of sculpture, but also introduce a painterly technique, not dissimilar to Velázquez's, which Cano would have observed while at the court in Madrid. The skin tones and the stubble, rather than being depicted in a meticulous manner, as in Juan Martínez Montañes's *Saint Bruno* (cat. 12), are applied freely and suggestively. Thin layers of colour, composed of whites, pinks, reds and browns are subtly blended together. To simulate the stubble, particularly above the lips, the light brown pigment has been smudged over the pale skin tones beneath. To avoid a sharp division between the carving of the hair and the rest of the head, Cano first painted over the sculpted hair and then, with a fine brush, painted individual strands that continue the hairline from the scalp to the forehead and neck. Such a masterful fusion of both carving and painting led Cano to produce some of the most exquisite pieces of sculpted portraiture in seventeenth-century Spain.

Cano's portrait head was almost certainly originally attached to a life-size dressed manikin, the kind of sculpture commonly known in Spain as an '*imagen de vestir*', whereby only the head, hands and feet were carved and polychromed (see cats 14 and 15). Although no contract or document survives to prove for whom the head was made, it has been suggested that it came from the now destroyed Convento de Nuestra Señora de la Victoria, Granada, where Saint John of God was first buried.[5]

XB

SELECT BIBLIOGRAPHY
Gómez-Moreno 1926, p. 30; Wethey 1955, p. 179; Gómez-Moreno 1964, no. IX, p. 34; Granada 1968, cat. no. 16, pp. 54–5; Sánchez-Mesa Martín 1971, pp. 151–2; Granada 1995, pp. 124–7; Granada 2002, pp. 370–1; Seville 2007, p. 376–7; Zaragoza 2008, p. 122.

NOTES
1 He also worked as a designer and architect, hence his nickname, the 'Michelangelo of Spain'.
2 No documentary proof has yet been found to confirm his training as a sculptor. Cano was, however, contracted as a 'maestro ensamblador y escultor' when he took over the Lebrija commission in 1629 (see Granada 2002, pp. 197–8).
3 Pedro de Raxis, *Verdadero Retrato de San Juan de Díos*, c.1590, Archivo-Museo 'Casa de los Pisa', Granada. See Seville 2007, pp. 356–7.
4 This technique may have been brought to Europe from Japan by Jesuit missionaries; Penny notes that in Japanese Kamakura sculpture rock crystal eyes were secured from inside the hollow heads by bamboo pins. See Penny 1993, p. 142.
5 Gómez-Moreno 1926, p. 30.

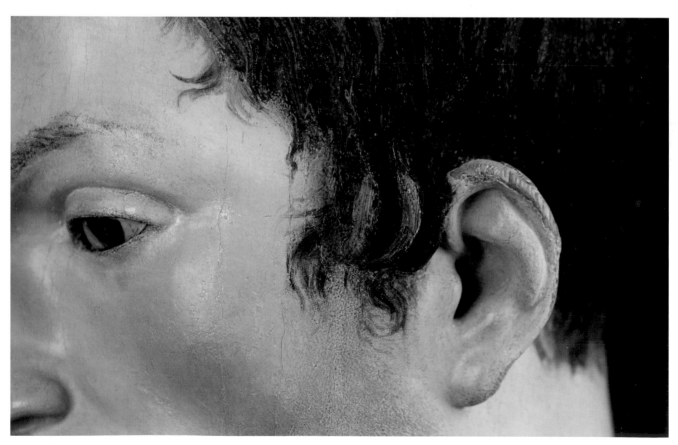

63 Detail of cat. 6

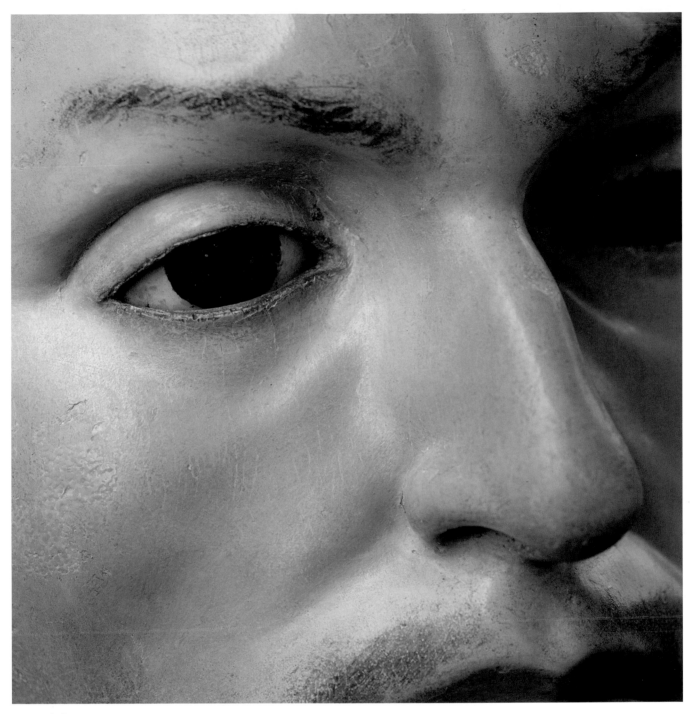

64 Detail of cat. 6

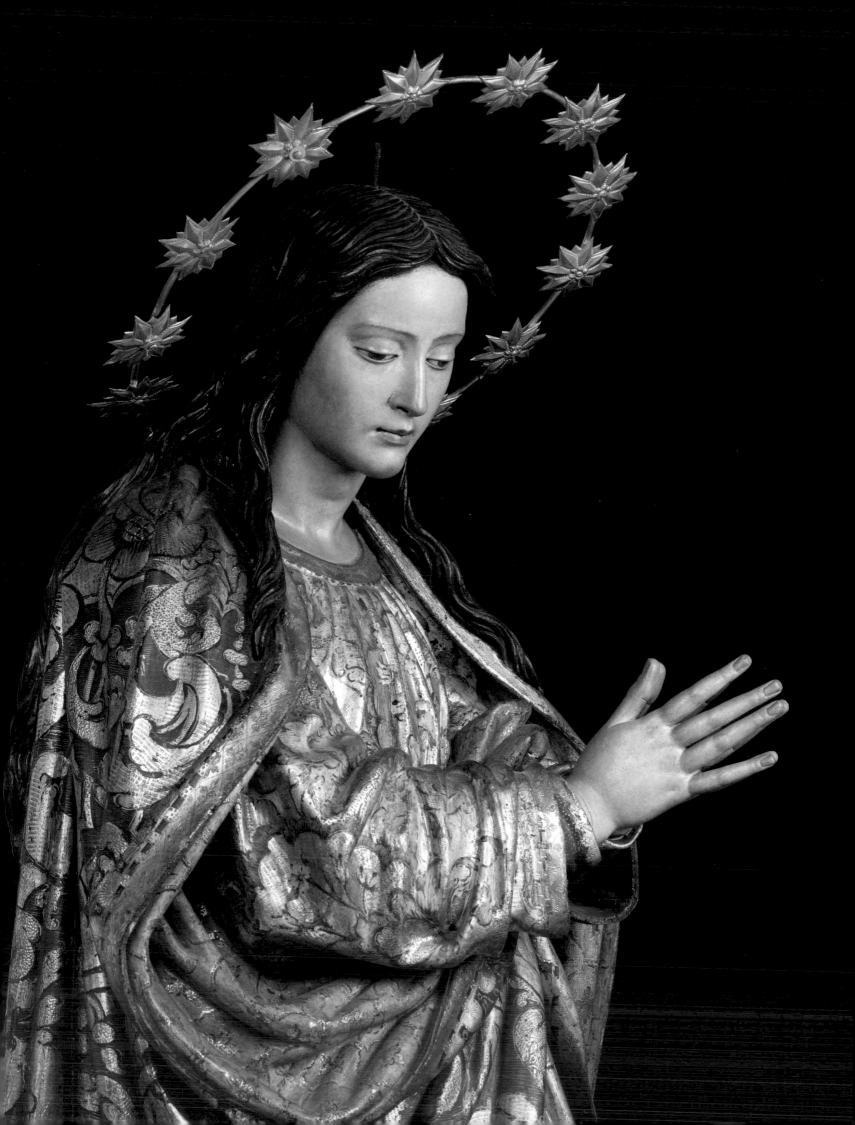

The Virgin of the Immaculate Conception

The Immaculate Conception – the belief that the Virgin Mary was born free of original sin – was a theologically complex doctrine, hotly debated in religious circles since the Middle Ages. The subject was particularly popular in Seville in the seventeenth century since the city had a special devotion to the Virgin. In 1613 a 'Marian War' broke out when a Dominican friar openly preached against the doctrine. A counter-attack was organised and Miguel Cid, a local poet, composed a poem in honour of the Immaculate Conception that was set to music and chanted in the streets of Seville: 'Todo el mundo en general/ A voces, Reina escogida/ Diga que sois Concebida/ Sin pecado original' ('Everyone together/ In a clamorous cry, Elect Queen/ Declares that you are conceived/ Without original sin.') A papal decree was finally issued in 1617 and, although it went no further than to forbid public denial of the doctrine, Seville rejoiced with festivities that lasted many days.

Meanwhile, sculptors and painters such Montañés and Pacheco worked together in establishing an orthodox image of the Virgin. Artists took as their chief source the description found in the Book of Revelation of 'a woman clothed with the sun, and the moon under her feet, and upon her head a crown of twelve stars . . .' (Revelation 12: 1–2). And Pacheco, in his treatise, further stipulated that the Virgin should be represented as a beautiful young girl of twelve or thirteen, with flowing golden hair, serious eyes and a perfect nose and mouth. The naturalism with which they depicted the Virgin (see cats 7 and 9) was to have a profound influence on later generations of artists, notably Velázquez and Cano.

65 Detail of cat. 9

7 Juan Martínez Montañés (1568–1649) and Francisco Pacheco (1564–1644)

The Virgin of the Immaculate Conception, 1606–8

Polychromed wood, 134 x 53 x 43 cm
Parish church of Nuestra Señora de la Consolación, El Pedroso

This is probably the first of several sculptures of the Virgin of the Immaculate Conception that Juan Martínez Montañés and Francisco Pacheco collaborated on in the course of their careers. On 9 May 1606, they signed a contract stipulating that they would deliver in eight months an altarpiece for the chapel of Santa Catalina in the parish church of El Pedroso, with at its centre, inserted into a niche, 'an image of the Immaculate Conception of Our Lady, which has to be carved in the round'.[1] Montañés was to supply the wood, design the altarpiece and direct the installation in person, while Pacheco was to paint the sculpture of the Virgin and two figures in high relief, Saint James the Great and Saint Bartholomew, also to be carved by Montañés. The commission took longer than expected and it was not completed until 1608 as the inscription at the base of the altarpiece records.[2]

The iconographic basis for the representation of the Virgin of the Immaculate Conception – the belief that the Virgin was conceived without stain of original sin – was Saint John's description of the Woman of the Apocalypse (Revelation 12: 1–4). Montañés and Pacheco's version of the subject follows the standard iconography, placing the Virgin on a crescent moon with her hands clasped in prayer. She looks down to her right with an expression of humility. The small opening in her head was probably for the crown of twelve stars, which has since been removed. Her shoulder-length brown hair frames a very youthful face suggesting that the Virgin was modelled on a young girl. She is as Pacheco prescribed in his treatise, 'in the flower of her youth, twelve or thirteen years old, as a most beautiful young girl, with fine and serious eyes'.[3]

Her mantle falls heavily around her body. Her bent right knee gives the only indication of her form underneath. The exterior of the mantle was gilded with gold leaf and then painted on top with blue and pink floral motifs. To replicate the gold threads of the fabric the *estofado* technique was employed, scratching into the paint surface to reveal the gold beneath, and for the inside of her mantle a reddish-pink colour was used to simulate the damask lining. Beneath this she wears

66 Detail of cat. 7

a simple cream tunic decorated with more floral motifs. It crumples at her feet and on top of the crescent moon on which she stands.

Along with Pacheco's own paintings on canvas of the subject, such sculptures helped establish in Seville an orthodox image of the Virgin of the Immaculate Conception, which was to have a particularly profound effect on the young Velázquez.

XB

SELECT BIBLIOGRAPHY
López Martínez 1935; Gómez-Moreno 1963, p. 143; Proske 1967, pp. 47–9; Hernández Díaz 1976, pp. 72–3; Harris 1982, p. 52; Hernández Díaz 1987, pp. 124–5; Edinburgh 1996, cat. no. 32, pp. 154–5; Córdoba 1999, pp. 9–14 and 24; Seville 1999, cat. 37, pp. 88–9; Seville 2004, pp. 250–2; Navarrete Prieto 2005, pp. 237–9; Boston-Durham 2008, cat. 47, p. 260

NOTES
1 'una imagen de la limpia concesión de Nuestra Sra. Que a de ser de todo relieve y redonda': C. López Martínez, 'Montañés y Pacheco en El Pedroso', in *El Liberal*, 15–1, 1935, partly quoted in Hernández Díaz 1987, p. 124.
2 The inscription on the base reads: ACABOSE ESTE RETABLO AÑO/ DE 1608 SIENDO CAPELLAN PERPETVO DE LA CAPELLANIA BARTOLOME/ DE MORALES RACIONERO DE LA SANTA IGLESIA DE OSUNO FUNDADOLA DIEGO PEREZ CLERIGO.
3 Pacheco 1649 (1990), pp. 576–7.

8 Diego Velázquez (1599–1660)

The Immaculate Conception, 1618–19

Oil on canvas, 135 x 101.6 cm
The National Gallery, London (NG 6424)
Bought with the aid of The Art Fund, 1974

Painted when Velázquez was only about nineteen years old, this *Immaculate Conception* was conceived as a pendant to a *Saint John the Evangelist* (fig. 67). It was Saint John who, while on the island of Patmos, had a vision of the Woman of the Apocalypse with 'the moon under her feet, and upon her head a crown of twelve stars' as described in the Book of Revelation 12: 1–2. The pair of paintings were first recorded in 1800 in the Chapter House of the now destroyed Convent of Shod Carmelites, Nuestra Señora del Carmen, in Seville, for which they were probably originally commissioned.[1] The choice of subject matter would have played an effective role as propagandistic

67 Diego Velázquez (1599–1660)
Saint John the Evangelist on the Island of Patmos, about 1618
Oil on canvas, 135.5 x 102.2 cm
The National Gallery, London (NG 6264)
Bought with a special grant and contributions from the Pilgrim Trust and The Art Fund, 1956

illustrations of the doctrine of the Immaculate Conception, which the Carmelites fervently upheld.

Velázquez's portrayal of the Immaculate Conception corresponds with many of his master Francisco Pacheco's prescriptions of how to represent this subject as noted in the *Arte de la Pintura* (1649). One of these is the inclusion of a transparent moon which 'although it is a solid planet, I [Pacheco] took the liberty to make it light and transparent.'[2] Velázquez follows tradition by portraying in the landscape at the bottom of the painting various symbols taken from the Song of Solomon and Ecclesiastes that were believed to allude to the Virgin's incorruptible purity, such as the temple, the palm tree, the city, the fountain and the ship.

At the time Velázquez painted these pictures he would have only very recently graduated (on 14 March 1617) from the workshop of Francisco Pacheco where it seems likely he had had early training in the art of painting sculpture. Sculpture would have been a natural source from which Velázquez would have copied and learnt. There were numerous sculpted images of the Immaculate Conception in Seville at this time, of which one of the best surviving examples is the one sculpted by Montañes and polychromed by Pacheco for the parish church of El Pedroso between 1606 and 1608 (see cat. 7).

What Montañes's sculpture and Velázquez's painting have in common is an emphasis on the naturalism of the Virgin. Far from being idealised, in both instances the figure of the Virgin seems to have been modelled on a young girl. When writing about his famous pupil, Pacheco noted that Velázquez would pay models to sit for him and adopt various attitudes and poses and different expressions, thereby attaining 'sureness in portraiture'.[3] Velázquez's Virgin has a broad face, the slightly plump cheeks of a young girl, and long dark brown hair. She may well be a portrait and indeed it has been suggested that she has the features of Juana Pacheco, Velázquez's young wife (and Pacheco's daughter), whom he married on 23 April 1618.[4]

An X-radiograph of the *Immaculate Conception* shows how originally the drapery of the blue mantle was much more free flowing, coming right across the bottom part of the red tunic as if being blown by the wind (fig. 70). Probably because it

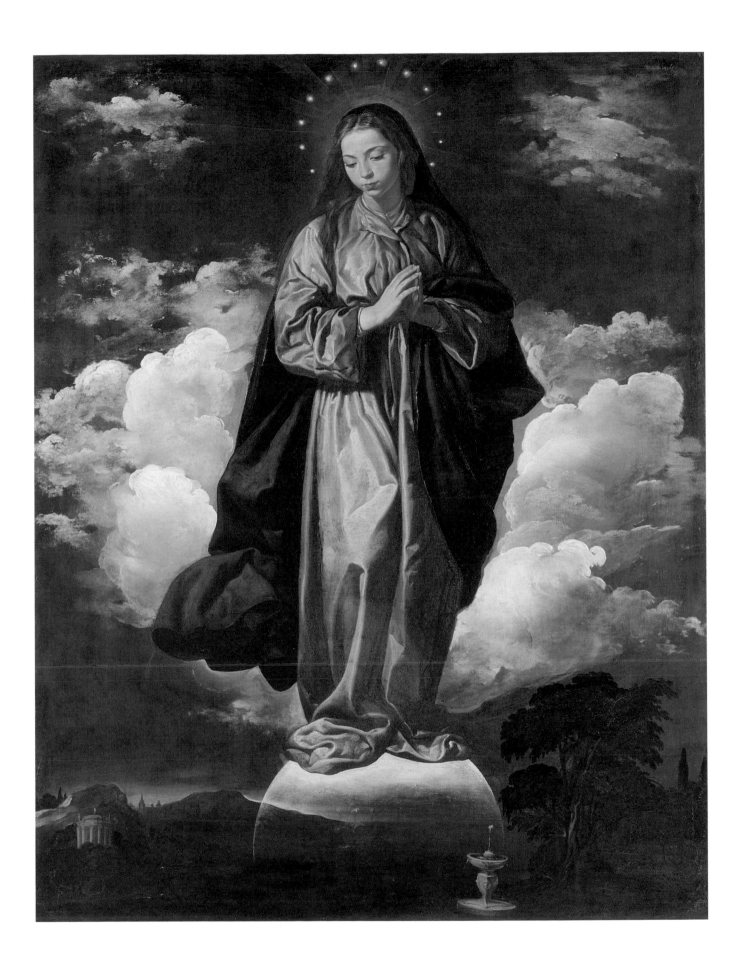

interfered with the sense of verticality and the statuesque quality he wanted to achieve, Velázquez decided eventually to keep the mantle tucked behind the Virgin's legs. Instead, we are made to concentrate on the folds of the red tunic which have piled up on top of the moon. The organisation of this tangible mass of cloth is similar to the way Montañés has arranged his drapery in the El Pedroso sculpture, again suggesting that Velázquez may have been inspired by looking at sculptural versions of the subject.

XB

SELECT BIBLIOGRAPHY
Martínez Ripoll 1983, pp. 201–8; Delenda 1993, pp. 47–9; Edinburgh 1996, cat. no. 33, pp. 156–7; Seville 1999, cat. no. 89, pp. 190–1; London 2006–7, cat. 9, pp. 132–5; Boston–Durham 2008, cat. 48, p. 260

NOTES
1 Ceán Bermúdez 1800, vol. III, p. 179.
2 Pacheco 1649 (1990), p. 577.
3 Pacheco 1649 (1990), pp. 527–8. See also Cherry in Edinburgh 1996, p. 73.
4 Delenda 1993, p. 48. See also London 2006–7, cats 9 and 10, p. 134.

68 Detail of cat. 8

69 Detail of cat. 7

70 X-ray detail of cat. 8

9 Attributed to Juan Martínez Montañés (1568–1649) and unknown polychromer
The Virgin of the Immaculate Conception, about 1628

Polychromed wood, 144 x 49 x 53 cm
Base: 37.5 x 97.5 x 58.5 cm
Church of the Anunciación, Seville University (1493-J)

This sculpture of the Virgin of the Immaculate Conception is the titular image of one of the altarpieces in the church of the Anunciación in Seville, formerly the Casa Profesa of the Jesuits. The Virgin is accompanied by two carved figures, executed earlier by an unknown artist, of her parents, Saints Joachim and Anne, who according to tradition conceived their daughter in a chaste embrace. The subject was represented in medieval art in the Embrace of Joachim and Anne at the Golden Gate in Jerusalem. The result of their union was the birth of the immaculate Virgin, free of original sin.

In Italy during the last quarter of the fifteenth century the iconography of the Immaculate Conception evolved and the Virgin became the sole figure represented. Sixteenth-century paintings of the subject, such as Federico Barocci's version of 1575 (Galleria Nazionale delle Marche, Urbino), also show the Virgin alone, but it was the Sevillian Baroque artists of the seventeenth century who established the definitive typology. Pacheco, Velázquez, Alonso Cano, Zurbarán, Murillo and Montañés all represented the subject, responding to the keen interest in Seville in the doctrine of the Immaculate Conception (see also cat. 7).

The name of the sculptor of this Virgin is not given in any documents, but on the basis of its typology the work has been attributed to Montañés. Records confirm the foundation in 1600 of the 'congregation of priests of the Immaculate Conception of the Virgin' in the Casa Profesa in Seville in 1600 and show that in 1628 an altarpiece and a sculpture of the Immaculate Virgin were unveiled in the church of the Anunciación there.[1]

If the present *Virgin of the Immaculate Conception* is assumed to be the one commissioned by the Jesuits in 1628, then it is significantly later than the one executed by Montañés and polychromed by Pacheco for the church of El Pedroso in 1606 (cat. 7), and the one made for the convent of Santa Clara in Seville (1621–3), which was polychromed by Baltasar Quintero and with which it reveals some parallels. In 1628 Montañés made the finest of all his images of the Virgin of the Immaculate Conception, a work popularly known as 'La Cieguecita' ('Little Blind Girl') (fig. 71), for the private chapel

of Francisco Gutiérrez de Molina and his wife, Jerónima de Zamudio, in Seville Cathedral.

The present work stands on a particularly fine pedestal with reliefs. The rear panel of the niche in which the Virgin is placed is decorated with symbols taken from the Song of Solomon and Ecclesiastes which were considered to foreshadow the doctrine of the Immaculate Conception.

<div style="text-align: right">MFMC</div>

SELECT BIBLIOGRAPHY
López Martínez 1928c; Gómez-Moreno 1942; Hernández Díaz 1942; Hornedo 1968; Bernales Ballesteros 1986, pp. 68–71; Hernández Díaz 1987, p. 267; Morón de Castro 2004

NOTE
1 Serrano y Ortega 1893, pp. 666 and 670.

71 Juan Martínez Montañés (1568–1649)
The Virgin of the Immaculate Conception, known as 'La Cieguecita' (Little Blind Girl) 1628–31
Polychromed wood, h 165 cm
Seville Cathedral

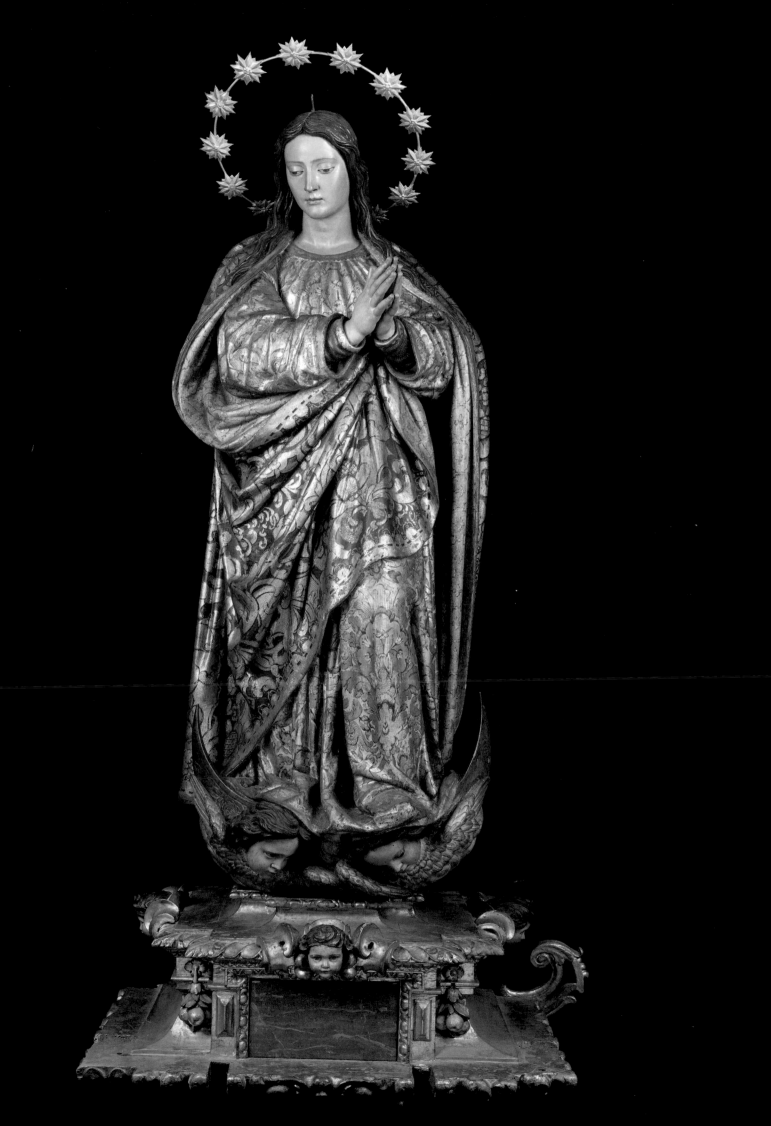

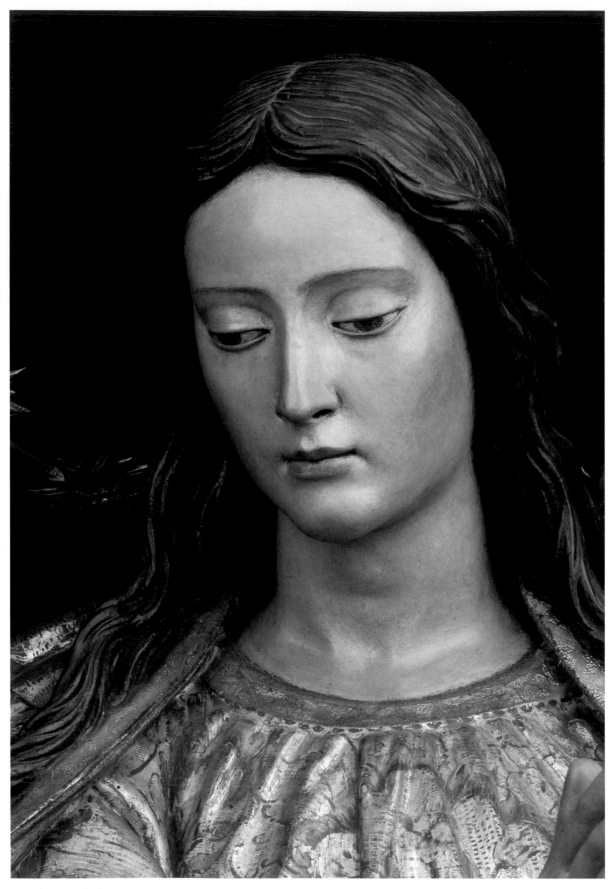

72 and **73** Details of cat. 9

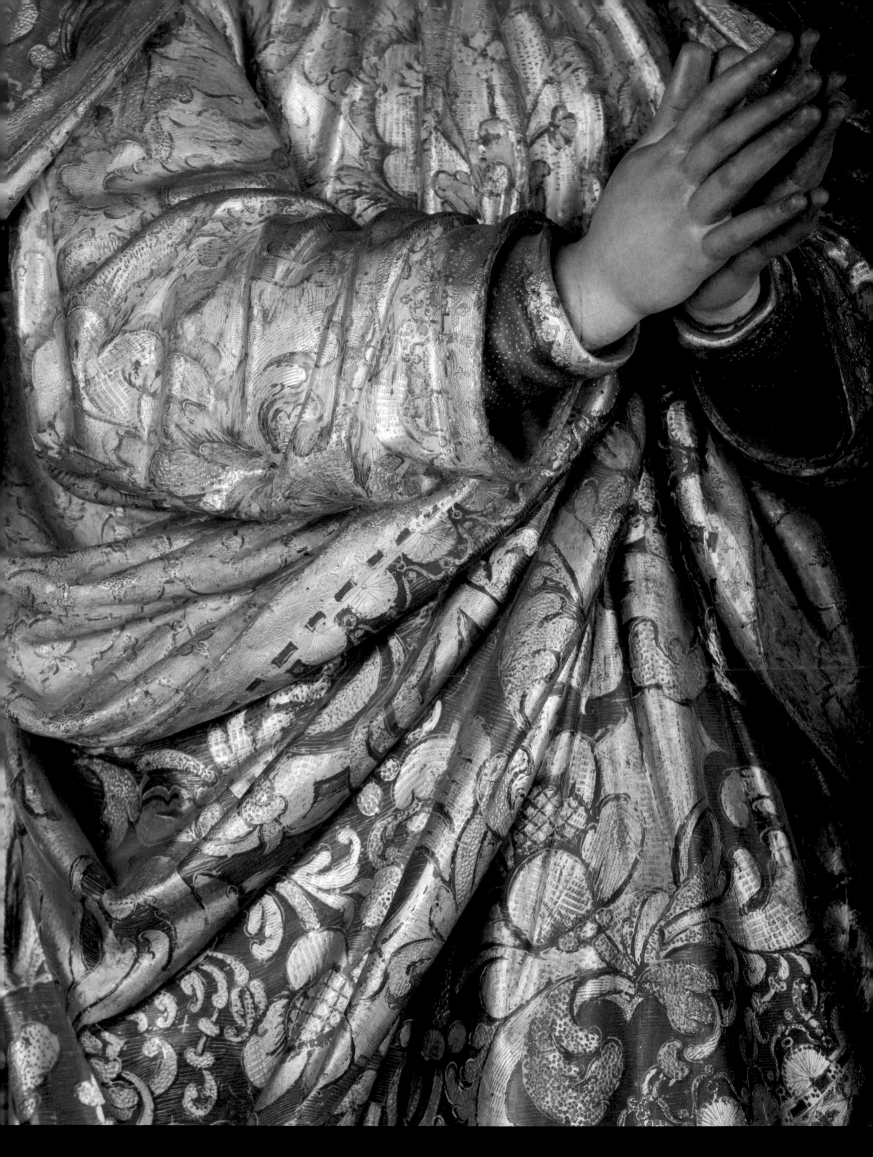

10 Alonso Cano (1601–1667)

The Vision of Saint Bernard of Clairvaux, also known as The Miracle of the Lactation, about 1657–60

Oil on canvas, 267 x 185 cm
Museo Nacional del Prado, Madrid (P-3134)

Saint Bernard (1090–1153) became the first abbot of the Cistercian abbey at Clairvaux in southern Champagne, France, in 1115, and it was under his direction that the Cistercians became one of the most successful monastic reform movements of the age. Bernard had particularly strong views on the adornment of monastic churches, which tended to be filled with costly paintings, sculpture and jewelled lamps.[1] Critical of the role of sculpture, believing it could incite idolatry, he argued that visual stimuli in monasteries distracted from prayer and instead he encouraged plain and unadorned churches. It is therefore somewhat ironic that Alonso Cano should represent Bernard kneeling before an altar decorated with a polychrome sculpture of the Virgin and Child that has miraculously come to life and is spurting milk into his mouth. A third figure, presumably the patron of the work, dressed in cardinal's robes, prays before the saint.[2]

By the seventeenth century, and particularly in Spain, Bernard's monastic virtues were strongly upheld by the Catholic Church. Monastic orders like the Carthusians and the Capuchins, who commissioned this painting for their monastery in Toledo, regarded him as a model reformer.[3] What made him especially attractive was the exemplary devotion he had to the Virgin Mary. Hailed as the Virgin's 'chaplain' ('Beatae Mariae capellanus'), Bernard wrote a treatise (De Laudibus Virginis) on her virgin birth, and his sermons, which were celebrated for their superb oratory and sophisticated language, earning him the nickname of 'Doctor Mellifluous', praised her as the perfect mediator between the faithful and Christ.[4] The miracle that Cano depicts is supposed to have occurred in 1119 in the church of St-Vorles at Châtillon-sur-Seine.[5] Kneeling in prayer before a sculpture of the Virgin breastfeeding the Christ Child, Bernard pronounced the words, 'Monstra te esse matrem' ('show yourself to be a mother'), upon which the sculpture came alive and squirted milk into his mouth.

The subject was traditionally depicted as a vision – for example by artists like Juan de Roelas and Murillo and even the sculptor Gregorio Fernández – with the Virgin mounted on clouds in a celestial light, but it was surely Cano's experience as a sculptor that led him to represent her as seemingly coming to life.[6] It is illustrative of the way sculpture was viewed during the period, that is, as an art form that because of its three-dimensionality was much closer to real life than paintings. For this reason, sculptures of religious figures on occasion led the devout to witness miracles when praying before them.

XB

SELECT BIBLIOGRAPHY
Palomino 1715–24 (1987), p. 237; Wethey 1955, p. 166; Cruz Valdovinos 1985, pp. 276–86; Geneva 1989, cat. no. 40, pp. 94, 276–86; Stoichita 1995, pp. 148–9; Granada 2001–2, pp. 91–2; Portús in Enciclopedia 2006, vol. VI, pp. 1965–6

NOTES
1 Bernard of Clairvaux (1970), pp. 3–69.
2 This may be the Cardinal Archbishop of Toledo, Bernard de Sandoval y Rojas, who gave permission for the Capuchins to settle in Toledo. See Cruz Valdovinos 1985, p. 283.
3 Palomino 1715–24 (1987), p. 237, was the first to mention the picture when he visited the Capuchin monastery of Santa Leocadia, Toledo.
4 Réau 1958, vol. III, p. 208.
5 Réau 1958, vol. III, p. 209. See also Dewez and van Iterson 1956, p. 181.
6 Roelas in the Hospital of San Bernardo, Seville, Murillo in the Museo Nacional del Prado (inv. no. 978), and Gregorio Fernández in the Monastery of Valbuena, Valladolid (see Martín González 1980, p. 239, fig. 219).

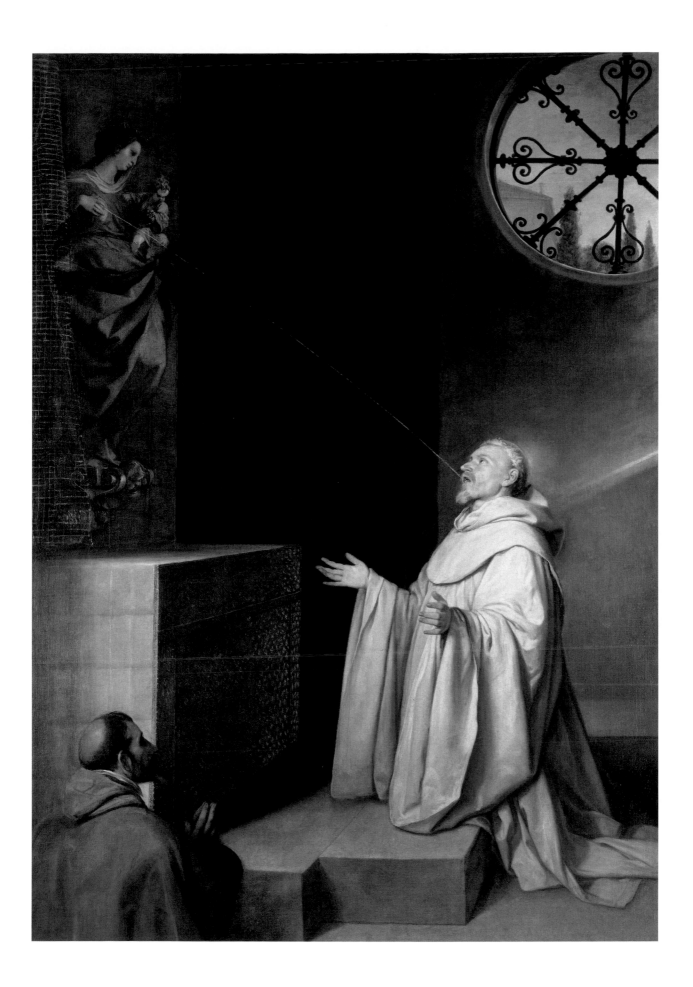

A True Likeness: Portraits

Polychrome sculpture had a fundamental advantage over painting in that it could simulate reality to a far greater degree. Sculptors and painters were, however, treading a thin line between representing a sacred subject and making a sculpture look so real that it had the power to delude the worshipper. This problem, which the Church feared could lead to idolatry, was not a new one. The last session of the Council of Trent in 1563 had encouraged devotion to the saints because 'it is good and useful . . . to invoke them, and to resort to their prayers, aid, and help', but warned that no 'divinity, or virtue, is believed to be in them' and no 'trust is to be reposed in images, as was of old done by the Gentiles who placed their hope in idols.'

Sculptures such as those by Montañés and Pacheco of the Jesuit saints Ignatius Loyola and Francis Borgia (cats 14 and 15) were designed to be venerated as 'prototypes' of the saints who resided in heaven. By producing highly accurate portraits (the sculpture of Ignatius is based on his death mask, a copy of which Pacheco owned), the viewer could be reminded intellectually of the saint without losing any sense of decorum. Pacheco rejected the use of glass eyes or real hair as techniques that placed an emphasis on a conjurer's deception rather than on artistic representation.

Pacheco's careful rendering of the features on Montañés's carving of *Saint Francis Borgia* not only inspired painted versions of the saint, notably Cano's (see cat. 13), but had also had a profound effect on the way Velázquez conceived one of his first portrait commissions, that of the Venerable Mother Jerónima de la Fuente (cat. 16). Velázquez gives her physical form an emphatic plasticity, with every line carefully recorded, that is reminiscent of the sculpted portraits he would have seen in his native Seville, and the palette of browns he used to depict her taut leathery skin is very similar to the palette of Pacheco's *Saint Francis Borgia*.

11 Francisco de Zurbarán (1598–1664)

The Virgin of Mercy of Las Cuevas, about 1644–55

Oil on canvas, 270 x 308 cm
Museo de Bellas Artes, Seville (CE0173P)

This painting is a perfect example of the way in which Zurbarán could fuse the traditional image of the Virgin of Mercy (more commonly known as the Madonna della Misericordia) with the contemporary. However, the over-sized figure of the Virgin towering over a group of kneeling monks, together with the archaic appearance of the composition, has led some to criticise it as 'Gothic' and therefore as an inferior work by Zurbarán.[1] Zurbarán does indeed employ an old-fashioned formula, which was probably based on a print source (see fig. 75),[2] and the iconography of the Virgin with her outspread mantle sheltering the faithful dates back to the thirteenth century, but the monks who kneel beneath her in their white habits – identifying them as members of the Carthusian order – are very likely contemporary portraits of monks from the monastery for which this painting was originally destined.

Although no contract survives to date this work precisely, we know that it was commissioned along with another two similarly sized paintings for the sacristy of the Carthusian monastery of Santa María de las Cuevas just outside Seville. The present picture acted as the centrepiece, while on the side walls were *Saint Hugh in the Refectory* and *Pope Urban II and Saint*

Bruno. As a set of three they were meant to symbolise three aspects of the Carthusian rule: prayer and faith in the Virgin was represented in the present painting; abstinence in *Saint Hugh in the Refectory;* and the vow of silence in *Pope Urban II and Saint Bruno*.[3]

The pictures are now in the Museo de Bellas Artes, Seville, and not in their original location (they became state property following the Secularisation Act of 1836), but the ornate plaster frames into which they were set have survived along with the sacristy itself. An eighteenth-century account of the history of the monastery by a Carthusian monk who had access to the now lost archives tells us how the sacristy was modernised by Father Blas Domínguez, who served twice as prior, from 1644 to 1648 and from 1652 to 1657. According to this manuscript, Domínguez 'expended with good taste 17,000 reales on the cupola and in the fine plasterwork that adorns the sacristy, the carving of which is by the excellent hand of Pedro Roldán ... For the three canvases, he summoned the celebrated Zubdarán [sic], who lavished upon them his draftsmanship and the delicacy of his brush and palette.'[4] In addition to this, the manuscript also mentions that the monks who feature in Zurbarán's paintings were 'true portraits of Father Don Blas Domínguez and his vicar Don Martín Infante, elder fathers or officers'.[5]

75 Schelte Bolswert (about 1586–1659)
Saint Augustine as Protector of the Clergy, 1624
Engraving

76 Pedro Roldán (1624–1699)
The plaster frame that contained Zurbarán's *Virgin of Mercy*
Sacristy, Monastery of Santa María de Las Cuevas, Seville

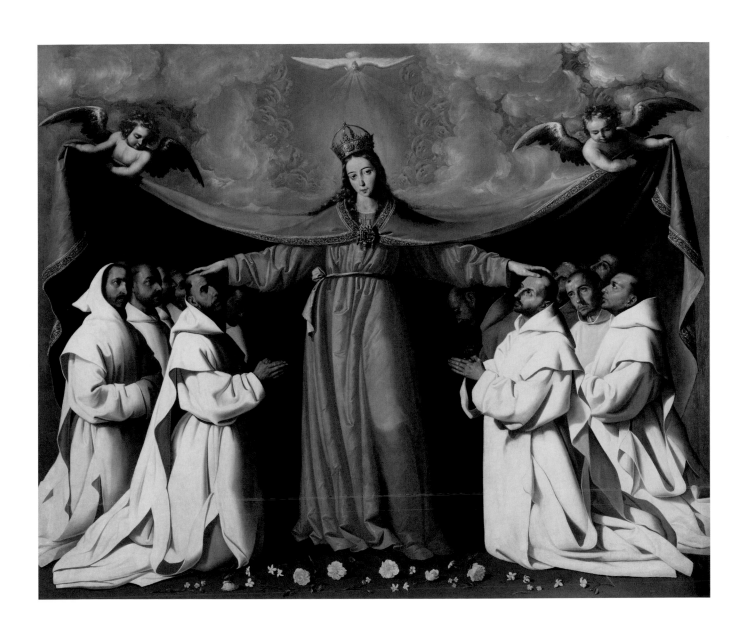

The manuscript also mentions that Pedro Roldán completed the plaster frames into which Zurbarán's paintings were inserted in 1655 (fig. 76).[6] This and the fact that Blas Domínguez was most probably Zurbarán's patron suggest that he painted his pictures between 1645 and 1655, later in his career than has previously been thought. The archaic composition of the Virgin of Mercy and its dependence on Schelte Bolswert's print of *Saint Augustine as Protector of the Clergy* (fig. 75) had led some art historians to place the paintings within the artist's early period of around 1630–5.[7] Until Zurbarán's contract is found, however, the exact date of execution will never be known.

Placing aside the problems of dating, one of the most striking aspects of this work is the way in which the white habits of the monks have been painted. Light and shadow define with precision each fold and texture of the cloth, bringing an extraordinary sense of volume to the composition. The painter and art historian Palomino observed in his biography of Zurbarán how skilled he was at painting white draperies and described them as a 'thing of wonder, for although they are all white, they are differentiated by their individual values. They are done with such admirable realism in the folds, colour and form that they counterfeit reality itself.'[8] His explanation for this incredible effect was

Zurbarán's use of a draped manikin along with his knowledge of Caravaggio. Palomino may indeed be right, but just as effective a model would have been Montañés's polychrome sculpture of *Saint Bruno meditating on the Crucifixion* (cat. 12) commissioned in 1634 for a chapel in the same monastery and which Zurbarán would certainly have seen above its altar.[9]

MVMR

SELECT BIBLIOGRAPHY
Ponz 1784, Carta Sexta, no. 26, p. 233; Ceán Bermúdez 1800, VI, p. 51; González de León 1844, II, p. 253; Gómez Imaz 1896, no. 222; Gestoso y Pérez 1912, no. 194; Kehrer 1918, pp. 66–71; Kehrer 1920–1, LV, pp. 248–52; Serra y Pickman 1934, pp. 19–20; Soria 1953, no. 68; Cuartera y Huerta 1950–4, II, pp. 16–17 and 627; Guinard 1960, no. 473; Bravo-Pemán 1963, pp. 5–13; Gállego-Gudiol 1976, no. 298; New York 1987, no. 38, pp. 230–3; Madrid 1988, no. 71, pp. 310–13; Izquierdo and Muñoz 1990, p. 140; Caturla 1994, pp. 29–42; Navarrete Prieto 1998, p. 262; Seville 1997, pp. 33–40; Seville 1998, no. 76

NOTES
1 See for example Cascales y Muñoz 1911, p. 174.
2 Kehrer 1918, pp. 66–71, was the first to point out the parallels with the print by Schelte Bolswert. See also Navarrete Prieto 1998, p. 262.
3 See New York 1987 , pp. 219–25.
4 Cuartero y Huerta 1988, II, pp. 16–17.
5 Cuartero y Huerta 1988, II, pp. 16–17. Translations taken from New York 1987, p. 223.
6 Cuartero y Huerta 1988, I, p. 26, and II, pp. 16–7.
7 See New York 1987, cat. no. 37. For many years this was considered an early work and was dated by Caturla to around 1635. See also Madrid 1988, pp. 297–316, and Pérez Sanchez 2000–1, pp. 29–30, and Bilbao 2000–1, cat. no. 6, pp. 73–6.
8 Palomino 1715–24 (1987), p. 184.
9 See the essay by Xavier Bray, pp. 33–5.

77 Detail of cat. 11

78 Detail of cat. 12

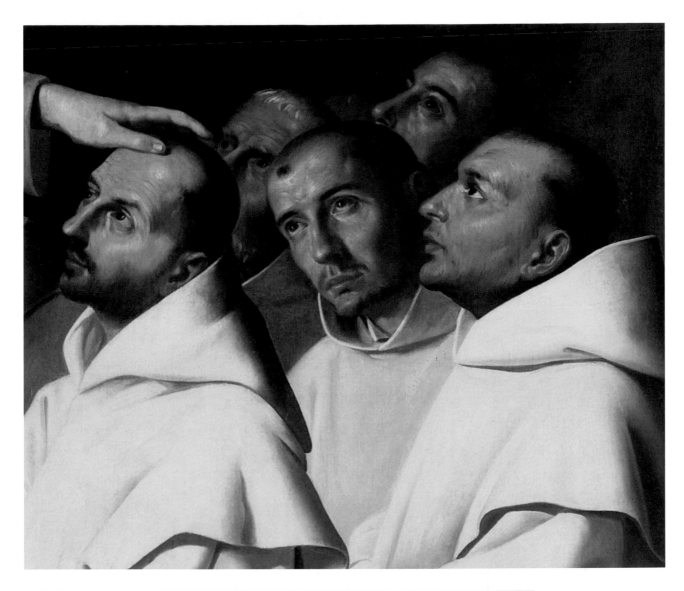

79 Detail of cat. 11

80 Detail of cat. 12

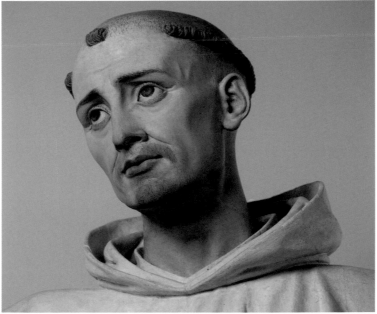

12 Juan Martínez Montañés (1568–1649) and unknown polychromer
Saint Bruno meditating on the Crucifixion, 1634

Polychromed wood, 160 x 73 x 62 cm
Museo de Bellas Artes, Seville (CE0181E)

The Carthusian Order arrived in Seville in 1399 when they founded the monastery of Santa María de la Cuevas. It contained a chapel dedicated to Saint Bruno, which the prior of the order, Pedro Manuel Deza, decided to remodel in 1633.[1] Juan Martínez Montañés was commissioned to execute a sculpture of Saint Bruno for the chapel's altarpiece, as stated in a notarial document of 1634.[2]

Montañés shows the saint standing, holding a crucifix in his right hand and a book indicating his learning in his left. He is dressed in the habit of the order, consisting of a belted woollen tunic with a hooded scapular on top. As is habitually the case with this sculptor, the image imparts a sense of solidity that brings it closer to a late Renaissance idiom rather than to the lighter forms that began to prevail during the course of the seventeenth century. It consequently does not convey a sense of movement, although the balanced nature of the composition with the raised right hand and projecting right leg avoids an excessively heavy feel. The artist guides the viewer's attention towards the principal focus of the work, namely the cross that symbolises Christ's passion, which Saint Bruno firmly grasps and contemplates with compassion. The ultimate aim of the work was to represent Bruno's spiritual life through a carved sculpture and to convey the notion of his ascetic, self-sacrificing existence to the monks of the order as an example worthy of imitation.

The polychromy, executed by an artist who is not mentioned in any of the known contemporary references to the work (but see Xavier Bray's essay on p. 22 where he suggests Baltasar Quintero with whom Montañés often worked in the 1630s), functions to heighten the realistic nature of the image. The most striking note is the white of the Carthusian habit. Now completely plain, it was originally gilded, and small traces of this are still visible. It also had foliate decoration, now covered with white, which is evident on the front of the

scapular and in the area of the shoulders. An eighteenth-century account of the history of the Carthusian Order in Seville mentions that gold leaf was applied to the carving with the intention of adding *estofado* decoration to the habit. Ultimately it would seem that the figure was left without any of the gilding being exposed in order to present a more austere appearance in line with the personality of this saint. The remaining traces of gold visible in some areas and the presence of areas of incised decoration confirm this documentary information.

The flesh tones are a good example of the matt polychromy which Pacheco advocated. In his *Arte de la Pintura*, Pacheco promoted the application of unpolished polychromy, criticising the use of highly polished flesh tones that gave the figure a glassy aspect.[4] Pacheco maintained that they gave a more natural result. The *Saint Bruno* of 1634 is thus a significant example of Montañés's later output, executed when the artist was sixty-six. It can be considered one of the finest of his sacred images, which were based on a firmly established repertoire of models and conveyed a distinctive spirituality.

IHR

SELECT BIBLIOGRAPHY
Cean Bermúdez 1800, pp. 84–91; Bago y Quintanilla 1930, p. 66; Cuartero y Huerta 1950–4, I, p. 667, and II p. 691; Hernández Díaz 1949 p. 70; Madrid 1969, p. 48, no. 51; González de León (1973) II, p. 497; Madrid 1981–2, pp. 114–15, no. 75; Hernández Díaz 1987, p. 239; Passolas Jáuregui and López-Fé Figueroa 2008, I, p. 311 and II, pp. 304–9

NOTES
1 Protocolo de la Cartuja of 1744, reproduced in Cuartero y Huerta 1950–4, p. 667.
2 Document of payment of 10 March 1634. Archivo de Protocolos Notariales de Sevilla, Oficio XIII, Francisco López Castellar 1634, Libro I, Folio 850v. Reproduced in Bago y Quintanilla 1930, pp. 66–7.
3 'se quedó el oro bajo la tez blanca, pareciendo así más a lo natural' ['the gold remained under the white cloth, thus appearing more lifelike'], Protocolo de la Cartuja of 1744 reproduced in Cuartero y Huerta 1950–4, p. 667.
4 Pacheco 1649 (1990), p. 497.

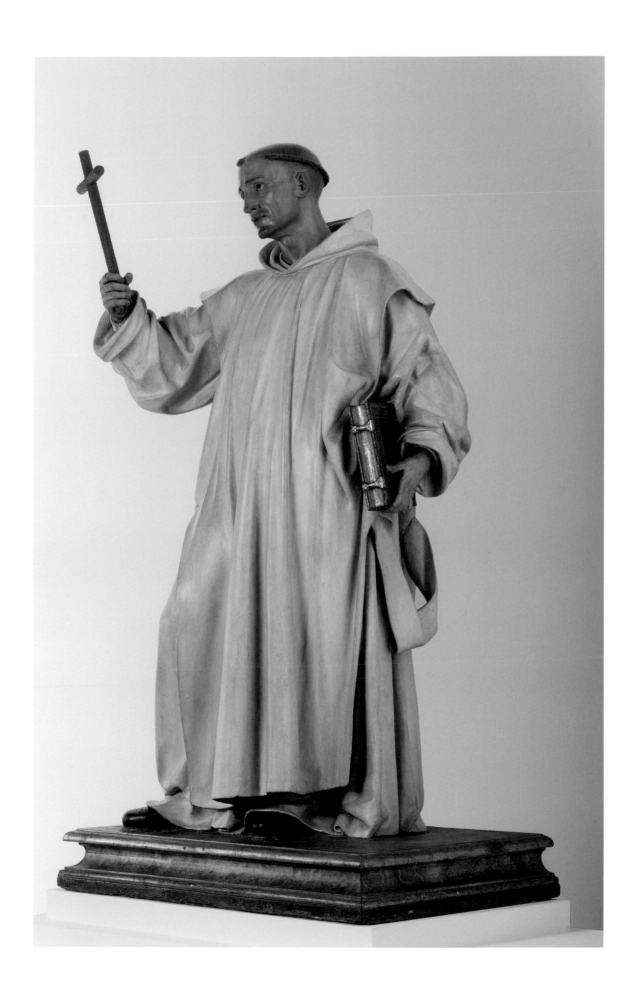

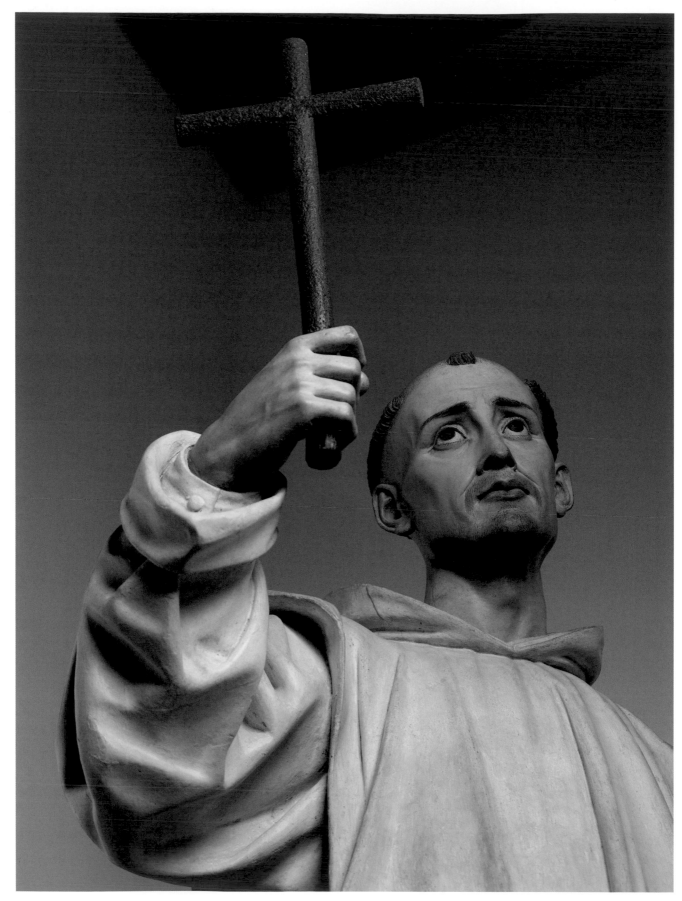

81 and 82 Details of cat. 12

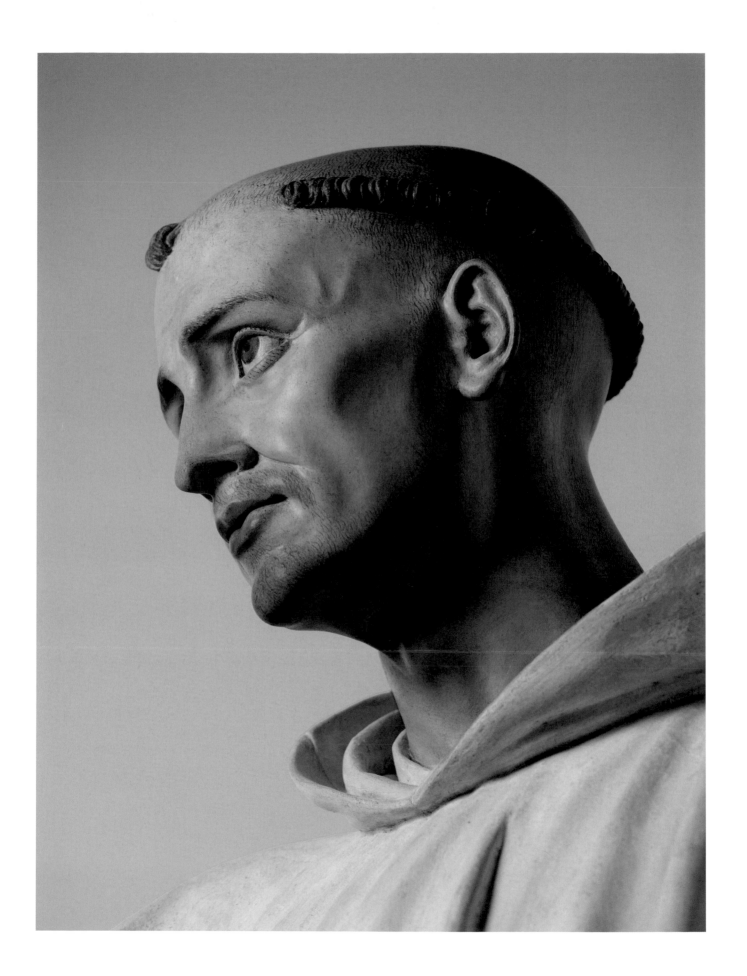

13 Alonso Cano (1601–1667)

Saint Francis Borgia, 1624

Oil on canvas, 186 x 120 cm
Signed and dated on the left side: VS. CANO / AÑ 1624
Museo de Bellas Artes, Seville (CE0087P)

Saint Francis Borgia was born in Gandía in 1510 to the noble family of the Dukes of Gandia. His friendship with the emperor Charles V led him to enter the service of the emperor and his wife, Isabel of Portugal, in 1527. In 1539, on the death of the empress, Francis's life underwent a radical change: on a visit to her tomb he was shocked to find when the coffin was opened that worms were eating her putrefying body. It was said that this encounter with the reality of death made him decide 'never again to serve a mortal master'. He abandoned court life and joined the Society of Jesus in 1546, becoming the third General of the order in 1565. He died in Rome in 1572, was beatified in 1624 and canonised in 1671.

In Cano's painting the saint is depicted full-length and life-size, dressed in the black habit of the Jesuits and contemplating a crowned skull that he holds in his left hand, a reference to the circumstances of his vocation. The three cardinals' hats at his feet refer to his refusal of this ecclesiastical position on three occasions. The Jesuits' device, the trigram IHS with three nails, appears at the upper left in a small cloud of glory. The figure of the saint, with its notably vertical emphasis, is outlined against a dark background from which it stands out through a carefully controlled interplay of light and shade. As in certain paintings by Cano's contemporary Zurbarán, this technique gives the figure a sculptural quality not unlike that of the work of Montañés, who in the same year, 1624, executed a sculpture of Saint Francis Borgia, which was polychromed by Pacheco (see cat. 14). The saint's face is inspired by numerous prints that disseminated his 'true effigy' and which faithfully reflected his actual appearance, recorded while he was still alive, with his broad brow and aquiline nose.

The formal type of a 'monumentalised saint' placed in the foreground, which was widely found in Sevillian painting at this period and which Cano adopts here, responds to Counter-Reformation guidelines, and such images came to be used for propagandistic purposes by the religious orders. Cano's stark composition has been compared to one of the Three Fathers of the Church painted by Zurbarán in 1626 for the Dominican monastery of San Pablo in Seville; in fact similarities between the early works of Cano and Zurbarán explain why this canvas was for many years attributed to Zurbarán.

The *Saint Francis Borgia* was made for the Noviciado de la Compañia de Jesus de Sevilla. It is the first precisely dated work from Cano's Seville phase, made in 1624 when he was still studying under Pacheco and two years prior to his examination for the status of master painter, but it already reveals the hand of a remarkably gifted artist. Part of the date and signature were rediscovered in 1946 at which point the work was firmly attributed to the artist. The restoration of 1994 revealed more of the signature but the fact that it is still incomplete and should presumably read 'ILDEFONSVS' [Alonso] may be because the canvas was cut down from its original size.[1]

RIM

SELECT BIBLIOGRAPHY
Catálogo 1897, p. 79, no. 15; Gestoso y Pérez 1912, p. 81, no. 189; Gómez Imaz 1917 edn, no. 9; Carriazo 1929, p. 176; Martínez Chumillas 1948, p. 82; Wethey 1955, pp. 167–8; Wethey 1958, pp. 12 and 33; Hernández Díaz 1967, p. 60, no. 93; Angulo Iñiguez 1971, p.151; Bernales Ballesteros 1976, pp. 82–3 and 157–8; Wethey 1983, pp. 46 and 136–7; Serrera 1986, pp. 336 and 338; Izquierdo-Muñoz 1990, p. 82, no. 87; Valdivieso 1992 edn, p. 156; Edinburgh 1996, cat. 9, pp. 114–15; Pérez Sánchez 1999a, p. 216; Pérez Sánchez 1999c, p. 102; Calvo Castellón 2001, p. 47 and 66; Cano Rivero 2001, p. 60; Delenda 2002, p.119

NOTE
1 According to Gómez Imaz's inventory (Gómez Imaz 1917 edn, no. 9), the painting was 'two varas and a half high and one and three quarters varas wide', that is, 209 x 144 cm.

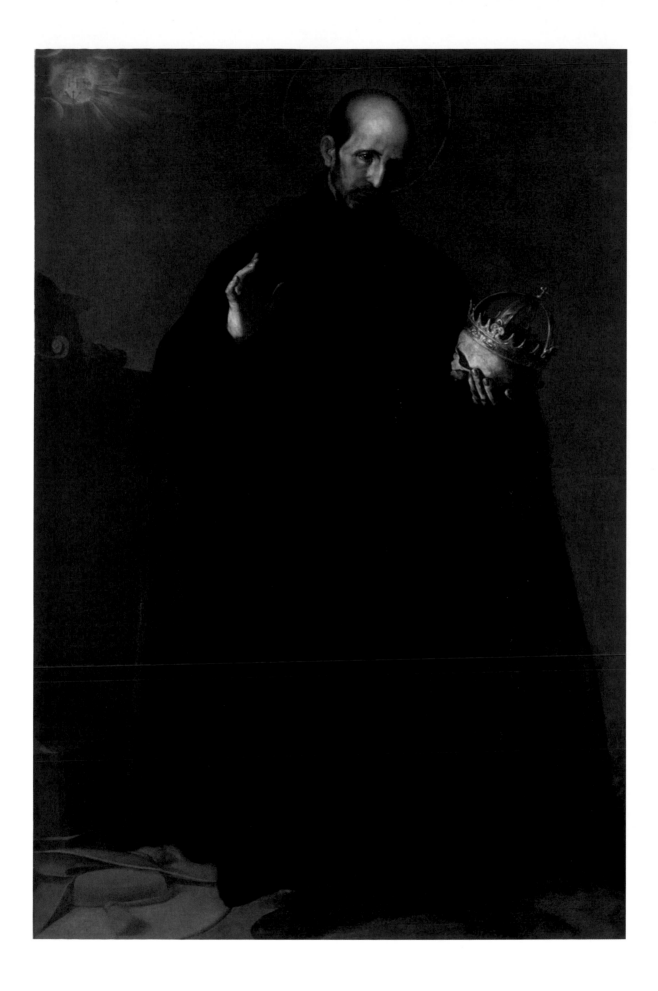

14 & 15 Juan Martínez Montañés (1568–1649) and Francisco Pacheco (1564–1644)

Saint Francis Borgia, about 1624

Polychromed wood and cloth, 174 x 68 x 51 cm

Saint Ignatius Loyola, 1610

Polychromed wood and cloth, 173.5 x 70 x 55 cm

Both Church of the Anunciación, Seville University
(1518-L and 1518-K)

These two figures are excellent examples of the type of sculpture known in Spain as an *'imagen de vestir'*, that is, a sculpture in which only the visible parts, namely the heads and hands, were carved. The bodies, which are covered with simple cassocks of sized cloth, were made in the form of manikins so that they could be dressed in elaborate liturgical dress on solemn occasions.[1] The realistic effect of this was further heightened by the polychromy of the flesh areas, which were painted by Pacheco using the matt finish technique, and imitated flesh tones in an extremely naturalistic manner.

The two works reflect the increasing interest in portraiture of religious figures that had developed since the late sixteenth century, to the extent that portraiture became an independent genre.[2] The realistic representation of the faces must have been in response to the requirements of the patrons, the Jesuits, who undoubtedly supplied Montañés with prints depicting the two saints in order to disseminate their true appearance. According to the so-called 'Ignatian method' the image always had to be doctrinally correct.

The physical appearance of Saint Ignatius, founder of the Jesuit Order, is in fact based on his death mask (preserved in Rome in the Gesù), from which plaster casts were made, one of which belonged to Pacheco. The saint was also the subject of a painting by Sánchez Coello that was directly formulated on the basis of advice from Father Pedro de Ribadeneyra, a close follower and personal acquaintance of Ignatius. This image was later reproduced in prints[3] following Ignatius's beatification in 1609 (he was canonised in 1622). In a contemporary account of the beatification, the saint is described as holding a framed trigram of Christ – IHS, the seal of the Jesuit Order – and gazing at it 'as if in a mirror'. Pacheco in his treatise proclaimed the *Ignatius* as the best of all representations of the saint 'because it seems really alive'. When the *Saint Ignatius* was first exhibited in 1610, the saint was apparently clothed in a black velvet soutane which had been embroidered by the nuns of the Convent of La Encarnación in Seville, and adorned with jewels brought by residents of the city.

The standard image of Saint Francis Borgia, great-grandson of the Borgia pope Alexander VI, had already been established in 1624, the date of his beatification. A painting in the collection of the Duke of Gandía, now in the convent of the Descalzas Reales in Madrid, testifies to his likeness. Alonso Cano also depicted Saint Francis Borgia in a painting signed and dated to the same year, 1624 (see cat. 13).

The documentation of these two sculptures is complex. In his *Arte de la Pintura* – our principal source of information – Pacheco states that Montañés executed the *Saint Ignatius Loyola* in 1610. We have no information regarding the date or attribution of the *Saint Francis Borgia*, but the formal parallels that it presents with *Saint Ignatius*, with which it forms a pair, make the attribution to Montañés quite clear. Less easily deduced is the date. It can be assumed that, as with the image of Saint Ignatius Loyola, that of Saint Francis Borgia must have been commissioned to mark his beatification in 1624,[4] although Pacheco makes no reference to this in his text. However, when he praises and recommends the use of matt polychromy for areas of flesh, he refers to the example of one of his finest works: 'The two heads of Saint Ignatius and Saint Francis Xavier in the Casa Profesa by Juan Martines.'[5] Some authors have suggested that Pacheco made a mistake and that he was actually referring to Saint Francis Borgia,[6] although we should bear in mind that the church of the Anunciación had an altarpiece by friar Gaspar de Padilla dedicated to Saint Francis Xavier. This was subsequently replaced with a new one, funded by Father Juan de Losada (died 1679), who also funded another one dedicated to Saint Ignatius Loyola; both were on the left side of the nave in the church of the Anunciación.[7]

The elegance of the poses of the two saints brings them close to classical sculpture, highly esteemed in intellectual circles in Seville since the sixteenth century. Montañés's particular merit lies in having been able to combine classicism

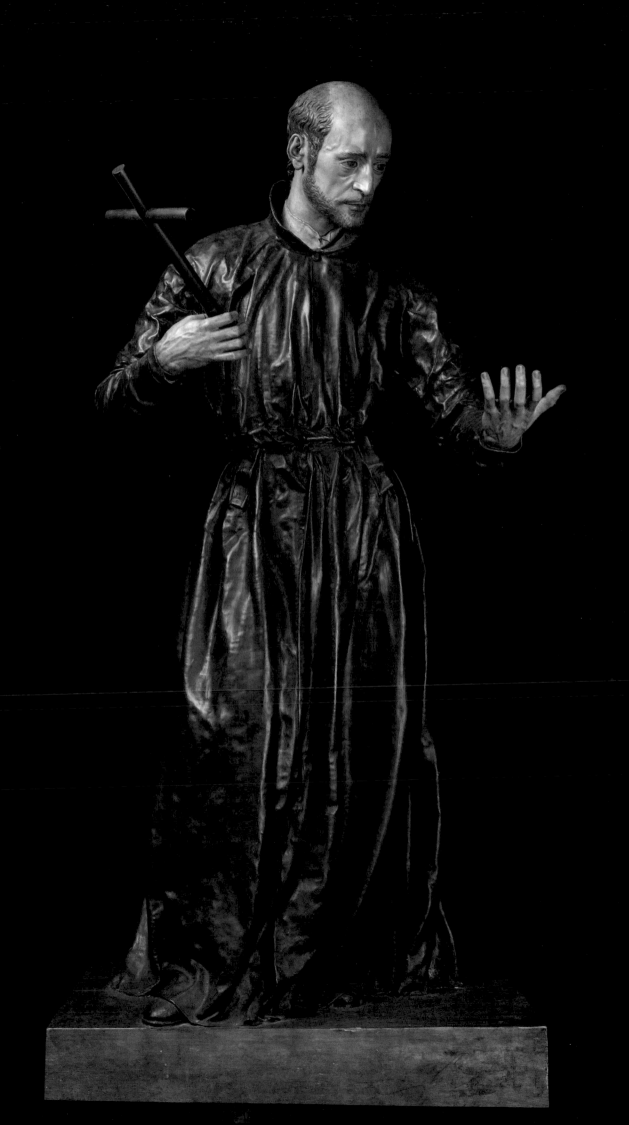

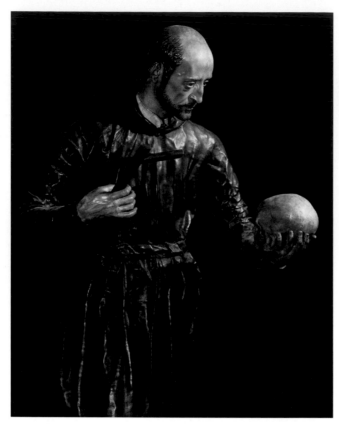

83 Detail of cat. 14, photographed in 1987 with the saint's attributes of crucifix and skull.

with realism. He depicts Saint Ignatius Loyola gazing intently at the cross in his right hand, and brilliantly conveys his mystical, self-absorbed expression. In his left hand the saint once held a rosary and the book of the Order of the Jesuits, but both these attributes are now lost. In contrast, the figure of Saint Francis Borgia conveys a greater sense of emotion, with his face expressing humility as he meditates on the fragility of life and the vanity of worldly power. In his left hand he holds a skull that originally had a crown, a reference to the Empress Isabella of Portugal, whom he served during her lifetime, and whose body he escorted to her tomb in Granada on her death (see also cat. 13).

MFMC

CAT. 14 SELECT BIBLIOGRAPHY
Pacheco 1649 (1990), p. 498; López Martínez1928c; Gómez-Moreno 1942; Hernández Díaz 1942; Proske 1967, pp. 76–8; Hornedo 1968, pp. 463–76; Bernales Ballesteros 1986, pp. 66–8; Hernández Díaz 1987, pp. 203 and 205; Sánchez-Mesa Martin 1991, pp. 159–61; Morón de Castro 2004

CAT. 15 SELECT BIBLIOGRAPHY
Pacheco 1649 (1990), pp. 498 and 709–10; López Martínez 1928c; Gómez Moreno 1942; Hernández Díaz 1942; Proske 1967, pp. 76–8; Hornedo 1968, p. 352; Bernales Ballesteros 1986, p. 66; Hernández Díaz 1987, pp. 167–8; Sánchez-Mesa Martin 1991, pp. 159–61; Edinburgh 1996, cat. 7, pp. 110–11; Morón de Castro 2004

NOTES
1 Luque Fajardo 1610; cited in Proske 1967, p. 155, note 233. The present soutane is made of stiffened fabric soaked in glue and probably dates from 1836, during the renovation of the chapel. It was around this time that the two sculptures were rediscovered, having for some time been relegated to storage.
2 The late Mannerist interest in the authentic representation of faces is evident in projects such as Paolo Giovio's museum of portraits, Vasari's *Lives* and Pacheco's *Libro de Descripción de verdaderos retratos de ilustres y memorables varones*.
3 The Jesuit interest in the iconography of their order's founder was evident from the time of Loyola's death. See Cendoya Echaniz and Montero Estebas 1993.
4 Documents record that the sculpture of Saint Ignatius Loyola was used in the celebrations that took place in the monastery of Saint Francisco in 1616 to mark the reception of the Confraternity of the Immaculate Conception. Contemporary documents record that it was commissioned from Montañés by the Congregation of the Holy Trinity. Nothing is said of the sculpture of Saint Francis Borgia, suggesting that it had not been executed by that date. See Serrano y Ortega 1893, p. 363, which reproduces a document by Pedro de Escalante of 1616 that gives an account of ceremonies held in Seville that year.
5 Pacheco 1649 (1990), pp. 498 and 709–10.
6 Proske 1967, p. 76, and Hornedo 1968, pp. 463–76.
7 Solís 1755, p. 130.

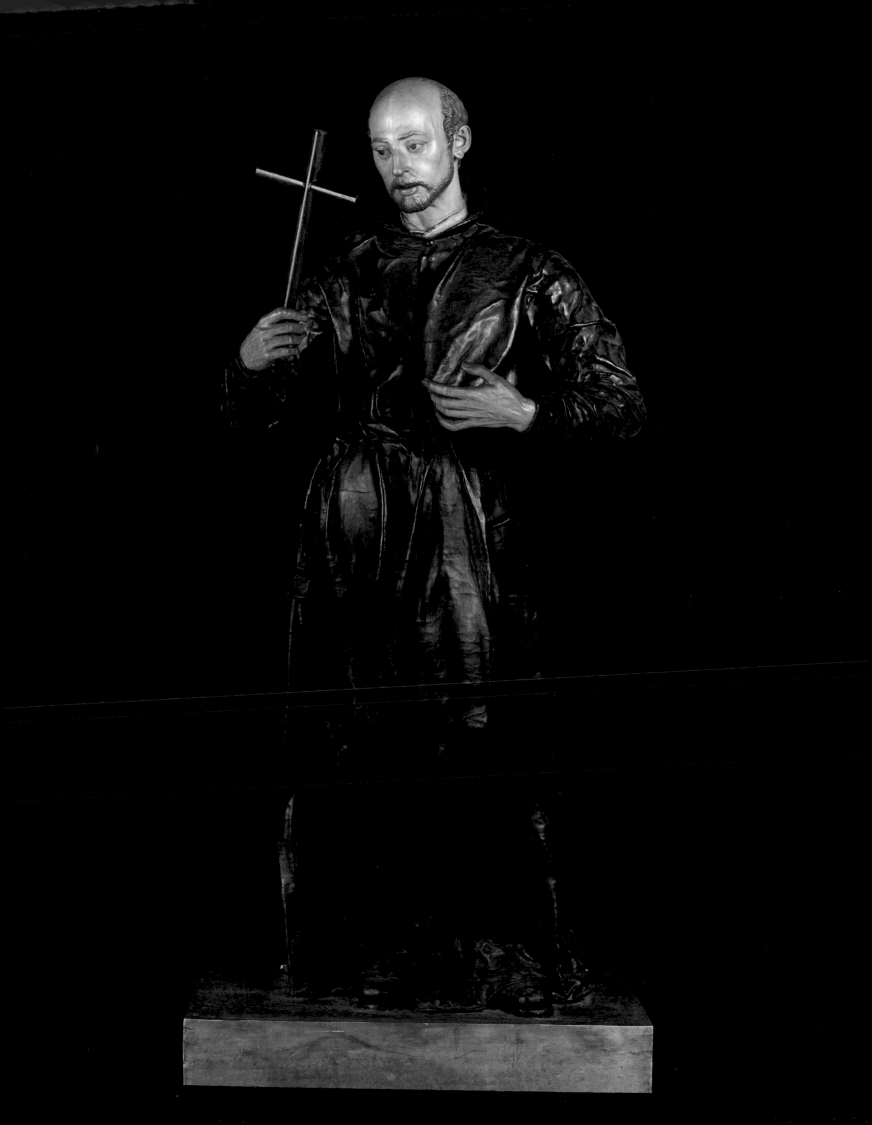

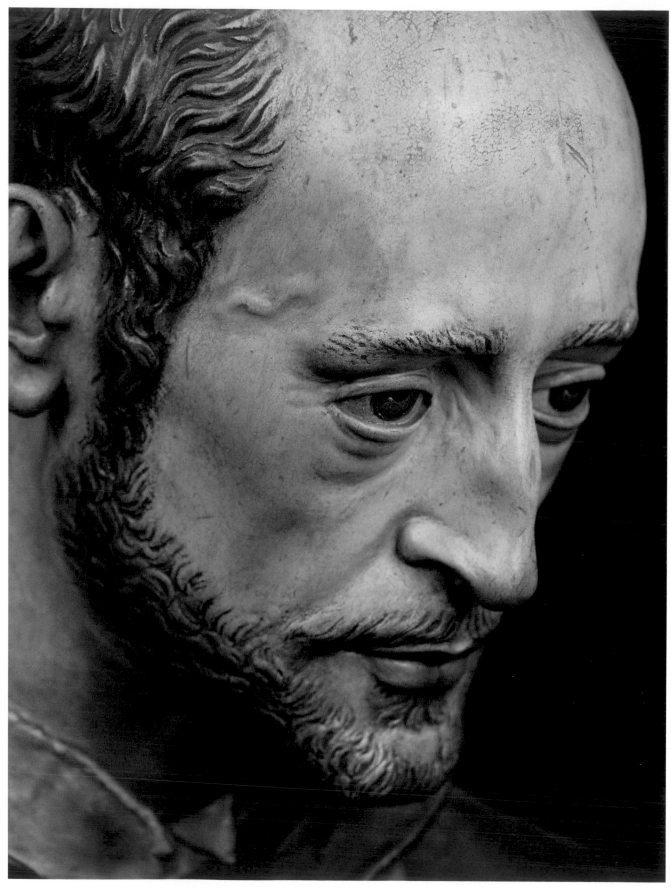

84 Detail of cat. 14

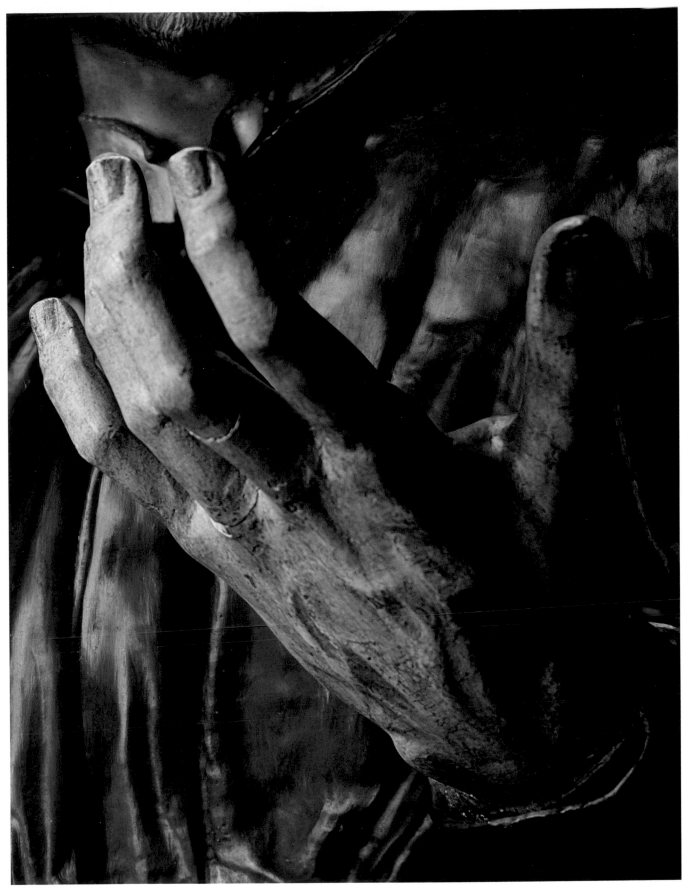

85 Detail of cat. 14

16 Diego Velázquez (1599–1660)

The Venerable Mother Jerónima de la Fuente, 1620

Oil on canvas, 162.5 x 105 cm
Signed and dated above the inscription on the left: DIEGO VELAZQUEZ F. 1620 (signature reinforced at a later date).
Private collection

The Latin inscription above her head translates literally as: 'It is good to wait with silence for the salvation of God' (see Lamentations 3: 26), and the inscription in the banderole: 'I shall be satisfied when thy glory shall appear' (see Psalms 17: 15).

The inscription at the bottom which has been painted on top of another similarly worded inscription reads: *Este es verdadero Retrato de la Madre Doña Jeronima de la fue⁻te Relixiosa del Coñvento de Sancta ysabel de los Reyes de T. fundadora y primera Abadesa del Convento de S. Clara de la Concepcion de la primera regla de la Ciudad de Manila en filipinas. salio a esta fundacion de edad de 66 años martes veinte y ocho de Abril de 1620 años salieron de este convento en su compania la madre Ana de Christo y la madre Leonor de sanct francisco Relixiosas y la hermana Juana de sanct Antonio novicia Todas personas de mucha importancia Para tan alta obra.'*

Velázquez painted Mother Jerónima de la Fuente's portrait in 1620 when she was passing through Seville on her way to Manila in the Philippines where she had been sent to found a sister convent. A Franciscan nun from the closed order of the Poor Clares, she was celebrated in her lifetime for her holiness, winning particular admiration for her austere programme of penitence and meditation. Her biographers tell how she achieved mystic communion with Christ through visions and revelations, re-enacting the Crucifixion by attaching herself to a cross and hanging unsupported for as much as three hours at a time.[1] Pledged to silence under the rules of her order, Velázquez's Jerónima leaves it to the white banderole next to her to do the 'talking' (see above). Velázquez portrays the rugged features of the sixty-six-year-old nun in a realistic and uncompromising fashion, creating a strong sense of her physical presence and profound spirituality.

Her imposing figure, positioned against a dark background, is lit from the front left, so that we clearly see her features beneath her white headdress. The leathery texture of her skin, the deep creases of her wrinkles, her thin lips and, most intimidating of all, her penetrating gaze, are all captured with utmost precision. She holds a polychromed crucifix in her right hand, and a Bible or the Rule of her Order in the other. The folds of her cloak and black veil are brought into sharp focus against the dark background, giving her an almost sculptural presence. Only the floor on which she stands gives any sense that she inhabits a 'real' space.

Velázquez painted two full-length portraits of Mother Jerónima. This version is generally considered an autograph replica of the first version now in the Museo del Prado. Although there are some stylistic differences between the

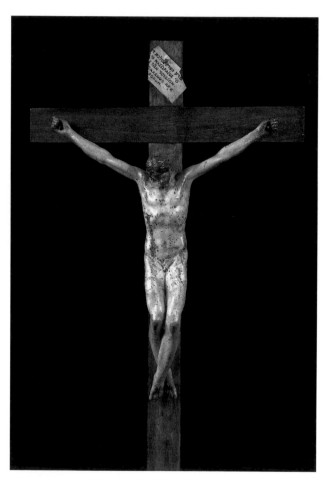

86 Anonymous
Christ on the Cross, early seventeenth century
Polychromed metal, h 25 cm
Private collection

two, and in general the present version is tighter and harder in execution than the Prado one, the only compositional difference is the position of the crucifix that she is holding. In the Prado painting, the crucifix is shown from the back so that only Christ's shoulders and loincloth are visible. Four metal studs hold the four nails with which Christ has been fixed to the wooden cross. In this version, the crucifix is turned towards the viewer so that Christ's figure is seen from side on. Although his right foot, which would have been attached with the fourth nail, is not visible, we can safely assume that it is the same crucifix as in the Prado picture.

This polychromed crucifix is remarkably similar to one Pacheco is known to have owned. In 1597, he was given a replica of a bronze crucifix with four nails thought to be based on a Michelangelesque model, which was brought back from Rome to Seville by the silversmith Juan Bautista Franconio and was much copied and reproduced by local artists.[2] Pacheco tells us in his *Arte de la Pintura* how he painted his version by employing the matt polychrome technique. From other polychromed versions of this crucifix that have survived (the loincloth was probably real cloth), it is quite possible that Velázquez used Pacheco's replica as a studio prop for his portrait of Mother Jerónima (fig. 86).[3]

By depicting the crucifix in shadow at an angle, Velázquez gives an extra sense of depth to his composition. Its physical presence further accentuates Mother Jerómina's indomitable stature. Velázquez's familiarity with polychromed sculpted portraits, such as Juan Martínez Montañés's *Saint Ignatius Loyola* (see cat. 15), would have helped him realise this powerful portrayal of holiness.

XB

SELECT BIBLIOGRAPHY
Garrido and Gómez Espinosa 1988, pp. 66–75; New York 1989–90, cat. 3, p. 68; Delenda 1993, pp. 65–9; Edinburgh 1996, cat. 43, pp. 174–6; Seville 1999, cat. 97, pp. 208–9; Véliz 1999; London 2006–7, cat. 14, pp. 142–3

NOTES
1 Ruano Santa Teresa 1993, p. 27.
2 See Pacheco 1649 (1990), pp. 497–8. See also Gómez-Moreno 1930, pp. 193–5.
3 I am grateful to Javier Moya Morales for showing me one of these versions. See Murcia 2008–9, p. 3.

17 Francisco Antonio Gijón (1653–about 1721) and unknown polychromer (possibly Domingo Mejías, active second half of seventeenth century)

Saint John of the Cross, about 1675

Polychromed and gilded wood, 168 x 93.3 x 72.2 cm
National Gallery of Art, Washington
Patrons' Permanent Fund (2003.124.1)

Together with Saint Teresa of Ávila (1515–1582), John of the Cross (1542–1591) founded religious communities that practised a stricter form of the Carmelite rule. They became known as the Discalced Carmelites, that is shoe-less, because in empathy with the poor the friars went barefoot or wore sandals, as in this sculpture. Saint John created some of the greatest Spanish poetry – profound mystical verse like the *Spiritual Canticle* (*Cántico Espiritual*) and the *Dark Night of the Soul* (*Noche Oscura*) – and he expanded on his poetry with prose commentaries: in *The Ascent of Mount Carmel* (*La Subida del Monte Carmelo*) the soul is tutored on how to reach union with God.[1] These writings are leading expressions of the ardent devotion of the Counter-Reformation that expound what has been called a theology of darkness[2] in which sensory deprivation and suffering are embraced as pathways to true faith.

On 11 March 1675 the friars of the Discalced Carmelite convent of Nuestra Señora de los Remedios, in Seville, commissioned Francisco Antonio Gijón to make a painted wood life-size effigy of the newly beatified John of the Cross. The sculpture described in the contract, which survives in the Seville archives, was thought to be lost until 2003 when José Roda Peña recognised it as the Washington statue.[3] The size and media (see the essay by Daphne Barbour and Judy Ozone on pp. 59–71), and the representation of John of the Cross as a divinely inspired writer, closely match the contract's instructions. The saint, wearing a richly decorated version of the traditional Carmelite brown habit with a white cloak, looks devoutly up to heaven, catching a glimpse of a now-missing dove over his right shoulder. In the delicately poised fingers of his right hand he held a plume, ready to pen the open book in his arthritic left hand. The incongruously scaled mountain peak sprouting from the book, once topped by a cross, forms an engaging iconographic pun and identifies the book as the *Ascent of Mount Carmel*.[4] The mountain, a feature required in the contract, is unique to Andalusian statues of Saint John.[5]

Though he had been an independent master for four years,

Gijón was only twenty-one when he made the *Saint John of the Cross*. It offers early evidence of his talent for 'true and lifelike' religious figures that 'move the will to devotion'.[6] The left hand, an iconographic and visual focal point, is a *tour de force* of expressive realism visible only to the kneeling devout. The minor painter and gilder Domingo Mejías, who served as guarantor to the contract, may be responsible for the gilded cloth decoration (*estofado*), which is of lesser quality than the confident carving and nuanced flesh tones. The saint's facial features and pained expression, the rendition of his arthritic hands and feet, the configuration of the drapery, and the open pose with the left leg forward, are so close to Gijón's 1676 statue of Saint Anthony Abbot, still in the church of San Antón in Seville,[7] as to secure the attribution.

EL

SELECT BIBLIOGRAPHY
Bernales Ballesteros 1982; Bruno de Jésus Marie 1929; Cano Navas 1984; Crisógono de Jesús Sacramentado 1946 (2nd edn); Florisoone 1975; Mármol Marín 1993; Roda Peña 2005, pp. 304–9; Rzepińska 1986, pp. 91–112; Zimmerman 1910

NOTES
1 John of the Cross was beatified in 1675, canonised in 1726, and in 1926 he was declared one of the thirty-three doctors of the Catholic Church. On his life see Bruno de Jésus Marie 1929; Crisógono de Jesús Sacramentado 1946; Zimmerman 1910.
2 Rzepińska 1986, pp. 100–2.
3 Correspondence in the National Gallery of Art curatorial files. The contract for the Remedios *Saint John of the Cross*, described in Bernales Ballesteros 1982, p. 71, was published by Roda Peña 2005, pp. 304–9.
4 The Carmelite shield consists of a stylised rendition of Calvary that also refers to Mount Carmel, the hermit site in the Holy Land from which the order takes its name.
5 Of the eight Spanish painted wood sculptures of John of the Cross listed in Florisoone (1975, pp. 239–46) only the one in the Carmelite convent of Sanlúcar de Barrameda (near Seville) features the mountain on the book (Florisoone 1975, p. 240). The mountain is also present in the *Saint John of the Cross* in the convent church of San José del Carmen (known as Las Teresas) in Seville (Cano Navas 1984, p. 83, fig. 12; Mármol Marín 1993, pp. 26–8, fig. 4).
6 Saint John of the Cross, *The Ascent of Mount Carmel*, 3, 35, 3. In book 3 of *The Ascent* Saint John wrote extensively on the use of sculptures for devotion, mostly cautioning against valuing them as objects rather than spiritual guides.
7 Bernales Ballesteros 1982, pp. 71–2.

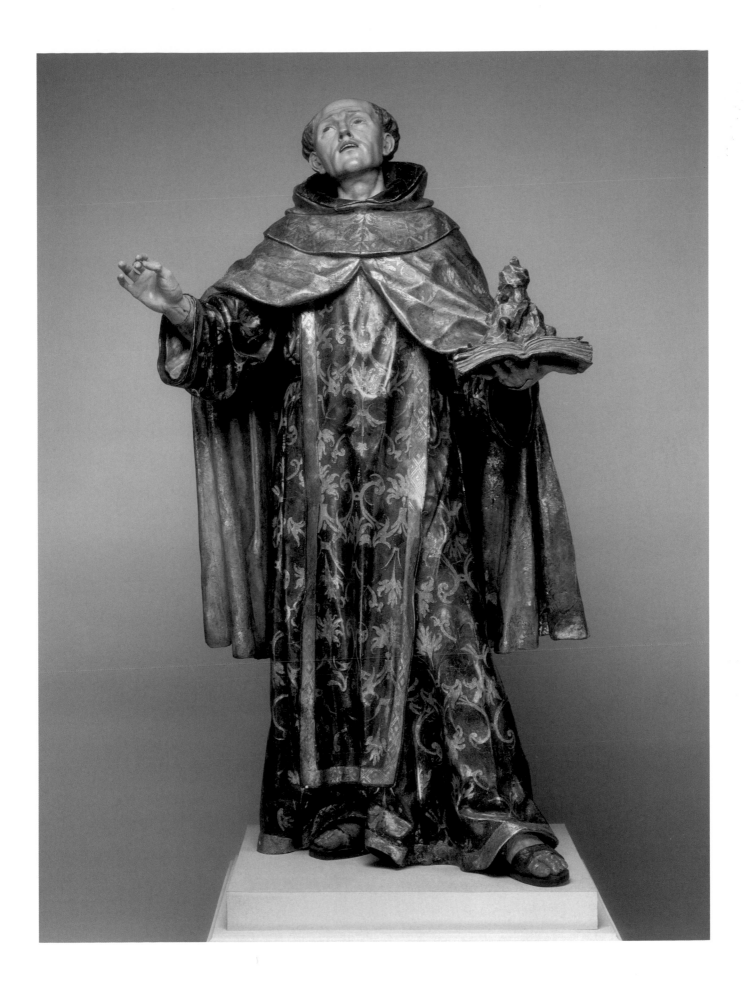

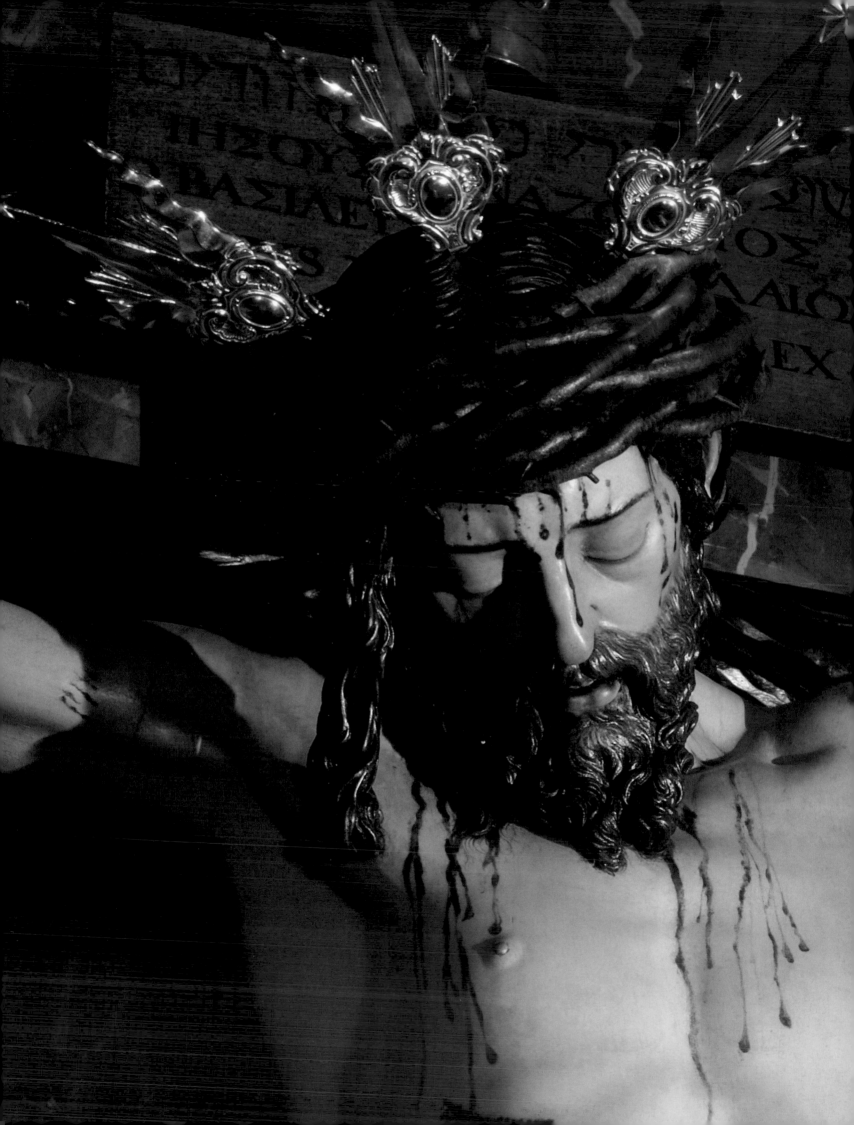

The Passion of Christ

Each year in Spain during Holy Week the Passion of Christ – that is, his suffering in the events leading up to his death and resurrection – is re-enacted in cities and towns all over Spain. Floats, or *pasos*, weighing up to two tons and bearing life-size painted sculptures, are carried through the streets, each float depicting a different episode from the Passion. Carried by some thirty men, the floats sway from side to side, giving the impression that the sculptures are alive. Crowds line the streets as they pass, many of the onlookers overwhelmed by the narrative being played out in front of them.

Most of the sculptures one sees during Holy Week today are modern creations but there are some which date back to the seventeenth and eighteenth centuries. Works such as Juan de Mesa's *Christ carrying the Cross*, popularly known as the 'Cristo del Gran Poder' ('Christ of the Great Power') and Gregorio Fernández's *Christ at the Column* are hugely celebrated and attract vast crowds in Seville and Valladolid. For many devout Christians it is as though they were witnessing the Passion first hand. This engagement with a powerfully realistic reconstruction of a Passion scene may be matched in – and may even have influenced – Velázquez's painting of *Christ after the Flagellation* (cat. 19) and Ribera's *Lamentation over the Dead Christ* (cat. 28).

Polychromed sculptures of the Passion were also commissioned for churches and for private devotion. For instance, Pedro de Mena's half-length figure of *Christ as the Man of Sorrows* (see cat. 21) was made for the illegitimate son of Philip IV, Don Juan José de Austria, and Gregorio Fernández's *Dead Christ* (cat. 27) was made for the Jesuit House in Madrid. Their uncompromising realism was intended to arouse feelings of empathy in the pious viewer, and though today they might appear horrifying, even shocking, they still have the power to move and impress the spectator.

18 Gregorio Fernández (1576–1636) and unknown polychromer
Ecce Homo, before 1621

Polychromed wood, glass and cloth, 182 x 55 x 38 cm
Museo Diocesano y Catedralicio, Valladolid

On 3 January 1621, Bernardo de Salcedo, the parish priest of the church of San Nicolás, Valladolid, drew up a legal document with the Confraternity of the Santísimo Sacramento y Ánimas (Holy Sacrament and All Souls), which had its headquarters in the same church and of which Salcedo was a member. It stated that, providing the confraternity agree to his terms, it would become the rightful owner of Gregorio Fernández's sculpture of the 'Santa Imaxen del Exçe Homo ('the Holy Image of the *Ecce Homo*').[1] The gift included the '*caja*' ('box') in which the sculpture was kept, a silver lamp, three veils and two mantles (probably purple in colour and used to cover Christ's shoulders). The conditions for receiving this gift were very particular, however. A member of the confraternity was to collect alms once a month in order to maintain the altar and its image; the sculpture should on no account leave the church; fifteen Masses a year should be said in front of the image; and lastly Fernández, 'que hizo la Imagen' ('who made the Image'), was also to be commemorated during the celebration of each of the fifteen Masses.[2]

Fernández shows the moment when having been bound, scourged and mocked by the soldiers (John 18:24) – who put a crown of thorns on his head and a purple garment on his shoulders – Christ was presented by Pontius Pilate, the Roman governor of Judaea, to the Jews outside the judgement hall with the words 'Ecce Homo!' ('Behold, the man!') (John 19:1–5).

This is one of Fernández's masterpieces. It demonstrates his sophisticated understanding of anatomy and his great skill in carving the male nude in wood. When the sculpture was restored in 1989, the loincloth (which is made from a piece of fabric stiffened with glue – *tela encolada*), was temporarily removed, revealing that Fernández initially conceived his Christ as a totally naked figure, including the genitalia, before adding the loincloth in accord with contemporary religious decorum (fig. 89).[3] Life-size and standing on a platform in a slight *contrapposto* pose, Christ can be seen from all sides; originally there would have been a real rope binding his wrists and possibly a crown of thorns and a purple garment.

Christ's mouth is open and his eyes, which are made of glass, look out with an expression of resignation. Blood trickles down his chest and on to the loincloth. His knees are grazed. To depict the flesh wounds on his back, a layer of gesso was removed and a pinkish-red colour was applied to the layer below. For the bruised and blemished skin, a mixture of blue and pink paint was applied with broad brushstrokes. By contrast, the white porcelain finish of Christ's front, which was achieved by employing the '*pulimento*' technique, gives the polychromy a glossy surface, almost like a marble sculpture (see pp. 19–21 and 64–5).

Despite the gruesome realism, the graceful forms, harmonious proportions and classical pose make Fernández's interpretation a restrained and contemplative one, similar to Velázquez's treatment of Christ in his painting *Christ after the Flagellation* (see cat. 19). Since Fernández's statue was originally placed in a chapel on the right of the high altar, it would seem that Fernández intended Christ's gaze to be directed at the congregation in order to inspire their devotion.[4]

Although Salcedo gives no reason as to why he wanted Fernández commemorated in the fifteen Masses, Fernández was celebrated as a sculptor and admired for his charitable works (his own home often functioned as a hospital for the

89 The loincloth from the *Ecce Homo* (cat. 18)

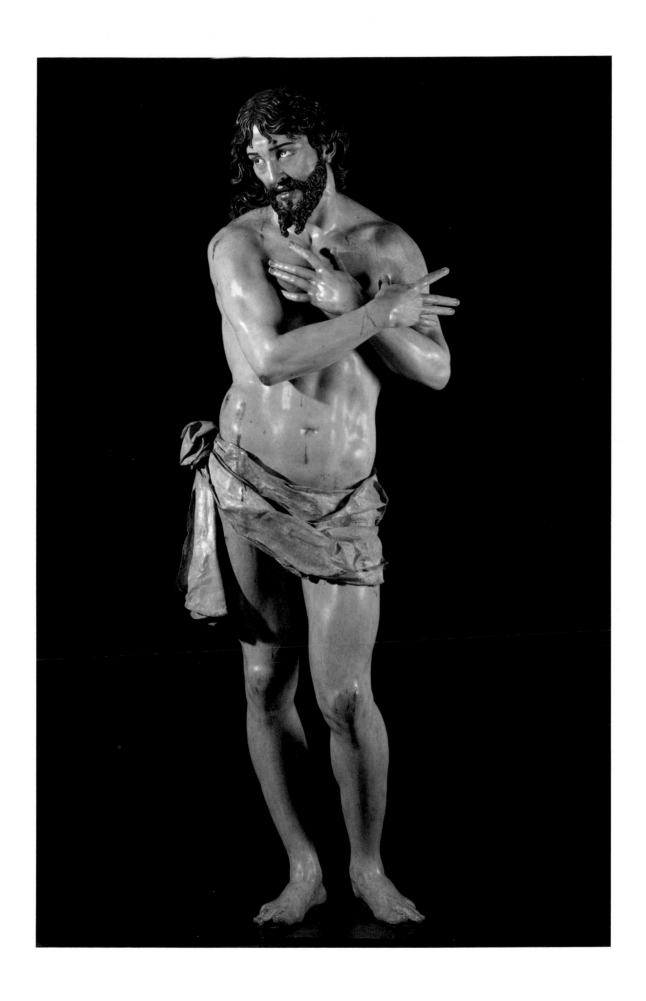

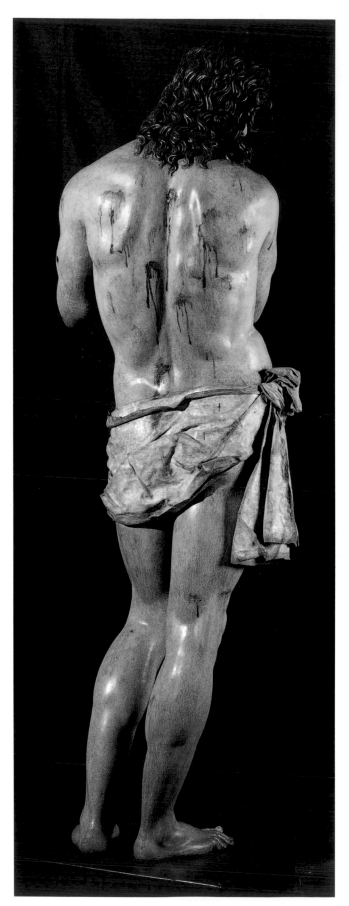
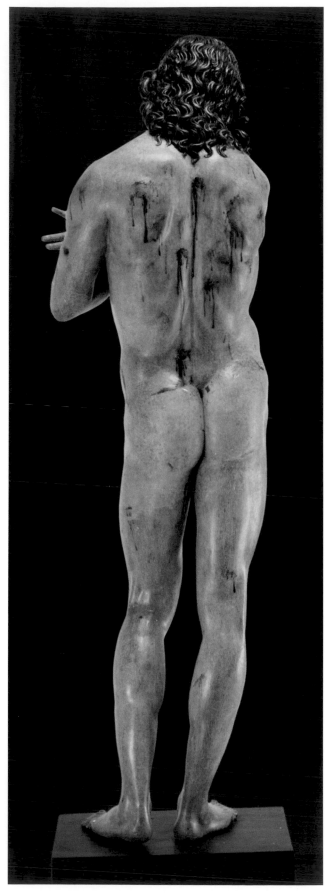

90, **91**, **92** and **93** Four views of the *Ecce Homo* (cat. 18). The nude figure (figs 91 and 93) was photographed during conservation in 1988–9.

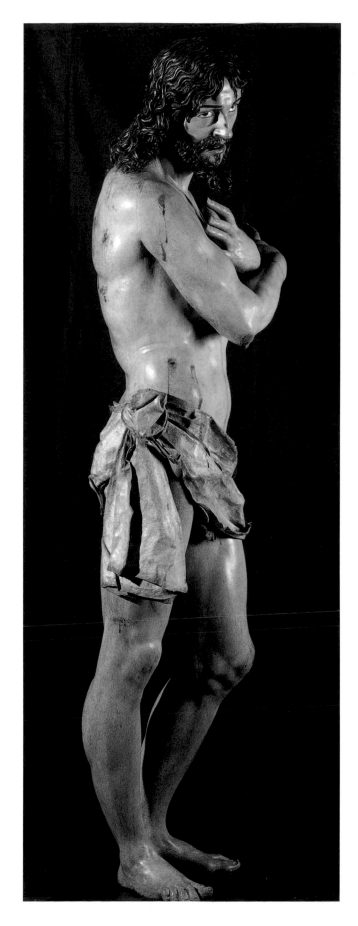
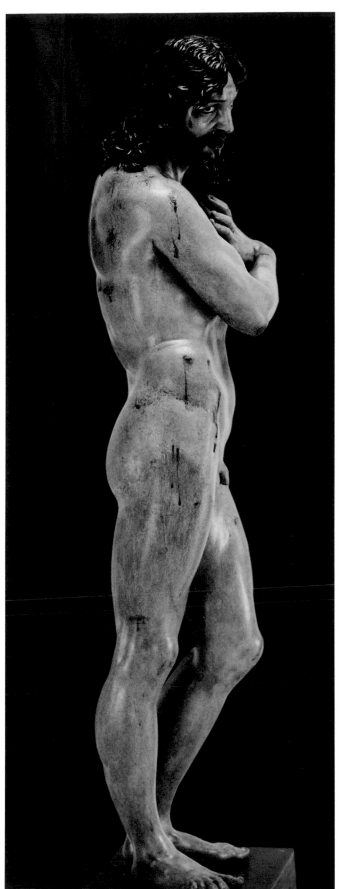

poor) and for his zealous piety. In his biography of the artist, Palomino described how Fernández, before making an 'effigy of Christ Our Lord' would prepare 'himself first by prayer, fast, penitence, and communion, in the hope that God might confer his grace upon him and make him succeed'.[5]

XB

SELECT BIBLIOGRAPHY
Urrea Fernández 1972; Plaza Santiago 1973; Martín González 1980, pp. 174–5; Salamanca 1993–4, pp. 113–15; Madrid 1999—2000, pp. 134–5; Valladolid 2008, pp. 120–1 and 143

NOTES
1 Plaza Santiago 1973.
2 Plaza Santiago 1973, p. 509. I am grateful to David Davies and Angel García Gómez for their assistance in interpreting this particular clause of the document.
3 The sculpture was restored by the Instituto de Patrimonio Histórico de España (IPCE) in 1988–9. I am particularly grateful to the staff of the IPCE for making this information available.
4 This was suggested by David Davies in conversation.
5 Palomino 1715–24 (1947), p. 829.

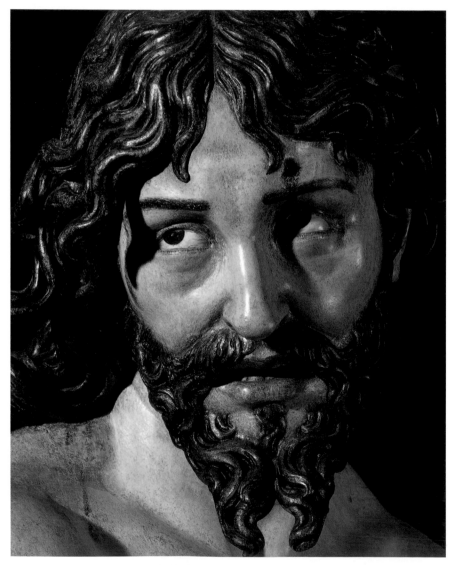

94 and **95** Details of cat. 18. The back of the figure is in excellent and near-original condition. The front was damaged in a fire and partly restored and repainted in the nineteenth century.

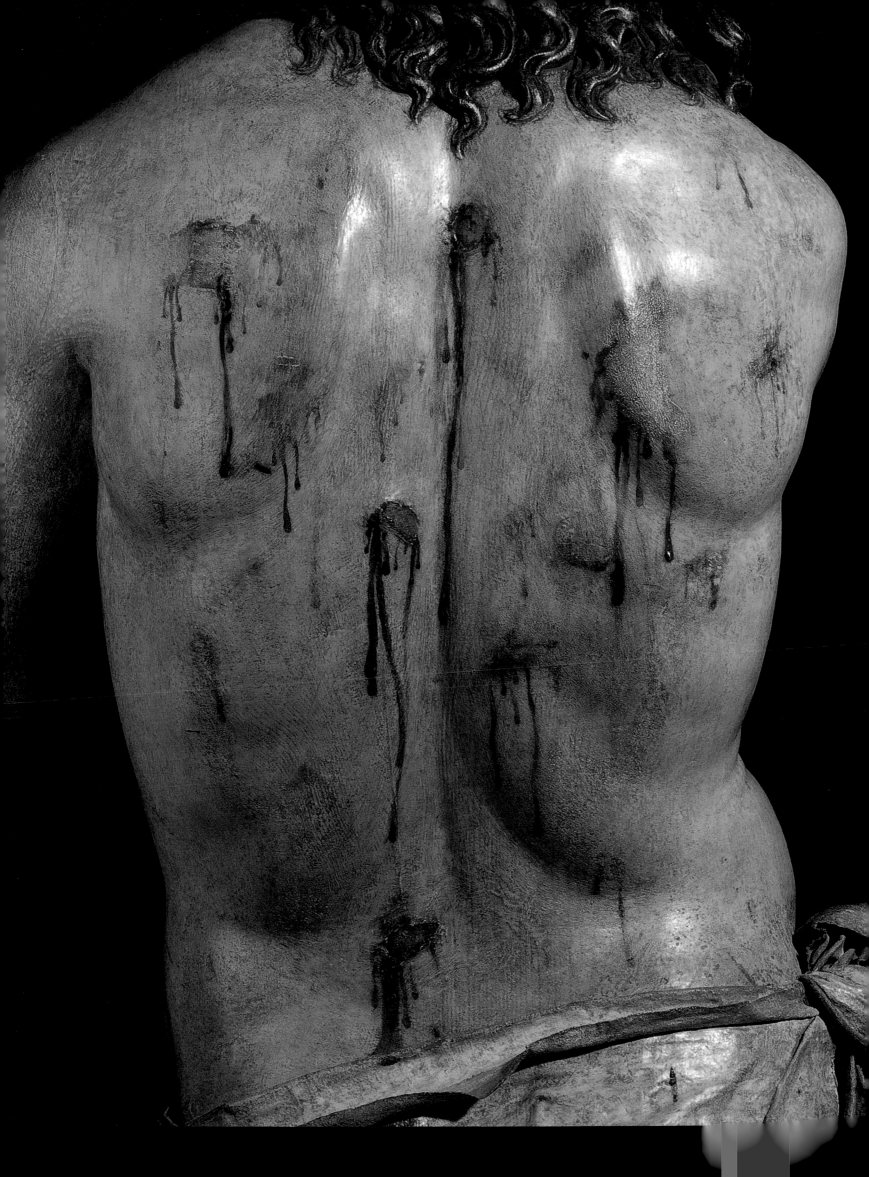

19 Diego Velázquez (1599–1660)

Christ after the Flagellation contemplated by the Christian Soul, probably 1628–9

Oil on canvas, 165.1 x 206.4 cm
The National Gallery, London (NG 1148)

Velázquez depicts a rarely represented Christian subject: following his flagellation Christ is visited by a Christian soul in the form of a child, accompanied by his guardian angel.[1] The Gospels tells only of Christ's scourging but there were commentaries and meditative texts that dwelt on the moments after his flagellation.[2]

Two earlier paintings of this subject have been identified, both of which Velázquez may have seen, by the Sevillian Jesuit priest-painter Juan de Roelas (1558–1625). The earliest of these was painted for King Philip III of Spain in 1616 (fig. 96) and originally bore an inscription: 'O Soul, have pity on me, for you have reduced me to this state.'[3] Roelas's later version, for the Dukes of Medina Sidonia in Sanlúcar de Barrameda (Cádiz), shows the Christian soul crying and holding a flaming heart, a

symbol of religious ardour that became associated with the Jesuits.[4] The existence of these two paintings by Roelas suggests that the subject was one that was both intellectual and fervently Catholic, in tune with post-Reformation iconography. As a Jesuit, Roelas was probably responsible for conceiving the subject and was very possibly inspired by Flemish prints, such as those by Hieronymus Wierix, examples of which show guardian angels protecting Christian souls in the form of children (fig. 97).

One further painted representation of this subject, by an unknown seventeenth-century painter, has been identified in the convent of San Francisco in Sanlúcar de Barrameda.[5] It is not certain whether this work predates Velázquez's version, but the composition is loosely based on Roelas's painting,

96 Juan de Roelas (about 1560–1624)
Christ after the Flagellation contemplated by the Christian Soul, 1616
Oil on canvas, 121 x 100.5 cm
Monasterio de la Encarnación, Madrid

97 Hieronymus Wierix (1553–1619)
Child protected by his Guardian Angel, before 1619
Engraving, 9.4 x 6.3 cm
The British Museum, London (1859.0709.4149)

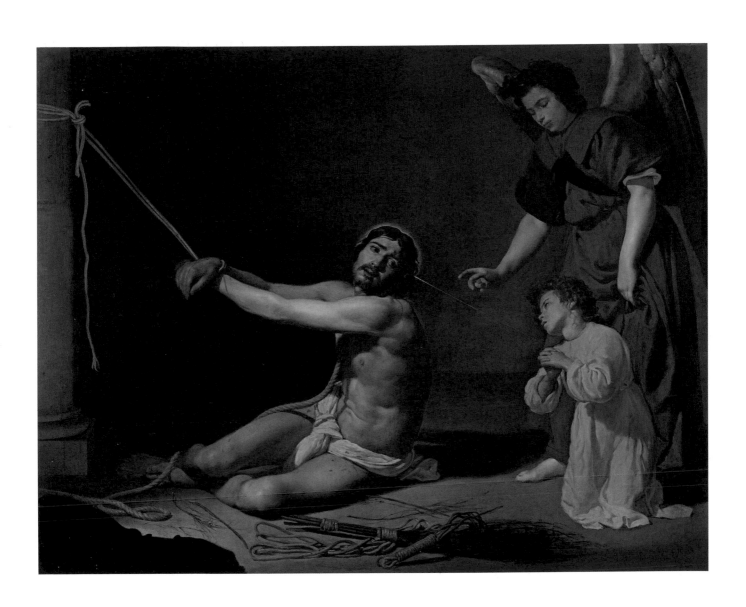

with Christ similarly positioned, but this time with two assailants. There is an inscription at the top of the painting, an abridged quotation from Isaiah 53, which focuses and elaborates on the guilt that all Christians bear for the suffering Christ endured.[6] These three surviving paintings help to elucidate the complex meaning behind Velázquez's painting, which is certainly strongly post-Tridentine and Catholic in sentiment. It is possible that Velázquez made this work for the private contemplation of one of the powerful and sophisticated ecclesiastical figures at the Spanish court, such as the king's Dominican confessor, Fray Antonio de Sotomayor, whom we know commissioned another devotional painting from Velázquez.[7]

In Velázquez's hands this unusual devotional subject is, however, interpreted in a more realistic manner. His composition is beautifully staged. Indeed, the fact that the angel's wings are apparently strapped on across his chest suggests that the figures were copied from the life in the studio. Certainly, the composition appears to have been composed piecemeal, for the scale of Christ is much larger than the attendant figures, so that if he stood up he would have towered over them. Velázquez's depiction of Christ at the column may have been informed by painted sculptures of this subject, most notably those by Gregorio Fernández, whose many examples were in churches and convents in Madrid and Valladolid (cat. 18 and fig. 98 and see the essay by Xavier Bray on pp. 15–43) and whose treatment of Christ is similarly classicising.

It seems likely that *Christ after the Flagellation* was painted in Madrid before Velázquez left for Italy in 1629.[8] It is a work that points to his Andalusian origins, although updated into a new and more classical manner. While Roelas's versions are more provincial and more overtly emotional, Velázquez's painting is imbued with a sense of calm that comes from the central placing of Christ and the empty space around him illuminated only by a shaft of heavenly light.

XB

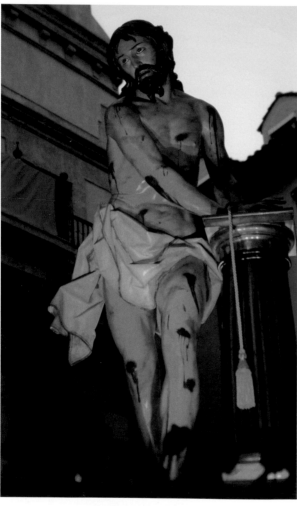

98 Gregorio Fernández (about 1576–1636)
Christ at the Column, about 1619, in procession during Holy Week
Polychromed wood, life-size
Iglesia de la Vera Cruz, Valladolid

99 Detail of cat. 19

SELECT BIBLIOGRAPHY
MacLaren and Braham 1970, pp. 119–21; Harris 1982, pp. 116–18; Brown 1986, pp. 67–8; Delenda 1993, pp. 90–5; López-Rey 1996, II, pp. 82–3, no. 35; London 2000, cat. no. 54, p. 136; London 2006–7, cat. no. 16, pp. 148–51; Keith and Carr 2009

NOTES
1 The correct identification of this unusual subject was made by Schneider 1905 pp. 157–8.
2 A popular medieval text was *Meditations* (1961), pp. 330–1. See also *The Scourging of Christ* by the Spanish Jesuit Fray Diego Alvarez de Paz, first published in 1611, which is cited by Delenda 1993, pp. 92–3, and Carr in London 2006, pp. 148–51. For a full iconographical study of this picture see Moffitt 1992.
3 'Alma duélete de mi, puesto que tú me pusiste así'. The painting was given by Philip III to the royal Monastery of the Encarnación, Madrid. See Valdivieso and Serrera 1985, cat. no. 83, p. 158.
4 Justi 1888 vol. 1, p. 424, saw this painting when it was in the church of La Merced, Sanlúcar de Barrameda, before it entered the Medina Sidonia palace. See Valdivieso and Serrera 1985, cat. no. 24, p. 143. This version is inscribed: *AVE REX NOSTER. TV. SOLVS. NOsTROS. ES MISERATVS EROReS* ('Hail, Our King. Only you can forgive our sins'.)
5 By the present author.
6 Although difficult to decipher the inscription reads: *VIDIMUS EUM ET NON FRATIBI ASPECTUS ET REPUTAVIMUS EUM QUASI LEPROSUM ET A DEO HUMILIATUM: ESAIAS 53.*
7 Finaldi and Bray in London 2000, p. 136, and Carr in London 2006, cat. 16, pp. 148–51.
8 Recent technical examination of the painting suggests it was painted before his trip to Italy (1629–31) rather than afterwards. See Keith and Carr 2009, pp. 52–70.

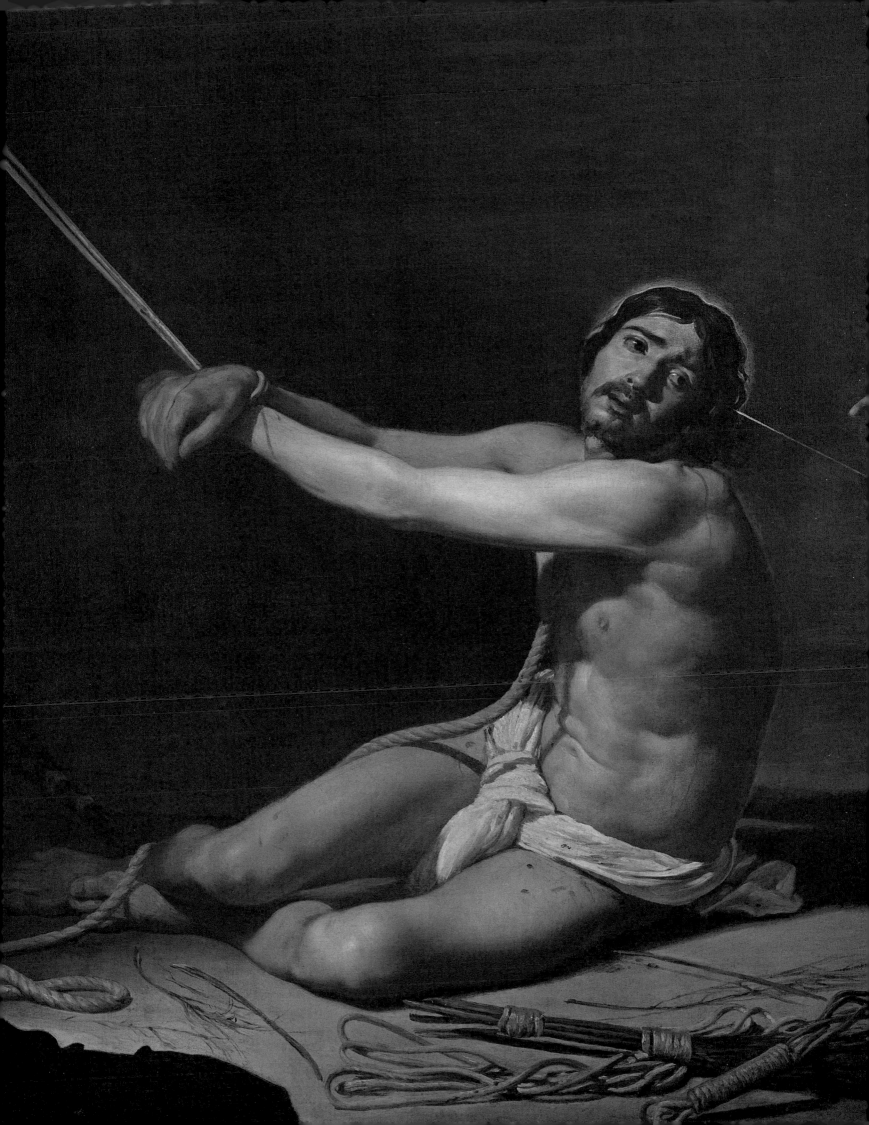

20 Pedro de Mena (1628–1688)

Christ as the Man of Sorrows (Ecce Homo), 1673

Polychromed wood, human hair, ivory and glass, 98 x 50 x 41 cm
Signed and dated in small black cursive letters on the lowest fold of the loincloth: *P.s de Mena y Medrano F.t. Malace, anno 1673.*
Real Monasterio de las Descalzas Reales, Patrimonio Nacional, Madrid

Like his sculptures of the *Virgin of Sorrows*, Pedro de Mena's sculptures of Christ as the Man of Sorrows were much in demand. The present work is one of his most accomplished versions of the subject and is in an excellent state of preservation. Apart from Christ's missing right index finger, the carving and polychromy are intact. Signed and dated 1673 on Christ's loincloth, the sculpture was made in Málaga, where Mena spent most of his career; it was later sent to the royal convent of the discalced Franciscan nuns in Madrid, where it remains today.

Mena's use of the half-length format was derived from the half-length Netherlandish painted diptych type (see cat. 21), but a more contemporary source that Mena may well have seen was a widely circulated print of Christ as the Man of Sorrows after a painting by Anthony van Dyck (fig. 100). In the hands of the printmaker Lucas Vorsterman the Younger, Van Dyck's beautiful and unblemished Christ is transformed into a tortured figure whose body is barely visible beneath the scratches and beatings he has suffered. Mena's Christ is similarly tortured, his body scarred and bloody, an effect that is achieved through an extraordinarily expressive use of polychromy. The pose of Christ is not unlike that of the figure of Christ in the print, whose bound hands are held out elegantly before him as he turns his head to the right. In the print Christ is turning away because he is recoiling from an aggressor, but in the sculpture Christ confronts us directly with the horror of the story.

Mena belonged to a generation of sculptors who both carved and painted their own pieces. A noticeable development from sculptors such as Montañes and Mesa was the manner in which Mena animates the piece of wood he sculpts, so that Christ appears to be enacting the religious drama through an increased sense of movement. As the viewer, one is encouraged to walk around the sculpture and indeed Christ's back is as skilfully painted as the front.

The polychromy of the *Christ as the Man of Sorrows* is truly remarkable: the way Mena suggests the purple bruising beneath the skin and the rivulets of blood which trickle down his body to be soaked up by the loincloth around his waist is

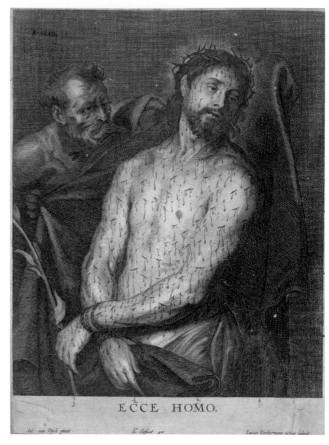

100 Lucas Vorsterman the Younger (1624–1666)
after Anthony van Dyck (1599–1641)
Ecce Homo (*Christ as the Man of Sorrows*)
Engraving, 28.8 x 20.9
Kupferstichkabinett der Akademie der bildenden Künste, Vienna
(AbK 18295)

extremely skilful. Glass eyes have been inserted into the eye sockets and real hair used for the eyelashes. The half-open mouth reveals a set of ivory or bone teeth.

It is very likely that this Christ was originally paired with a companion piece, and still surviving in the Descalzas Reales is a *Virgin of Sorrows* by Mena. The Virgin's hands are clasped together in front of her in sorrow or pain, and her eyes raised heavenwards; she wears a voluminous blue mantle and is

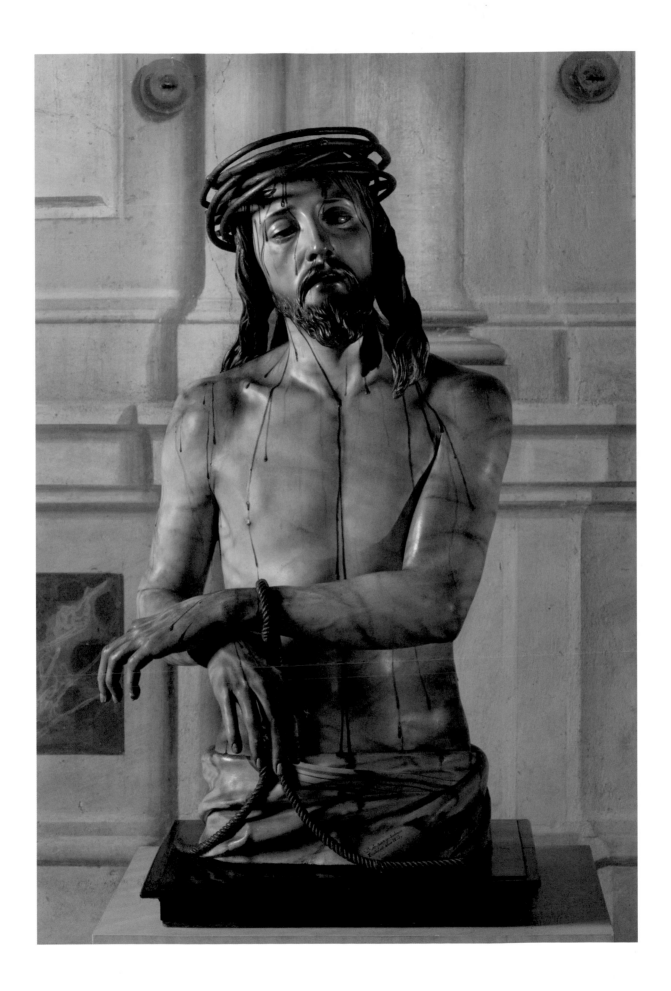

similarly half-length in format.[1] There is an almost identical autograph copy of the two sculptures, dated 1674, in the parish church of Budia, a town near Guadalajara (Spain), which further suggests that they were originally paired.[2] How they entered the collections of the Descalzas Reales is not clear but it has recently been suggested that they may have been commissioned and given to the convent by Philip IV's illegitimate son, Don Juan José de Austria (1629–1679), who is known to have owned two carvings by Mena, one of a Christ crowned with Thorns and the other of his Sorrowing Mother ('Un Christo Coronado de espina bañado en sangre y Su Dolorida Madre').[3]

XB

SELECT BIBLIOGRAPHY
Orueta y Duarte 1914, pp. 210–11; Junquera de Vega and Ruíz Alcón 1961, p. 27; Souto 1983, pp. 21–9; Málaga 1989, cat. no. 33, p. 222; Anderson 1998, no. 20, p. 90; Gila Medina 2007, pp. 187–8

NOTES
1 Málaga 1989, cat. no. 34, pp. 224–5.
2 Souto 1983, pp. 21–9.
3 See González Asenjo 2005, p. 434.

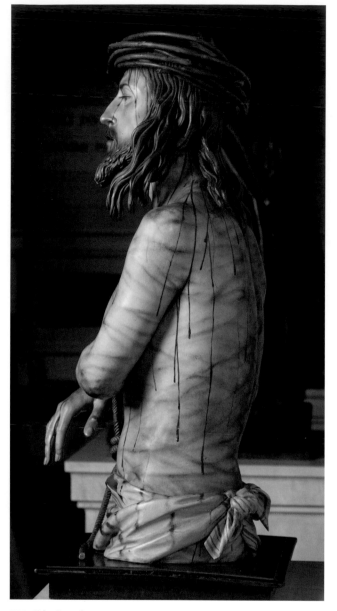

101 Side view of cat. 20

102 Detail of cat. 20

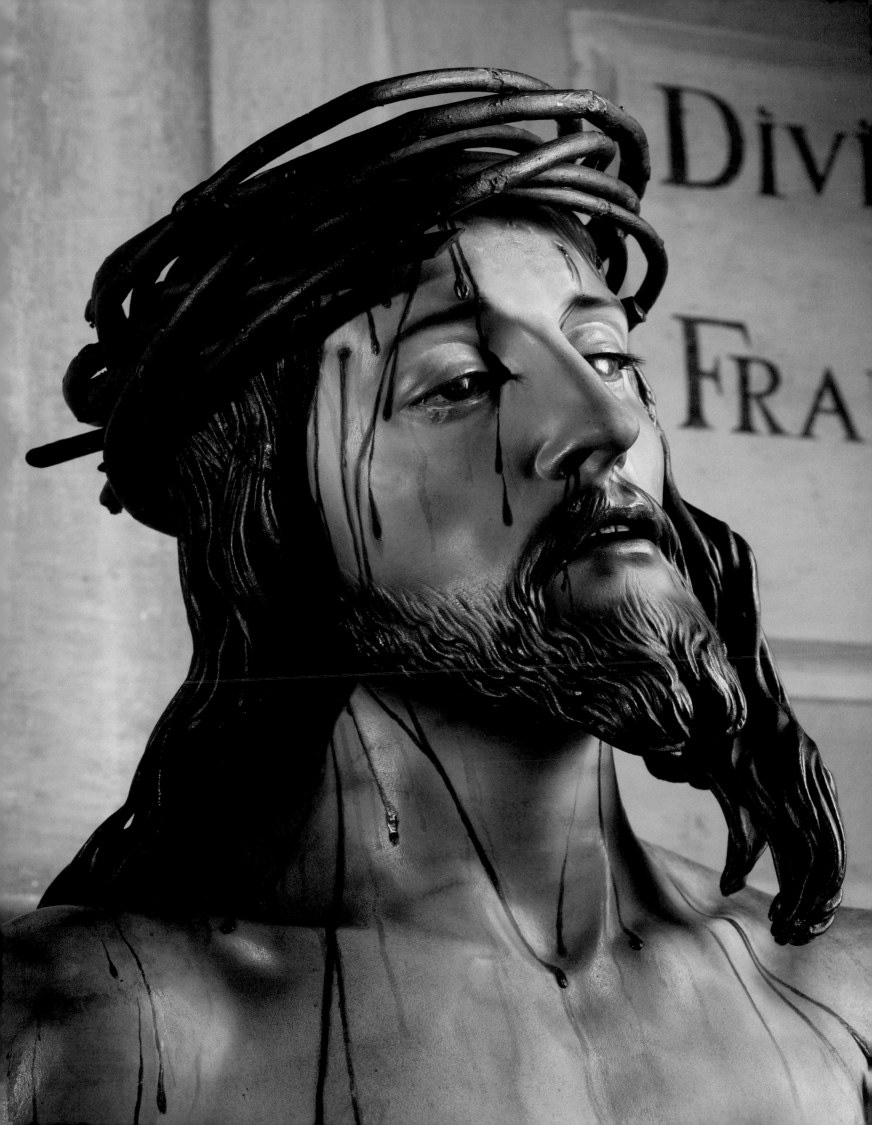

21a & 21b Pedro de Mena (1628–1688)

The Virgin of Sorrows (Mater Dolorosa), about 1670–5

Polychromed wood (probably pine), 62.2 x 49 x 29 cm
Church and Sanctuary of Santa Maria de la Victoria, Málaga

The Virgin of Sorrows (Mater Dolorosa), about 1673

Polychromed wood, 74 x 73.5 x 48.5 cm
Museo del Monasterio Real de San Joaquín y Santa Ana, Valladolid

Pedro de Mena's highly expressive sculptures of the *Virgin of Sorrows* were extremely popular and much in demand in his lifetime. Often conceived as companion pieces to sculptures of Christ as the Man of Sorrows (see cat. 20), numerous examples by Mena and his workshop can be found throughout Spain, and some were even exported as far afield as Austria and Mexico.[1] Mena successfully adapted the popular devotional diptych format that was explored in the Netherlands by such artists as Dirk Bouts (figs 103 and 104), and transformed it into sculptural form.

Mena chose the half-length or bust format to invite intimacy and maximise the emotional intensity of the work. The figures are often life-size, so that the viewer seems to interact directly with them. Although the sculptures were sometimes exhibited in separate glass cases, other examples were placed on either side of an altar looking across at each other. Mena himself was to specify in his will that his autograph sculptures of the Virgin and Christ should be displayed in this way in his burial chapel in the Cistercian convent in Málaga.[2]

In the present works, the Virgin's hands are tightly clasped together to communicate her anguish and her parted lips give the impression that she is uttering a cry of lament. The wafer-thin pieces of wood that make up her blue headdress – all of which were separately carved and then slotted on top of each other – and the inner white veil made of plastered canvas laid on to wood protect as well as frame her face. When seen from

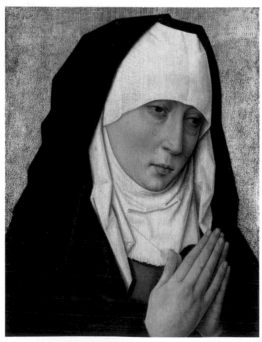

103 Workshop of Dirk Bouts (1400?–1475)
Mater Dolorosa, probably about 1470–5
Oil on oak, 36.8 x 27.9 cm
The National Gallery, London (NG 711)

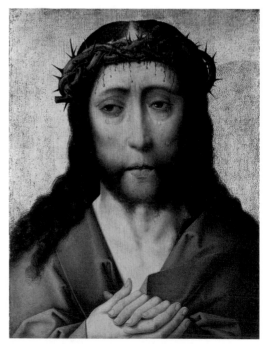

104 Workshop of Dirk Bouts (1400?–1475)
Christ Crowned with Thorns, probably about 1470–5
Oil on oak, 36.8 x 27.9 cm
The National Gallery, London (NG 712)

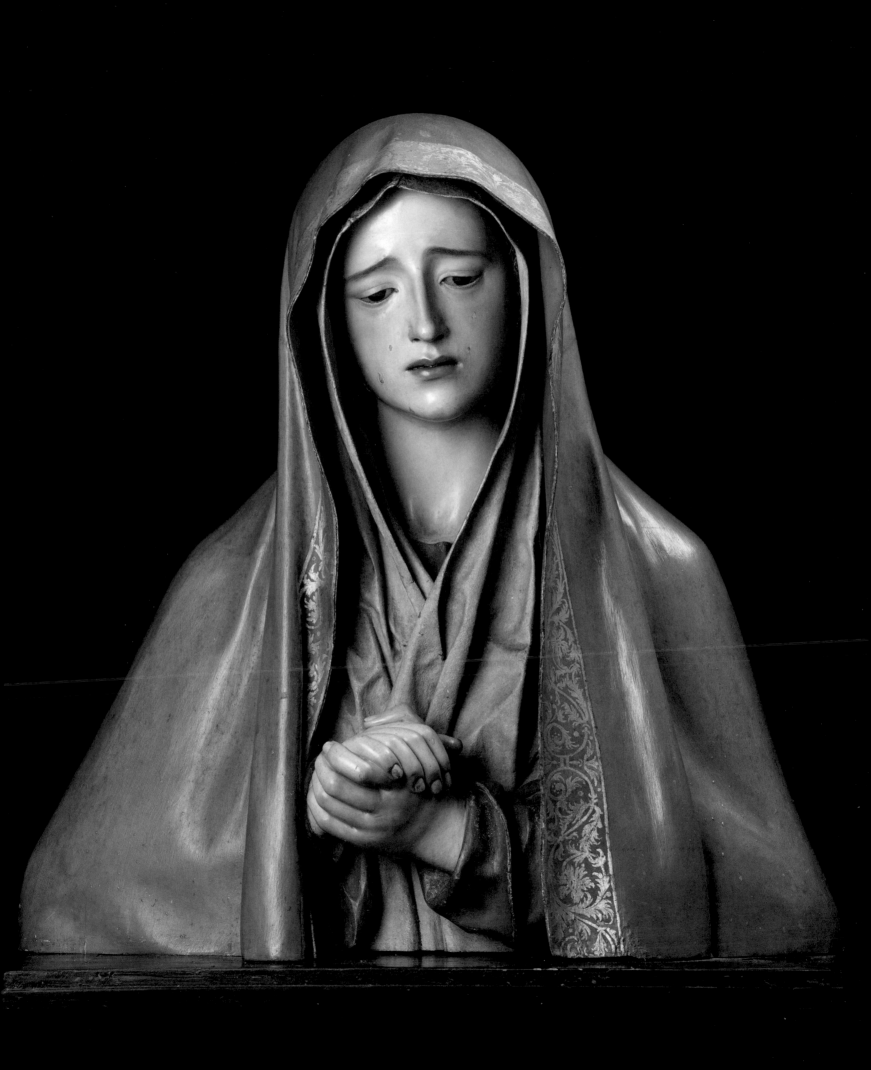

the back or from the side, this outer blue drapery produces simple and abstract shapes and completely conceals her face. It is only when we look at her directly that we engage with her.

The excellent preservation of the polychromy in both sculptures allows us to appreciate Mena's remarkable skill at capturing the variations of skin tones, such as the way the Virgin's tears affect the tone of her skin between her eye sockets and nose, as well as her cheeks. It is not just the sculptural form that expresses pain, but the colour of her flesh, blotched and tired. The eyebrows are painted on, using thin brushstrokes to delineate every single hair.

Remnants of the pathway of her tears, probably made out of animal glue or resin, are also visible. The glass tears, originally glued on, have fallen off in the Málaga version, but one remains on the Valladolid version. The tears would once have caught the light, which would have made them seem all the more naturalistic. Real hair for the eyelashes was inserted into the eyelids, and ivory teeth and glass eyes were glued into position inside the hollowed-out wooden face.

The Málaga *Virgin of Sorrows* is almost certainly the 'señora de la Angustias' listed in the collection of Antonio Manrique de Lara, the Count of Mollina y Frigiliana.[3] A knight of Santiago, he was also the deputy mayor of Málaga and appears to have been an important social contact and patron for Mena. His 1688

inventory lists five sculptures by the artist, among them this 'Lady of Sorrows' which was given by his niece to the family burial chapel in what is today the Church and Sanctuary of Santa María de la Victoria, outside Málaga's city walls. How the version in the convent of San Joaquín y Santa Ana came to Valladolid is not known, but the fact that the nuns there were Cistercians and that Mena had a special link with the Cistercian convent in Málaga may suggest that the sculpture was sent from Málaga to Valladolid at some time.

XB

CAT. 21A SELECT BIBLIOGRAPHY
Orueta y Duarte 1914, p. 187; Anderson 1998, pp. 150–1; Málaga 1989, pp. 104–5 and cat. 37, pp. 230–1; Gila Medina 2007, p. 193; Seville 2007, pp. 372–3

CAT. 21B SELECT BIBLIOGRAPHY
Valladolid 1989–90, cat. 17, p. 34

NOTES
1 A *Virgin of Sorrows* by Mena can be found for example in the Dreifaltigkeitskirche in Vienna, Austria (see Aurenhammer 1954, pp. 111–28, and Richter, Schäfer and van Loon 2005, p. 225). For works by Mena in Mexico see Angulo Iñiguez 1935, pp. 131–49.
2 For Mena's will see Málaga 1989, p. 300: 1 December 1679: 'Enterramiento en el convento de las Monjas Recoletas de las Descalzas del Cister, en la Iglesia Nueva, en la Capilla de Ecce Homo, o en la de la Dolorosa, realizadas por él, en los colaterales del Altar Mayor.'
3 See Romero Torres in Málaga 1989, pp. 104–5.

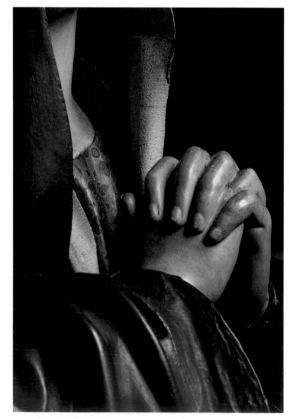

105 Detail of cat. 21a

106 Detail of cat. 21b

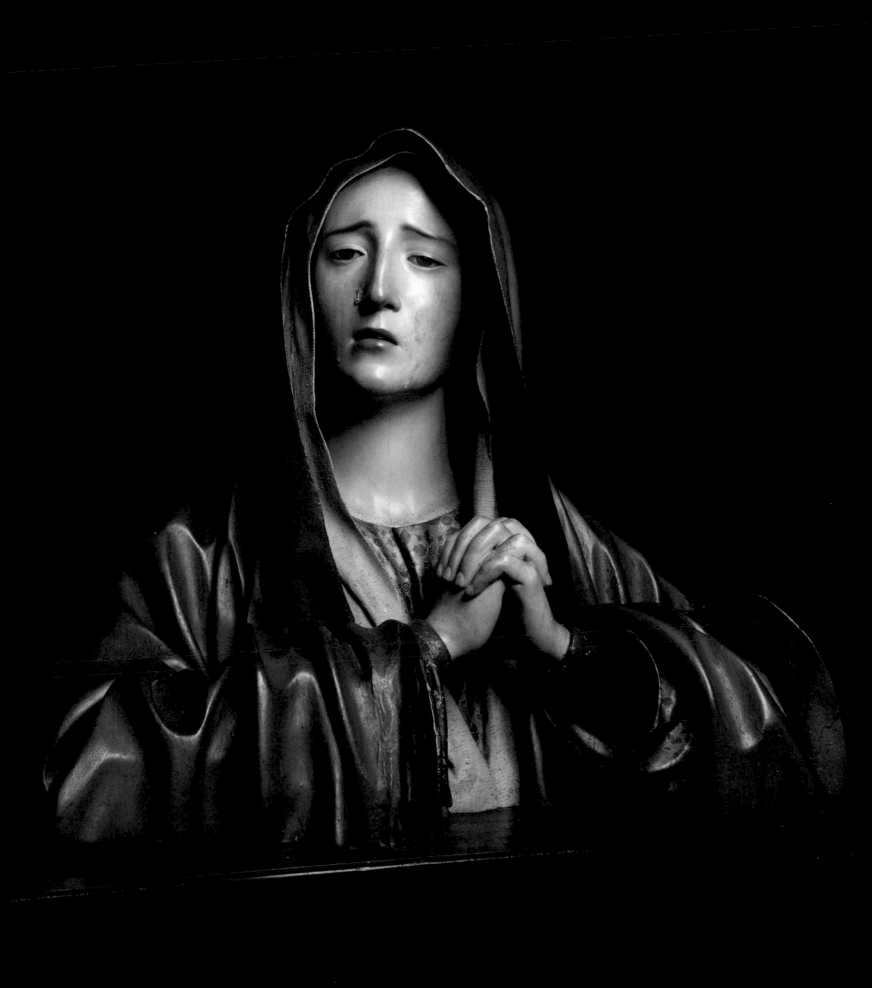

22　José de Mora (1642–1724)

The Virgin of Sorrows (Mater Dolorosa), about 1680–1700

Painted pine 48.5 x 49 x 29 cm
Victoria and Albert Museum, London (1284-1871)

During the seventeenth and early eighteenth centuries busts of the sorrowing Virgin (*Dolorosas*) were widely produced in Spain (see also cats 21 a and b). As well as recalling fifteenth-century Netherlandish devotional paintings, they are also reminiscent of reliquary busts, which would have been placed on side altars and which contained relics of the saints. They are often to be seen in churches and convents throughout the Iberian peninsula, especially in Andalusia.

This bust is ingeniously constructed from separate pieces of pine, with eyes probably made of glass, and teeth of ivory. It has not been possible to ascertain whether the eyes are indeed of glass; they may be painted ivory. The ringlets of hair are made of corkscrews of wood-shavings. Some of the original colour of the sculpture has been lost: the robe would almost certainly have once had an olive-green lustre, its sheen enhanced by gold powder. The blue veil would also have once been more luminous; powdered blue frit (a type of glass) was probably applied to it with a brush. Traces of tears might well have been visible on the cheeks; these have now been lost. Nevertheless, despite the changes wrought by time, the simple power of this piece is still apparent. The strength of feeling is seen in the fine rendering of the Virgin's mournful expression, and the piece's mimetic qualities are evident in the virtuoso carving of the crumpled veil. The bust exemplifies how Spanish artists could convey intense emotion and religious power through seemingly plain naturalistic forms.

Although the work was formerly attributed to Pedro de Mena, the style is unmistakeably that of José de Mora, who was a generation younger than Pedro de Mena. José de Mora specialised in devotional painted wood sculptures, the most celebrated of which was a full-length *Virgin of Sorrows*, installed in the church of Santa Ana in Granada in 1671. A contemporary chronicler recorded that it was taken through the streets of the city to be installed there at midnight, accompanied by a devout congregation holding torches, and that it miraculously healed a gravely ill woman as it passed by her house.

MT

SELECT BIBLIOGRAPHY
Trusted 1996, cat. no. 46, pp. 103–6 (with earlier literature); Trusted 1997, pp. 55–7; London 2009, cat. no. 126 and plate 4.50

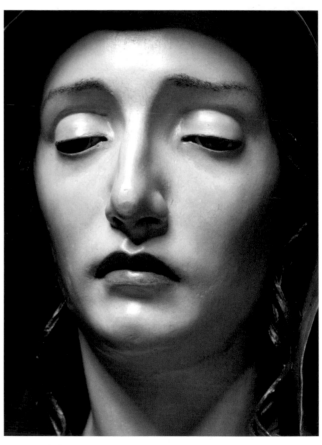

107　Detail of cat. 107

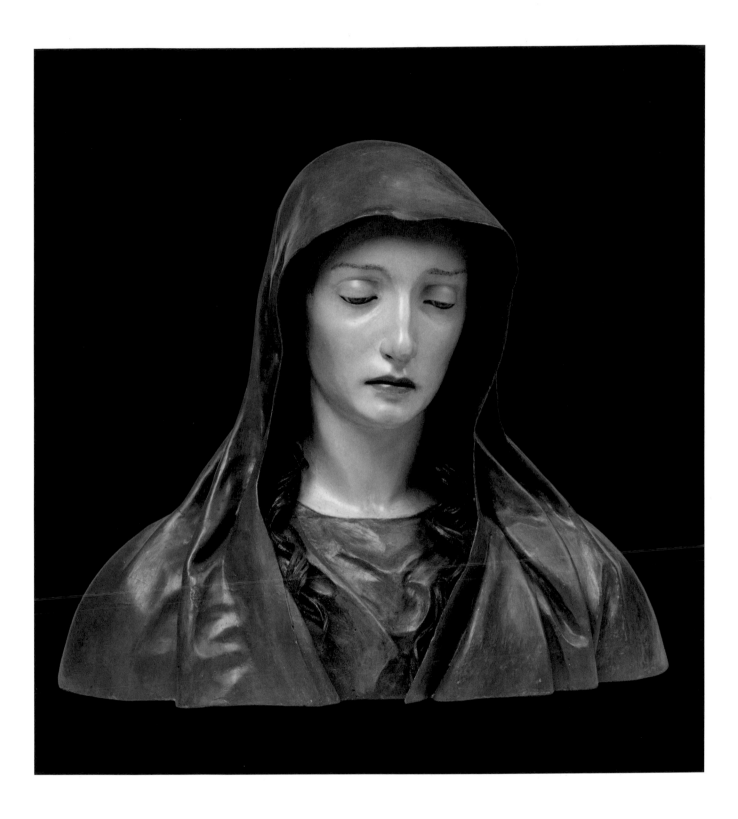

23 Pedro de Mena (1628–1688)

Mary Magdalene meditating on the Crucifixion, 1664

Polychromed cedar and glass, 171 x 52 x 61 cm
Signed and dated on small ornamental plaques on the base: *Faciebat, anno 1664* (right side),
Petrus D Mena y medrano (front), and *Granatensis, Malace* (left side).
Museo Nacional del Prado, Madrid (E-577). On long loan to the Museo Nacional Colegio de San Gregorio, Valladolid

This sculpture, which is slightly larger than life, was made in 1664 for the Jesuit house (Casa Profesa) in Madrid and is one of Mena's masterpieces. The Magdalen is shown as if in a moment of intense prayer before the crucifix she holds in her left hand. She steps forwards in a dynamic pose, her right hand clasped to her breast, her mouth open as if gasping for breath, overwhelmed by the empathy she feels for Christ's suffering. Mena's ability to animate his figures as if they are enacting a role is one of his most intriguing qualities as a sculptor. She is dressed in a long coat of coarsely woven rushes with a knotted belt tied around her waist. Her arms are bare and her hair falls to her waist, evoking her femininity.

Technically this sculpture is one of Mena's most proficient works. For the Magdalen's long flowing hair, the *tour de force* of Mena's sculpture, he used several strands of twisted wicker which were tacked with nails to the upper part of her scalp (carved as part of her head). These were covered with gesso and then painted with a rich chestnut colour. Like his *Virgin of Sorrows* and *Ecce Homo* (cats 20 and 21a and b), the flesh tones are remarkably naturalistic. In this case, however, because her anguish is so internalised, no tears have yet blemished the Magdalen's pale skin. The crucifix she holds was carved separately and can be removed. X-radio-graphs of Mena's sculpture have revealed that the main body of the figure was created from a column of wood, whose lower part was hollowed out (fig. 110). It was to this column that Mena attached the separately carved 'body' parts using animal glue and long nails measuring between 8 and 13.5 cm.[1] The arms and feet were nailed on to the main body and to the base, while the head and shoulders, which were also carved separately, were hollowed out and then placed within the main structure. The face was temporarily removed so that glass eyes and teeth could be inserted, and then reattached.

When Mena travelled to Toledo in 1663 to carve his celebrated *Saint Francis standing in Ecstasy* for the cathedral (cat. 33), he very likely visited Madrid, possibly with the object of petitioning the king for a position as court sculptor. It was probably at this date that Mena received this commission from the Jesuits in Madrid and it is likely that during his visit he also saw an earlier sculpture of the penitent Magdalen, dated to the 1620s, in the royal monastery of the Descalzas Reales, which has been tentatively attributed to Gregorio Fernández (fig. 108).[2] Although both pieces are similar in pose, the naturalism with which Mena endows his work takes painted sculpture on to another level of reality. Indeed, Mena's sculpture was so admired by contemporaries that the court poet Francisco Antonio Bances Candamo wrote a eulogy to it, praising Mena's ability to transform matter into a seemingly living form.[3]

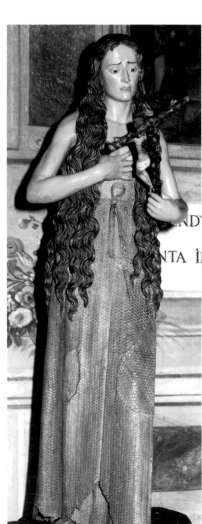

108 Attributed to Gregorio Fernández (1576–1636) *Penitent Magdalen*, 1620s Polychromed wood, life-size Real Monasterio de las Descalzas Reales, Patrimonio Nacional, Madrid

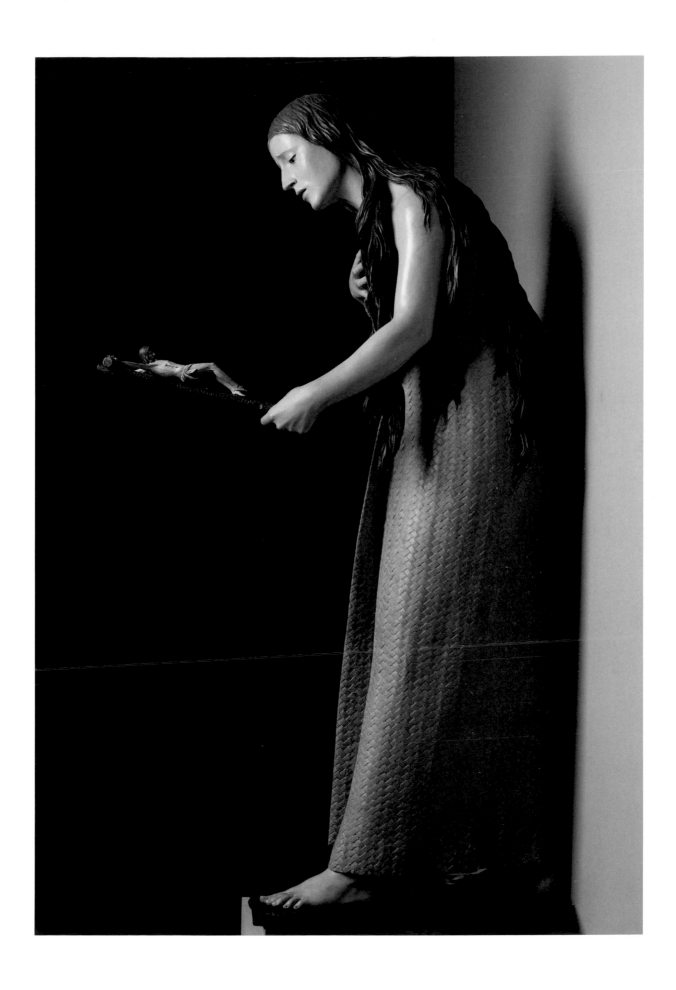

The several workshop copies after Mena's sculpture,[4] and the fact that other examples by him appear in seventeenth-century private collections, confirm that Mena's Magdalen was recognised early on as a masterpiece of polychrome sculpture.[5]

It is not known how the Jesuits exhibited Mena's *Mary Magdalene* in the Casa Profesa before it was confiscated following their expulsion from the Spanish territories in 1767. Although it can be admired in the round, it may have been set on an altar and seen from the front. Other seventeenth-century examples that survive, however, such as the one in the church of Santa Magdalena in Granada, or the copy of the present work in the ex-Jesuit church of San Miguel in Valladolid (fig. 109), show her standing in a chapel that has been turned into a grotto, so that the faithful can pray to her in a carefully staged atmosphere of penitence.

XB

SELECT BIBLIOGRAPHY
Palomino 1715–24 (1987), p. 316; Vega 1910, pp. 25–7; Orueta y Duarte 1914, pp. 176–82; Mélida 1928, n.p.; Málaga 1989, cat. no. 30, p. 216; Valladolid 1989–90, cat. no. 14, p. 48; Portús Pérez 1990; Garrido 1992, pp. 42–5; Anderson 1998, no. 10, pp. 81–2; Gila Medina 2007, pp. 123–5

NOTES
1 Garrido 1992, pp. 42–5.
2 María Elena Gómez-Moreno supports the attribution to Fernández (see Gómez-Moreno 1963, p.74), while Martin Gonzalez 1980, p. 279, does not.
3 See Portús Pérez 1990.
4 One of these can be found in the ex-Jesuit church of San Miguel, Valladolid. For additional examples see Valladolid 1989, cat 28, pp. 76–7. Palomino also mentions that Mena made a smaller version of his sculpture for the chapel of Saint Gertrude in the church of San Martín, Madrid. See Palomino 1715–24 (1987), p. 316.
5 In an inventory made of the collection of the Condesa de Villaumbrosa in 1702: 'una Magdalena en su urna de ébano, hechura de Pedro de Mena' See Agulló y Cobo 1978, p. 16.

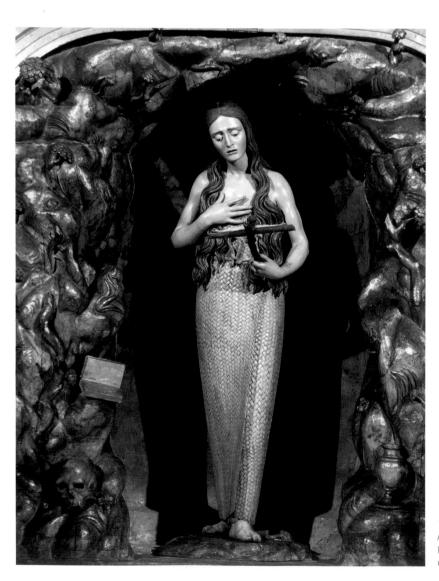

109 After Pedro de Mena (1628–1688)
Mary Magdalene meditating on the Crucifixion, late 1660s
Polychromed wood, life-size
Church of San Miguel, Valladolid

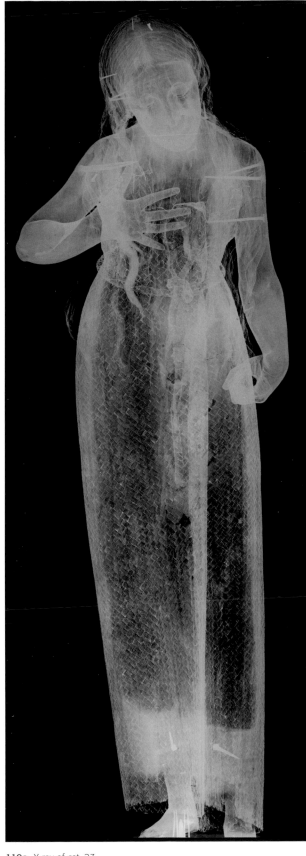

110a X-ray of cat. 23

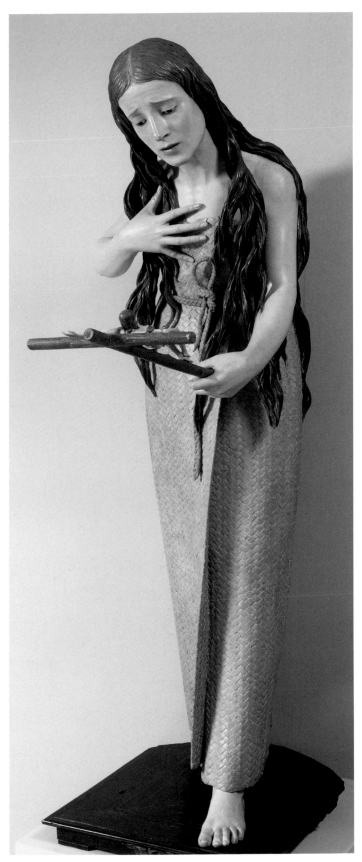

110b Front view of cat. 23

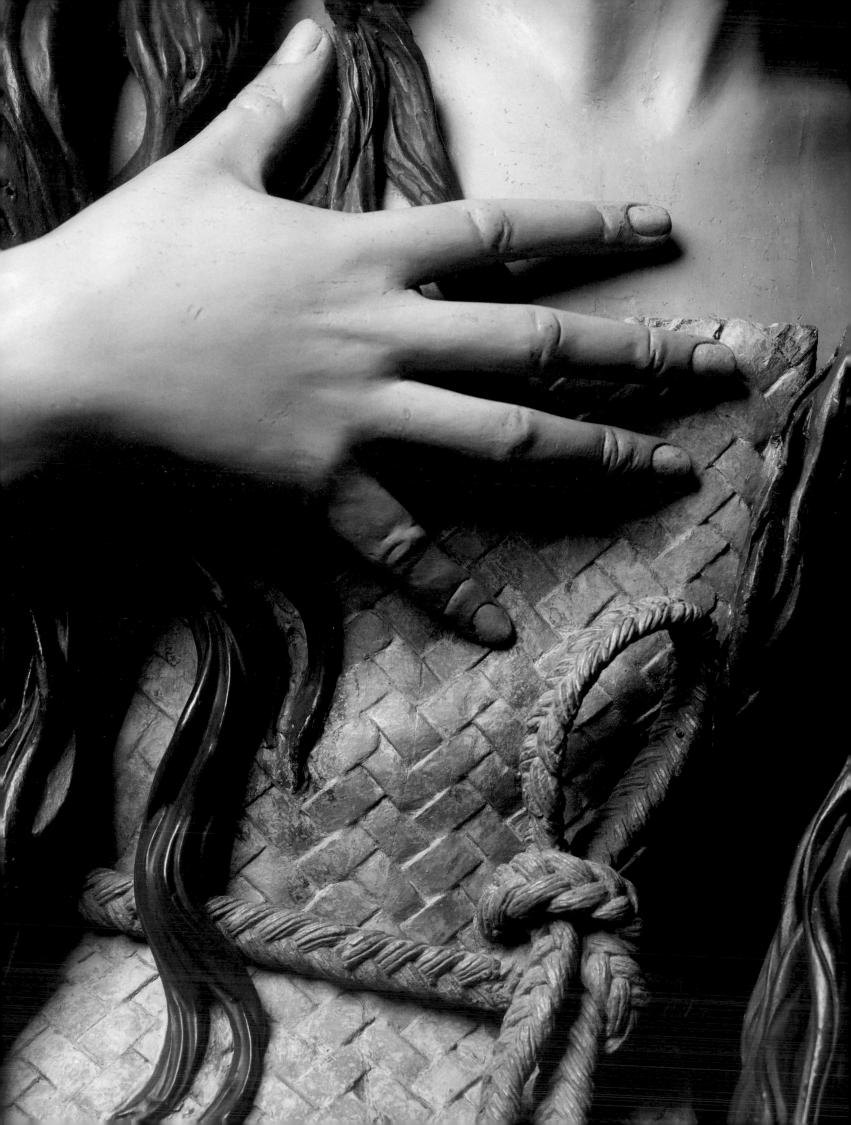

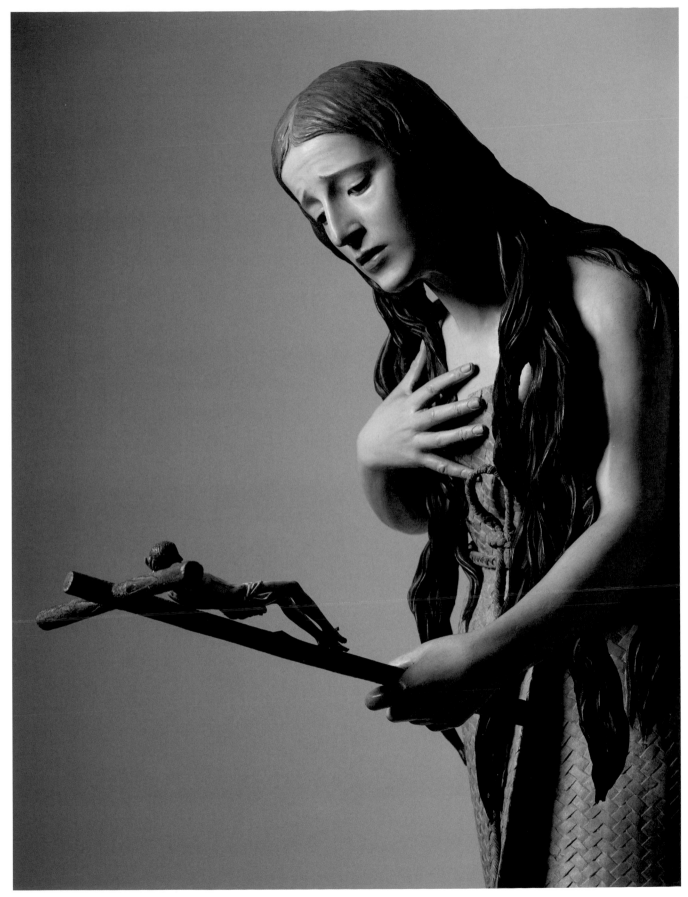

111 and 112 Details of cat. 23

24 Juan Martínez Montañés (1568–1649) and unknown polychromer
Christ on the Cross ('Cristo de los Desamparados'), 1617

Polychromed wood, 185 x 160 x 46 cm
Iglesia Conventual del Santo Ángel, Carmelitas Descalzos, Seville

Juan Martínez Montañés produced several versions of the *Christ on the Cross* throughout his career, the most celebrated being the *Christ of Clemency* which was made in 1603 for the private chapel of the archdeacon of Carmona, Mateo Vázquez de Leca (see fig. 20). On the strength of its fame, Montañés was commissioned to execute a number of other Crucifixions – even dispatching one to Lima, Peru – of which the present work is among the most accomplished. It was commissioned in 1617 by the Discalced Carmelite monks for their church of the Santo Ángel in Seville, where it still hangs today.

Unlike the *Christ of Clemency*, where Christ is represented still alive in the final moments before his death, Montañés here presents Christ in the more traditional way, with life having been drained out of him, and his skin porcelain white. Blood from the wound in his side has already begun to congeal. A long strand of hair has escaped from his crown of thorns and falls down the right side of his face – a motif that Montañés also used in the *Christ of Clemency*.

The carving is particularly refined, especially the classical proportions of Christ's slender form and the magnificent swathe of white drapery around his waist. Known in Spanish as the *paño de pureza* ('cloth of purity'), Christ's loincloth has a life of its own. Large and voluminous, it has been wrapped twice round his waist and tied into a loose knot to one side. The endless creases of its folds are testimony to Montañés's skill as a sculptor and to his nickname, *el dios de la madera* – the god of wood.

An X-radiograph of this sculpture, which has recently been restored and cleaned,[1] revealed how different pieces of wood, separately carved and hollowed, were joined together using animal glue and nails (fig. 113). While most of the joins were carefully concealed by the gesso and paint applied on top of the wood, some, like those that link the arms to the shoulders, are still visible. To prevent the wood from warping and breaking, sculptures like this were often hollowed out. This meant that even life-size figures weighed relatively little, around 25–30 kilos, a bearable load for processing through the streets during

113 X-ray of cat. 24

Holy Week.[2] This sculpture, like the *Christ of Clemency*, however, was probably commissioned for an altar in one of the chapels that adjoined the Carmelite convent.[3]

XB

SELECT BIBLIOGRAPHY
Proske 1967, pp. 89–90; Hernández Díaz 1987, pp. 171, 174 and 177; Córdoba–Seville 2001–2, no. 52, pp. 142–3

NOTES
1 The sculpture was restored by the Instituto Andaluz del Patrimonio Histórico in 2007.
2 I am grateful to the restorers at the Instituto for this information and for supplying us with an X-radiograph of this work.
3 Seville 2001–2, no. 52, pp. 142–3, mentions that in the nineteenth century it hung in the second chapel on the right as one faces the altar.

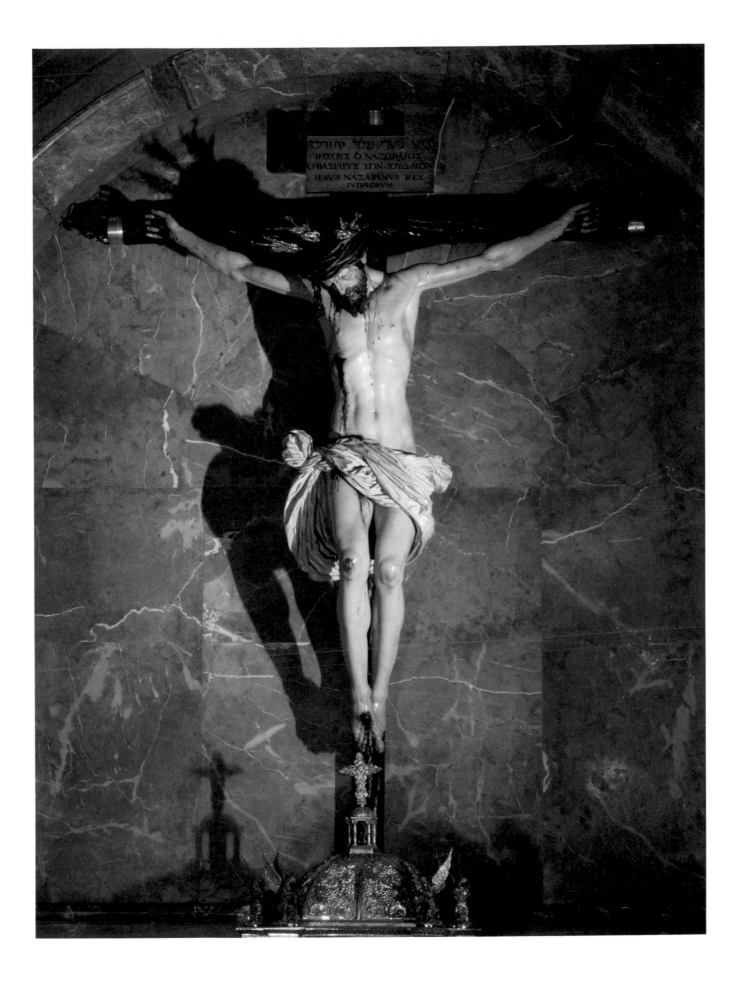

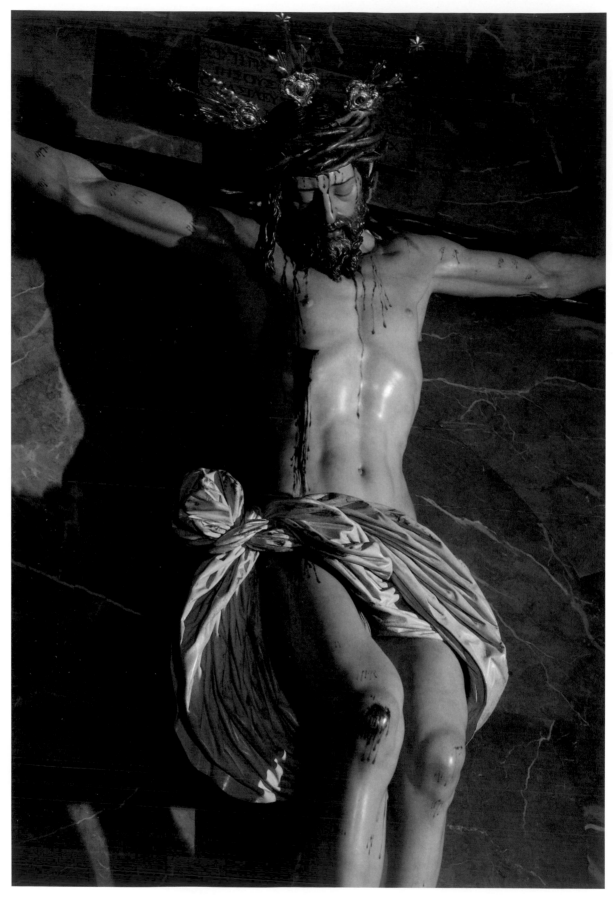

114 and 115 Details of cat. 24

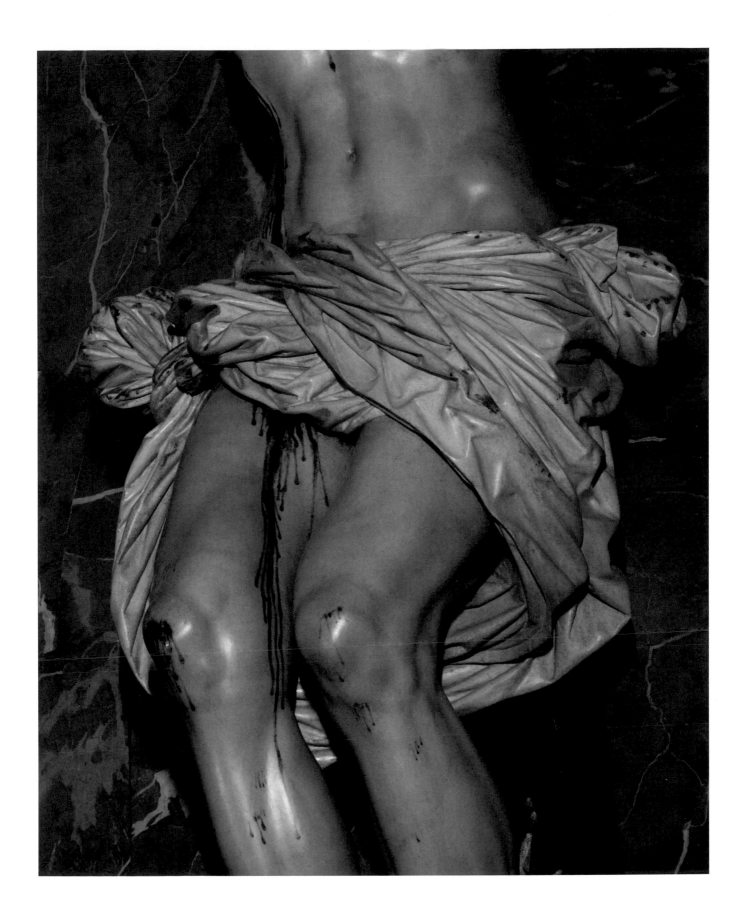

25 Francisco de Zurbarán (1598–1664)

Christ on the Cross, 1627

Oil on canvas, 290.3 x 165.5 cm
Signed and dated on the scrap of paper at the foot of the cross: *Franco Dezur fa [t?] 1627*
The Art Institute of Chicago. Robert A. Waller Memorial Fund (1954.15)

Zurbarán painted this *Christ on the Cross* in 1627 for the Dominican friary of San Pablo el Real in Seville. It originally hung in an arched alcove above an altar in a chapel in the sacristy of the church, a relatively small space (measuring 5.5 by 3.75 metres) which it would have dominated (fig. 19).[1] When the Spanish art historian and painter Antonio Palomino (1653–1726) visited the chapel he wrote: 'there is a crucifix from his [Zurbarán's] hand which is shown behind a grille of the chapel (which has little light), and everyone who sees it and does not know believes it to be sculpture.'[2]

Nailed to a rough-hewn cross, Christ's lifeless body emerges from the impenetrable blackness behind, illuminated by bright light. The scene is entirely devoid of narrative detail and so the viewer is forced to focus his attention on the subject presented. Depicted with an extraordinary attention to detail, Zurbarán's painting takes the illusion of reality to a new level: it is as though the sacrifice of Christ is taking place right in front of us. The palms of Christ's hands and his feet, punctuated by four nails, have begun to turn a bluish grey and his face too, with eyes closed, is grey.[3] The way in which the light catches the loincloth around his waist is a masterpiece of painting; each crease is meticulously depicted, a complex arrangement of crisp folds onto which light falls and shadow is cast.

Zurbarán was highly skilled at working within real architectural space. The two windows on the right-hand side of the chapel provided natural light that would have illuminated the painting from the right side, an effect that was then mirrored by Zurbarán within the painting. This blend of natural and artificial light would have compounded the question of what was real and what was an illusion, a game that Zurbarán plays throughout. His signature, on a white piece of paper, is attached to the foot of the cross, and so convincing is the portrayal that for a moment we question whether the paper is stuck to the wood of the cross or on to the picture itself.

Whether or not Zurbarán was modelling his painting directly on a sculpture, he certainly demonstrates an acute awareness of how sculpture works in space. The illusion that Palomino remarked upon was a conceit that Zurbarán may well have intended. We know he painted sculpture, and he may even have carved a Crucifixion himself at the beginning of his career (see pp. 18 and 80), but in this work he produces a convincing painterly illusion of a three-dimensional Christ crucified. This is ultimately achieved with a level of realism and skill that glorified his prowess as a painter. Of all the painters of the period, it was Zurbarán who evolved most completely a sculptural style, and this work is perhaps the greatest testimony to his powers.

XB

SELECT BIBLIOGRAPHY
Palomino 1715–24 (1987), pp. 184–5; Milicua 1953, pp. 177–86; Soria 1955, pp. 48–9; Guinard 1960, no. 90; New York 1987, cat. 2, pp. 76–9; Brown 1991c, p. 54

NOTES
1 For a full provenance see New York 1987, cat. no. 2, pp. 76–9.
2 Palomino 1715–24, III, p. 275: 'En la sacristía del Convento de San Pablo . . . hay un Crucifijo de su mano que la muestran cerrada la reja de la capilla (que tiene poca luz), y todos los que lo ven, y no lo saben, creen ser de escultura.'
3 Zurbarán's use of four nails may reflect his knowledge of Francisco Pacheco's earlier version of the subject. See cat. 2.

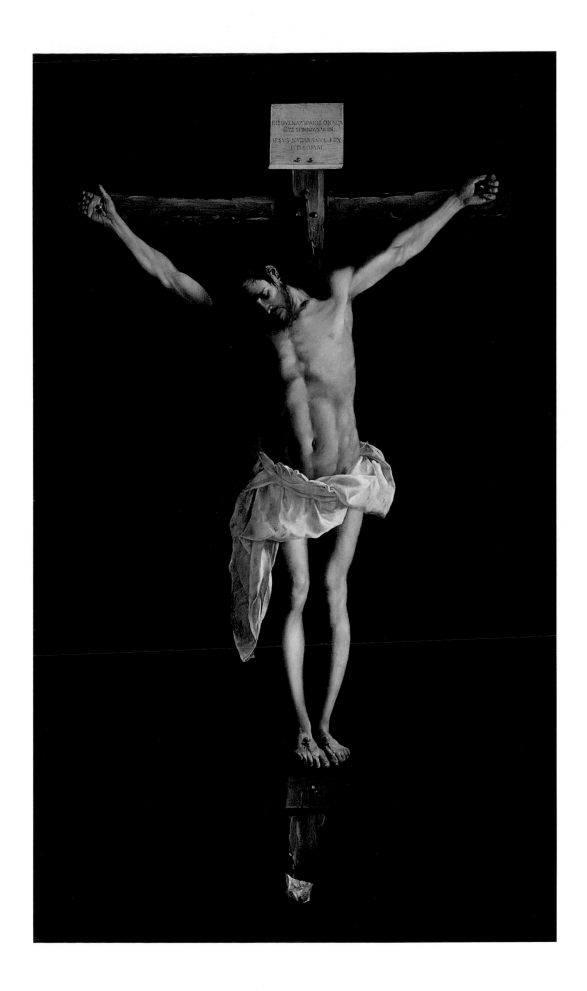

26 Francisco Ribalta (1565–1628)

Christ embracing Saint Bernard of Clairvaux, about 1624–7

Oil on canvas, 158 x 113 cm
Museo Nacional del Prado, Madrid (P-2804)

The practice of praying in front of sculptures and paintings, especially those depicting Christ and the Virgin, led some religious figures to experience a mystical union with them (see cat. 10). Saint Catherine of Siena, for example, received the stigmata from a medieval painted crucifix, while Saint Bernard reputedly received Christ into his arms after praying before a sculpture of Christ on the cross. It is this vision of Saint Bernard's which is represented here by Ribalta, who was probably inspired by the account that the Jesuit historian Pedro de Ribadeneyra (1526–1611) provided in his 1599 edition of the lives of the saints: 'The Lord so cherished Saint Bernard that one day when the latter was kneeling before the Cross, the Crucified Christ stretched out his arm and lay it on him, embracing and stroking him most lovingly. Immersed in this ineffable gentleness and deep silence, he united with the Supreme Being in an extremely chaste embrace.'[1]

To communicate Saint Bernard's rapturous visionary state, Ribalta shows him with his eyes closed and a smile on his face. Having surrendered himself to Christ, Bernard's body has gone limp and Christ bends forwards to support him. What is remarkable is the way in which Christ has seemingly metamorphosed from a wooden sculpture into a living being. While Bernard's eyes are closed, Christ's are open and full of tenderness for the saint he embraces. The saint's body is swathed in white drapery whereas Christ is naked. The physicality of Christ is the most resonant and shocking aspect of the painting. His heroic and classical physique is bathed in a golden light as it emerges from the blackness behind.

We know Ribalta was affected by the paintings of Caravaggio because he made a reduced copy after a celebrated copy of Caravaggio's *Martyrdom of Saint Peter* in the Colegio de Corpus Christi in Valencia,[2] and his work has strong echoes of Caravaggio in the close-up format and dramatic lighting. However, he may also have seen a sculptural representation of the subject of Christ embracing Saint Bernard by Gregorio Fernández made in 1613–14 for the main altar of the monastery of the Huelgas Reales, in Valladolid (indeed, a close connection between the two is apparent when Fernández's sculpture is viewed from below; fig. 116).[3] Having travelled to Madrid around 1620, Ribalta may have studied Fernández's realistic and powerful polychrome sculptures and introduced their

116 Gregorio Fernández (about 1576–1636)
Detail of the main altar with *Christ embracing Saint Bernard*, 1613–14
Monastery of the Huelgas Reales, Valladolid

sense of physicality into his own composition.

Painted around 1624–7, Ribalta's painting is recorded as having been in the prior's cell at the Carthusian monastery of Porta Coeli near Valencia.[4] The remarkable parallel between the lives of Saint Bernard, abbot of Clairvaux, and Saint Bruno, the founder of the Carthusians, as well as their common desire to follow an ascetic path, may explain why Ribalta was commissioned to paint this subject.

XB

SELECT BIBLIOGRAPHY
Ponz 1779, Carta Septima, no. 7, p. 158; Kowal 1981, II, pp. 433–6; Valencia–Madrid 1987–8, cat. no. 41, p. 168; Benito Domenech 1988, cat. no. 22, p. 104; Geneva 1989, cat. no. 15, p. 44; Brown 1991b, p. 112; Stoichita 1995, pp. 159–60; Barcelona 2005–6, cat. no. 56, pp. 238–9; Benito Domenech in *Enciclopedia* 2006, vol. III, pp. 872–4

NOTES
1 Quoted in Stoichita 1995, pp. 152 and 159.
2 See Seville-Bilbao 2005–6, cat. 23, pp. 174–5. Ribalta's copy is in the Principe Pio di Savoia collection, Mombello.
3 Sánchez Cantón 1942b, p. 147. See also Martín González 1980, pp. 101–7, for the Fernández commission.
4 Ponz 1779, Carta Septima, no. 7, p. 158.

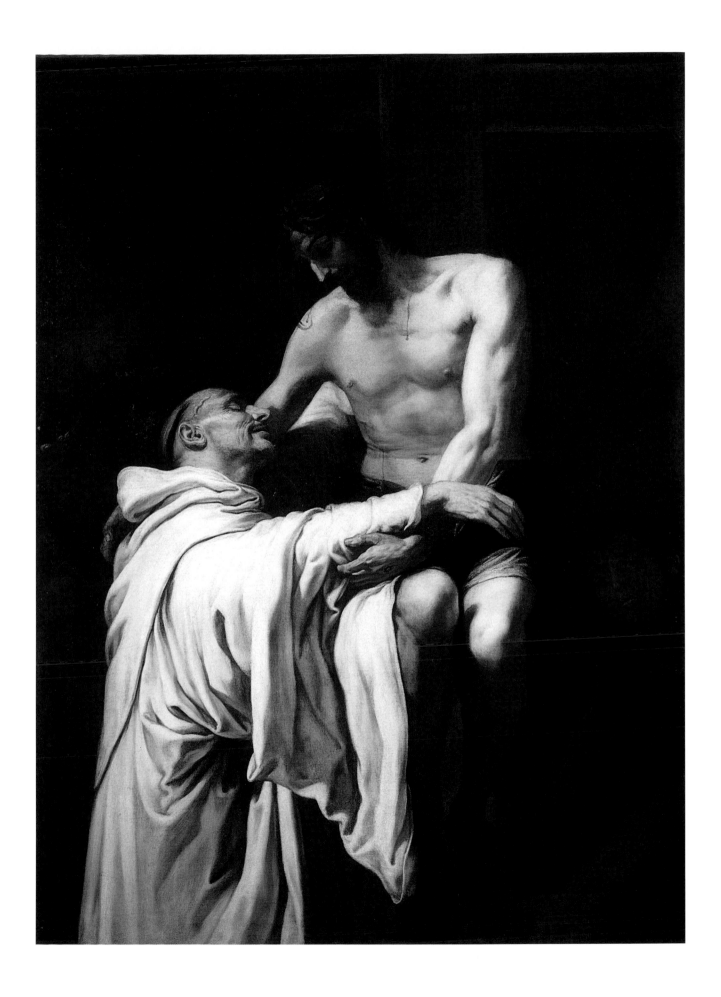

27 Gregorio Fernández (1576–1636) and unknown polychromer
Dead Christ, about 1625–30

Polychromed wood, horn, glass, bark, and ivory or bone, 46 x 191 x 74 cm
Museo Nacional del Prado, Madrid (E-576). On loan to the Museo Nacional Colegio de San Gregorio, Valladolid

Gregorio Fernández specialised in scenes of the Passion. His work was known for its gruesome and bloody nature, and often incorporated realistic touches such as we see in this *Dead Christ,* a commission he received towards the end of his career in 1625–30 from the Jesuits in Madrid.[1] The fingernails are made from the horn of a bull, the eyes are glass (see also cat. 33), and to simulate the effect of coagulating blood, the bark of a cork tree painted with red pastose paint was used. Fernández combined these realistic techniques with a great sensibility for the male nude, often with a strong classical vein (see cat. 18 and pp. 29–30).

Fernández was effectively responsible for bringing up to date the kind of imagery of the Passion which showed Christ completely devoid of life and laid out in state on a white cloth. It was a completely new type of realism that verged on the hyperreal. Earlier images of the Dead Christ, such as Gaspar de Becerra's *Dead Christ* of 1544, in the convent of the Descalzas Reales, in Madrid, were less realistic. Fernández's first versions, including the one commissioned by the Duke of Lerma in 1609 for the Dominican monastery of San Pablo, portray Christ in a classic heroic manner so that his body seems idealised. Later in his career, as this present example demonstrates, he opted for a very different approach.

Completely naked, apart from the loincloth, Christ's body is thin and angular. The softer and more rounded anatomy characteristic of Fernández's earlier pieces is replaced by the reality of bones pushing through flesh. Christ's eyes are expressionless. His mouth is half open, revealing a set of ivory or bone teeth. The polychromer (who is unfortunately not documented, although Fernández often worked with the Valladolid painter Valentín Diaz) skilfully captures the sense of life seeping out of Christ's body. The corpse has not yet been washed and prepared for burial, and blood still oozes from his wounds. His knees are grazed; his lips and toes have gone a bluish grey. By omitting the lamenting figures of the Virgin, Saint John the Evangelist and Mary Magdalene, Fernández invites us to focus on the pale and lifeless corpse, so that the viewer becomes the mourner.

Although we do not know how this particular *Dead Christ* was originally displayed, a glass case with a gilded frame was commissioned in 1629 by a Franciscan convent in Aránzazu, in Guipúzcoa (Basque country), into which was to be inserted their version of the sculpture.[2] This glass case was referred to as a '*tabernáculo*' and was placed beneath an altar, an appropriate location, given that the sacrifice of Christ was celebrated by the priest on the altar during the Mass.[3]

XB

SELECT BIBLIOGRAPHY
Palomino 1715–1724 (1987), p. 70; Gómez-Moreno 1953, n. 33, p. 38; Gómez-Moreno 1964, p. 49; Martin González 1980, pp. 197–8; Belda Navarro in *Enciclopedia* 2006, vol. III, pp. 879–81; Madrid 2007–8, cat. 23, pp. 320–1

NOTES
1 Palomino 1715–24 (1987), p. 70.
2 Madrid 1999–2000, p. 142.
3 Indeed, the Lerma Christ of 1609 has a small compartment in the chest into which a host is placed on Good Friday. See also Saint-Saëns 1995, pp. 66–7, and Mulcahy 2008, pp. 131–3.

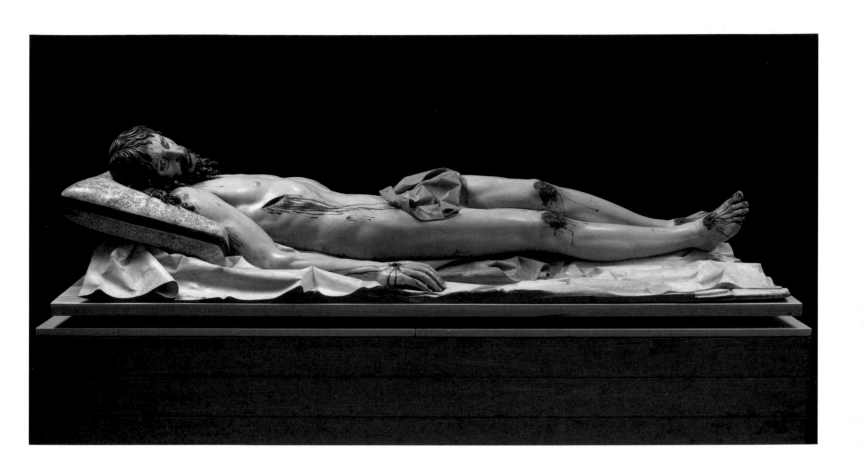

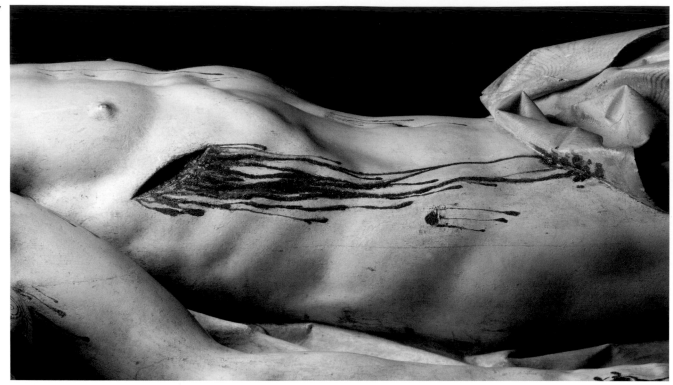

117–119 Details of cat. 27. The cloth is thinly painted in oils which reveal the wood grain beneath, resembling moiré silk. This effect probably owes more to the increased transparency of oil paint, with age, than to the artist's original intentions.

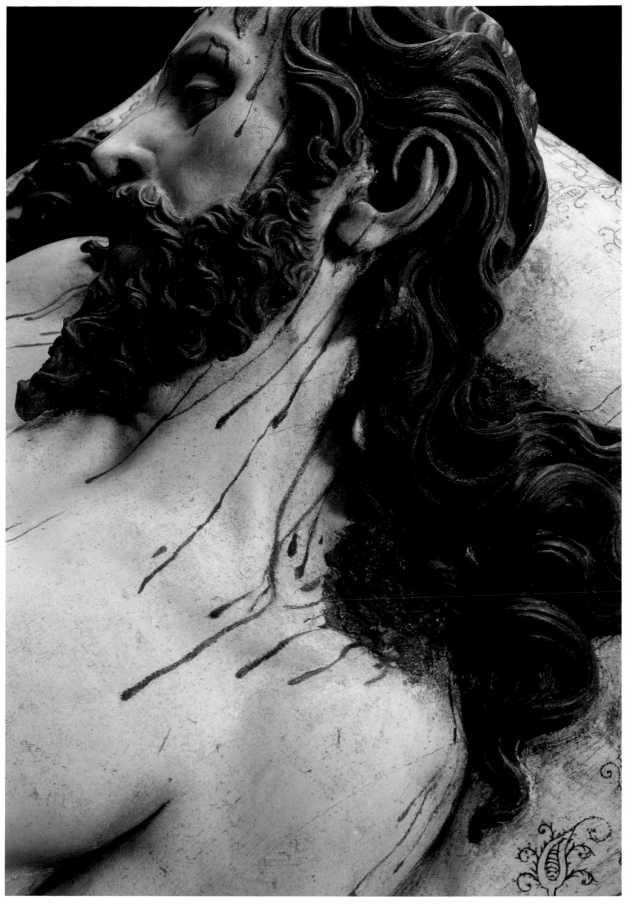

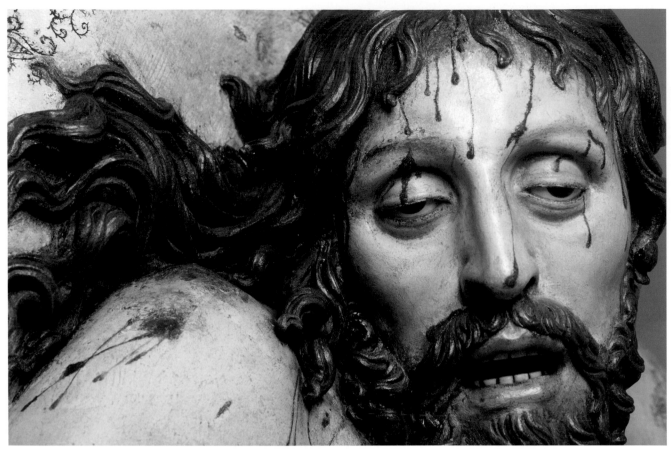

120

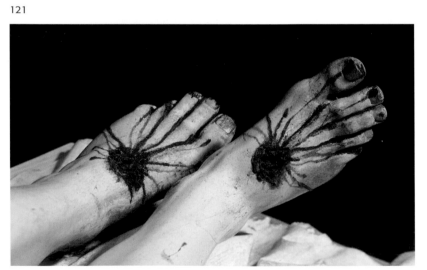

121

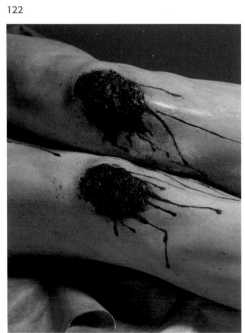

122

120, 121 and **122** Details of cat. 27
123 Opposite: cat. 27 seen from above

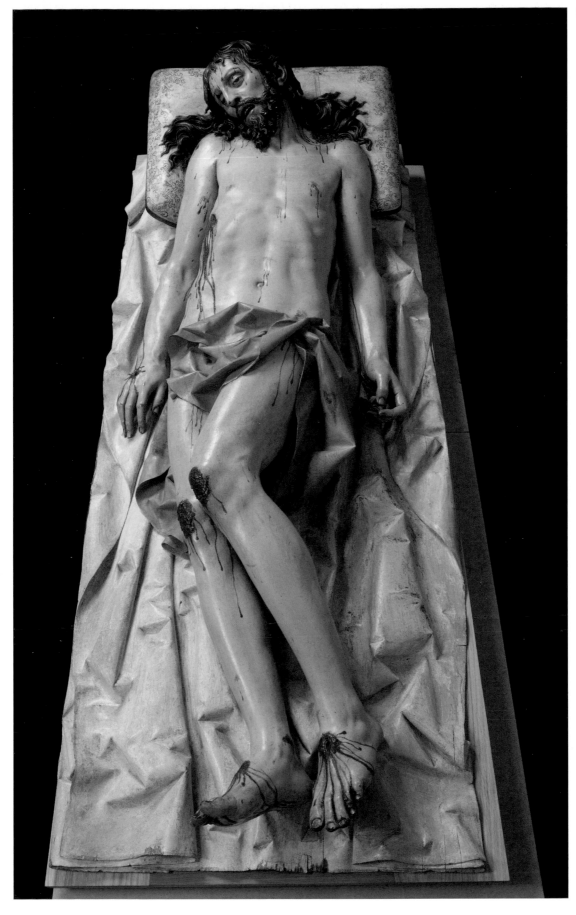

28 Jusepe de Ribera (1591–1652)

The Lamentation over the Dead Christ, early 1620s

Oil on canvas, 129.5 x 181 cm
The National Gallery, London (NG 235)

Ribera painted the subject of the Lamentation over the Dead Christ several times over the course of his career. This version would appear to be one of the earliest, painted when Ribera had established himself in the port city of Naples, then part of the Spanish dominions. There are two references to a Lamentation by Ribera in early seventeenth-century sources, either of which may be identifiable with this work: Giulio Mancini mentions a 'Christo Deposto' by the artist which was acquired by a Spanish collector in Rome, and we know that the Genoese aristocrat Marcantonio Colonna commissioned a 'Christo morto' by Ribera, via his agent in Naples, which is recorded in his will.[1] Colonna is generally believed to have been the more likely candidate, which would date the painting to the early 1620s, a suggestion that fits well with the style of the work.

Christ's body, in the process of being prepared for burial, is as unblemished as a marble sculpture; the only trace of blood visible is around his forehead. He is bathed in a cold light which brings the alarming pallor of his flesh into sharp focus. Saint John the Evangelist holds Christ by the shoulders, gently lifting him up so that the Virgin can look at him, while Mary Madgalene leans forwards to kiss his feet.

Little is known about Ribera's early training as a painter. He is thought to have first studied in Valencia, possibly with the local painter Francisco Ribalta (see cat. 26), before moving to Italy where he is first recorded in 1610–11.[2] He settled in Naples in 1616 where he was to spend the rest of his life.

In this painting, Ribera displays his skill at depicting the male nude – something he would have learnt by drawing after life models or from antique sculptures in Italy – as well as his knowledge of Caravaggio's use of dramatic lighting. This painting is, however, quite different from Caravaggio's works in its sensibility. Christ's naked body is proffered to the viewer with a realism that recalls Ribera's Spanish heritage. It is entirely possible that he was influenced by the painted sculptures he would have grown up with in Spain. Whether he received some training in painting wooden sculptures, as his contemporaries Velázquez or Zurbarán did, is not known. The existence of several religious confraternities in Xátiva where Ribera was born suggests that he was at the very least familiar with such sculptures and, interestingly, the guild of shoe-makers, to which his father belonged, commissioned a

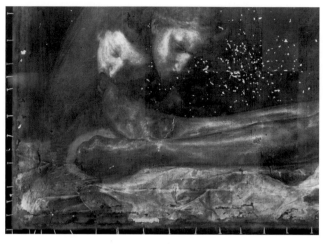

124 X-ray detail of cat. 28

polychrome sculpture of Christ at the Column for their confraternity in the early part of the seventeenth century.[3]

Ribera's staging of the scene, placing Christ's body centre stage on a crumpled white sheet and surrounding it by the kneeling figures of Saint John the Evangelist, the Virgin and Mary Magdalene, contains a strong element of a tableau vivant, reminiscent of the groups of religious sculptures on the pasos (floats) during Holy Week. We know that the sculptor Gregorio Fernández's many versions of the Dead Christ were venerated in very much the same way as the Magdalen venerates Christ in this painting. X-radiography of the present work reveals that the Magdalen's face was originally much closer to his feet, and that she was probably actually kissing them (fig. 124), just as sacred images were often kissed before they were carried in procession through the streets. Ribera was perhaps mindful of a need for religious decorum and also aware that by preserving a distance between the two figures there was a stronger sense of narrative.

XB

SELECT BIBLIOGRAPHY
MacLaren and Braham 1970, pp. 92–4; Finaldi 2003, cat. 1, pp. 86–91; Spinosa 2003, cat. A47, pp. 264–5.

NOTES
1 Finaldi 2003, pp. 16–21.
2 Finaldi 1992, pp. 3–4.
3 Although the sculpture was destroyed during the Spanish Civil War, the Cofradía del Santísimo Cristo de la Flagelación in Xativa still exists.

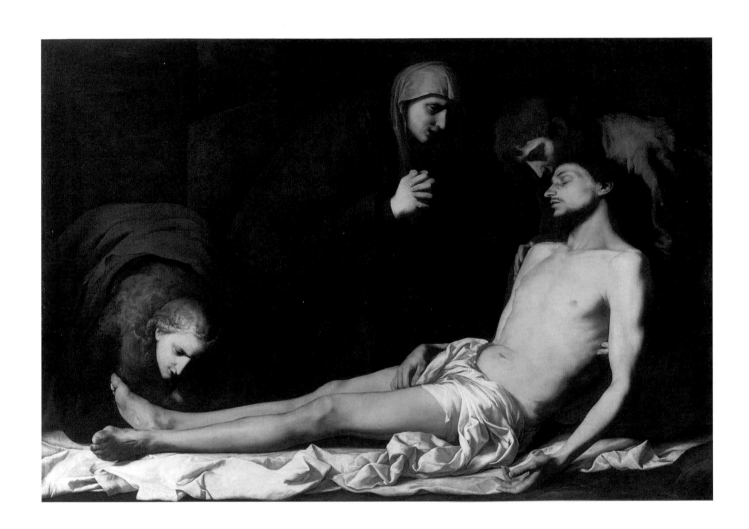

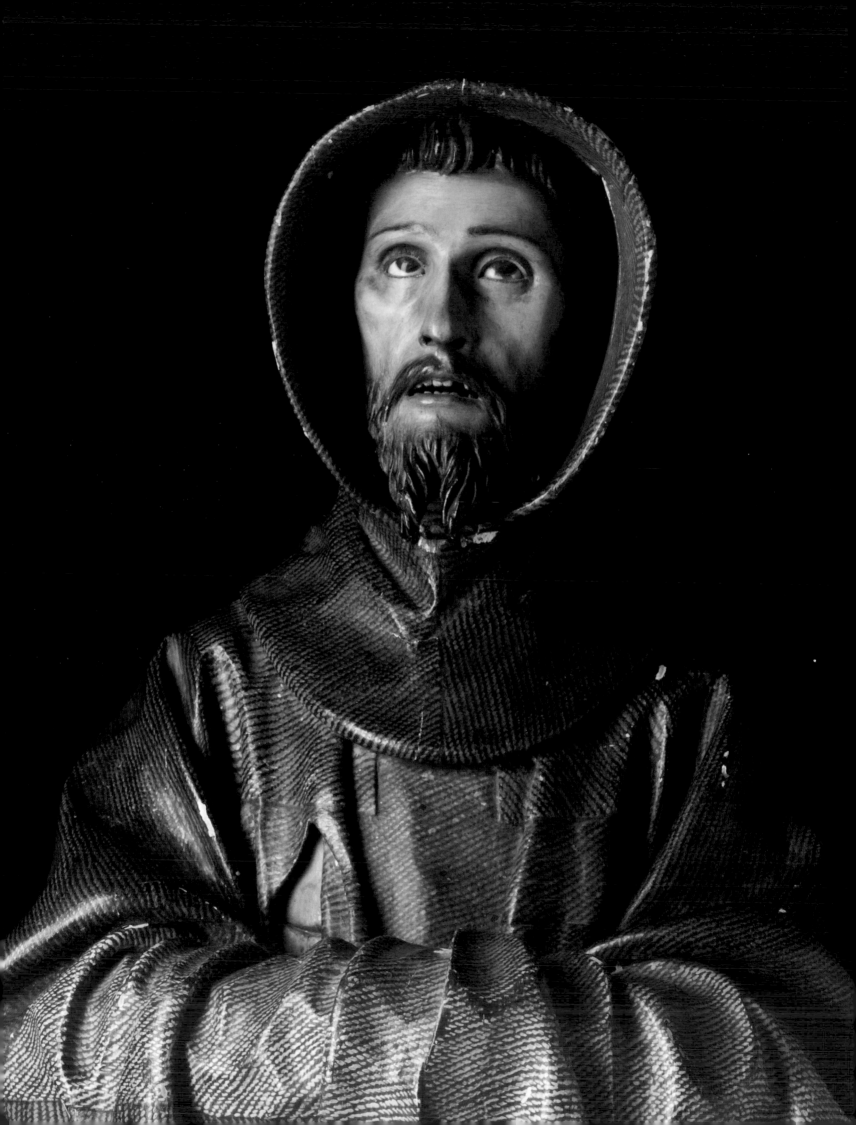

Saint Francis in Meditation

When writing about the artistic treasures to be seen in Toledo Cathedral in 1845, Richard Ford, author of *A Hand-Book for Travellers in Spain*, urged his readers to seek out Pedro de Mena's *Saint Francis standing in Ecstasy* (see cat. 33 and opposite), which he described as 'a masterpiece of cadaverous extatic [sic] sentiment'. This is an early – although ambiguous – tribute to the artistic power of this celebrated sculpture. In fact, polychrome sculptures of Saint Francis in Ecstasy, like Mena's, are known to have been specially blessed: whoever recited a *Pater Noster* and an *Ave Maria* in front of them would receive four days of indulgence – that is, remission of the temporal punishment for sin.

Mena's sculpture is indeed one of the great masterpieces of seventeenth-century Spanish polychrome sculpture, and may well have been inspired by Francisco de Zurbarán's painted depiction of the saint in exactly the same pose (see cats 31 and 32). Both artists depict Saint Francis (1181–1226) in a state of ecstasy, standing upright, as he was found by Pope Nicholas V who visited his tomb in 1449. Zurbarán's painting is unusually sculptural, devoid of any narrative detail, except for a suggestion of candlelight which illuminates the figure.

The Franciscan Order was one of the two great preaching orders of the Church. It was characterised by devotion to the principles of poverty, chastity and charity, and was popular throughout the Catholic world. Francisco Pacheco was a member of the lay branch of the order, the Third Order of Saint Francis, and requested that he be buried wearing the habit of the reformed branch of the order, the Capuchins.

125 Detail of cat. 33

29 Francisco de Zurbarán (1598–1664)

Saint Francis in Meditation, 1635–9

Oil on canvas, 152 x 99 cm
The National Gallery, London (NG 230)

Zurbarán has set the scene in a darkened room, the composition edited down to the bare essentials. A shaft of light brings into sharp focus the sculptural form of a friar deep in prayer. His eyes are entirely hidden from the viewer by the shadow of his cowl; only his nose and mouth are lit. If it were not for the mark of the stigmata just visible on his right hand, we might think this was a representation of a contemporary seventeenth-century monk rather than Saint Francis himself.

In 1224, Saint Francis experienced a vision that left him with the marks of Christ's wounds – the stigmata – imprinted on his feet, hands and side. Having 'physically' experienced Christ's Passion, Saint Francis realised that instead of fearing death, one should embrace it as a means of uniting one's soul with God. When the saint was lying on his deathbed two years later, he is said to have welcomed death as his 'sister'.[1] It is precisely this moment of realisation that Zurbarán depicts.

The brown habit that Saint Francis wears with its distinctive pointed hood or *cappuccio* was to become the habit of the Capuchin Order, a reformed branch of the Franciscans founded in 1528 in Italy. The Capuchins, a product of Counter-Reformation zeal, followed rigorously the first rule of Saint Francis and led lives of prayer and extreme austerity.[2] Their main focus was on mental prayer and it was around this practice that their day was organised.[3] The Capuchins arrived in Spain in 1575, but their first monastery was not founded in Seville until 1627. Zurbarán's close links with the religious orders in Seville at this date and the fact that he shows Saint Francis wearing a habit that became closely associated with the Capuchins may indicate that this painting was originally a Capuchin commission. The saint's intense absorption in his meditation suggests that the painting was probably intended for private devotion, perhaps for a small cell or private chapel, where the friars could remind themselves of their founder's example.

The majority of the commissions Zurbarán received in the 1620s and 1630s were designed for particular architectural settings, often taking into account the effect of natural light, as with his celebrated *Christ on the Cross* of 1627 (cat. 25). In the present work, the clearly defined single shaft of light which enters the composition from the left suggests a specific location. What has not to date been fully explained are the two darker strips of colour that run down the sides of the composition. These are not later additions and it may be that Zurbarán originally intended the painting to be inserted into a narrower frame than it is today. The verticality of the composition would thus be emphasised and the sense of Saint Francis's three-dimensionality enhanced.[4]

XB

SELECT BIBLIOGRAPHY
Guinard 1960, no. 354; MacLaren and Braham 1970, pp. 137–8; Baticle and Marinas 1981, no. 356, pp. 227–8; New York 1987, cat. 53, pp. 271–2; Caturla and Delenda 1994, p. 225; Barcelona 1998, cat. 6, pp. 96–103; New York 2003, cat. 85, pp. 461–2

NOTES
1 Réau 1958, p. 517.
2 Hélyot and Bullot 1714–19, VII, pp. 120, 137.
3 Schmucki 1978, p. 81.
4 Zurbarán's *Virgin of Mercy of Las Cuevas* (see cat. 11), for example, was inserted into a plaster-moulded frame designed by Pedro Roldán in 1655 as part of a general decorative scheme.

30 Attributed to Francisco de Zurbarán (1598–1664)
Head of a Monk, about 1620–30

Black chalk, with dark grey wash on yellowish paper, 27.7 x 19.6 cm
The British Museum, London (1895, 0915.873)

When this drawing first appeared in the nineteenth century, it formed part of the collection of the Spanish Neoclassical painter and director of the Museo del Prado, José de Madrazo y Agudo (1781–1859). He attributed it to Zurbarán who was known at the time as the 'painter of monks', having spent his career in the service of the monastic orders, and the attribution remains today, as catalogued by the British Museum.[1]

This highly finished black chalk study is still something of an enigma, however, not least because there are no drawings securely attributed to Zurbarán with which to compare it. Probably made from the life, it seems to depict a cowled monk with his eyes lowered as if in the act of reading. The suggestion has also been made that the young monk is in fact dead and that the artist made this study on his funeral bier, but this seems unlikely given that the monk appears to be depicted upright and, crucially, that the pupils of his eyes still seem to be visible.[2] What is extraordinarily compelling about the drawing is the sense of the monk's absorption in his task, arousing in the viewer a desire to share in his moment of intense and very private concentration.

Strong lighting creates areas of deep shadow in the gaunt hollow of his cheekbones and in his eye sockets, and a strip of shadow bisects his lips. The light source appears to come from the front, slightly to the left, with the result that the right side of the monk's face is a masterful depiction of reflected light with a line of diffused light down the right cheekbone. Viewed from close up and in such strong light the face has an extraordinary three-dimensional quality. This compares well with Zurbarán's style of painting at this date and particularly with his many painted depictions of Saint Francis (see cats 31 and 32). It is notable that in these works Zurbarán tended to create areas of deeply contrasted light and shadow around the saint's face as seen beneath his cowl, which lends weight to the attribution of this drawing to Zurbarán.

<div align="right">XB</div>

SELECT BIBLIOGRAPHY
Robinson 1876, no. 424, p. 149; Soria 1953, no. 34, p. 14; Guinard 1960, no. 397, p. 256; Angulo Iñiguez and Pérez Sánchez 1985, no. 245, p. 60; London 1996, cat. 51, pp. 106–7.

NOTES
1 London 1996, cat. 51, pp. 106–7.
2 Soria 1953, no. 34, p. 141, suggests that this drawing could be a preparatory study for the *Saint Bonaventura on his Bier* (1629) in the Musée du Louvre, Paris.

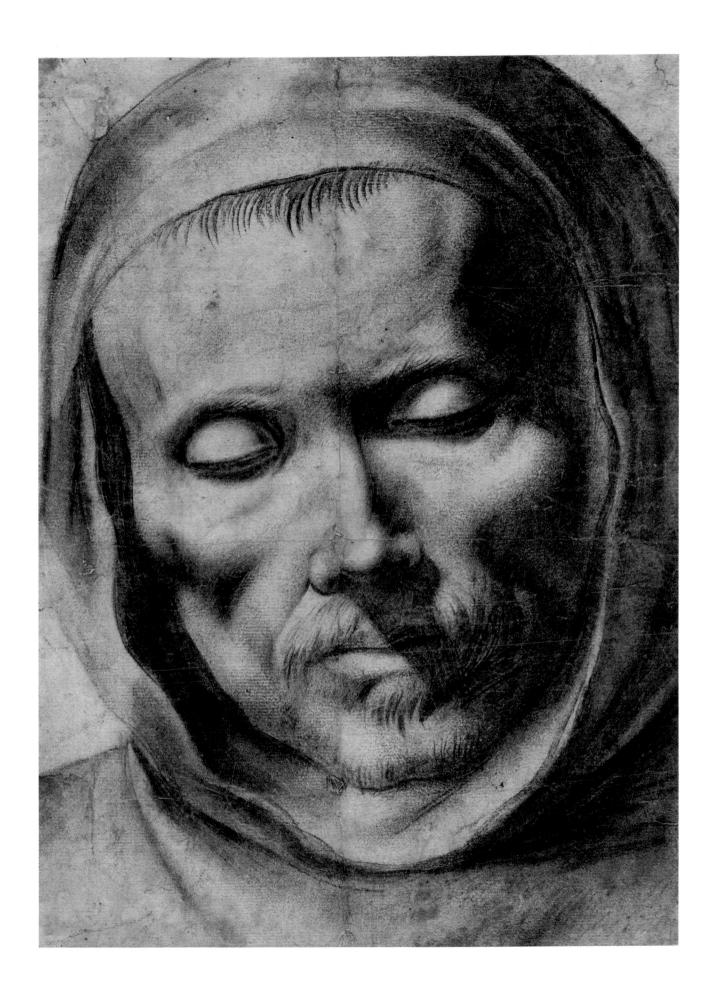

31 & 32 Francisco de Zurbarán (1598–1664)

Saint Francis standing in Ecstasy, about 1640

Oil on canvas, 177 x 108 cm
Museu Nacional d'Art de Catalunya, Barcelona (11528)

and

Saint Francis standing in Ecstasy, about 1640

Oil on canvas, 207 x 106.7 cm
Museum of Fine Arts, Boston, MA. Herbert James Pratt Fund, 1938 (38.1617)

According to legend, when Saint Francis's tomb at Assisi was opened in the presence of Pope Nicholas V in 1449, his body was found to be miraculously preserved and standing upright. The scene is described by one of the cardinals accompanying the pope:

> It was a strange thing, that a human body, dead for so long before, should be in that manner in which it was: for it stood straight up upon the feet; without leaning, or being supported on one side or the other. The eyes were open, as of a living man, and moderately lifted up to heaven. It held the hands covered with the sleeves of the habit before its breast, as the Friars Minorites are wont to hold them [We saw] that in that holy foot there was a wound, with the blood as fresh and red, as if it had been then made with a nail on some living body.[1]

Such a precise description of the event, first officially published in 1562 and subsequently reprinted by Counter-Reformation hagiographers, led to several images of the saint being commissioned by the Franciscan and Capuchin orders particularly in Spain.[2] In 1613, for example, Eugenio Cajés made a drawing for a now lost painting for the Franciscan convent in Madrid depicting Nicholas V and his retinue examining the wounds on Saint Francis's feet and illuminating the crypt with a burning torch like archaeologists in an Egyptian tomb (fig. 126). By contrast, Zurbarán isolates the figure of Saint Francis and inserts him into a shallow niche, his statuesque presence filling the composition. A powerful stream of light bears down upon him, sharply outlining his body and causing it to cast a shadow against the wall. His habit, with its long, parallel folds, hangs straight down, emphasising the rigid verticality of the saint's posture.

Zurbarán's simple but highly effective composition recreates the eeriness of the event. It is as if we, the viewers, had entered the sepulchre by candlelight and come face to face

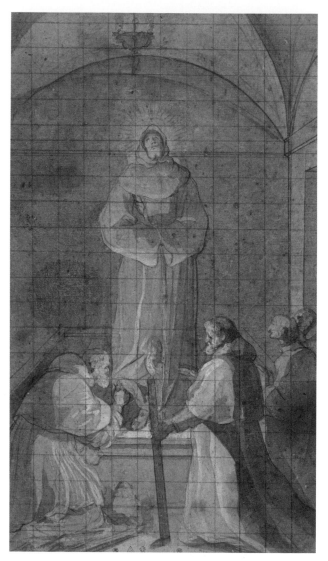

126 Eugenio Cajés (1575–1634)
Pope Nicholas V before the body of Saint Francis, about 1613
Black lead and pen and ink and sepia wash with white lead on brown-coloured paper, squared in pencil, 30 x 17.2 cm
Albertina, Vienna (13069)

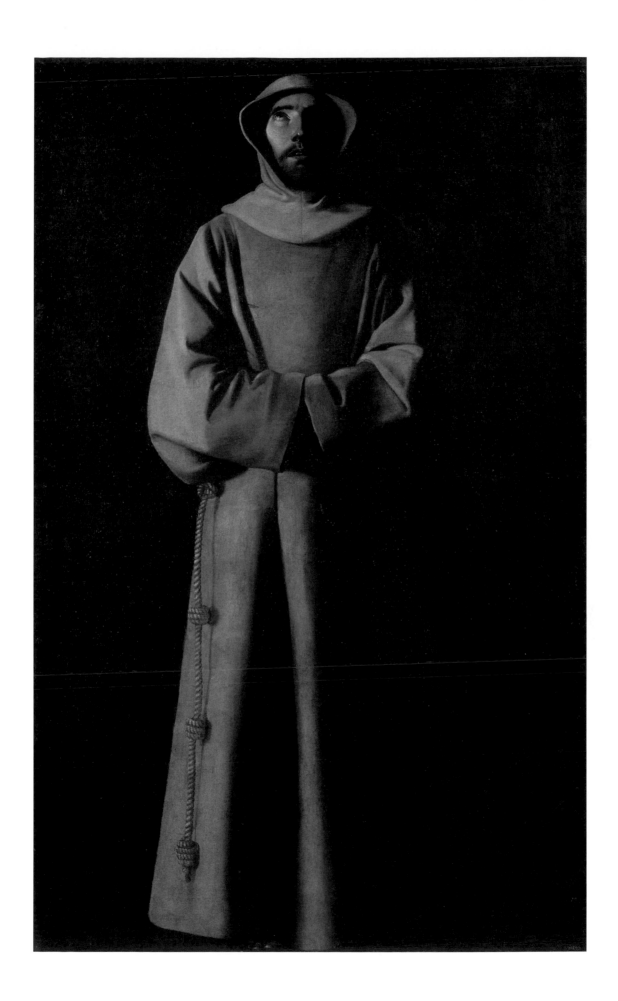

with Saint Francis's uncorrupted body. Despite the signs
that indicate he is dead – the pallor of his face and the blood
coagulating in his wounds – his ecstatic expression reveals a
man still in communication with God. Although Zurbarán
may have based his figure on a live model, polychrome
sculptures of the subject also existed. Gregorio Fernández, for
example, devised a life-size figure of Saint Francis around 1620
for the monastery of the Descalzas Reales in Valladolid, and
although it does not bear a direct connection with Zurbarán's
painted version, its three-dimensionality may have been an
inspiration for Zurbarán.[3] Certainly, we know that Zurbarán's
painting inspired the sculptor Pedro de Mena to make his
polychrome figure of Saint Francis, standing in exactly the
same pose (see cat. 33).

The original patron of this painting is not known, but the
existence of several versions by Zurbarán and his workshop
suggests that the composition was much in demand (see also
fig. 28).[4] The Franciscan order would seem likely patrons, but
we know that painted sculptures of this subject belonged to
individuals and were prayed to for indulgences.[5] The painting
may therefore have belonged to a private individual, perhaps a
member of the Third Order of Saint Francis, a lay branch of the
Franciscans. Francisco Pacheco, for example, was a member of
this order and in his will he stipulated that he should be buried
in a Capuchin habit on his death.[6] By praying before Saint
Francis in his miraculous state of preservation, the devout
would have a glimpse of the afterlife.

XB

SELECT BIBLIOGRAPHY
New York 1987, cat. 69, pp. 306–9 (Lyon version); Madrid 1988, cat. 102,
pp. 400–2 (Barcelona version); Brown 1991c, p. 108 (Boston version);
Barcelona 1998, cat. 7, pp. 104–9 (Barcelona version); Barcelona 2005–6,
pp. 324–7 (Barcelona version)

NOTES
1 Ribadeneyra 1669, II, p. 769. Some sources name the pope as Nicholas IV
and give the date 1288. See, for example, Réau 1958, p. 530.
2 See Sánchez Cantón 1926, pp. 40–1.
3 Some of the first sculpted interpretations of the subject seem to have been
produced by Gregorio Fernández; one is in the Monasterio de las Descalzas
Reales, Valladolid (c.1620); the other in the church of Santo Domingo in
Arévalo (Ávila) (c.1625–30).
4 The best preserved autograph version of this subject is the painting in the
Musée des Beaux-Arts, Lyon. See New York 1987, cat. 69, pp. 306–9.
5 The base of Fernando Ortiz's sculpture of Saint Francis standing in Ecstasy in
the Museo Nacional de Escultura, Valladolid, contains the following inscription:
'EL Yllmo. S.or D.n Miguel de Aguar, Obispo de Zeuta bendixo Esta ymagen y
concedia 4 dias de indulgencia A qualesquiera qe rezare un padre nuestro y
un Ave María delante de el en el mes de 1 de julio, de 1738.' See Valladolid
1989–90, cat. 22.
6 'quiero morir y ser enterrado en el ávito de Capuchino de nro. Pe. San
francisco con su cordón y una cruz grande de ciprés.' See Salazar
1928, p. 157.

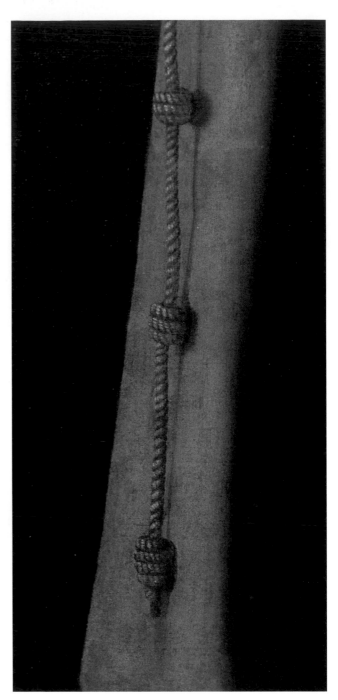

127 Detail of cat. 31

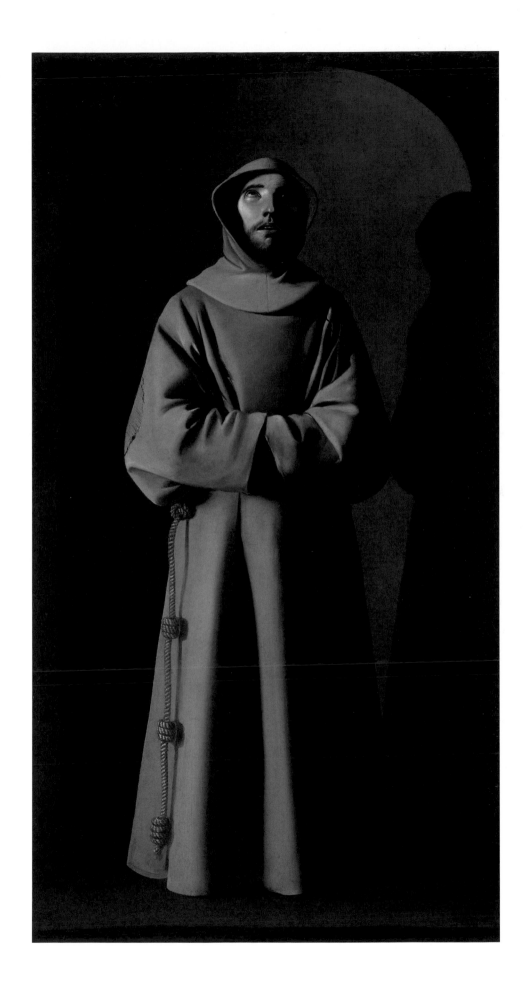

33　Pedro de Mena (1628–1688)

Saint Francis standing in Ecstasy, 1663

Polychromed wood, glass, cord and human hair, 97 x 33 x 31 cm (with plinth)
Toledo Cathedral

We do not know whether Pedro de Mena ever saw Zurbarán's celebrated painting of *Saint Francis standing in Ecstasy* (see cats 31 and 32), but there is a remarkable affinity between Zurbarán's painted composition and Mena's painted sculpture of the subject. Although the sculpture was made some twenty years later, the manner in which these two artists interpreted the subject is almost identical. Standing erect on an ebony pedestal, with one foot protruding from his habit as if to show us the mark of the stigmata, Saint Francis looks up out of his cowl with an ecstatic expression. His eyes are raised heavenwards and his lips are parted.

Mena's skill as a carver and as a polychromer is especially apparent in this piece. Saint Francis's face was carved separately and hollowed out like a mask. Before it was fitted into the cowl, Mena inserted two small glass 'cups' into the eye cavities.[1] A set of ivory teeth was placed in the mouth (one upper and one lower tooth are missing, but this may have been intentional). Real hair has been used for the eyelashes. To capture Saint Francis's deathly pallor, Mena has given the skin a matt surface. The texture of the hair, both on his head and in his bifurcated beard, is delineated with a painted gloss to enhance its three-dimensional quality. The paint on the face is cleverly unified with the carving: brown paint has been applied down the sideburns and on the chin, for example, to make the growth of beard hair – which is rendered in sculpture – seem more naturalistic. A dark line has been applied beneath the eyelids to enhance the drama of his pupils, raised up to heaven.

A small slit in the saint's habit reveals the wound in his right side, a detail that Zurbarán also depicted in his painting. The habit and cowl are made from a carved and hollowed piece of wood which was painted with fine striations of brown and white to simulate the coarse weave of wool – in accordance with his strict vow of poverty, Saint Francis is said to have recycled patches of wool and sewed them together himself. Mena slightly raised the relief of his carving and painted those areas with a variation in tone so that the different patches of dark, medium and medium-light browns are clearly defined. Finally, a real knotted cord was attached to a carved cord around Saint Francis's waist.

While Zurbarán chose to depict his painted Saint Francis illuminated by an artificial light source from the front left, obliging the viewer to view the saint from this direction only, Mena's sculpture offers the possibility of a three-dimensional view. The fact that it is highly worked up from every angle suggests that Mena intended it to be seen in the round. Furthermore, the glass case (possibly the original) in which the sculpture is installed allows the viewer to look at it from all sides.

Mena and his workshop produced a number of sculptures of Saint Francis standing, which varied in scale (see cat. 34).[2] The prime version is this one in Toledo which stands 83 cm high (without the plinth). It was probably presented by the sculptor himself to the cathedral of Toledo in thanks for his award of the position of 'master sculptor' on 7 May 1663.[3]

XB

SELECT BIBLIOGRAPHY
Palomino 1715–24 (1987), p. 316; Sánchez Cantón 1926, pp. 40–3; Anderson 1998, cat. 9, pp. 79–81; Gomez-Moreno 1964, no. X, pp. 34–5; Málaga 1989, pp. 86–7; Gila Medina 2007, pp. 118–22

NOTES
1　During the course of preparing this book this work was examined and conserved by the Instituto del Patrimonio Cultural de España, and the report was published: see Redondo Álvarez et al., 2009. We are very grateful to the Instituto for providing us with new photography and X-radiography of Mena's sculpture.
2　For a list of other versions see Trusted 1996, no. 24, p. 65, and cat. 34.
3　Ceán Bermúdez 1800, p. 111. See also Orueta y Duarte 1914, p. 77.

Page 184: **128** and **129**　Front and side views of cat. 33

Page 185: **130** and **131**　Side and back views of cat. 33

All photographed before conservation

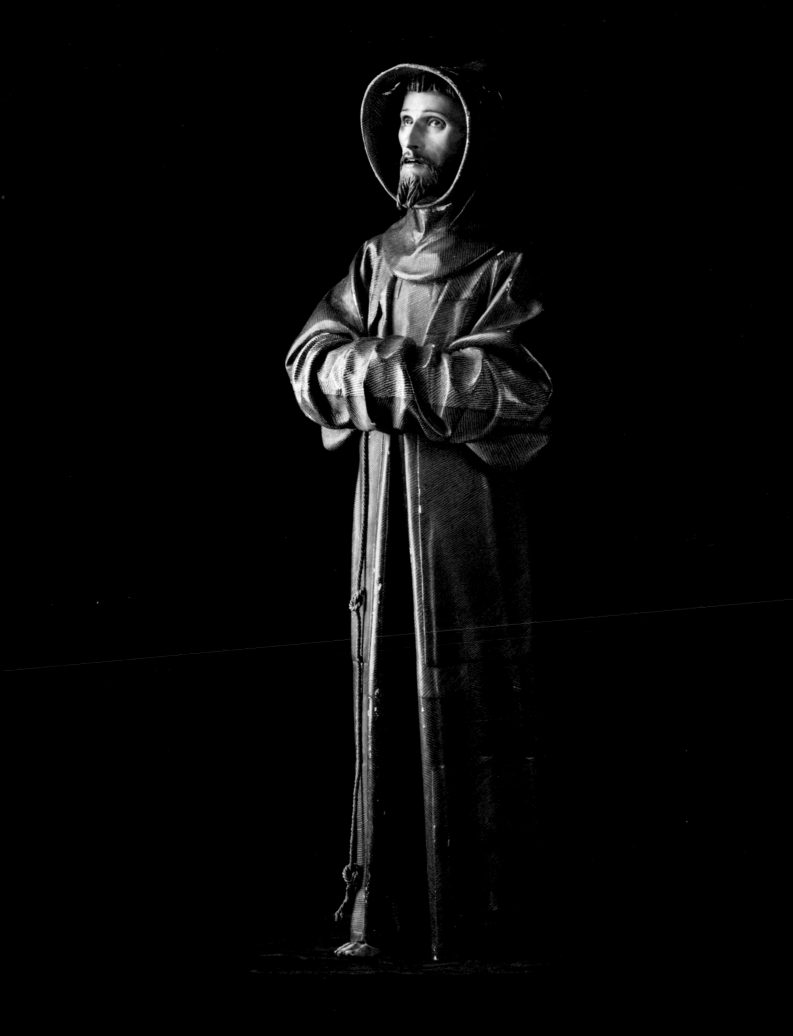

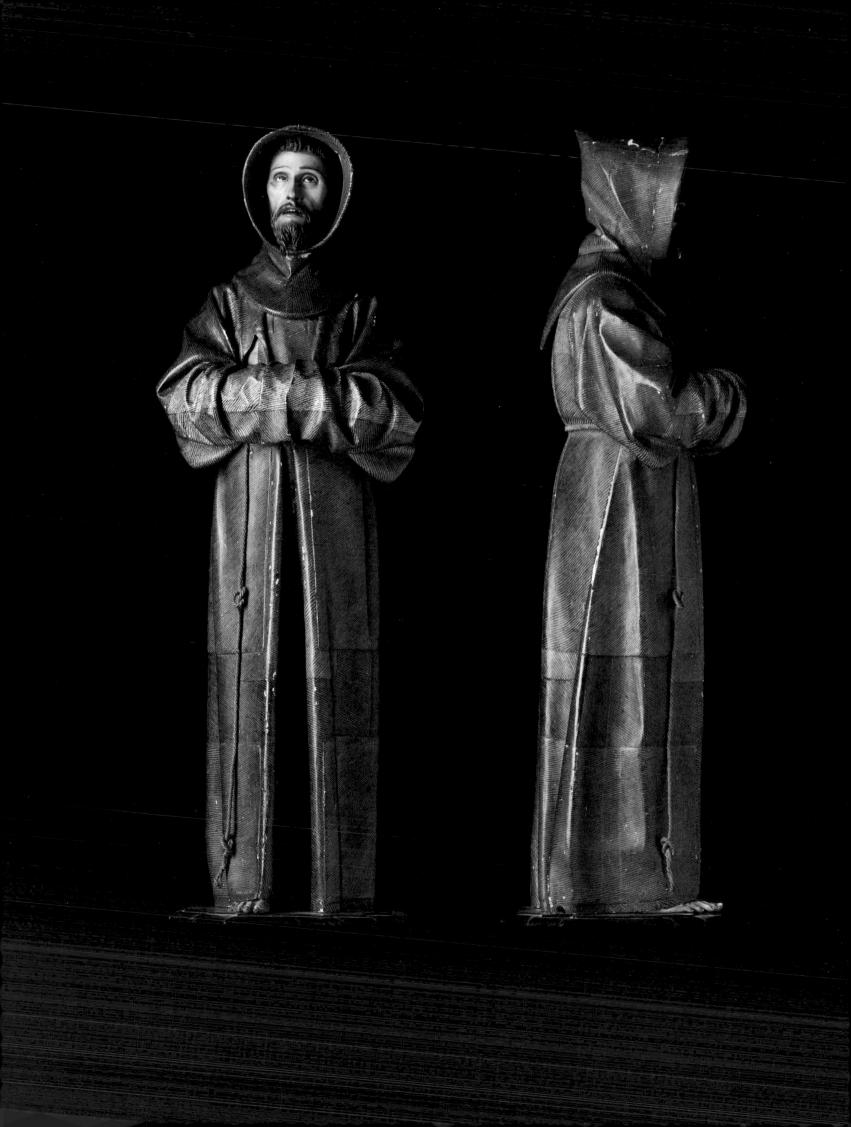

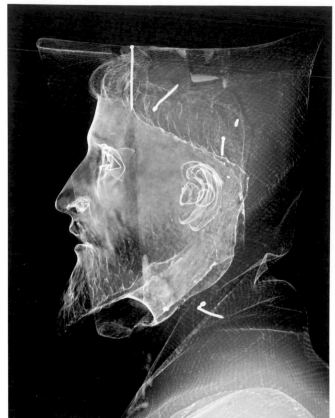

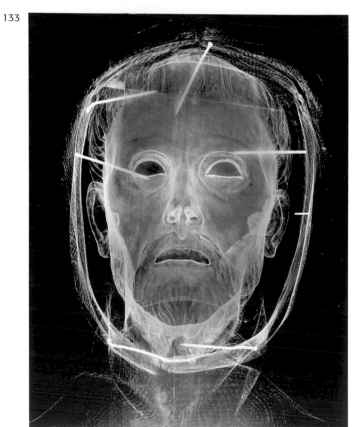

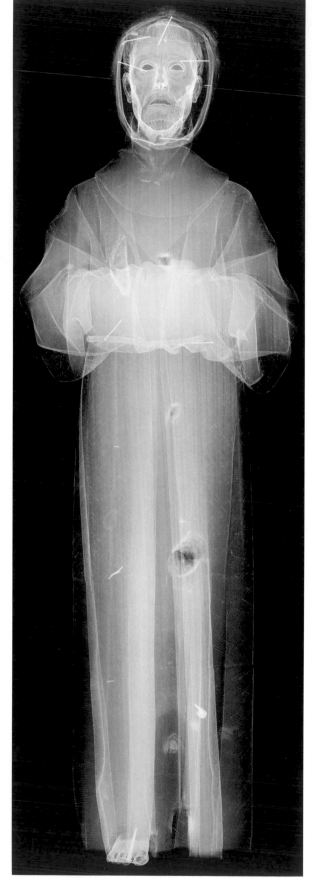

132, 133 and **134** X-rays of cat. 33. The convex shape of the glass eyes and the nails used to reattach the cowl are clearly visible. As X-rays do not distinguish layer structure or volume, both ears can be seen in fig. 132.

135

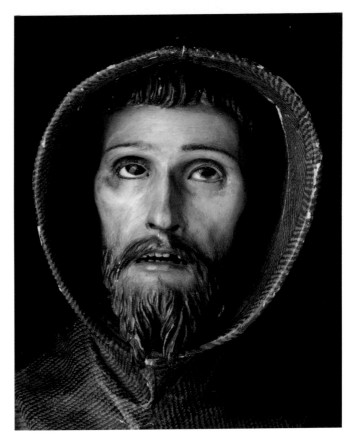

136

135, 136, 137, 138 and **139** Details of cat. 33.
The sculpture appears to have been carved from a single block, apart from the right foot (fig. 138), the head and a small piece inserted in the top of the cowl. Part of the carved rope (fig. 137) has been broken off; the rope hanging from the saint's waist at the front is real fibre.

137

138

139

34 After Pedro de Mena (1628–1688)

Saint Francis standing in Ecstasy, about 1700–40?

Polychromed pinewood, cord and glass, 50.5 x 13.3 x 13.4 cm
Victoria and Albert Museum, London (331-1866)

This statuette is a reduced variant (about half the size) of the celebrated figure of Saint Francis of Assisi by Pedro de Mena in the Treasury of Toledo Cathedral, dating from 1663 (cat. 33). The saint is shown standing, his body miraculously preserved, his eyes open, and his hands clasped together, as seen when his tomb was opened in the presence of Pope Nicholas V in 1449.[1] The protruding right foot prominently displays the blood-red mark of the stigmata. Because this is a version of a larger figure it is difficult to date accurately. It is technically accomplished, and recalls seventeenth-century sculptures, but the slightly freer folds of the drapery suggest a date somewhat after the Toledo figure, and it was probably made in the early decades of the eighteenth century.

Pedro de Mena's statue was the object of great veneration, and a number of sculptures based more or less closely on it were produced from the seventeenth century onwards, including a version made in the 1870s by the French sculptor and poet Zacharie Astruc (1833–1907).[2] These became cult figures, and were originally housed in churches or chapels. Other representations of the miracle had been produced in Spain from the 1620s onwards, including a sculpture by the Castilian artist Gregorio Fernández and a painting by Francisco Zurbarán (cat. 31). But it was Pedro de Mena's figure that was most emulated. A signed version by Fernándo Ortiz of Málaga dated 1738 is now in the Museo Nacional de Escultura in Valladolid, and another anonymous one, dated 1732, is in the Convento de Santa Clara, in Medina de Rioseco.[3] Nineteenth-century variants are also known.[4]

Sacred images were widely reproduced in Spain and South America during the seventeenth and eighteenth centuries. In the case of Saint Francis of Assisi, seen as living after death, his image had a particular significance, and although stylistic variations are evident, the central type remained the same, because of its sacred identity. As well as images of Saint Francis, certain representations of the Virgin of the Immaculate Conception and Christ as the Man of Sorrows became renowned, and then imitated and disseminated within the Peninsula, imbued with a sanctity reminiscent of relics.[5]

This small sculpture was acquired from a dealer in Madrid in 1866 by the first curator of the South Kensington (later Victoria and Albert) Museum, John Charles (later Sir Charles) Robinson (1824–1913), who was a keen and astute collector of Spanish sculpture.[6] He wrote in an article of 1897, 'The most important gatherings of the South Kensington Museum ... were mainly the result of [my] successive yearly expeditions of several months' duration [to Spain], in which innumerable art auctions, dealers' gatherings, old family collections, convent and church treasures, yielded up an infinity of treasures.'[7] Robinson's enthusiasm and expertise were in defiance of other nineteenth-century British commentators on Spanish sculpture. The eminent traveller and writer on Spain Richard Ford (1796–1858) had written of Spanish sculpture in 1845: '[N]o feeling for fine art or good taste entered into the minds of those who set up those tinsel images. They made sculpture the slave of their end and system; they used it to feed the eye of the illiterate many; to put before those who could not read, a visible tangible object, which realised a legend or dogma.'[8]

Without doubt this statuette of Saint Francis 'realised a legend', and was intended to speak visually to the 'illiterate many'. It simultaneously embodied certain aspects of the Spanish Catholic Church, often feared or despised by Northern European Protestants. Clearly it did not conform to the ideals of Neoclassical monochrome marble sculpture admired in Europe during the nineteenth century. It does, however, epitomise an extraordinary form of Baroque sculpture, and in a concentrated form suggests the power and resonance of a miraculous image.

MT

SELECT BIBLIOGRAPHY
Penny 1993, p. 142; Trusted 1996, cat. no. 24, pp. 64–7; Trusted 1997, pp. 57–60; Trusted 2007, pp. 54–6

NOTES
1 Ribadeneyra, 1669, II, p. 769, and Réau 1958, p. 530. See also cat. 31.
2 Málaga 1989; Trusted 1996, pp. 64–7, and 1997, pp. 57–60; Bray 2007–8, pp. 127–9.
3 Málaga 1989, cat. no. 22, pp. 64–5, and cat. no. 33 pp. 86–7.
4 Málaga 1989, cat. no. 36, pp. 92–3; see also Trusted 1997, note 54, p. 180.
5 Trusted 2007, pp. 52–6.
6 Trusted 1996, pp. 3–7.
7 Quoted in Trusted 1996, p. 4.
8 Quoted in Trusted 1996, p. 3.

I am grateful to Sofia Marques and Paul Robins for their help in discussing the techniques used in the making of this sculpture, and to Xavier Bray for his comments on my entry.

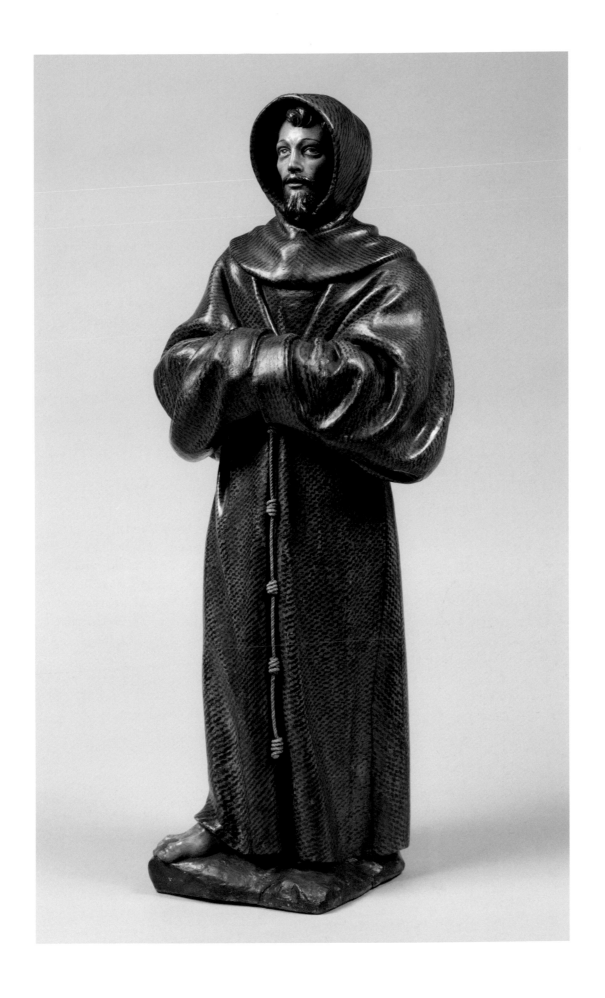

The 'Spanish Paragone': Saint Serapion

In Italy there had been an ongoing debate about the relative merits of painting and sculpture since the fifteenth century. Leon Battista Alberti, Leonardo da Vinci and Giorgio Vasari were among the first to argue in their writings that painting was superior to sculpture, because it required the intellect rather than physical labour. In seventeenth-century Spain, this so-called 'paragone' (from the Italian word meaning 'comparison') was little discussed in artistic treatises but was certainly known. It must have had some influence on disputes between painters and carvers about the strict division of labour involved in making a polychrome sculpture.

In 1621, two of Seville's most eminent artists, Montañés and Pacheco, engaged in a bitter argument. The sculptor Montañés had signed a contract to execute a large altarpiece for the Convent of Santa Clara in Seville which gave him complete control over the painting and gilding. Pacheco was furious at this violation of the painters' essential rights and threatened a lawsuit. He explained in detail the position of the painters in his epistle 'A los professores del' Arte de la Pintura', dated 16 July 1622 (see pp. 194–5), and asserted his belief in the superiority of painting over sculpture. It was Pacheco's opinion that the application of colour revealed 'the passions and concerns of the soul with great vividness' and that painting was the 'most universal, most delightful, most spiritual, most useful of all the arts'.

The close relationship that existed between painting and sculpture in seventeenth-century Spain led to some remarkable innovations in painting. Zurbarán, the most sculptural of painters, illustrates this most strikingly in his *Saint Serapion* (cat. 35). Overall, the 'Spanish paragone' produced sculpture that was exceptionally painterly and paintings that were remarkably sculptural.

140 Detail of cat. 35

35 Francisco de Zurbarán (1598–1664)

Saint Serapion, 1628

Oil on canvas, 120.2 x 104 cm
Inscribed, signed, and dated on a piece of paper near the right edge: *B. Serapius. franco de Zurbaran fabt. 1628*
Wadsworth Atheneum Museum of Art, Hartford, Connecticut
The Ella Gallup Sumner and Mary Catlin Sumner Collection Fund (1951.40)

Peter Serapion was born in England in 1178 and went to Spain to fight the Moors alongside Alfonso IX of Castile. Impressed by the endeavours of the Mercedarians to act as hostages to ransom Christian captives in danger of losing their faith, he joined the order in 1222. He later became director of novices, and attempted without success to establish the order in England.

According to the most reliable account of his martyrdom, Serapion was captured in Scotland in 1240 by English pirates.[1] Bound by his hands and feet to two poles, he was beaten, dismembered and disembowelled, and his neck was partially severed. Zurbarán has shown Serapion moments after the ordeal, his head sunken between his shoulder blades, his wrists still bound.[2] Although he was not canonised until 1728, he became the model martyr for future generations of Mercedarians.

Crucially, however, Zurbarán has eliminated any detail of gore; instead, it is the white unblemished habit of the Mercedarian order (identified by the scarlet, white and gold shield pinned to the front of it) worn by the saint and a symbol of his virtue that is the focus of the painting. Zurbarán's rendering of the drapery and the manner in which light and shadow fall on its deep folds is a *tour de force* of painting and endows the figure with a physicality and grandeur that belie his broken body. The saint is portrayed so realistically that we feel we could reach out and touch him, but Zurbarán is at pains to remind us that this is ultimately only a painted representation, fictively pinning a piece of paper with his signature on to the canvas.

Painted in 1628 the *Saint Serapion* was executed for the Monastery of Nuestra Señora de la Merced in Seville. It was destined to hang in the Sala *De Profondis*, a mortuary chapel where deceased monks lay in state before burial. It is almost certainly for this reason that Zurbarán has shown Serapion seemingly 'asleep', his white habit emphasising the dignity of his martyrdom. The moment of his passing is extremely poignant and the painting would have been entirely appropriate for a mortuary chapel.

It is not known where Zurbarán's painting was hung in the chapel, although an eighteenth-century account describes two paintings of 'Holy Martyrs' by Zurbarán facing each other near a door.[3] It is likely that originally the two 'martyrs'[4] occupied a more central position in the Sala *De Profondis*, perhaps near the altar of the chapel which we know was dedicated to the Passion of Christ.[5] The way in which Serapion's head falls to one shoulder is not unlike that of Christ on the cross, and his open-armed acceptance of his suffering is in direct imitation of Christ's example.

XB

SELECT BIBLIOGRAPHY
Remón 1618; Soria 1953, no. 28, p. 140; Guinard 1947, p. 161; Guinard 1960, no. 411, p. 259; New York 1987, cat. no. 5, pp. 102–3; Brown 1991c, p. 56; *Wadsworth Atheneum* 1991, pp. 328–31

NOTES
1 Remón 1618, folios 165–6.
2 It is details such as this, together with the indication that the saint's neck has been severed, that suggest that Zurbarán was following Remón's account rather than the more popular version (cited by Brown 1991, p. 56, and *Wadsworth Atheneum* 1991 p. 330, note 12), according to which Serapion was martyred by the Moors in Algiers as ransom for eighty-seven prisoners, and his entrails wound on a winch.
3 Ponz 1780, Carta Tercera, no. 48, pp. 106–7.
4 The other 'Holy Martyr' was tentatively identified as in a private collection: see Soria 1953, no. 29, p. 140.
5 For a description of the layout of the monastery see Pérez Escolano 1982, pp. 545–9.

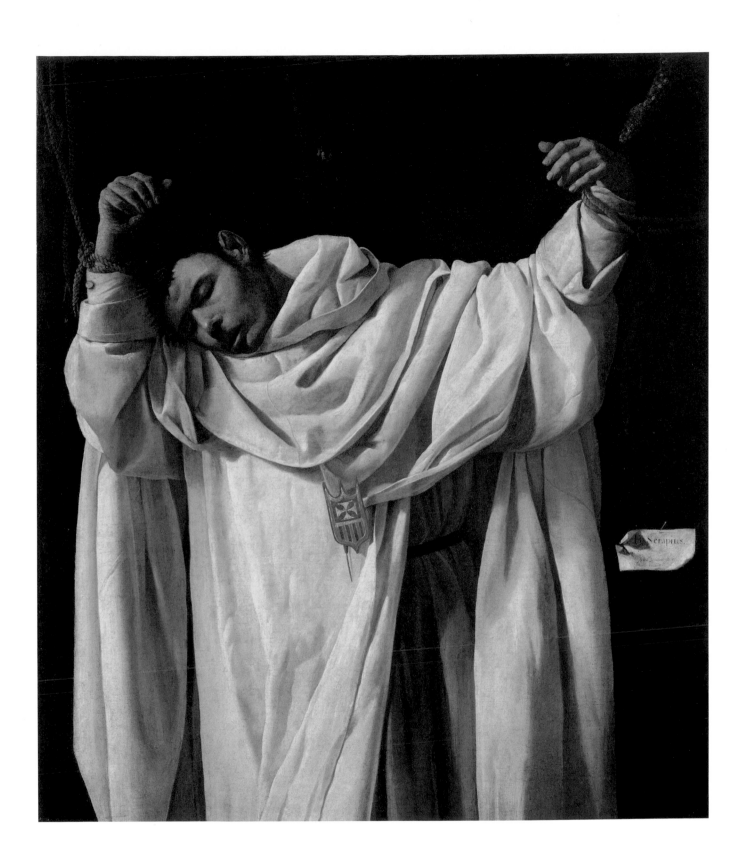

Francisco Pacheco's Letter of Rebuttal to Juan Martínez Montañés

141 Francisco Pacheco (1564–1644), 'A los professores del' Arte de la Pintura' ('To the practitioners of the art of painting'), Seville 1622. First page of Pacheco's letter of rebuttal to Juan Martínez Montañés, 16 July 1622. Biblioteca Nacional de España, Madrid (Mss 1713, fols 283 and 290)

Extracts from Pacheco's Letter

To the Practitioners of the art of Painting (*a reply to Montañés*)

I find myself obliged, because of what I owe to this noble faculty (although the least of its sons), to cast some light on the differences between it and sculpture. This would not be necessary if my book were published. But it is with the greatest modesty possible that I shall speak in this paper, heeding the present circumstances so that part of it may serve as a memorandum to the judges should they deign to do the honour of glancing at it …

[Sections on Antiquity and Nobility of Painting omitted]

The Difference between Painting and Sculpture

But let us come to the difference between these two arts, which is the principal aim. Some have wished to consider them as a single art, since their sole aim is to imitate things, be they artificial, natural or imagined. But the fact is, they have different definitions, and that of painting, which I am obliged to know, can be put this way: Painting is the art that teaches how to imitate with lines and colours, as I explain at great length in the first chapter of my book.

How much more vividly painting imitates, without being dependent on any other art, can be seen in an example. The portrait of the Emperor Charles V will be more easily recognised by all when it is strikingly painted with the colours of a Titian than when made of wood or marble by any sculptor of equal calibre. And so it is with any other image you can name. This is because colour reveals the passions and concerns of the soul with greater vividness. The figure of marble and wood requires the painter's hand to come to life. But painting needs no one's help to do this. Pliny writes of notable examples of the deceptions wrought in antiquity by famous men of this art. And so that you can see how venerable is the practice of great sculptors employing great painters to give their works life, Pliny gives this example. When Praxiteles was asked which of his marbles he liked most, he answered, those on which Nikias has set his hand: hence Nikias painted the sculpture of Praxiteles. The painter works by adding, the sculptor by taking away. The obligations of a painter are much greater, because he imitates all of God's creations – the sky, water, trees, the animals and fish, storms, fires, and so on, with all their different colours. But what the sculptor imitates is limited. Painting is the most universal, most delightful, most spiritual, most useful of all the arts, because almost all the other arts make use of her; and her practitioners have been more notably honoured than those of any art, as can be seen in every age by the favours and praises bestowed upon them. And although this has also happened to sculptors, the ratio is one to a hundred.

Laws governing the Painting of Statuary

It remains to get to our principal point and to finish this discourse by saying something about the Ordinances of Painters drawn up in the times of the Catholic Kings Don Ferdinand and Doña Isabel, those just and holy rulers. The First Ordinance divides painting into four parts and functions, and says that he who has been examined in one may use that one and no others.

The Third says that gilders are not permitted to paint the faces of large-scale figures without being examined in that practice. The Eighth says that the artisan who has been examined in one of the four parts cannot make use of another person examined in the same part to do something in one of the other parts, but can only use one who has been examined in that part. In the Sixteenth it says that he who is only a gilder cannot even apply gilding where there is painting or on sculpture in the round. All of this applies to practitioners of the art of painting, and if they are restricted in this manner, so that they cannot use any part except that in which they have been examined, how much more does it apply to sculptors, carvers and carpenters. And so it says in the Eighteenth Ordinance: 'Moreover, neither master carver nor carpenter shall be allowed to

paint, but only those masters examined in the trade, under pain of punishment', which is 600 *maravedis* for the first offence, 1,200 for the second, and 1,200 *maravedis* and nine days imprisonment for the third. In accordance with these laws, the only way out for Juan Martínez Montañés and the others is to take the examination [for painting], which upon passing it will entitle them to use painting and to accept commissions for it.

Rebuttal of Juan Martínez Montañés

Let us discuss briefly the points he offers in his defence. He says that he hires certified masters for the works and pays them better than do their patrons. Of course if he discovers that the painters he finds do not know how to do the work, then he says that he will teach them. What a lot of nonsense it is for someone who has never learned painting, nor has even studied it, to think that he knows more than those who have spent their whole lives learning the theory and practice of it.

But out of courtesy let us concede that he knows how to teach this skill (which is not so); if the Ordinances, as I have noted, prohibit painters who have not been examined to do this kind of work, why should they permit it to those who have learned another art altogether? And if they fine and punish painters for breaking this law, how much more justified is it to take action against other artists who do not know about painting? [You can just imagine the] righteous indignation with which they [the sculptors] would take action against these same painters if they undertook works of sculpture or carpentry!

But let us suppose . . . that the sculptors were authorised to collaborate with examined painters and to divide the payments so that they could keep whatever they could get for themselves. Would this, by any chance, be legal? Would not this constitute a monopoly of the commissions for the best work around Seville? . . . He [Montañés] does not understand that it is tyranny to distribute 6,000 ducats for the altarpiece of the convent of Santa Clara in this city so that he takes 4,500 ducats for himself, leaving the rest for the poor painter, who deserves as much as himself, according to traditional practice. He will say that the patrons sought him out, asking and begging him to take charge of the whole work, because they trusted him and did not want to be defrauded by the painters. Only God knows why they think this could happen and whether they were persuaded by him to believe this. But once they put their confidence in him he was obliged to find the best masters and this he did not do. Rather he sought out those who would lower their price to allow him a greater share. All this shows the lack of sincerity in the agreements and contracts made under the guise of mutual convenience, when only his is in question.

And if, as he says, he is so eminent that he can teach an art that he has never learned (nor acquired as a gift of God) and instruct the painter, I ask, are the other sculptors, carvers and carpenters of Seville also entitled to do this? Or the others that will come afterwards? Is it justice to break the law for his sake? Or that new laws be made against the common good and against such justified and sacred practices? Or that it is useful and profitable for sculptors and carvers to take care of anything but their wood? One thing is certain, that ever since altarpieces have been made for churches, and works of great importance and expense made by order of the priests for their buildings and monasteries, they have contracted for each part

separately, agreeing upon each thing with the masters examined in sculpture and painting. Thus if any damage or injury occurs, it is only necessary to call the one who was in charge of the particular part. If this arrangement has been altered upon occasion, and the work commissioned from a single sculptor or painter, it has been only because he was a master examined in both the arts and had given public demonstration of his skill.

And although some mercenary or ignorant painters submit (under pressure) to be instructed by him, they have no reason or justification to call him 'master', even though he showed them a thing or two. Because not only can people of good taste instruct mediocre painters, but even humble craftsmen can instruct the greatest artists, as in the case of the shoemaker who enlightened Apelles about the shoes on one of his figures. But he did not become his master on this account. On the contrary, having given stupid advice about correcting other things, he was severely reprimanded by Apelles with the sententious words reported by Pliny in Chapter 10 of the book referred to: *Ne sutor ultra crepidam* (A shoemaker should only judge shoes).

I saw two clever men in my own house point out to a certain sculptor (as highly regarded as Juan Martínez Montañés) a fault that he had made in the tunic of a Saint Jerome in Penitence, saying to him that the collar looked like a leather belt and that the buttons were on the wrong side. And in our presence he brought out his tools and took off the buttons and altered the collar because he agreed that the criticisms were just. But, I ask you, is it fair to call my friends masters of equal skill?

To those who say that painting clothing and faces on sculpture is different from the art of painting, I will not respond because I have already said that it is the same and because our Ordinances explicitly say so. And it would be even greater foolishness to give an intelligent answer to his statement that it is something very different [the painting of sculpture], because it is easier than drawing and painting a picture with a story.

Neither will I set about judging the defects in his works, although those who know in Seville find them even in his most careful productions. Because I am convinced that he is a man like any other and thus it is no wonder that he errs like the rest. For this reason I would counsel my friends to cease praising or damning his works, because he does the former better than anyone while there is no lack of people to do the latter.

And this will suffice to fulfil my obligation to answer the wild imaginings and dreams of Juan Martínez Montañés. On this occasion it has been necessary to expose the truth and to answer for my art, with the guidance of those learned men whose pardon I ask for this extended discussion.

July 16, 1622 (Signed) Francisco Pacheco

Biographies of the Artists

Alonso Cano (1601–1667)

Alonso Cano was a painter, sculptor, designer and architect, hence his nickname, the 'Michelangelo of Spain'. He was born in Granada and is traditionally said to have been trained by Juan Martínez Montañés. He entered Francisco Pacheco's workshop in Seville in 1616 and obtained his diploma as a '*pintor de ymaginería*' ('painter of religious images') in 1626. He worked as court painter in Madrid between 1638 and 1651, and returned to Granada as prebendary to the cathedral in 1652. It was probably during this last period that he produced sculptures carved as well as painted by his own hand.

Gregorio Fernández (1576–1636)

Fernández was one of the most sought after sculptors in Castille, working chiefly in Valladolid, where he is first recorded in 1605. He probably trained there with the sculptor Francisco de Rincón (*c*.1567–1608). He was also influenced by the work of an earlier Valladolid sculptor, Juan de Juni (*c*.1507–1577). Fernández worked mainly in wood, carving figures and reliefs for altarpieces as well as images for processional groups (*pasos*). Some of his iconographic types, such as his *Dead Christ* (see cat. 27), were widely imitated in the seventeenth century. Most of his works were made for churches in Castille and Valladolid and his *Christ at the Column* is still carried through the streets of Valladolid every year on Good Friday.

Francisco Antonio Gijón (*c*.1653–1721)

Gijón was born in Utrera but moved to Seville at a young age. When he was fifteen he enrolled in the Sevillian academy La Lonja and continued to study there even after becoming an apprentice to the sculptor Andrés Cansino. Around this time he was also influenced by Pedro Roldán, whose Baroque style he assimilated. On the death of Cansino he married Cansino's widow, who was fifteen years his senior. By 1671 he was a master sculptor and by 1673 he had set up his own workshop. He was only twenty-one when he made the *Saint John of the Cross* (cat. 17) for the Convent of Nuestra Señora de los Remedios in Seville. Little is known of his later career but during his lifetime he was renowned for the emotional quality and expressive style of his images. His most famous sculpture of the Crucifixion, known as 'El Cachorro', is still processed through the streets of Seville today.

Juan Martínez Montañés (1568–1649)

Montañés was called 'the god of wood' by his contemporaries, so great was his skill in carving. He trained in Seville and in Granada and by 1588 he was established in Seville. In 1635 he was called to Madrid to model a portrait of Philip IV for a bronze equestrian statue of the king. While he was in Madrid Velázquez painted his portrait (cat. 1). Montañés was a deeply religious man and his images conformed to the demands of the Counter-Reformation in their popular realism and didactic character. A number of versions exist of his most famous images such as *The Virgin of the Immaculate Conception* (cats 7 and 9). His *Christ Child* for the Confraternity of the Holy Sacrament was widely imitated by later Andalusian artists.

Pedro de Mena (1628–1688)

Pedro de Mena y Medrano was born in Granada, the son of the sculptor Alonso de Mena. Trained by his father, he later worked with Alonso Cano and then, in 1658, he left Granada for Málaga where he was commissioned to make the choir stalls for the cathedral. This work brought him considerable fame and in 1663 he was made sculptor to Toledo Cathedral. However, he failed in his attempt to become court sculptor (*escultor de cámara*) in Madrid and continued to work mainly in Málaga. Pedro de Mena excelled in the portrayal of contemplative figures and scenes and versions of his sculptures of the *Virgin of Sorrows* (cats 21a and b) and *Christ as the Man of Sorrows* (cat. 20) were much in demand.

Juan de Mesa (1583–1627)

Originally from Córdoba, Juan de Mesa moved to Seville in 1606 and joined the workshop of Montañés, whose style greatly influenced him, although he soon developed his own natural and more expressive manner. He executed his figures with particular attention to anatomical accuracy and it has been suggested that he visited hospitals to study cadavers. He specialised in processional sculpture and was probably more in tune with popular taste than Montañés. Before his early death in 1627 from tuberculosis he produced some of the most expressive sculptures of the period. His moving image of Christ carrying the Cross, known popularly as *Cristo del Gran Poder*, is revered almost as a divine object.

José de Mora (1642–1724)

José de Mora came from a family of sculptors and was active in Granada where he worked with his father and brother until about 1666 when he left for Madrid. In 1672 he was created court sculptor (*escultor de cámara*) in the service of the last Habsburg king of Spain, Charles II. He later returned to Granada but according to Palomino's *Lives of the Artists* he became a recluse and his mental health deteriorated after the death of his wife. He died insane in 1724. Jose de Mora specialised in devotional polychrome sculptures and although many of his works were destroyed during the Spanish Civil War his *Soledad* (*Mourning Virgin*) in the church of Santa Ana, Granada, and the two statues of Saint Bruno in the Charterhouse, Granada, are justly celebrated.

Francisco Pacheco (1564–1644)

Scholar, painter and theorist, Pacheco was one of the leading figures in the Seville art world in the first part of the seventeenth century. Director of an artistic and literary academy, he was the master of Velázquez, who married his daughter in 1618. His *Arte de la Pintura,* written in 1638 and published posthumously in 1649, is one of the most important sources of information about the production of sculpture and painting in Seville. Pacheco painted many of the sculptures of Juan Martínez Montañés and collaborated with him on a number of life-size statues of religious figures. He was particularly interested in religious iconography, notably in that of the Virgin of the Immaculate Conception and of the Crucifixion. The doctrine of the Immaculate Conception was propagated with great fervour in Seville and Pacheco's painting of the subject was widely influential.

Francisco Ribalta (1565–1628)

Ribalta was born in Solsona, Catalonia. Palomino (1655–1726) says he trained in Italy but this remains unproven. He painted mainly religious pictures and was influenced by the Italians whose work he saw at El Escorial, and also by Caravaggio and Sebastiano del Piombo. He settled in Valencia in 1599 and his early work there was very eclectic in style, borrowing from all available sources, including prints by Dürer, but later he found a more sober style. The physicality of his painting of Christ embracing Saint Bernard (cat. 26) may have been influenced by Gregorio Fernández's sculptural representation of the subject. Ribalta visited Madrid in about 1620 and may have seen other polychrome sculptures by Fernández there.

Jusepe de Ribera (1591–1652)

Ribera was born in the small town of Xátiva, near Valencia, and is thought to have first trained with Ribalta (see above), before moving to Italy where he was known as Lo Spagnoletto, 'the little Spaniard'. He is documented as having worked in Parma in 1610–11 and in Rome in 1612 before settling in Naples, which at that time was part of the Spanish dominions and ruled by a succession of Spanish viceroys. By the late 1620s Ribera had become the leading painter in Naples. His *Lamentation over the Dead Christ* (cat. 28), which may have been painted for the Genoese nobleman Marcantonio Doria, is reminiscent of a tableau vivant. His staging of the scene recalls the groups of religious sculptures seen on processional floats during Holy Week. Ribera died in Naples in 1652 without returning to Spain but many of his paintings were brought back by his Spanish patrons.

Diego Velázquez (1599–1660)

Born in Seville, Velázquez trained under his future father-in-law Francisco Pacheco. It is likely that he also received some training there as a painter of sculpture. He probably first met Montañes, whose portrait he later painted (cat. 1), in Pacheco's studio and he may have helped the sculptor with the polychromy of some of his woodcarvings. The influence of sculpture on Velázquez's paintings is apparent in his early *Immaculate Conception* (cat. 8), but the most obviously 'sculptural' of his paintings is his *Christ on the Cross* (fig. 21) of 1633. Velázquez settled permanently in Madrid in 1623 and was made court painter to Philip IV, whose portrait he painted on a number of occasions. He visited Italy twice, in 1629 – a visit of fundamental important for his development as an artist – and again in 1649. In the last years of his life he produced his great masterpiece, *Las Meninas.*

Francisco de Zurbarán (1598–1664)

Born in Extremadura, Zurbarán trained in Seville and established himself in that city in 1626, becoming the preferred artist of the city's religious and civic institutions. Early in his career, before he moved to Seville, he had worked as a polychromer and in 1624 had been commissioned to carve and polychrome a life-size sculpture of the Crucifixion (now lost). One of the reasons for his success was his naturalistic style. Indeed, his painting of Christ on the Cross (cat. 25) was so realistic that it could be mistaken for a three-dimensional work. Zurbarán was the perfect interpreter of the devout Seville of the Counter-Reformation and the painter *par excellence* of saints and the monastic life.

Bibliography

Agulló y Cobo 1978
M. Agulló y Cobo, *Documentos sobre escultores, entalladores y ensambladores de los siglos XVI al XVIII*, Valladolid 1978

Anderson 1998
J.A. Anderson, *Pedro de Mena, Seventeenth-Century Spanish Sculptor*, Lewiston 1998

Angulo Iñiguez 1935
D. Angulo Iñiguez, 'Dos Menas en Méjico. Esculturas sevillanas en América', *Archivo español de arte y arqueología*, XI (1935), pp. 131–52

Angulo Iñiguez 1971
D. Angulo Iñiguez, 'Pintura del siglo XVII', *Ars Hispaniae: historia universal del arte hispánico*, XV, Madrid 1971

Angulo Iñiguez and Pérez Sánchez 1977
D. Angulo Iñiguez and A.E. Pérez Sánchez, *A Corpus of Spanish Drawings: Volume Two: Madrid 1600–1650*, Oxford 1977

Angulo Iñiguez and Pérez Sánchez 1985
D. Angulo Iñiguez and A.E. Pérez Sánchez, *A Corpus of Spanish Drawings: Volume Three: Seville 1600–1650*, Oxford 1985

Antón 1988
L.C. Antón, 'Informe de conservación y restauración del Cristo yacente de Gregorio Fernández', Madrid 1988

Arias Martínez 2000
M. Arias Martínez, 'Una escultura reencontrada procedente del retablo de San Juan Bautista de Juan de Juni', *Boletín del Museo Nacional de Escultura*, 4 (2000), pp. 17–21

Atlanta–Denver–Seattle 2007–8
Inspiring Impressionism: The Impressionists and the Art of the Past, ed. A. Dumas, exh. cat., High Museum of Art, Atlanta, Denver Art Museum, Denver, and Seattle Art Museum, Seattle 2007–8

Aurenhammer 1954
H. Aurenhammer, 'Zwei Werke des Pedro de Mena in Wien', *Alte und neue Kunst*, III (1954), pp. 111–32

Bago y Quintanilla 1930
M. de Bago y Quintanilla, 'Aportaciones documentales' in *Documentos* 1930, pp. 5–104

Barcelona 1998
Zurbarán al Museu Nacional d'Art de Catalunya, ed. M.M. Cuyàs, exh. cat., Museu Nacional d'Art de Catalunya, Barcelona 1998

Barcelona 2005–6
Caravaggio y la pintura realista europea, eds J. Milicua and M.M. Cuyàs, exh. cat., Museu Nacional d'Art de Catalunya, Barcelona 2005–6

Bassett and Alvarez forthcoming
J. Bassett and M.-T. Alvarez, 'Luisa Roldán's *Saint Ginés de la Jara*', forthcoming

Baticle and Marinas 1981
J. Baticle and C. Marinas, *La Galerie espagnole de Louis-Philippe au Louvre: 1838–1848*, Paris 1981

Benito Domenech 1988
F. Benito Domenech, *The Paintings of Ribalta 1565–1628*, New York 1988

Bernales Ballesteros 1973
J. Bernales Ballesteros, *Pedro Roldán: Maestro de escultura (1624–1699)*, Seville 1973

Bernales Ballesteros 1976
J. Bernales Ballesteros, *Alonso Cano en Sevilla*, Seville 1976

Bernales Ballesteros 1982
J. Bernales Ballesteros, *Francisco Antonio Gijón*, Seville 1982

Bernales Ballesteros 1986
J. Bernales Ballesteros, 'Retablos y esculturas' in *Universidad de Sevilla: Patrimonio monumental y artístico: Arquitectura, Escultura, Pintura y Artes ornamentales*, eds T. Falcón Márquez et al., Seville 1986, pp. 63–109

Bernard of Clairvaux (1970)
Bernard of Clairvaux, *Cistercians and Cluniacs: St Bernard's apologia to Abbot William*, trans. M. Casey, Kalamazoo, Mich., 1970

Bilbao 2000–1
Zurbarán: La obra final: 1650–1664, ed. A.E. Pérez Sánchez, exh. cat., Museo de Bellas Artes de Bilbao, Bilbao 2000–1

Blüher 1969
K.A. Blüher, *Séneca en España: Investigaciónes sobre la recepción de Séneca en España desde el siglo XIII hasta el siglo XVII*, Madrid 1969

Boston–Durham 2008
El Greco to Velázquez: Art during the Reign of Philip III, eds S. Schroth and R. Baer, exh. cat., Museum of Fine Arts, Boston, and Nasher Museum of Art, Durham 2008

Bray 2007
X. Bray, 'Demystifying El Greco: The Use of Wax, Clay and Plaster Models' in *El Greco's Studio, Proceedings of the International Symposium, Rethymnon, Crete, 2005*, ed. N. Hadjinicolaou, Iraklion 2007, pp. 323–42

Bray 2007–8
X. Bray, 'Sketches of Spain: The Spanish Old Masters and the French Impressionists' in Atlanta–Denver–Seattle 2007–8, pp. 111–33

Brown 1978
J. Brown, *Images and Ideas in Seventeenth-Century Spanish Painting*, Princeton, New Jersey, 1978

Brown 1986
J. Brown, *Velázquez, Painter and Courtier*, New Haven and London 1986

Brown 1991a
J. Brown, 'Retrato de Juan Martínez Montañés' in *Mirar un cuadro en el Museo del Prado*, eds R. Alberti et al., Madrid 1991, pp. 162–3

Brown 1991b
J. Brown, *The Golden Age of Painting in Spain*, New Haven and London 1991

Brown 1991c
J. Brown, *Zurbarán*, 2nd edn, London 1991

Bruno de Jésus Marie 1929
Bruno de Jésus Marie, *Saint Jean de la Croix*, Paris 1929

Bruno de Jésus Marie 1932
Bruno de Jésus Marie, *Saint Jean de la Croix*, Paris 1932

Bruquetas Galán 2002
R. Bruquetas Galán, *Técnicas y materiales de la pintura española en los siglos de oro*, Madrid 2002

Calvo Castellón 2001
A. Calvo Castellón, 'Alonso Cano en la pintura de sus epígonos próximos y tardíos: evocaciones iconográficas', *Cuadernos de arte de la Universidad de Granada*, XXXII (2001), pp. 45–76

Calvo Serraller 1981
F. Calvo Serraller, *Teoría de la pintura en el Siglo de Oro*, Madrid 1981

Camón Aznar 1972
J. Camón Aznar, *Arte y pensamiento en San Juan de la Cruz*, Madrid 1972

Cano Navas 1984
M.L. Cano Navas, *El convento de San José del Carmen de Sevilla: estudio historico–artístico*, Seville 1984

Cano Rivero 2001
I. Cano Rivero, 'Aportaciones a la Historia de la dispersión del Patrimonio Pictórico en Sevilla 1770–1810', Universidad de Sevilla, 2001

Carriazo 1929
J. de M. Carriazo, 'Correspondencia de don Antonio Ponz con el Conde del Aguila', *Archivo español de arte y arqueología*, V (1929), pp. 157–83

Cascales y Muñoz 1911
J. Cascales y Muñoz, *Francisco de Zurbarán: Su época, su vida y sus obras*, Madrid 1911

Cascales y Muñoz 1918
J. Cascales y Muñoz, *Francisco de Zurbarán: His Epoch, His Life, and His Works*, trans. N.S. Evans, New York 1918

Catálogo 1897
Catálogo de las Pinturas y Esculturas del Museo Provincial de Sevilla, Seville 1897

Caturla 1994
M.L. Caturla, *Francisco de Zurbarán*, ed. and trans. O. Delenda, Paris 1994

Ceán Bermúdez 1800
J.A. Ceán Bermúdez, *Diccionario Histórico de los más ilustres profesores de las Bellas Artes en España*, 6 vols, Madrid 1800

Cendoya Echaniz and Montero Estebas 1993
I. Cendoya Echaniz and P.M. Montero Estebas, 'La influencia de la "vita beati patris ignatii . . ." grabada por Barbé en los ciclos iconográficos de San Ignacio', *Cuadernos de arte e iconografía*, VI, 11 (1993), pp. 386–95

Checa 1983
F. Checa, *Pintura y Escultura del Renacimiento en España, 1450–1600*, Madrid 1983

Cherry 1996
P. Cherry, 'Artistic Training and the Painter's Guild in Seville' in Edinburgh 1996, pp. 67–75

Ciudad Real 2005–6
El arte en la España del Quijote, ed. J. Portús Pérez, exh. cat., Antiguo Convento de la Merced, Ciudad Real 2005–6

Córdoba 1999
La Inmaculada en el arte andaluz, ed. T. Falcón Márquez, exh. cat., Sala de Exposiciones Museísticas CajaSur, Córdoba 1999

Córdoba–Seville 2000–1
Alonso Cano (1601–1667) y la escultura andaluza hacia 1600, exh. cat., Sala de Exposiciones Museísticas CajaSur, Córdoba, and Museo de Bellas Artes, Seville 2000–1

Córdoba–Seville 2001–2
Y murió en la cruz, exh. cat., Sala de Exposiciones Museísticas CajaSur, Córdoba, and Museo de Bellas Artes, Seville 2001–2

Crisógono de Jesús Sacramentado 1946
Crisógono de Jesús Sacramentado, *San Juan de la Cruz*, 2nd edn, Barcelona 1946

Cruz Valdovinos 1985
J.M. Cruz Valdovinos, 'Varia canesca madrileña', *Archivo español de arte*, LVIII (1985), pp. 276–86

Cuartero y Huerta 1950–4
B. Cuartero y Huerta, *Historia de la Cartuja de Santa María de las Cuevas, de Sevilla, y de su filial de Cazalla de la Sierra*, 2 vols, Madrid 1950–4

Cuartero y Huerta 1988
B. Cuartero y Huerta, *Historia de la Cartuja de Santa Maria de las Cuevas, de Sevilla, y de su filial de Cazalla de la Sierra*, 2 vols, Madrid 1988

Cuartero y Huerta 1992
B. Cuartero y Huerta, *Historia de la Cartuja de Santa Maria de las Cuevas de Sevilla, y de su filial de Cazalla de la Sierra. Apendices documentales*, Seville 1992

Cumberland 1782
R. Cumberland, *Anecdotes of Eminent Painters in Spain, during the Sixteenth and Seventeenth Centuries; with Cursory Remarks upon the Present State of Arts in that Kingdom*, 2 vols, London 1782

Dávila Fernández 1980
M. del P. Dávila Fernández, *Los sermones y el arte*, Valladolid 1980

Davillier 1879
Ch. Davillier, *Les arts décoratifs en Espagne au moyen-age et à la renaissance*, Paris 1879

Delenda 1993
O. Delenda, *Velázquez: Peintre religieux*, Geneva 1993

Delenda 2002
O. Delenda, 'Alonso Cano y Francisco de Zurbarán: atribuciones problemáticas' in *Alonso Cano y su época: symposium internacional*, eds E.A. Villanueva Muñoz and M. Córdoba Salmerón, Granada 2002, pp. 117–31

Delenda and Garraín Villa 1998
O. Delenda and L. Garraín Villa, 'Zurbarán Sculpteur: aspects inédits de sa carrière et de sa biographie', *Gazette des Beaux-Arts*, CXXXI (1998), pp. 125–38

Dewez and van Iterson 1956
L. Dewez and A. van Iterson, 'La Lactation de saint Bernard. Légende et iconographie', *Cîteaux in de Nederlanden*, VII (1956), pp. 165–89

Dexter 1986
E.C. Dexter, *The Relationship between the Arts of Painting and Sculpture in Seventeenth-Century Spain, 1600–1675*, 2 vols, M.Phil thesis, Courtauld Institute of Art, London 1986

Documentos 1928
Documentos para la Historia del Arte en Andalucía: Documentos varios, I, Seville 1928

Documentos 1930
Documentos para la Historia del Arte en Andalucía: Documentos varios, II, Seville 1930

Domínguez Ortiz 1970
A. Domínguez Ortiz, *La Sociedad Española en el siglo XVII: El estamento eclesiástico*, II, Madrid 1970

Domínguez 1997
M. Domínguez, 'El proceso de restauración' in *La restauración de los Zurbaranes de la Cartuja*, exh. cat., Museo de Bellas Artes de Sevilla, Seville 1997, pp. 33–41

Duby 1982
G. Duby, *San Bernardo e l'arte cisterciense*, Turin 1982

Duits 2001
R. Duits, *Gold Brocade in Renaissance Painting: an Iconography of riches*, PhD diss., Universiteit Utrecht, Utrecht 2001

Edinburgh 1996
Velázquez in Seville, ed. M. Clarke, exh. cat., National Gallery of Scotland, Edinburgh 1996

Enciclopedia 2006
Enciclopedia del Museo del Prado, 6 vols, Madrid 2006

Enggass and Brown 1970
R. Enggass and J. Brown, *Italy and Spain: 1600–1750: Sources and Documents*, Englewood Cliffs, New Jersey, 1970

Ettinghausen 1972
H.M. Ettinghausen, *Francisco de Quevedo and the Neostoic Movement*, Oxford 1972

Finaldi 1992
G. Finaldi, 'A Documentary Look at the Life and Work of Jusepe de Ribera' in *Jusepe de Ribera: 1592–1652*, eds A.E. Pérez Sánchez and N. Spinosa, exh. cat., The Metropolitan Museum of Art, New York 1992, pp. 3–8

Finaldi 2003
G. Finaldi, *Ribera: la Piedad*, exh. cat., Museo Thyssen–Bornemisza, Madrid 2003

Florisoone 1975
M. Florisoone, *Jean de la Croix: iconographie général*, Brussels 1975

Freedberg 1989
D. Freedberg, *The Power of Images: Studies in the History and Theory of Response*, Chicago 1989

Gállego and Gudiol 1976
J. Gállego and J. Gudiol, *Zurbarán: 1598–1664*, Barcelona 1976

Gálvez 1928
C. Gálvez, 'Dos esculturas de Juan de Mesa en el Colegio de San Luis Gonzaga del Puerto de Santa María' in *Documentos 1928*, pp. 75–6

Gañán Medina 2001
C. Gañán Medina, *Técnicas y evolución de la imaginería polícroma en Sevilla*, 2nd edn (1st edn 1999), Seville 2001

García Chico 1946
E. García Chico, *Documentos para el estudio del Arte en Castilla: Pintores*, III.1, Valladolid 1946

García Gutiérrez 1985
P.F. García Gutiérrez, *Iconografía mercedaria: Nolasco y su obra*, Madrid 1985

Garrido and Gómez Espinosa 1988
M. del C. Garrido and M.T. Gómez Espinosa, 'Estudio técnico comparativo de los dos retratos de la venerable madre Sor Jerónima de la Fuente', *Boletín del Museo del Prado*, IX (1988), pp. 66–76

Garrido 1992
M. del C. Garrido, 'Technical Examination of Pedro de Mena's *Magdalen*' in *Conservation of the Iberian and Latin American Cultural Heritage*, eds H.W.M. Hodges, J.S. Mills, and P. Smith, London 1992, pp. 42–5

Geneva 1989
Du Greco à Goya: Chefs d'oeuvre du Prado et des collections espagnoles; 50. anniversaire de la sauvegarde du patrimoine artistique espagnol: 1939–1989, ed. A. E. Pérez Sánchez, exh. cat., Musée d'art et d'histoire, Geneva 1989

Gestoso y Pérez 1912
J. Gestoso y Pérez, *Catálogo de las Pinturas y Esculturas del Museo Provincial de Sevilla*, Seville 1912

Gila Medina 2007
L. Gila Medina, *Pedro de Mena: escultor, 1628–1688*, Madrid 2007

Gómez González et al. 2002
M. Gómez González et al., 'Estudio analítico de la policromía castellana del siglo XVII' in *Policromía*, Lisbon 2002, 228–9

Gómez Imaz 1917
M. Gómez Imaz, *Inventario de los cuadros sustraídos por el gobierno intruso en Sevilla el año de 1810*, 2nd edn (1st edn 1896), Seville 1917

Gómez-Moreno 1916
M. Gómez-Moreno, 'El Cristo de San Plácido. Pacheco se cobra de un descubierto que tenían con él Velázquez, Cano y Zurbarán', *Boletín de la Sociedad Española de Excursiones*, XXIV (1916), pp. 177–88

Gómez-Moreno 1926
M.E. Gómez-Moreno, 'Alonso Cano, escultor', *Archivo español de arte y arqueologia*, II (1926), pp. 177–214

Gómez-Moreno 1942
M.E. Gómez-Moreno, *Juan Martínez Montañés*, Barcelona 1942

Gómez-Moreno 1951
M.E. Gómez-Moreno, *Breve historia de la escultura española*, 2nd edn (1st edn 1935), Madrid 1951

Gómez-Moreno 1953
M.E. Gómez-Moreno, *Gregorio Fernández*, Madrid 1953

Gómez-Moreno 1963
M.E. Gómez-Moreno, 'Escultura del siglo XVII', *Ars Hispaniae*, XVI, Madrid 1963

Gómez-Moreno 1964
M. Gómez-Moreno, *The Golden Age of Spanish Sculpture*, Greenwich, Conn.,, 1964

Gómez Piñol 2000
E. Gómez Piñol, *La iglesia colegial del Salvador: arte y sociedad en Sevilla (siglos XIII al XIX)*, Seville 2000

Gómez Piñol 2003
E. Gómez Piñol, 'Nuevas atribuciones e hipótesis sobre la evolución de la escultura Sevilla de principios del siglo XVII' in *Juan de Mesa (1627–2002): visiones y revisiones: Actas de la III Jornadas de Historia del Arte, Córdoba–La Rambla, 28, 29 y 30 de noviembre de 2002*, eds A. Villar Movellán and A. Urquízar Herrera, Córdoba 2003, pp. 61–107

González Asenjo 2005
E. González Asenjo, *Don Juan José de Austria y las artes (1629–1679)*, Madrid 2005

González de León (1973)
F. González de León, *Noticia artística de todos los edificios públicos de esta muy noble ciudad de Sevilla*, 2 vols, Seville 1973 (1st edn 1844)

Granada 1968
III Centenario de la muerte de Alonso Cano en Granada, exh. cat., Hospital Real de Granada, Granada 1968

Granada 1995
Imágenes de San Juan de Dios, exh. cat, Orden Hospitalaria de San Juan de Dios, Hospital Real, Granada 1995

Granada 2001–2
Alonso Cano: Espiritualidad y modernidad artistica, IV centenario Alonso Cano, ed. I. Henares Cuéllar, exh. cat., Hospital Real, Granada 2001–2

Granada 2002
Alonso Cano: arte e iconografía, exh. cat., Museo Diocesano Alonso Cano, Granada 2002

Güell y Jover 1925
E. Güell y Jover, *La sculpture polychrome religieuse espagnole: Une collection*, Paris 1925

Guinard 1947
P. Guinard, 'Los conjuntos dispersos o desaparecidos de Zurbarán: anotaciones a Ceán Bermúdez (II)', *Archivo español de arte*, XX (1947), pp. 161–201

Guinard 1960
P. Guinard, *Zurbarán et les peintres espagnols de la vie monastique*, Paris 1960

Hardá Muxica 1727
A.A. de Hardá Muxica, *El nuevo machabeo del Evangelio y cavallero de Christo, San Serapio mártyr, del Re. y militar Orden de ntra. Sra. de la Merced*, Madrid 1727

Harris 1982
E. Harris, *Velazquez*, Oxford 1982

Hellwig 1999a
K. Hellwig, *La literatura artística española del siglo XVII*, Madrid 1999

Hellwig 1999b
K. Hellwig, 'Ut pictura sculptura: Zu Velázquez' Porträt des Bildhauers Montañés', *Zeitschrift für Kunstgeschichte*, LXII (1999), pp. 298–319

Hélyot and Bullot 1714–19
P. Hélyot and M. Bullot, *Histoire des ordres monastiques, religieux et militaires, et des congrégations séculières de l'un et de l'autre sexe, qui ont esté establies jusqu'à présent; contenant les vies de leurs fondateurs . . . avec des figures qui représentent tous les différens habillemens, etc.*, 8 vols, Paris 1714–19

Hernández Díaz 1928
J. Hernández Díaz, 'Documentos varios (continuación)' in *Documentos* 1928, pp. 145–63

Hernández Díaz 1942
J. Hernández Díaz, *La Universidad Hispalense y sus obras de arte*, Seville 1942

Hernández Díaz 1949
J. Hernández Díaz, *Juan Martínez Montañés*, Seville 1949

Hernández Díaz 1967
J. Hernández Díaz, *Museo Provincial del Museo de Bellas Artes de Sevilla*, Madrid 1967

Hernández Díaz 1972
J. Hernández Díaz, *Juan de Mesa: Escultor de imaginería (1583–1627)*, Seville 1972

Hernández Díaz 1976
J. Hernández Díaz, *Juan Martínez Montañés: El Lisipo andaluz (1568–1649)*, Seville 1976

Hernández Díaz 1983
J. Hernández Díaz, *Juan de Mesa*, Seville 1983

Hernández Díaz 1987
J. Hernández Díaz, *Juan Martínez Montañés (1568–1649)*, Seville 1987

Hernández Perera 1954
J. Hernández Perera, 'Iconografía española. El Cristo de los Dolores', *Archivo español de arte*, XXVII (1954), pp. 47–62

Hornedo 1968
R. Hornedo, 'Martínez Montañés y los jesuitas', *Razón y Fe*, 178 (1968), pp. 463–76

Izquierdo and Muñoz 1990
V. Izquierdo and R. Muñoz, *Museo de Bellas Artes de Sevilla. Inventario de pinturas*, Seville 1990

Jacobs 1998
L.F. Jacobs, *Early Netherlandish Carved Altarpieces, 1380–1550: Medieval Tastes and Mass Marketing*, Cambridge 1998

Jáuregui 1618
J. de Jáuregui, 'Diálogo entre la naturaleza y las dos artes, pintura y escultura, de cuya preminencia se disputa y juzga. Dedicado a los práticos y teóricos en estas artes' in Calvo Serraller 1981, pp. 151–6

Junquera de Vega and Ruíz Alcón 1961
P. Junquera de Vega and M.T. Ruíz Alcón, *Monasterio de las Descalzas reales: guia turistica*, Madrid 1961

Justi 1888
C. Justi, *Diego Velazquez und sein Jahrhundert*, 2 vols, Bonn 1888

Kamen 1993
H. Kamen, *The Phoenix and the Flame: Catalonia and the Counter Reformation*, New Haven, Conn., 1993

Kamen 1998
H. Kamen, *Cambio cultural en la sociedad del siglo de oro: Cataluña y Castilla, siglos XVI–XVII*, Madrid 1998

Kasl 1993–4
R. Kasl, 'Painters, Polychromy and the Perfection of Images' in New York–Dallas–Los Angeles 1993–4, pp. 39–41

Katz 2002
M.R. Katz, 'Architectural Polychromy and the Painter's Trade in Medieval Spain', *Gesta*, XLI, 1 (2002), pp. 3–14

Kehrer 1918
H. Kehrer, *Francisco de Zurbarán*, Munich 1918

Kehrer 1920–1
H. Kehrer, 'Neues über Francisco de Zurbarán', *Zeitschrift für bildende Kunst*, LV (1920–1), pp. 248–52

Keith and Carr 2009
L. Keith and D.W. Carr, 'Velázquez's *Christ after the Flagellation*: Technique in Context', *National Gallery Technical Bulletin*, 30 (2009), pp. 52–70

Kowal 1981
D.M. Kowal, *The Life and Art of Francisco Ribalta (1565–1628)*, 3 vols, PhD diss., University of Michigan, Ann Arbor 1981

Larios Larios 2002
J. M. Larios Larios, *San Juan de Dios: la imagen del santo de Granada*, Albolote (Granada) 2002

London 1996
Old Master Drawings from the Malcolm Collection, eds M. Royalton-Kisch, H. Chapman and S. Coppel, exh. cat., British Museum, London 1996

London 2000
The Image of Christ, ed. G. Finaldi, exh. cat., National Gallery, London 2000

London 2005
Caravaggio: The Final Years, eds N. Spinosa et al., exh. cat., National Gallery, London 2005

London 2006–7
Velázquez, ed. D.W. Carr, exh. cat., National Gallery, London 2006–7

London 2009
Baroque 1620–1800: Style in the Age of Magnificence, eds M. Snodin, N. Llewellyn and J. Norman, exh. cat., Victoria and Albert Museum, London 2009

López-Guadalupe Muñoz 2002
M.L. López-Guadalupe Muñoz, 'Las cofradías y su dimensión social en la España del Antiguo Régimen' in *La represión de la religiosidad popular: Crítica y acción contra las Cofradías en la España del siglo XVIII*, eds I. Arias de Saavedra Alías and M.L. López-Guadalupe Muñoz, Granada 2002, pp. 49–103

López Martínez 1928a
C. López Martínez, *Arquitectos, Escultores y Pintores Vecinos de Sevilla*, Seville 1928

López Martínez 1928b
C. López Martínez, *Retablos y Esculturas de Traza Sevillana*, Seville 1928

López Martínez 1928c
C. López Martínez, 'Testimonios para la biografía de Juan Martínez Montañés' in *Documentos* 1928, pp. 211–30

López Martínez 1932
C. López Martínez, *Desde Martínez Montañes hasta Pedro Roldán*, Seville 1932

López Martínez 1935
C. López Martínez, 'Montañés y Pacheco en El Pedroso', *El Liberal*, 15/1/1935, n. p.

López-Rey 1996
J. López-Rey, *Velázquez: Catalogue Raisonné*, 2 vols, Cologne 1996

Loyola 1996
Saint Ignatius of Loyola, *Personal Writings: Reminiscences, Spiritual Diary, Select Letters including the Text of The Spiritual Exercises*, eds and trans. J.A Munitiz and P. Endean, London 1996

Luque Fajardo 1610
F. de Luque Fajardo, *Relación de la fiesta que se hizo en Sevilla a la beatificación del glorioso San Ignacio*, Seville 1610

MacLaren and Braham 1970
N. MacLaren and A. Braham, *National Gallery Catalogues: The Spanish School*, 2nd edn, revised, London 1970

Madrid 1969
Martínez Montañéz (1568–1649) y la escultura andaluza de su tiempo, ed. J. Hernández Díaz, exh. cat., Cason del Buen Retiro, Madrid 1969

Madrid 1981–2
El arte en la época de Calderón, exh. cat., Palacio de Velázquez, Parque del Retiro, Madrid 1981–2

Madrid 1988
Zurbarán, eds S. Saavedra and J.M. Serrera, exh. cat., Museo del Prado, Madrid 1988

Madrid 1990
Velázquez, eds A. Domínguez Ortiz, A.E. Pérez Sánchez and J. Gállego, exh. cat., Museo del Prado, Madrid 1990

Madrid 1999–2000
Gregorio Fernández 1576–1636, ed. J. Urrea Fernández, exh. cat., Fundación Santander Central Hispano, Madrid 1999–2000

Madrid 2004–5
El retrato español: del Greco a Picasso, ed. J. Portús Pérez, exh. cat., Museo del Prado, Madrid 2004–5

Madrid 2007–8
Fábulas de Velázquez: Mitología e historia sagrada en el Siglo de Oro, ed. J. Portús Pérez, exh. cat., Museo del Prado, Madrid 2007–8

Málaga 1989
Pedro de Mena: III centenario de su muerte: 1688–1988, ed. D. Sánchez-Mesa Martin, exh. cat., Catedral de Málaga, Málaga 1989

Malibu 2008
The Color of Life: Polychromy in Sculpture from Antiquity to the Present, ed. R. Panzanelli, exh. cat., Getty Villa, Malibu 2008

Mármol Marín 1993
M.D. Mármol Marín, 'Cuatro imágines de la iconografía carmelitana en la escultura barroca andaluza', *Cuadernos de arte e iconografía*, VI, 12 (1993), pp. 22–8

Martín González 1980
J.J. Martín González, *El escultor Gregorio Fernández*, Madrid 1980

Martínez Blanes, Muñoz Rubio and de la Paz Calatrava 2001
J.M. Martínez Blanes, M. del V. Muñoz Rubio and F. de la Paz Calatrava, 'Estudio científico de muestras procedentes de pinturas de Francisco de Zurbarán en el Museo de Bellas Artes de Sevilla' in *III Congreso Nacional de Arqueometría*, Seville 2001, pp. 159–69

Martínez-Burgos García 1990
P. Martínez-Burgos García, *Ídolos e imágenes: La controversia del arte religioso en el siglo XVI español*, Valladolid 1990

Martínez Chumillas 1948
M. Martínez Chumillas, *Alonso Cano: Estudio monográfico*, Madrid 1948

Martínez Ripoll 1983
A. Martínez Ripoll, 'El San Juan Evangelista en la isla de Patmos, de Velázquez, y las fuentes e inspiración iconografica', *Aréas, Revista de Ciencias Sociales*, 3–4 (1983), pp. 201–8

McKim-Smith 1993–4
G. McKim-Smith, 'Spanish Polychrome Sculpture and its Critical Misfortunes' in *Spanish Polychrome Sculpture 1500–1800 in United States Collections*, ed. S.L. Stratton, exh. cat., Queen Sofia Spanish Institute, New York, Meadows Museum, Dallas, and Los Angeles County Museum of Art, Los Angeles 1993–4, pp. 13–31

Meditations **(1961)**
Meditations on the Life of Christ. An Illustrated Manuscript of the Fourteenth Century, Paris, Bibliothèque Nationale, MS. Ital. 115, trans. I. Ragusa and eds I. Ragusa and R.B. Green, Princeton, New Jersey, 1961

Mélida 1928
J.R. Mélida, 'Magdalena–Museo del Prado' in *Pedro de Mena escultor: homenaje a su tercer centenario 1628–1928*, Málaga 1928, n. p.

Meyer 1945
F.S. Meyer, *A Handbook of Ornament*, Chicago 1945 (1st edn 1896)

Milicua 1953
J. Milicua, 'El Crucifijo de San Pablo, de Zurbarán', *Archivo español de arte*, XXVI (1953), pp. 177–86

Moffitt 1992
J.F. Moffitt, 'The Meaning of "Christ After the Flagellation" in Siglo de Oro Sevillian Painting', *Wallraf-Richartz-Jahrbuch*, LIII (1992), pp. 139–54

Morón de Castro 2004
M.F. Morón de Castro, *Patrimonio Artístico de la Universidad de Sevilla*, Seville 2004

Mulcahy 2008
R. Mulcahy, 'Images of Power and Salvation' in Boston–Durham 2008, pp. 123–45

Müller 1966
T. Müller, *Sculpture in The Netherlands, Germany, France, and Spain: 1400 to 1500*, trans. E. and W. Robson-Scott, Harmondsworth, Middlesex, 1966

Murcia 2003
Nicolás de Bussy, ed. M.C. Sánchez-Rojas Fenoll, exh. cat., Palacio Almudí, Murcia 2003

Murcia 2008–9
Ecos de Miguel Angel en el Legado Gómez-Moreno, ed. J. Moya Morales, exh. pamphlet, Cajamurcia Belluga, Murcia 2008–9

Nancarrow Taggard 1998
M. Nancarrow Taggard, 'Luisa Roldán's Jesus of Nazareth: The Artist as Spiritual Medium', *Woman's Art Journal*, XIX, 1 (1998), pp. 9–15

Nash 2005
S. Nash, 'Claus Sluter's "Well of Moses" for the Chartreuse de Champmol Reconsidered: Part I', *Burlington Magazine*, CXLVII (2005), pp. 798–809

Nash 2006
S. Nash, 'Claus Sluter's "Well of Moses" for the Chartreuse de Champmol Reconsidered: Part II', *Burlington Magazine*, CXLVIII (2006), pp. 456–67

Nash 2008
S. Nash, 'Claus Sluter's "Well of Moses" for the Chartreuse de Champmol Reconsidered: Part III', *Burlington Magazine*, CL (2008), pp. 724–41

Navarrete Prieto 1998
B. Navarrete Prieto, *La pintura andaluza del siglo XVII y sus fuentes grabadas*, Madrid 1998

Navarrete Prieto 2005
B. Navarrete Prieto, 'El Vignola del Colegio de Arquitectos de Valencia y sus retablos de traza Sevillana: Juan Martínez Montañés', *Archivo español de arte*, LXXVIII (2005), pp. 235–44

Navarrete Prieto 2009a
B. Navarrete Prieto, 'Nueva incorporación a la Colección permanente del *Centro Velázquez*', *Noticias-Fundación Fondo de Cultura de Sevilla*, 80 (2009), pp. 1–2

Navarrete Prieto 2009b
B. Navarrete Prieto, 'Velázquez y Sevilla: La Inmaculada del Deán López Cerero recuperada', *Ars Magazine*, II, 3 (2009), pp. 101–17

New York 1987
Zurbarán, ed. J. Baticle, exh. cat., The Metropolitan Museum of Art, New York 1987

New York 1989–90
Velázquez, eds A. Domínguez Ortíz, A.E. Pérez Sánchez and J. Gállego, exh. cat., The Metropolitan Museum of Art, New York 1989–90

New York 2003
Manet/Velázquez: The French Taste for Spanish Painting, eds G. Tinterow and G. Lacambre, exh. cat., The Metropolitan Museum of Art, New York 2003

Núñez Beltrán 2000
M.A. Núñez Beltrán, *La oratoria sagrada de la época del barroco: doctrina, cultura y actitud ante la vida desde los sermones sevillanos del siglo XVII*, Seville 2000

Okada 1991
H. Okada, 'La forma de trabajo de los pintores sevillanos en la época de Velázquez: una aproximación' in *Velázquez y el arte de su tiempo*, Madrid 1991, pp. 233–8

Ordenanzas de Sevilla 1632
Ordenanzas de Sevilla, que por su original son aora nuevamente impresas, con licencia del señor Asistente, Seville 1632

Orso 1989
S.N. Orso, 'A note on Montañés's lost Bust of Philip IV', *Source: Notes in the History of Art*, VIII, 2 (1989), pp. 21–4

Orueta y Duarte 1914
R. de Orueta y Duarte, *La vida y la obra de Pedro de Mena y Medrano*, Madrid 1914

Pacheco 1649 (1956)
F. Pacheco, *Arte de la Pintura*, ed. F.J. Sánchez Cantón, 2 vols, Madrid 1956

Pacheco 1649 (1990)
F. Pacheco, *Arte de la Pintura*, ed. B. Bassegoda i Hugas, Madrid 1990

Pacheco 1649 (2001)
F. Pacheco, *Arte de la Pintura*, ed. B. Bassegoda i Hugas, 2nd edn, Madrid 2001

Palomero Páramo 1983
J.M. Palomero Páramo, *El retablo sevillano del Renacimiento: análisis y evolución (1560–1629)*, Seville 1983

Palomero Páramo 1992
J.M. Palomero Páramo, 'El Cristo de la Clemencia', *ABC*, 21 June 1992, p. 94

Palomino 1715–24
A.A. Palomino de Castro y Velasco, *El museo pictórico y escala óptica*, 3 vols, Madrid 1715–24

Palomino 1715–24 (1947)
A.A. Palomino de Castro y Velasco, *El museo pictórico y escala óptica*, ed. J.A. Céan y Bermudez, Madrid 1947

Palomino 1715–24 (1987)
A.A. Palomino de Castro y Velasco, *Lives of the Eminent Spanish Painters and Sculptors*, trans. N. Ayala Mallory, Cambridge 1987

Pareja López et al. 2006
E.F. Pareja López et al., *Juan de Mesa: Grandes Maestros Andaluces*, Seville 2006

Passolas Jáuregui and López-Fé Figueroa 2008
J. Passolas Jáuregui and C.M. López-Fé Figueroa, *Juan Martínez Montañés*, 2 vols, Seville 2008

Pemán 1963
C. Pemán, *Zurbarán y otros estudios sobre pintura del XVII español*, Madrid 1963

Penny 1993
N. Penny, *The Materials of Sculpture*, New Haven and London 1993

Pérez Escolano 1982
V. Pérez Escolano, 'El convento de la Merced Calzada de Sevilla a la luz de la *Relación* de Fray Juan Guerrero (mediados del siglo XVII) y la planta aproximada de 1835' in *Homenaje al Profesor Hernández Díaz*, I, Seville 1982, pp. 545–61

Pérez Sánchez 1992
A.E. Pérez Sánchez, 'Trampantojos "a lo divino"', *Lecturas de historia del arte*, III (1992), pp. 139–55

Pérez Sánchez 1999a
A.E. Pérez Sánchez, 'La Pintura de Alonso Cano' in *Figuras e imágenes del barroco: estudios sobre el barroco español y sobre la obra de Alonso Cano*, Madrid 1999, pp. 213–36

Pérez Sánchez 1999b
A.E. Pérez Sánchez, 'Novedades Velázqueñas', *Archivo español de arte*, LXXII (1999), pp. 371–90

Pérez Sánchez 1999c
A.E. Pérez Sánchez, 'Zurbarán, Cano y Velázquez' in *Zurbarán ante su centenario [1598–1998]: Textos de las ponencias presentadas en el Seminario de Historia de Arte: En Soria del 21 al 25 de julio de 1997*, ed. A.E. Pérez Sánchez, Valladolid 1999, pp. 101–14

Pérez Sánchez 2000–1
A.E. Pérez Sánchez, 'El Último Zurbarán' in Bilbao 2000–1, pp. 15–37

Plaza Santiago 1973
F.J. de la Plaza Santiago, 'El pueblo natal de Gregorio Fernández', *Boletín del Seminario de Estudios de Arte y Arqueología*, XXXIX (1973), pp. 505–9

Pliny the Elder (1876)
Pliny the Elder, *The Elder Pliny's Chapters on the History of Art*, trans. K. Jex-Blake, London 1876

Ponz 1779
A. Ponz, *Viage de España, en que se da noticia De las cosas mas apreciables, y dignas de saberse, que hay en ella*, t. IV, 2nd edn, Madrid 1779

Ponz 1780
A. Ponz, *Viage de España, en que se da noticia De las cosas mas apreciables, y dignas de saberse, que hay en ella*, t. IX, Madrid 1780

Ponz 1784
A. Ponz, *Viage de España, en que se da noticia De las cosas mas apreciables, y dignas de saberse, que hay en ella*, t. VIII, 2nd edn, Madrid 1784

Portús Pérez 1990
J. Portús Pérez, 'Los poemas de Bances Candamo dedicados a la *Magdalena* de Pedro de Mena' in *Pedro de Mena y su Epoca*, Simposio Nacional, Málaga 1990, pp. 585–600

Proske 1967
B.G. Proske, *Juan Martínez Montañés: Sevillian Sculptor*, New York 1967

Réau 1958
L. Réau, *Iconographie de L'Art Chrétien: Tome III: Iconographie des Saints, I, A-F*, Paris 1958

Redondo Álvarez et al. 2009
M. Redondo Álvarez, M. Fernández de Córdoba, T. Antelo, A. Gabaldón, M. Bueso and A. Anaya, 'Estudio y restauración de la talla de San Francisco de Asís en el IPCE', Madrid 2009

Remón 1618
A. Remón, *Historia general de la Orden de Nra. Sª de la Merced*, 2 vols, Madrid 1618

Ribadeneyra 1669
P. de Ribadeneyra, *The lives of saints with other feasts of the year according to the Roman calendar*, trans. W. Petre, 2 vols, St Omer 1669

Richter, Schäfer and van Loon 2005
M. Richter, S. Schäfer and A. van Loon, 'El tratado Arte de la Pintura de Francisco Pacheco y su influencia en la técnica de ejecución de las encarnaciones en la escultura Alemana del siglo XVIII: Primeros resultados obtenidos de análisis avanzados realizados en micromuestras' in *Investigación en Conservación y Restauración, II Congreso del Grupo Español de IIC*, Barcelona 2005, pp. 225–34

Robinson 1876
J.C. Robinson, *Descriptive Catalogue of Drawings by the Old Masters, Forming the Collection of John Malcolm of Poltalloch, Esq.*, 2nd edn (1st edn 1869), London 1876

Rocca 1609
A. Rocca, *De particula ex pretioso et vivifico ligno sacratissimae crucis Salvatoris Iesu Christi desumpta, sacris imaginibus et elogiis eodem ligno incisis insignita, et in Apostolico Sacrario asservata commentarius*, Rome 1609

Rocca 1719
A. Rocca, *F. Angeli Rocca camertis ordinis s. Augustini apostolici sacrarii praefecti, ac episcopi Tagasten opera omnia*, 2 vols, Rome 1719

Roda Peña 2003
J. Roda Peña, *Francisco Antonio Ruiz Gijón: escultor utrerano*, Utrera 2003

Roda Peña 2005
J. Roda Peña, 'A "St John of the Cross" attributed to Francisco Antonio Gijón: a recent acquisition at the National Gallery of Art, Washington', *Burlington Magazine*, CXLVII (2005), pp. 304–9

Rodríguez G. de Ceballos 1984
A. Rodríguez G. de Ceballos, 'La repercusión en España del decreto del Concilio de Trento acerca de las imágenes sagradas y las censuras al Greco' in *El Greco: Italy and Spain*, eds J. Brown and J. M. Pita Andrade, Washington 1984, pp. 153–8

Rodríguez G. de Ceballos 1990
A. Rodríguez G. de Ceballos, 'La literatura ascética y la oratoria cristiana reflejadas en el arte de la Edad Moderna: el tema de la Soledad de la Virgen', *Lecturas de Historia del Arte*, II (1990), pp. 80–91

Rodríguez G. de Ceballos 1991
A. Rodríguez G. de Ceballos, 'Fuentes literarias e iconográficas del cuadro de Velázquez *Cristo y el alma cristiana*', *Cuadernos de arte e iconografía*, IV, 8 (1991), pp. 82–91

Rodríguez G. de Ceballos 2002
A. Rodríguez G. de Ceballos, 'Juan de Mesa y la Compañía de Jesús. La espiritualidad tridentina' in *Juan de Mesa (1607–2002). Visiones y revisiones*, Córdoba 2002, pp. 227–48

Rodríguez G. de Ceballos 2004
A. Rodríguez G. de Ceballos, 'El Cristo Crúcificado de Velázquez: trasfondo histórico–religioso', *Archivo español de arte*, LXXVII (2004), pp. 5–19

Ruano Santa Teresa 1993
P. Ruano Santa Teresa, *La V. M. Sor Jerónima de la Asunción: Fundadora del Monasterio de Santa Clara de Manila y primera mujer misionera en Filipinas*, Madrid 1993

Ruiz Martín 1983
F. Ruiz Martín, 'La población española al comienzo de los tiempos modernos' in B. Bennassar, *La España del Siglo de Oro*, Barcelona 1983, pp. 194–202

Rzepińska 1986
M. Rzepińska, 'Tenebrism in Baroque Painting and Its Ideological Background', *Artibus et historiae*, VII, 13 (1986), pp. 91–112

Saint John of the Cross (1935)
Saint John of the Cross, *The Complete Works of Saint John of the Cross*, ed. and trans. E. Allison Peers, 3 vols, London 1935

Saint-Saëns 1995
A. Saint-Saëns, *Art and Faith in Tridentine Spain (1545–1690)*, New York 1995

Salamanca 1993–4
Las Edades del Hombre: El contrapunto y su morada, ed. J.E. Velicia Berzosa, exh. cat., Salamanca 1993–4

Salazar 1928
C. Salazar, 'El testamento de Francisco Pacheco', *Archivo español de arte y arqueologia*, IV (1928), pp. 155–60

Salazar 1949
M.D. Salazar, 'Pedro Roldán, escultor', *Archivo español de arte*, XXII (1949), pp. 317–39

San Juan de la Cruz (2003)
San Juan de la Cruz, *Obras Completas*, eds L. López-Baralt and E. Pacho, 2 vols, Madrid 2003

Sánchez Cantón 1926
F.J. Sánchez Cantón, *San Francisco de Asís en la Escultura Española*, Madrid 1926

Sánchez Cantón 1941
F.J. Sánchez Cantón, *Fuentes literarias para la historia del arte español*, V, Madrid 1941

Sánchez Cantón 1942a
F.J. Sánchez Cantón, 'Cómo vivía Velázquez', *Archivo español de arte*, XV (1942), pp. 69–91

Sánchez Cantón 1942b
F.J. Sánchez Cantón, 'Gregorio Fernández y Francisco Ribalta', *Archivo español de arte*, XV (1942), pp. 147–50

Sánchez Cantón 1961
F.J. Sánchez Cantón, 'Sobre el "Martínez Montañés" de Velázquez', *Archivo español de arte*, XXXIV (1961), pp. 25–30

Sánchez Guzmán 2008
R. Sánchez Guzmán, *El escultor Manuel Pereira (1588–1683)*, Madrid 2008

Sánchez Lora 1988
J.L. Sánchez Lora, *Mujeres, conventos y formas de la religiosidad barroca*, Madrid 1988

Sánchez-Mesa Martín 1971
D. Sánchez-Mesa Martín, *Técnica de la escultura policromada granadina*, Granada 1971

Sánchez-Mesa Martín 1991
D. Sánchez-Mesa Martín, *Historia del arte en Andalucía: El arte del Barroco: Escultura-pintura y artes decorativas*, VII, Seville 1994

Sánchez-Mesa Martín 2001
D. Sánchez-Mesa Martín, 'Lo múltiple en Alonso Cano escultor', *Archivo español de arte*, LXXIV (2001), pp. 345–74

Schmucki 1978
O. Schmucki, 'Prayer and Contemplation in the Legislation and the Life of the First Capuchins: The Capuchin Reform: Essays in commemoration of its 450th anniversary, 1528–1978', *Analecta Ordinis Fratrum Minorum Capuccinorum*, XCIV, 5 (1978), pp. 75–96

Schneider 1905
F. Schneider, 'Mathias Grünewald et la mystique du moyen age', *Revue de l'art chrétien*, 48 (1905), pp. 92–4 and 157–8

Sebastián 1975
S. Sebastián, 'Zurbarán se inspiró en los grabados del aragonés Jusepe Martínez', *Goya: Revista de Arte*, 128 (1975), pp. 82–4

Serra y Pickman 1934
C. Serra y Pickman, *Discursos leídos ante la Academia de Bellas Artes de Santa Isabel de Hungría de Sevilla por D. Carlos Serra y Pickman, Marqués de San José de Serra, y D. José Hernández Díaz en la recepción pública del primero: estudio histórico de los cuadros de la Cartuja de Santa María de las Cuevas*, Seville 1934

Serrano y Ortega 1893
M. Serrano y Ortega, *Glorias sevillanas: noticia histórica de la devoción y culto que la ciudad de Sevilla ha profesado a la Inmaculada Concepción de la Virgen María, desde los tiempos de la Antigüedad hasta la presente época*, Seville 1893

Serrera 1986
J.M. Serrera, 'Alonso Cano y los Guzmanes', *Goya: Revista de Arte*, 192 (1986), pp. 336–47

Seville 1992
La Iglesia en América: Evangelización y Cultura, exh. cat., Pabellón de la Santa Sede, Exposición Universal de Sevilla, Seville 1992

Seville 1998
Zurbarán: IV centenario, ed. E. Valdivieso, exh. cat., Museo de Bellas Artes de Sevilla, Seville 1998

Seville 1999
Velázquez y Sevilla, ed. J.M. Serrera, exh. cat., Monasterio de la Cartuja de Santa María de las Cuevas, Seville 1999

Seville 2004
Inmaculada: 150 años de la proclamación del dogma, ed. E. Pareja López, exh. cat., Santa Iglesia Catedral Metropolitana, Seville 2004

Seville 2007
Antigüedad y Excelencias, eds I. Henares Cuéllar and R. López Guzmán, exh. cat., Museo de Bellas Artes, Seville 2007

Seville–Bilbao 2005–6
De Herrera a Velázquez: El primer naturalismo en Sevilla, eds A.E. Pérez Sánchez and B. Navarrete Prieto, exh. cat., Hospital de los Venerables, Seville, and Museo de Bellas Artes, Bilbao 2005–6

Solís 1755
A. de Solís, *Los dos espejos que representan los dos siglos que han pasado de la fundación de la Casa Profesa de la Compañía de Jesús en Sevilla y sujetos que han florecido y muerto en ella con las noticias historiales de cada año que á ella pertenecen y que expone á la vista de todos*, Seville 1755

Soria 1953
M.S. Soria, *The Paintings of Zurbaran: Complete Edition*, London 1953

Soria 1955
M.S. Soria, 'Zurbarán's Crucifixion', *The Art Institute of Chicago Quarterly*, IL (1955), pp. 48–9

Sotheby's 1994
Old Master Paintings, auction catalogue, 6 July, London 1994

Souto 1983
J.L. Souto, 'Esculturas de Pedro de Mena en Budia (Guadalajara). Una Dolorosa y un Ecce-Homo, réplica de otro de las Descalzas Reales', *Reales Sitios*, XX, 75 (1983), pp. 21–9

Spinosa 2003
N. Spinosa, *Ribera: l'opera completa*, Naples 2003

Stoichita 1995
V.I. Stoichita, *Visionary Experience in the Golden Age of Spanish Art*, London 1995

Stratton 1988
S.L. Stratton, 'La Inmaculada Concepción en el arte español', *Cuadernos de arte e iconografía*, I, 2 (1988), pp. 3–127

The Canons (1851)
The Canons and Decrees of the Council of Trent, trans. T.A. Buckley, London 1851

Trapier 1943
E. du Gué Trapier, 'The Son of El Greco', *Notes Hispanic*, III (1943), pp. 1–47

Trapier 1948
E. du Gué Trapier, *Velázquez*, New York 1948

Trusted 1996
M. Trusted, *Spanish Sculpture: Catalogue of the Post-Medieval Spanish Sculpture in Wood, Terracotta, Alabaster, Marble, Stone, Lead and Jet in the Victoria and Albert Museum*, London 1996

Trusted 1997
M. Trusted, 'Art for the Masses: Spanish Sculpture in the Sixteenth and Seventeenth Centuries' in *Sculpture and its Reproductions*, eds A. Hughes and E. Ranfft, London 1997, pp. 46–60

Trusted 2007
M. Trusted, *The Arts of Spain: Iberia and Latin America 1450–1700*, London 2007

Urrea Fernández 1972
J. Urrea Fernández, 'Un Ecce Homo de Gregorio Fernández', *Boletín del Seminario de Estudios de Arte y Arqueología*, XXXVIII (1972), pp. 554–6

Valdivieso and Serrera 1985
E. Valdivieso and J.M. Serrera, *Historia de la pintura española: Escuela sevillana del primer tercio del siglo XVII*, Madrid 1985

Valdivieso 1992
E. Valdivieso, *Historia de la Pintura Sevillana*, Seville 1992

Valencia–Madrid 1987–8
Los Ribalta y la pintura valenciana de su tiempo, ed. F. Benito Domenech, exh. cat., Lonja de Valencia, Valencia, and Museo del Prado, Madrid 1987–8

Valladolid 1989–90
Pedro de Mena y Castilla, exh. cat., Museo Nacional de Escultura, Valladolid 1989–90

Valladolid 2008
Gregorio Fernández: La gubia del barroco, eds A. Álvarez Vicente and J.C. García Rodríguez, exh. cat., Sala Municipal de Exposiciones de la Pasión and Iglesia Penitencial de la Vera Cruz, Valladolid 2008

Varia velázqueña 1960
Varia velázqueña: homenaje a Velázquez en el III centenario de su muerte, 1660–1960, ed. A. Gallego y Burín, 2 vols, Madrid 1960

Vega 1910
F. de P.L. de la Vega, *Indice crítico de las obras del escultor Pedro de Mena y Medrano, existentes en Málaga*, Madrid 1910

Véliz 1986
Z. Véliz, *Artists' Techniques in Golden Age Spain: Six Treatises in Translation*, Cambridge 1986

Véliz 1999
Z. Véliz, 'Retratos de sor Jerónima de la Fuente: iconografía y función' in *Velázquez*, Barcelona 1999, pp. 397–411

Verdi Webster 1998
S. Verdi Webster, *Art and Ritual in Golden-Age Spain: Sevillian Confraternities and the Processional Sculpture of Holy Week*, Princeton, New Jersey, 1998

Wadsworth Atheneum 1991
Wadsworth Atheneum Paintings II: Italy and Spain: Fourteenth through Nineteenth Centuries, ed. J.K. Cadogan, Hartford, Conn., 1991

Wethey 1955
H.E. Wethey, *Alonso Cano: Painter, Sculptor, Architect*, Princeton 1955

Wethey 1958
H.E. Wethey, *Alonso Cano, pintor*, trans. M. Cirre, Madrid 1958

Wethey 1983
H.E. Wethey, *Alonso Cano: Pintor, escultor, arquitecto*, trans. R. Palencia del Burgo, Madrid 1983

Zaragoza 2008
Del Ebro a Iberia, ed. A.-I. Meléndez Alonso, exh. cat., Museo Ibercaja 'Camón Aznar', Zaragoza 2008

Zimmerman 1910
B. Zimmerman, 'Saint John of the Cross' in *The Catholic Encyclopedia*, VIII, New York 1910, pp. 480–1

Further Reading

J. Agapito y Revilla, *Las cofradías, las procesiones y los pasos de Semana Santa en Valladolid*, Valladolid 2007 (1st edn 1925)

M. Agulló y Cobo, *Documentos para la historia de la escultura española*, Madrid 2005

M. Baker, 'Spain and South Kensington. John Charles Robinson and the Collecting of Spanish Sculpture in the 1860s' in *The V&A Album 3*, London 1984, pp. 340–9

F. Calvo Serraller, 'El problema del naturalismo en la crítica artística del Siglo de Oro', *Cuenta y razón*, 7 (1982), pp. 83–99

O. Delenda, *Francisco de Zurbarán pintor 1598–1664*, Madrid 2007

M. Dieulafoy, *La statuaire polychrome en Espagne*, Paris 1908

A. Gallego y Burín, *José de Mora: su vida y obra*, Granada 1925

A. Gallego y Burín, *Estudios de escultura española*, ed. D. Sánchez-Mesa Martín, Granada 2006

E. García Chico, *La Cofradía Penitencial de la Santa Vera Cruz*, Valladolid 1962

J. Hazañas y la Rúa, *Vázquez de Leca: 1573–1649*, Seville 1918

K. Hellwig, *Die spanische Kunstliteratur im 17. Jahrhundert*, Frankfurt am Main 1996

Father A. de Llordén, 'El imaginero Pedro de Mena, notas y documentos', *La Ciudad de Díos*, CXXXVIII, 2 (1955), pp. 106–57

J.J. López-Guadalupe Muñoz, *José de Mora*, Granada 2000

J.J. Martín González, 'Los "Pasos" de Semana Santa y sus relaciones con el dibujo y la pintura', *Boletín del Seminario de Estudios de Arte y Arqueología*, 19 (1955), pp. 141–2

J.J. Martín González, *El artista en la sociedad española del siglo XVII*, Madrid 1984

J.J. Martín González, *Escultura barroca en España, 1600–1770*, 3rd edn, Madrid 1998

J. Moya Morales and J.M. Rodríguez-Acosta Márquez, *Alonso Cano en el legado Gómez-Moreno*, Madrid 2008

M. Nancarrow Taggard, 'Piety and Profit in Spanish Religious Art', *Gazette des Beaux-Arts*, CXXXIV (1999), pp. 201–12

J. Roda Peña, 'Valdés Leal, escultor. Aportación a su catálogo', *Laboratorio de Arte*, 14 (2001), pp. 51–64

Index

Numbers in *italics* refer to illustrations; numbers in **bold** refer to catalogue entries

Alberti, Leon Battista 191
Alcala, 3rd Duke of 76
Alfonso IX 192
Aránzazu 164
Astruc, Zacharie 188
Augustinians 46
Azuaga: Mercedarian monastery 18, 80

Bances Candamo, Francisco Antonio 150
Becerra, Gaspar 18
 Dead Christ 164
Benedictines 28, 46, 49
Bernard of Clairvaux, Saint 17, 31, 102, *103*, 162, *163*
Berruguete, Alonso 18
Bolswert, Schelte: *Saint Augustine as Protector of the Clergy* 33, 34, 106, *106*, 108
Bonaventura, Saint (attrib.): *Vita Christi* 52
Borgia, Saint Francis 19
 see also under Cano, Alonso; Montañés, Juan Martínez
Bouts, Dirk, workshop of
 Christ Crowned with Thorns 144, *144*
 Mater Dolorosa 144, *144*
Bridget of Sweden, Saint: *Revelations* 52, 76
brotherhoods 46, *see* confraternities
Bruno, Saint 18, 55–6, 162
 see also under Montañés, Juan Martínez
Burgos: Cartuja de Miraflores 34, *52*, 55

Cajés, Eugenio: *Pope Nicholas V before the body of Saint Francis* 178, *178*
Camilo, Francisco 19, 50
Cano, Alonso 18, 21–2, 26, 30, 31, 38, 60, 86, 91, 196
 Saint Francis Borgia (cat. 13) 30–1, 105, **114–15**, 116
 Saint John of God (cat. 6) 21, 22, *22*, *72*, 73, **86–9**
 Saint Teresa's Vision of the Resurrected Christ 46
 Virgin of the Immaculate Conception 26, 53, *55*
 The Vision of Saint Bernard of Clairvaux (*The Miracle of the Lactation*) (cat. 10) 17, 31, **102–3**
Cansino, Andrés 60
Capuchins 48, 102, 173, 174, 178
Caravaggio, Michelangelo Merisi da 15, 17, 108, 170
 Martyrdom of Saint Peter 162
Carmelites, Barefoot/Discalced 46, 47, 59, 126, 156
Carthusians 33, 46, 55, 56, 102, 106, 110, 162
Catherine of Siena, Saint 162
Charles V, Emperor 57, 114, 194

Christ as the Man of Sorrows see *Ecce Homo*
 see also under Fernández, Gregorio; Mena, Pedro de; Mora, José de
Christ on the Cross (anon.) *122*
Cid, Miguel 91
Cistercians 46, 102, 146
Coello, Sánchez: *Saint Ignatius Loyola* 116
cofradías see confraternities
Colonna, Marcantonio 170
confraternities 19, 40, 46, 47, 48, 78, 130, 170
Crucifixion with Four Nails 76, *76*

Dominguez, Father Blas 106
Dominic, Saint (Domingo de Guzmán) 55, *57*
Dominicans 15, 46, 49, 53, 55, 91, 114, 138, 160, 164
Dürer, Albrecht
 Calvary 76
 The Mass of Saint Gregory 50

Ecce Homo 16, *26*, 40, 52, 62, 130, 140, *140*
 see also under Fernández, Gregorio; Mena, Pedro de; Mora, José de
El Pedroso, Seville: Church of Santa María/Nuestra Señora de la Consolación 19, *29*, 53, 92

Fernández, Gregorio 19, 29, 33, 47, 50, 102, 188, 196
 Christ at the Column 30, 50, *51*, 129, 138, *138*
 Christ embracing Saint Bernard 162, *162*
 Dead Christ (cat. 27) *12–13*, 29, 52, 62, *64*, 129, **164–9**
 The Dead Christ (*Cristo del Pardo*) 48
 Ecce Homo (cat. 18) 29, 30, *33*, 40, 50, 62, 65, **130–5**, 138
 Penitent Magdalen (attrib.) 150, *150*
 Saint Francis 180
Ford, Richard 173, 188
Francis of Assisi, Saint 18, 21, *21*, 53
 see also under Mena, Pedro de; Zurbarán, Francisco de
Franciscans 46, 52, 53, 140, 164, 173, 178, 180
Franconio, Juan Bautista 124

Galván, Francisco Fernández 18
Giambologna
 Equestrian statue of Philip III 45
 Samson and a Philistine 29–30
Gijón, Francisco Antonio 60, 196
 Saint Anthony Abbot 126
 Saint John of the Cross (cat. 17) 57, *58*, 59–62, *63*, *64*–6, *67*, 68, *69*, 70, **126–7**

Granada 47
 Cathedral 26, *55*
 Church of Santa Ana 148
 Church of Santa Magdalena 152
 Convent of Santa Isabel 26, *26*
 Instituto Gómez-Moreno 30, 76
 Museo de Bellas Artes 86
guilds 18, 47, 60, 70, 73

Hieronymites 19, 28, 46

Inquisition, the 49
Isabella of Portugal, Empress 57, 114, 118

Jáuregui, Juan de: *Diálogo entre la naturaleza y las dos artes pintura y escultura* 38
Jerome, Saint 28
 see also under Montañés, Juan Martínez
Jesuits 19, 30, 46, 47, 49, 50, 52, 57, 76, 98, 105, 114, 116, 136, 150, 152, 162, 164
John of Ávila 52
John of God, Saint 86
 see also under Cano, Alonso
John of the Cross, Saint 17–18, 45–6, 47
 The Ascent of Mount Carmel 45, 57, 59, 126
 see also under Gijón, Francisco
John the Baptist, Saint 82
John the Evangelist, Saint 53, 92, 94, 164, 170
Juan de Pineda, Padre: *Sermón de la Llagas* 76
Juan José de Austria, Don 129, 142
Juana, Queen of Portugal 52

La Fuente, Jerónima de 50, 105
Leonardo, José 19
Leonardo da Vinci 191
Lerma, Duke of: collection 29, 164
Llanos y Valdés, Sebastián: *Head of Saint John the Baptist* 82, 84
Losada, Father Juan de 116
Loyola, Saint Ignatius 47
 see also under Montañés, Juan Martínez
 Spiritual Exercises 40, 50
Luis de Granada 52
Luke, Saint 31, 80, *81*

Madrazo y Agudo, José de 176
Madrid 19
 Church of the Casa Profesa (Jesuit House) 50, 52, 129, 150, 152
 Convent of the Descalzas Reales 28, 28, 53, 116, 140, 142, 150, 164
 Convent of the Encarnación de San Plácido 28, 49, *136*
 Museo Nacional del Prado *31*, *56*, 74, 80, 102, 122, 124, 162, 176

Malouel, Jean: *Well of Moses* 19
Mancini, Giulio 170
Manrique de Lara, Antonio, Count of Mollina y Frigilliana 146
Mary, Virgin 52
 see also under Cano, Alonso; Mena, Pedro de; Montañés, Juan Martínez
Mary Magdalene 150, *150*, 170
 see also under Mena, Pedro de
Mater Dolorosa see *Virgin of Sorrows*
Medina de Rioseco: Convento de Santa Clara 188
Medina Sidonia, Dukes of 136
Mejías, Domingo 60, 126

Mena, Pedro de 26, 38, 49, 50, 52, 142, 196
 Christ as the Man of Sorrows (*Ecce Homo*) (cat. 20) *2*, 50, 52, *53*, 129, **140–3**
 Mary Magdalene meditating on the Crucifixion (cat. 23) 50, 53, 62, 86, **150–5**
 Mary Magdalene meditating on the Crucifixion (after Mena) 152, *152*
 Saint Francis standing in Ecstasy (cat. 34) (after Mena) **188–9**
 Saint Francis standing in Ecstasy (cat. 33) 38, *39*, 53, 55, *65*, 150, *172*, 173, 180, **182–7**
 Virgin of Sorrows (*Mater Dolorosa*) (cat. 21) *44*, *49*, 129, 140, **144–7**, 150
Mercedarians 18, 46, 56, 80, 192
Mesa, Juan de 18, 47, 78, 196
 Christ carrying the Cross (*Cristo del Gran Poder*) 40, *41*, 48, 129
 Christ on the Cross (cat. 3) **78–9**
 Christ on the Cross (*Cristo del Amor*) 78, *78*
 Christ on the Cross (*Cristo de la Buena Muerte*) 15, 17, 49–50
 Cristo de Medinaceli 40
 Head of Saint John the Baptist (cat. 5) 73, **82–5**
Montañés, Juan Martínez 19, 21, 22, 25, 40, 47, 60, 82, 86, 191, 194–5, 196
 Christ carrying the Cross (*Cristo de la Pasión*) 16, 17, 48
 Christ on the Cross, also known as *Christ of Clemency* (*Cristo de la Clemencia*) (with Pacheco) *24*, 25, 28, *31*, 49, 76, 156
 Christ on the Cross (*Cristo de los Desamparados*) (cat. 24) *128*–9, **156–9**
 Inmaculada see *The Virgin of the Immaculate Conception* (below)
 Niño Jesús 19

Penitent Saint Jerome (with Pacheco) 19, *20*, 61, 74
portraits 73, 74, *75* (Velázquez), 74, *74* (Varela)
Saint Bruno meditating on the Crucifixion (cat. 12) 21, *21*, 33–4, *35*, 55, 88, 108, *108*, *109*, **110–13**
Saint Dominic flagellating himself (with Pacheco) 55, *57*
Saint Francis 21, *21*
Saint Francis Borgia (with Pacheco) (cat. 14) 19, 21, *23*, 30, 56–7, 62, 64, 73, 88, *104*, 105, **116–18**, *120*, *121*
Saint Ignatius Loyola (with Pacheco) (cat. 15) 57, 62, 64, 73, 88, 105, 116, 118, *119*, 124
The Virgin of the Immaculate Conception (with Pacheco) (cat. 7) 19, 29, *29*, 53, 68, 73, 91, **92–3**, 94, *96*
The Virgin of the Immaculate Conception (attrib.) (cat. 9) *54*, *90*, 91, **98–101**
The Virgin of the Immaculate Conception ('Little Blind Girl') 98, *98*
Mora, José de 26, 196
Ecce Homo 26, *26*, *27*
The Virgin of Sorrows (*Mater Dolorosa*) 26, *26*, *27*
The Virgin of Sorrows (*Mater Dolorosa*) (cat. 22) 53, 62, 86, **148–9**
Murillo, Bartolomé 98, 102

Nicholas IV, Pope 53, 188
Nicholas V, Pope 38, 178, *178*
Nolasco, Saint Pedro 56, *56*
Núñez Delgado, Gaspar 21, 84

Oratorians 46
Ortiz, Fernándo 188

Pacheco, Francisco 18, 19, 21, 22, 25, 28, 30, 38, 49, 53, 74, 86, 94, 124, 173, 180, 191, 194–5, 197
Arte de la Pintura 19, 49, 59, 64, 65, 66, 68, 76, 80, 91, 94, 110, 116, 124
Christ on the Cross (cat. 2) 28, *30*, 49, **76–7**
see also under Montañés, Juan Martínez
Padilla, Father Gaspar de: altarpiece 116
Palomino, Antonio 15, 18, 160
Life of Alonso Cano 22, 70
Life of Gregorio Hernández [*Fernández*] 33, 134
Life of Pedro de Mena 52
Life of Juan Martínez Montañés 40

Life of Zurbarán 108, 160
Pereira, Manuel 19
Ecce Homo 50
Saint Bruno meditating on the Crucifixion 34, *52*, 55–6
Philip II, of Spain 49, 52
Philip III, of Spain 45, 48, 136
Philip IV, of Spain 45, 48, 49, 56, 73, 74, 129
Poor Clares 50, 52, 122

Quintero, Baltasar 22, 25, 110
Virgin of the Immaculate Conception 98

Raxis, Pedro de: *Saint John of God* 86
Ribadeneyra, Father Pedro de 116, 162
Ribalta, Francisco 170, 197
Christ embracing Saint Bernard of Clairvaux (cat. 26) **162–3**
The Vision of Father Simón 17, *17*
Ribera, Jusepe 197
The Lamentation over the Dead Christ (cat. 28) 52, 129, **170–1**
Rincón, Francisco: *The Raising of the Cross* 48
Rioja, Francisco de 76
Robinson, Sir (John) Charles 188
Roda Peña, José 59–60, 126
Roelas, Juan de 102
Christ after the Flagellation contemplated by the Christian Soul 136, *136*, 138
Roldán, Luisa: *Saint Ginés de la Jara* 62
Roldán, Pedro 19, 26, 60
plaster frames 106, *106*, 108
Ruiz del Peral, Torcuato 84

Salcedo, Bernardo de 40, 130
Sanlúcar de Barrameda: Convent of San Francisco 136
Santiponce: San Isidoro del Campo 19, *20*
Serapion, Saint 36, *36–7*, 56, 192
see also under Zurbarán, Francisco de
Seville 17, 19, 47, 50, 92, 98, 116, 129
Basilica de Nuestro Padre Jesús del Gran Poder (Church of San Lorenzo) 41, 48
Cathedral *31*, 49, 82, 98, *98*
Church of the Casa Profesa 57
Church of El Salvador *16*, 48
Church of San Antón 17
Church of the Santa Ángel 156
Collegiate Church of El Salvador 78, *82*
Confraternity of the Holy Sacrament 19

Convent of La Encarnación 116
Convent of Nuestra Señora de los Remedios 59, 126
Convent of Santa Clara 22, 82, 84, 191
Friary of San Pablo 15
Guild of Saint Luke 28
Iglesia Conventual de Santo Ángel 156
Monastery of Buenavista 28
Monastery of Nuestra Señora de la Merced 192
Monastery of San Pablo el Real 15, 49, 114, 160
Monastery of Santa María de Las Cuevas 32, 106, 110
Museo de Bellas Artes *57*, 106, 110, 114
University 98, 116
see also El Pedroso
Sluter, Claus: *Well of Moses* 19
Soto, Domingo de 55
Sotomayor, Fray Antonio de 138

Tacca, Pietro: *Equestrian statue of Philip IV* 45, 74
Teresa of Ávila, Saint 45–6, *46*, 47, 59
Libro de la vida 47, 50
Theatines 46
Toledo Cathedral 55, 150, 173, 182, 188
Torrigiano, Pietro: *Penitent Saint Jerome* 28
Trent, Council of / Tridentine decrees 40, 45, 46, 47, 49, 53, 56, 65, 105

Valdés Léal, Juan de 19, 26
Valentín Díaz, Diego 19, 49, 164
Valladolid 19, 29, 30, 47, 48, 129
Church of San Miguel 152, *152*
Church of San Nicolás 130
Church of the True Cross 51
Confraternity and Church of the True Cross 30, 48, *51*
Confraternity of the Santísimo Sacramento y Ánimas 130
Confraternity of the Santo Sacramento 40
Monastery of the Huelgas Reales 162, *162*
Museo del Monasterio Real de San Joaquín y Santa Ana 144, 146
Museo Diocesano y Catedralicio 130
Museo Nacional Colegio de San Gregorio 48, 150, 164
Museo Nacional de Escultura 188
Van Dyck, Anthony: *Ecce Homo* 148, *140*
Varela, Francesco: *Portrait of Juan Martínez Montañés* 61, 74, *74*
Vasari, Giorgio 191

Vázquez Cano, Juan 84
Vázquez de Leca, Mateo 25, 49, 156
Velázquez, Diego 18, 19, 28, 30, 88, 91, 92, 197
Christ after the Flagellation contemplated by the Christian Soul (cat. 19) 29, 30, 50, 129, 130, **136–9**
Christ on the Cross 289, *31*, 49, *50*, 76
The Immaculate Conception (cat. 8) 29, *29*, 53, **94–7**
Portrait of Juan Martínez Montañés (cat. 1) 73, **74–5**
Saint John the Evangelist on the Island of Patmos 94, *94*
The Venerable Mother Jerónima de la Fuente (cat. 16) 50, 105, **122–5**
Villanueva, Jerónimo de 49
Virgin of Sorrows 26, *26*, 49, 52, 53, 140, 144, 148
see also under Mena, Pedro de; Mora, José de
Vitoria, Francisco de 55
Vorsterman, Lucas, the Younger: *Ecce Homo* 140, *140*

Wierix, Hieronymus: *Child protected by his Guardian Angel* 136, *136*

Xavier, Saint Francis 116

Yepes, Tomás: *Virgen de los Desamparados* 28, *28*

Zapata, Cardinal Antonio 55
Zurbarán, Francisco de 17, 18, 21, 31, 114, 197
Christ on the Cross (cat. 25) *14*, 15, 18, *30*, 32, *32*, 34, *36*, 40, 49, 76, **160–1**, 174
Head of a Monk (cat. 30) **176–7**
Pope Urban II and Saint Bruno 106
Saint Francis kneeling in Meditation (cat. 29) **174–5**
Saint Francis standing in Ecstasy (cats 31 and 32) 38, *39*, 53, 55, 173, **178–81**, 182, 188
Saint Hugh in the Refectory 106
Saint Luke contemplating the Crucifixion (cat. 4) 31, 73, **80–1**
Saint Pedro Nolasco's vision of the Crucified Saint Peter 56, *56*
Saint Serapion 36, *36–7*, 56, *190*, 191, **192–3**
The Virgin of Mercy of Las Cuevas (cat. 11) 32–3, 34, *34*, **106–9**

List of Lenders

Barcelona
Museu Nacional d'Art de Catalunya

Boston
Museum of Fine Arts

Chicago
The Art Institute of Chicago

Granada
Fundación Rodríguez-Acosta

Hartford, Connecticut
Wadsworth Atheneum

London
The British Museum
Victoria and Albert Museum

Madrid
Museo Nacional del Prado
Patrimonio Nacional

Seville
Archicofradía del Santísimo Cristo del Amor
Iglesia Conventual del Santo Ángel
Museo de Bellas Artes
Seville Cathedral
Seville University

Toledo
Toledo Cathedral

Valladolid
Monasterio Real de San Joaquín y Santa Ana
Museo Diocesano y Catedralicio

Washington DC
National Gallery of Art

Private collection

Cats 2, 3, 5, 6, 10, 11, 12, 16, 23, 27, 29, 30, 31, 32 and 34 shown in London only.

Photographic credits

Barcelona
© MNAC - Museu Nacional d'Art de Catalunya, Barcelona. Photographers: Calveras/Mérida/Sagristà: cat. 31, fig. 127

Boston
© 2009 Museum of Fine Arts, Boston, MA: cat. 32

Burgos
Cartuja de Miraflores © Photo Imagen M.A.S.: fig. 35

Cádiz
Convento de San Francisco © Photo Luis Arenas, Seville: fig. 6

Chicago, Illinois
© The Art Institute of Chicago: cat. 25, figs 1, 19, 22

Granada
Cathedral © akg-images / Erich Lessing: fig. 38; Convento de Santa Isabel la Real, Granada © Photo Imagen M.A.S. courtesy of Convento de Santa Isabel la Real, Granada: figs 11, 12, 13, 14; Instituto Gómez-Moreno de la Fundación Rodríguez-Acosta, Granada © Courtesy of Fundación Rodríguez-Acosta, Granada, photo Javier Algarra: cat. 2, fig. 18; Museo de Bellas Artes, Granada © Photo Imagen M.A.S. Courtesy of Museo de Bellas Artes, Granada: cat. 6, figs 8, 54, 61–64

Hartford, Connecticut
© Wadsworth Atheneum Museum of Art, Hartford, Connecticut: cat. 35, figs 26, 140

London
© By Permission of The British Library, London: fig. 56; © The Trustees of The British Museum: cat. 30; fig. 97; © The National Gallery, London: back cover, cats 8, 19, 28, 29, figs 4, 16, 67, 68, 70, 99, 103, 104, 124; © V&A Images / Victoria and Albert Museum, London: cats 22, 34, fig. 107

Lyon
Musée des Beaux Arts de Lyon © Photo12.com – ARJ: fig. 28

Madrid
© Biblioteca Nacional de España, Madrid: endpapers, fig. 141; Colección Forum Filatélico, Madrid © Photo Imagen M.A.S.: fig. 31; Monasterio de la Encarnación, Madrid © Patrimonio Nacional, Madrid: fig. 96; Museo Nacional del Prado, Madrid © Museo Nacional del Prado, Madrid: cats 1, 4, 10, 26, figs 21, 33, 39, 110a; Museo Nacional del Prado, Madrid © Photo Imagen M.A.S. Courtesy of Museo Nacional del Prado, Madrid: pp. 12–13, cats 23, 27, figs 46, 47, 110b–112, 117–123; Real Monasterio de las Descalzas Reales © Patrimonio Nacional, Madrid: figs 15, 108; Real Monasterio de las Descalzas Reales © 2009 Photo Gonzalo de la Serna. Reproduction courtesy of Patrimonio Nacional, Madrid: p. 2, cat 20, figs 36, 101, 102

Málaga
© Photo Imagen M.A.S. Courtesy of the Church and Sanctuary of Santa Maria de la Victoria: cat. 21a; figs 30, 105

El Pedroso
Parish Church of Nuestra Señora de la Consolación © Photo The National Gallery, London: cat. 7, figs 17, 66, 69

Paris
Bibliothèque nationale de France: fig. 75

Private collections
© 2009 Photo Gonzalo de la Serna, by courtesy of the owner: cat. 16, fig. 87; © Photo courtesy of the owner: fig. 86

Santiponce
Monasterio de San Isidoro del Campo © Photo The National Gallery, London: fig. 5

Seville
Archicofradía del Santísimo Cristo del Amor © Photo The National Gallery, London: cat. 3; Ayuntamiento de Sevilla © Photo The National Gallery, London. Courtesy of Centro Velázquez. Fundación Focus-Abengoa / Ayuntamiento de Sevilla: fig. 55; Basílica de Nuestro Padre Jesús del Gran Poder, Seville © Photo The National Gallery, London: fig. 29; Chapel of the University of Seville © Photo The National Gallery, London. Courtesy of Universidad de Sevilla: fig. 2; Church of the Anunciación, University of Seville © Photo Imagen M.A.S. Reproduction courtesy of Universidad de Sevilla: front cover, back cover, cats 9, 14, 15, figs 9, 37, 65, 72–74, 84, 85; Church of the Anunciación, University of Seville © Photo Luis Arenas, Seville. Reproduction courtesy of Universidad de Sevilla: fig. 83; Cofradía del Cristo de la Pasión, Collegiate Church of El Salvador, Seville © Photo Luis Arenas, Seville: fig. 3; Dependencias de la Hermandad del Amor, Collegiate Church of El Salvador, Seville © Photo The National Gallery, London: fig. 57; Collegiate Church of El Salvador, Seville © Instituto Andaluz del Patrimonio Histórico. Photo José Manuel Santos: fig. 58; Iglesia Conventual del Santo Ángel, Carmelitas Descalzos, Seville © Instituto Andaluz del Patrimonio Histórico. Photo: Eugenio Fernández Ruiz: fig. 113; Iglesia Conventual del Santo Ángel, Carmelitas Descalzos, Seville © Photo The National Gallery, London: cat. 24, figs 88, 114, 115; Sacristy, Monastery of Santa María de Las Cuevas, Seville © Photo Xavier Bray: fig. 76; Museo de Bellas Artes, Seville © Museo de Bellas Artes, Seville: cat. 13; Museo de Bellas Artes, Seville © Photo Imagen M.A.S. Courtesy of Museo de Bellas Artes, Seville: cats 11, 12, figs 7, 24, 25, 77–82; Museo de Bellas Artes, Seville © Photo The National Gallery, London. Courtesy of Museo de Bellas Artes, Seville: fig. 40; Museo de Bellas Artes, Sevilla (on long loan to Seville Cathedral) © Photo The National Gallery, London. Courtesy of Museo de Bellas Artes de Sevilla: figs 10, 20; Seville Cathedral © Photo The National Gallery, London: cat. 5, figs 59, 60, 71

Toledo
Toledo Cathedral © Fototeca de Obras Restauradas. Instituto del Patrimonio Cultural de España. Dirección General de Bellas Artes y Bienes Culturales. Ministerio de Cultura. Gobierno de España. Photo: José Luis Municio: cat. 33, figs 27, 48, 125, 128–131, 135–139; © Fototeca de Obras Restauradas. Instituto del Patrimonio Cultural de España. Dirección General de Bellas Artes y Bienes Culturales. Ministerio de Cultura. Gobierno de España: figs 132–134

Valladolid
Iglesia de la Vera Cruz © Photo José María Pérez Concellón. Courtesy of Junta de Cofradías de Semana Santa de Valladolid: fig. 34; Iglesia de la Vera Cruz © Photo Pedro J. Muñoz Rojo. Courtesy of Junta de Cofradías de Semana Santa de Valladolid: fig. 98; Iglesia de San Miguel, Valladolid © Photo Andrés Alvarez Vicente: fig. 109; Monastery of the Huelgas Reales, Valladolid © Photo Imagen M.A.S.: fig. 116; Museo del Monasterio Real de San Joaquín y Santa Ana, Valladolid © Photo Imagen M.A.S. Courtesy of Museo del Monasterio Real de San Joaquín y Santa Ana: cat. 21b, fig. 106; Museo Diocesano y Catedralicio, Valladolid. Instituto del Patrimonio Cultural de España © Fototeca de Obras Restauradas. Instituto del Patrimonio Cultural de España. Dirección General de Bellas Artes y Bienes Culturales. Ministerio de Cultura. Gobierno de España. Photo: José Luis Municio: cat 18, figs 23, 89–95; © Museo Nacional Colegio de San Gregorio, Valladolid: fig. 32

Vienna
© Albertina: fig. 126; © Kupferstichkabinett der Akademie der bildenden Künste, Wien: fig. 100

Washington, DC
Image courtesy of the Board of Trustees, National Gallery of Art, Washington, DC.: cat. 17, figs 41–45, 49–53

The translation of Pacheco's letter to Montañés on pp. 194–5 is reproduced by kind permission of Jonathan Brown.

This exhibition has been made possible with the assistance of the Government Indemnity Scheme which is provided by DCMS and administered by MLA.

THE SACRED MADE REAL

SPANISH PAINTING AND
SCULPTURE 1600–1700

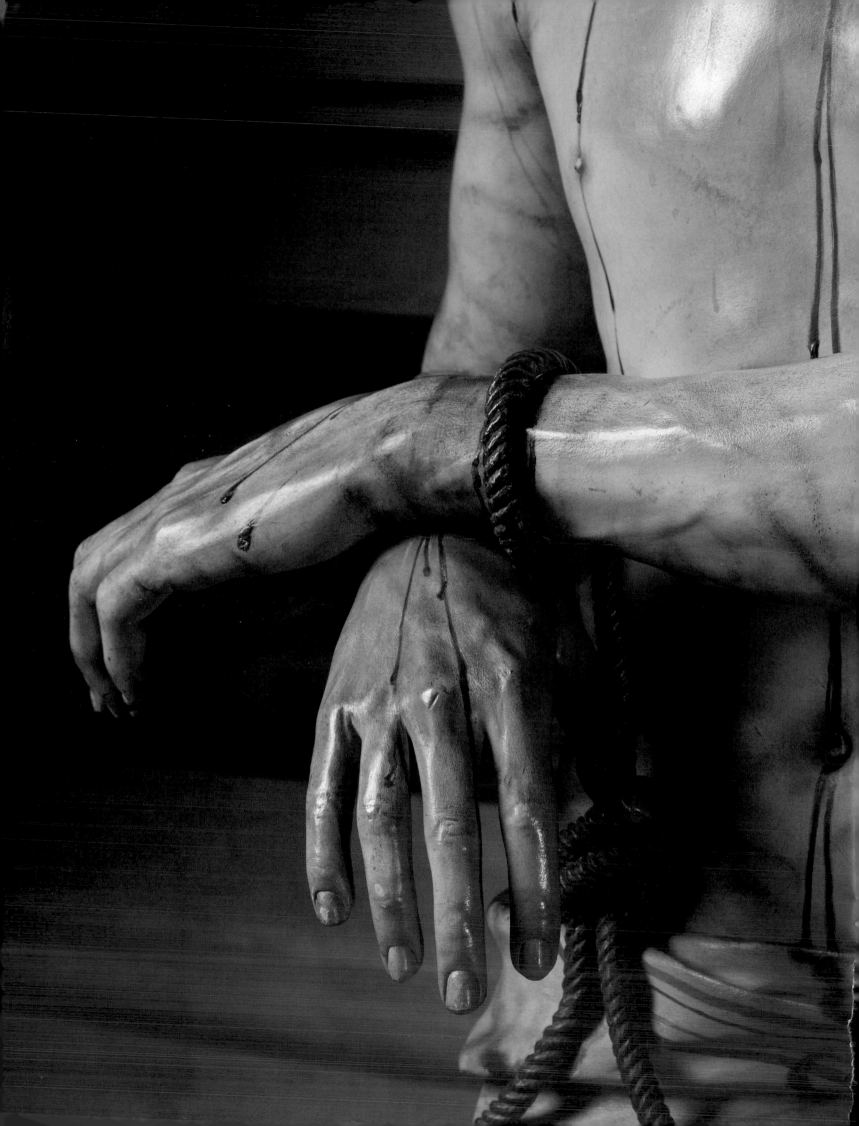